I'LL BE YOUR MIRROR

I'LL BE YOUR MIRROR

I'LL BE YOUR MIRROR

The Selected Andy Warhol Interviews

1962–1987

Edited by
KENNETH GOLDSMITH

Introduction by
REVA WOLF

Afterword by
WAYNE KOESTENBAUM

CARROLL & GRAF PUBLISHERS
NEW YORK

I'LL BE YOUR MIRROR
The Selected Andy Warhol Interviews, 1962-1987

Carroll & Graf Publishers
An Imprint of Avalon Publishing Group Inc.
245 West 17th Street
11th Floor
New York, NY 10011

AVALON
publishing group incorporated

Library of Congress Cataloging-in-Publication Data is available.

ISBN: 0-7867-1364-X

Design by Simon M. Sullivan
Photo insert design by Maria Elias
Printed in the United States of America
Distributed by Publishers Group West

JORDAN CRANDALL: Do you look at yourself in the mirror?

ANDY WARHOL: No. It's too hard to look in the mirror. Nothing's there.

CONTENTS

THE SIXTIES

THE SEVENTIES

THE EIGHTIES

Introduction Through the Looking-Glass

REVA WOLF

Can an interview be a work of art? This is one of the many questions Andy Warhol posed for us in the hundreds of interviews in which he was a participant—interviews in which he was sometimes the interviewee, sometimes the interviewer, and sometimes played both roles at once. He posed this question by refusing, in the cleverest ways imaginable, to take interview questions seriously. It is as though the *less* serious his answers or his questions were, the *more* serious the ideas left behind for posterity to sort out; and, the more evasive his utterances, the more profound their implications. An answer such as "I don't know," to take a conspicuous example, came to have the tenor of a zany philosophical meditation. Just look at the following collection of questions and answers, excerpted from interviews conducted with Warhol over a period of some fifteen years:

What is Pop Art trying to say?
I don't know.
(1962)[1]

How did you get started making movies?
Uh . . . I don't know. . . .
(1965)[2]

What do you believe in?
Andy Warhol put his fingers in front of his mouth in a characteristic gesture. It was as though he wanted to stuff the words back in as they came out. "I don't know," he said. "Every day's a new day."
(1966)[3]

What is your role, your function, in directing a Warhol film?

I don't know. I'm trying to figure it out.
(1969)[4]

*But why Elvis Presley, I mean why did you suddenly pick on poor Elvis
to do the silkscreens of?*
I'm trying to think. I don't know.
(1972)[5]

What does life mean to you?
I don't know. I wish I knew.
(1975)[6]

Such a sequence of questions and answers raises the sorts of unanswerable questions that to greater and lesser degrees we all bump into, grapple with, try to ignore, and otherwise contend with as we maneuver through life. Why, even now as I write this essay, I wonder: do I really know what I want to say? do I know my "role" or "function," or my intentions? and, by extension, do I know what life means to me? These questions of existence are so fundamental—newly reinvented for each generation—that they can be embarrassing to articulate. What is extraordinary about how Warhol asked them is that he found a way to get around this embarrassment through the use of evasion—and, more precisely, through the particular forms, nuances, and textures of evasion that he created.

Through his masterful use of evasion, Warhol also elicited all kinds of questions about the interview itself. What is the appeal of both published and broadcast interviews, and why have they become so extraordinarily ubiquitous in the past fifty years? How do interviews with artists affect our understanding of an artist's work? What do we make of the fact that most interviews are edited in one way or another, but have the look of verbatim transcriptions? Are there formulas and traditions specific to the interview? What is the history of interviews with visual artists, and how does this history connect with the histories of interviews with literary figures, politicians, or entertainers?

The Interview and Art History:
Formulas and Traditions Exposed

If Warhol avoided answering a question in a direct way, there was a good chance it had to do with the formulaic, or canned, nature of that question. What Warhol accomplished through avoidance was more important than answering the question: he exposed its predictability (even though he sometimes invented his own formulas in the process). One of the most predictable types of question in interviews with visual artists concerns what they think of their predecessors.[7] (An entire book of interviews appeared recently that is devoted to this very question.[8]) Behind this question is the issue of influence — of artistic genealogy—a standard topic of art-historical discourse.

A veritable genre of interviewing that became popular in the 1970s consisted of an art critic asking each of a handful of artists her or his thoughts about the same art-world luminary; all the responses were then published together as a collection. For example, Jeanne Siegel polled eleven artists — Warhol among them—about the abstract expressionist painter Barnett Newman on the occasion of a large retrospective exhibition of Newman's work held in 1971 at the Museum of Modern Art in New York. The artists dutifully spoke about what they perceived to be the significance of Newman's work. Warhol spoke about the art, too, making light of Newman's reductive abstract compositions of vertical lines. However, what seemed to really grip him was Newman's social life, about which he said:

> The only way I knew Barney was I think Barney went to more parties than I did. I just don't know how he got around—I mean he'd go off to the next party. And it's just so unbelievable; why I just think he's at another party. Don't you think he's just at another party? Maybe he didn't have to work a lot if he just painted one line, so he had time for parties.[9]

In this passage, to the extent that there is discussion about art, it is covered over by what appears to be banal chitchat about parties.[10] Still, under this

cloak of banality, Warhol loosely concealed a surprising poignancy, which
is exposed once we realize that Newman had died in 1970, not long before
this interview occurred. At this point, it becomes clear that being "at
another party" was Warhol's idea of Newman's afterlife, and that there was
a pathos in his words. It is a pathos achieved as if by magic: in one moment
the cloak has nothing under it; in the next, it bulks up with emotion. What
is communicated in the end is that it's neither the art nor the parties, but
mortality itself that really matters.

Nearly ten years after the interview about Newman, Warhol con-
tributed his remarks to another, similar, collection of interviews, this time
about none other than Pablo Picasso. Like the Newman compendium, this
one was prompted by a major retrospective of the artist's work at the
Museum of Modern Art, for which occasion art critic Judd Tully asked
twelve artists for their estimations of Picasso's significance. The replies he
received were, by and large, what we might have expected to hear, and
tended to reflect what were by then commonly held views. Let's look at a
few examples. Paul Jenkins was of the opinion that "the dominant feature
of his work is the distortion of the classical which eventually became the
classical itself." Romare Bearden explained that Picasso "remained a very
Spanish painter." And Roy Lichtenstein said "I think of Picasso as the most
important artist of the twentieth century."[11] Warhol, avoiding such weighty
art-historical pronouncements, offered this observation:

> Ah, the only thing I can really relate to is his daughter Paloma. She's
> wonderful. Do you know her at all? She comes to town. You should
> maybe interview her sometime. She comes here every other week.
> I'm just glad he had a wonderful daughter like Paloma.[12]

Warhol, in fact, did often socialize with Paloma Picasso in the late 1970s
and early 1980s (and *he* had actually worked on an interview with her).[13] It
is also true, however, that from the outset of his painting career he had paid
careful attention to Picasso's art, prolific output, and reputation.[14] His
choice to talk about Paloma when the topic at hand was really her father

trivializes the entire discussion of Pablo Picasso's artistic merit. Yet Warhol used his typically atypical response here, as elsewhere, to avert the risk of sounding pompous. As if by some sleight of hand, his reply actually sounds fresh and original, while by comparison the serious, straightforward responses given by his colleagues end up sounding trite and cliché!

The apparent banality of Warhol's comments tended to intensify when he disliked, or felt uncomfortable with, the interviewer. When, in a 1971 documentary film, art critic Barbara Rose asked him what he thought of the artist Jasper Johns (whose work is often noted as a strong early influence on Warhol), he responded with a simple and characteristic "I think he's great." When pressed to say why, Warhol explained: "Ohhh, uh, he makes such great lunches. He does this great thing with chicken. He puts parsley *inside* the chicken."[15] While it very well may have been true that Johns was a terrific cook, Warhol's description of his chicken recipe was, needless to say, not the kind of information Rose was seeking, and was clearly meant to rile her.[16] At the same time, it is likely that Warhol here found a way to "out" Johns by focusing on a stereotypically female activity. (Johns, as Warhol was aware, preferred to keep his sexual preferences private.[17]) And so Warhol's words now became a form of exposure, while also being a means of avoiding the lackluster, commonplace pronouncements about artistic influence that are the bread and butter of art history and of interviews with artists.

The Interview as Collaboration

We see from the example of the Barbara Rose interview how Warhol's feelings toward the interviewer affected how he responded to her questions. If his responses in this case reflected a dislike for the interviewer, on other occasions, by contrast, they reflected instead what appeared to be an attraction to the interviewer. The ensuing flirtation was yet another way Warhol directed the conversation *away* from his art. Asked in 1966 how much time he spent on his paintings, Warhol replied: "No time . . . what color are your eyes?"[18] Sometimes this "personal" approach to the interview went much

further—and was much funnier—as in an interview with art critic Paul Taylor that occurred toward the end of Warhol's life (and was published posthumously). Let's listen in:

AW: You looked great the other night. I took lots of photos of you in your new jacket. . . . Next time you come by, I'll take some close-ups.

PT: *For the Upfront section of* Interview [Warhol's magazine] *perhaps? Except that I'm not accomplished enough.*

AW: You could sleep with the publisher.[19]

This tongue-in-cheek flirtation developed out of a previous interaction between Taylor and Warhol, and because, in this instance, the interviewer played along with, rather than resisted, Warhol's game rules. Here, as well as in numerous other interviews, Warhol wanted us to see some of the ordinarily concealed information about the making of the interview. In the process, he called special attention to the collaborative quality of all interviews, a quality nicely summarized in a 1969 study of the rhetoric of interviews: "Any statement in an interview is . . . the collaborative product of interviewer and interviewee, not a spontaneous remark. . . . The interview is a rhetorical form whose most essential quality is its collaborative origin."[20] Collaborative by definition, the interview was perfectly suited to Warhol, whose work in other areas—whether in film, painting, or writing—also involved collaboration in some measure.

How interviewers worked their side of the collaboration was no less revealing or intriguing than Warhol's operating methods on his side of it. These operating methods invited the more imaginative of interviewers to exercise a degree of creativity not usually found in interviews with artists. When in the mid-1970s the French art historian Jean-Claude Lebensztejn probed eight artists about the meaning of Henri Matisse's work, he failed to get the direct answers from Warhol (as you will already have guessed) that were provided by the other artists he communicated with (Lichtenstein, Sharits, Wesselmann, Andre, Stella, Marden, and Judd). So he intellectually and visually bracketed Warhol's response: at one end, he put a passage

about Matisse that he had found in a book on Warhol; on the other end, as the conclusion to the entire collection of interviews, he put a statement by Matisse that served to ingeniously complement *and* compliment Warhol's own limited commentary, as well as to complement the passage from the book. Here is what the whole thing looks like:

A friend once asked Andy Warhol what he really wanted out of life, and he replied, "I want to be like Matisse."

(Quoted from Calvin Tomkins, "Raggedy Andy," in John Coplans's *Andy Warhol*, New York, *New York Graphic*, 1971.)

Warhol: "What can we say about Matisse, Fred? Couple of lines. . . ."

"He who wants to dedicate himself to painting should start by cutting out his tongue."

—Henri Matisse[21]

Lebensztejn's way of giving meaning to Warhol's words involved a breaking out of the question-and-answer mold in which the interview by definition is usually cast.

History: Role Reversals, Hollywood, Radio, and the Art Press

Warhol's own inventiveness in interviews tended to stay within that mold, but hinted at how it was just a mold, and therefore gave someone like Lebensztejn license to break it. With his seemingly banal answers, Warhol constructed this space for the creativity of the interviewer. He further encouraged such creativity through reversing and otherwise confusing the roles of interviewer and interviewee. He had already introduced this approach in his first known published interview, of 1962, which appeared in a then-new (but now-defunct) magazine called *Art Voices*. By way of introducing this interview (which is reprinted in the present volume), the

magazine's editors informed us that they told Warhol: "let us interview you as a spokesman for Pop Art, and he said no, let me interview you."[22]

Within only a few years, by the mid-1960s, Warhol had become notorious for asking interviewers to provide the answers to their own questions. In the 1965 book *Pop Art*, we learn that when a reporter questioned Warhol about his background, he proposed, in response, "Why don't you make it up?"[23] The following year, art critic Alan Solomon recounted his experience of trying to interview Warhol for television. "I'll tell you what," the artist proposed, "why don't you give the answers too." Solomon objected on the grounds that he did not *know* the answers. "That's all right," Warhol responded, "just tell me what to say."[24]

A comment about interviewers in Warhol's 1975 book, *The Philosophy of Andy Warhol*, provides one explanation for such behavior. "I've found that almost all interviews are preordained," he explained. "They know what they want to write about you and they know what they think about you before they ever talk to you, so they're just looking . . . to back up what they've already decided they're going to say."[25] This is a common feeling of people who are interviewed with any regularity. Bob Dylan clearly shared it, and in some of his interviews of the 1960s he, like Warhol, repeated the interviewer's questions (but with more of an edge) and otherwise prodded them to answer their own questions. An example:

REPORTER: Are you trying to accomplish anything?
BOB DYLAN: Am I trying to accomplish anything?
REPORTER: Are you trying to change the world or anything?
BOB DYLAN: Am I trying to change the world? Is that your question?
REPORTER: Well, do you have any idealism or anything?
BOB DYLAN: Am I trying to change the idealism of the world? Is that it?
REPORTER: Well, are you trying to push over idealism to the people?
BOB DYLAN: Well, what do you think my ideas are?[26]

Dylan, like Warhol before him, was resisting attempts to pigeonhole and to be pigeonholed. When interviewees try to resist such attempts in a more

direct way, they risk sounding most unattractive, or even ridiculous. Witness Susan Sontag angrily telling one interviewer:

> I'm going to get up and walk out of here if you keep on going like this. I don't live the way your question seems to imply . . . don't try to put words into my mouth, I don't think this way. It would be trivial. It would be silly.[27]

By opting to *appear* trivial or silly, Warhol escaped such distastefully self-important language.

One model for Warhol's deferral to the interviewer was the widespread practice, in the film industry, of the studio controlling what its movie stars said in interviews: the actors *literally* were told what to say.[28] It's highly likely that Warhol would have been familiar with such scripted interviews from childhood when he listened regularly to the radio, including such celebrity interview shows as *Forty-Five Minutes in Hollywood* and *Hollywood in Person* in the 1930s, and *Breakfast at Sardi's*, *Hollywood Startime*, and Hedda Hopper's five-minute interview shows in the 1940s. As an avid movie-star fan, he also would have seen such interviews on the pages of fan magazines such as *Photoplay*.

The Hollywood scripting of interviews was only marginally veiled, if at all; readers often knew exactly what they were getting, or at least that some degree of control over the interview had been exercised. Already in the 1930s this kind of star control was sufficiently familiar to be parodied. It was even parodied on the pages of an art periodical. A 1934 issue of the *Art News* featured a "special interview" with Mickey and Minnie Mouse, in which Minnie expressed concern that her publicity manager approve of the quality of this interview:

> "You are sure," she inquired anxiously, wiggling her high-heeled pump, "that the *Art News* is the type of paper that will give us a refined interview? Our publicity manager is extremely particular and I'm not really acquainted with your publication."[29]

The history of the Hollywood interview is filled with allusions to its own artifice. The case of actor Victor Mature is but one conspicuous example. As the 1959 edition of *Celebrity Register* reported it, Mature,

> . . . whose "hobby," he once told Hedda Hopper, was "publicity," was a hard man to know in any length of time, but not hard to know about. . . . He would turn to a reporter at the end of some wild yarn and say, "Now that's absolutely off the record—when will it be published?"[30]

In the interview with the artist, as in the Hollywood celebrity interview, stock-in-trade inquiries about the interviewee's life manifest a central purpose to reveal the person behind the work. It is that *person* we seek when we read or listen to an interview (but whom, so the rhetoric goes, we never quite seem able to grasp, as the just-quoted characterization suggests about Victor Mature). And so, early in the history of published interviews with artists (at least as that history unfolds in the *Art News*, a mainstay of the American art press), visual portraits accompanied the words, giving us a face to go with the "voice."

By the early 1960s, when Warhol gave his first interviews, such portraits tended to be omitted, a shift in publication practice that reflects broader journalistic trends. Within the field of art criticism, formalist analysis, based on the belief that we should understand the art object by studying it alone, without drawing upon biographical or any other sort of information external to the art, came to exert a powerful influence in the 1950s and 1960s, as art historians have long recognized. With the same impulse to achieve objectivity, ideas concerning the role that journalists should play in interviews likewise changed markedly between the 1930s and the 1950s.

Interviews published in the *Art News* in the 1930s (including the 1934 interview with Mickey and Minnie Mouse) were articles rather than transcriptions of dialogues, including only an occasional quotation.[31] Not until 1963 did this magazine, now recast as *Artnews*, utilize the full-fledged question-and-answer format that is so familiar to us today. As it happens,

its debut occurred in a series of interviews with several artists, called "What Is Pop Art?" that included Warhol's most famous interview (reprinted in the present volume).[32] *Artnews* most likely modeled its new interview format on popular journalism—an apt choice for a sequence of interviews about the then-still-new art that was called pop.[33]

Another, and perhaps more significant, model for *Artnews*'s innovative, objective-looking format came from more highbrow journalism, most notably *Paris Review*. From its inception in 1953, this journal established, as a regular feature, its highly influential question-and-answer format.[34] (This same year also saw the debut of Edward R. Murrow's television interview program, *Person-to-Person*, as radio broadcasting staples such as the celebrity interview migrated to the newer medium of television.) By the late 1950s, the *Paris Review* interviews started to be reprinted as book-length collections (as they still are today), thereby broadening their dissemination.

Malcolm Cowley observed, in the introduction to the first of these collections, published in 1958, "[t]he interviewers belong to a new generation that has been called 'silent,' although a better word for it would be 'waiting' or 'listening' or 'inquiring.' "[35] The desire to repress the journalist's voice is articulated elsewhere, too, during the second half of the 1950s. For example, in the foreword to Selden Rodman's 1957 book, *Conversations with Artists*, we are told: "Rodman wisely keeps his own opinions down to a smooth purr throughout the book."[36] (It would seem interviewers were now modeling their practices after those of murmuring Freudian psychoanalysts, who were exerting a great influence at just this time.)

So, precisely when the idea of giving the interviewee more control over the content of interviews was embraced, and just as the seemingly objective question-and-answer format gained wide acceptance within the realm of serious journalism, Warhol, through his apparent evasiveness, showed that its claims to documentary objectivity were trickery. After all, interviews nearly always are rehearsed, edited, or otherwise manipulated, and are not the spontaneous conversations that the question-and-answer format would suggest.

The Realm of Ideas

The idea that image and reality are not the same thing—yet are so deeply intertwined that they are not necessarily distinguishable from one another—came to be articulated in a wide range of theoretical and historical writings of this same period, the late 1950s and early 1960s. We see this one idea at the core of sociologist Edgar Morin's observation that "the real person cannot be distinguished from the person fabricated by the dream factories and the person invented by the spectators," and of publicist and journalist Ezra Goodman's claim that in Hollywood the press "does not merely chronicle the show" but is "part of the show itself"; and we see it in Jan Vansina's characterization of oral history as a "mirage of history," and in Erving Goffman's sociological consideration of the performance-based nature of human behavior.[37] Here was an idea whose time had come. Warhol, it would seem, internalized this idea and then experimented with it in interviews as well as in films, paintings, and even a novel.

The writer whose examination of this realm of appearances most clearly corresponded to Warhol's own activities was historian Daniel J. Boorstin. In his book *The Image*, published in 1961—just prior, that is, to Warhol's first experiments with interviews—Boorstin characterized the interview (not to mention photography, advertising, and many other products of modern life) as a "pseudo-event." For Boorstin, the pseudo-event was an occurrence that lacked spontaneity and existed primarily in order to be reported (a notion so commonly held today that we take it for granted). Boorstin explained:

> Concerning the pseudo-event the question, "What does it mean?" has a new dimension. While the news interest in a train wreck is in *what* happened and in the real consequences, the interest in an interview is always, in a sense, in *whether* it really happened and in what might have been the motives. Did the statement really mean what it said?[38]

Warhol's suggestions to interviewers that they fabricate his background, or

answer his questions for him, bring to the very surface of the interview the problems Boorstin had identified as being inherent in the genre. Boorstin, however, wrote his book in order to attack as morally bankrupt the ubiquity of the pseudo-event within American culture, while Warhol took a much more complicated and also, generally speaking, more positive stance toward this phenomenon. If the ambiguous relation of the interview to reality disturbed Boorstin, it delighted Warhol. We see this delight in his recollection of what it was like to be interviewed in the mid-1960s:

> In those days practically no one tape-recorded news interviews; they took notes instead. I liked that better because when it got written up, it would always be different from what I'd actually said—and a lot more fun for me to read. Like if I'd said, "In the future everyone will be famous for fifteen minutes," it could come out, "In fifteen minutes everybody will be famous."[39]

Reversal: Part II

Warhol began using the tape recorder himself in the mid-1960s, after having acquired an early cassette model. Soon he was turning it on when he was being interviewed, yet his purpose was hardly to clarify the circumstances or content of the interview. For the 1966 interview for *Cavalier* magazine reprinted in the present volume, he brought his recorder along and acted as if he were the interviewer. We learn from the introductory remarks that accompanied this particular interview that "[b]efore we could get our tape recorder warmed up, Andy Warhol produced his own transistorized set and placed the microphone before us."[40] An implication of this statement is that Warhol used his machine to reverse the role of interviewer and interviewee, just as he had done previously by asking interviewers to answer his questions for him. The ensuing confusion was highlighted later on in this same interview when Warhol asked Ondine, a member of Warhol's coterie, to speak. Ondine, the "protagonist" of Warhol's 1968 book, *a: a novel*—itself composed of transcriptions from tape recordings—entered the conversation; but as he

did, the interviewers took care to distinguish their microphone (which they referred to as "the real taping") from Warhol's. Irrepressible, Ondine's reaction was to just go ahead and speak into *Warhol's* microphone.

In the 1970s, Warhol's practice of turning on his recording device while being interviewed became more common. As filmmaker Emile de Antonio reminisced about his experience making the segment on Warhol of his 1972 documentary film, *Painters Painting,*

> As we filmed and talked, Andy audiotaped everything. At the time he was audiotaping his entire life with others. . . . There is a social history of strange times in Andy's tape collection; enough to make five writers rich and famous.[41]

But those five writers would need to live long lives indeed, and have near superhuman stamina, to even listen to—never mind transcribe—all those tapes (now housed at the Andy Warhol Museum in Pittsburgh) to which de Antonio referred! Warhol's documentation of his world was so vast that it is virtually impossible to take in. And this documentation included— along with the sound recordings—videotapes, which Warhol began making in the mid-1960s, came to use with great frequency in the 1970s, and also turned on while he was being interviewed. A reporter for the New York *Daily News* described, for example, how when he visited Warhol's studio, a video recorder was taping the various "goings-on (*including* our interview)."[42]

By the mid 1970s, Warhol's practice of treating the interviewer as an interviewee reached what in retrospect seems like its logical conclusion as he began conducting many of the question-and-answer sessions for his *Interview* magazine, which he had established in 1969. Still later, in 1985, he moved into the arena of television interviewer with the launching of an MTV show, called *Andy Warhol's Fifteen Minutes* (cut short by his death two years later).[43]

In this later role of interviewer, Warhol at times continued to present himself, as he had in his role of interviewee, as not knowing what to say.

Bob Colacello, in his chronicle of his experiences as editor of *Interview* magazine, observed that Warhol always falsely claimed that he never knew what to ask the interviewees. According to Colacello, Warhol always told him: "I'll ask a few Eugenia Sheppard questions, Bob, and then you've got to come up with the Edward R. Murrow ones for me."[44] In other words, Warhol would play the role of fashion and gossip columnist, while Colacello would play that of serious reporter. In this statement, Warhol also revealed his awareness of, and sensitivity to, distinct types of journalistic interviews; this awareness allowed him to appropriate their formulas and language patterns.

Appropriation

In his interviews, Warhol often uttered formulas and phrases circulating in the media, statements made by other artists, and key words that he found in reviews of his own work, just as he pillaged the expansive visual encyclopedia of popular culture to create his own paintings. In each case, we are led to an awareness of our own inevitable borrowings, intended or not, from the world of sound bites and media imagery that swirl around us.

Warhol's most familiar, if misquoted, interview pronouncement, "in the future, everyone will be world-famous for fifteen minutes,"[45] now itself a phrase we see and hear over and over again in the press, is a good place to start as we look at his use of appropriation in interviews. His selection of the particular time interval of fifteen minutes—instead of, say, five, ten, or thirty—most probably derives from the fifteen-minute duration that was standard in the field of broadcasting from the early days of radio programming to the television news shows of the 1950s and 1960s (nowadays, of course, these time slots are generally of thirty or sixty minutes).[46] This airtime length was even incorporated into the title of some radio variety shows, such as *Fifteen Minutes with Bing Crosby* or *The Camel Quarter Hour*, both of the 1930s.[47]

From his very first interviews, Warhol practiced this sort of borrowing from the language and formatting of the media. In his first known published

interview—the one in *Art Voices* that is reprinted in the present volume—
he deployed a particular standard format of interviewing, wherein the
answers are either "yes" or "no." Interviewers working in all fields—from
anthropology and sociology, to media and even the FBI—are advised to
avoid questions that elicit those two answers, for the obvious reason that
such questions tend to yield only limited information—which is exactly
why Warhol favored them.[48] (In the social sciences, the yes/no format of
interviewing is called "closed," in contrast to the eloquence-inviting
"open" format advocated most influentially by sociologist Robert Merton
and his colleagues at Columbia University in the 1940s and 1950s.)[49]

In collaboration with the editors of the *Art Voices* interview, Warhol
used the yes/no format to comic effect. And he used it in such a way that
we actually learn more than the answers "yes" and "no" ordinarily convey.
For example, when asked, "What is Pop Art?" he replied, "Yes." This one-
word utterance itself sounds "pop," as if Warhol were providing an illustra-
tion, rather than a definition, of that word. His "yes" also gave him a way
to endorse his artistic creations without coming across as pompous or
heavy-handed (often a pitfall of such interviews, as I have already noted).

As the *Art Voices* interview progressed, Warhol broke out of his self-
imposed verbal straitjacket and began to use more words, while at the same
time continuing to derive his vocabulary from the wellspring of all-too-
familiar, overused expressions. Interviews with politicians (interestingly,
the first modern interviews, of the mid-1850s, *were*, it seems, with politi-
cians)[50] are the source for the following exchange, which the questioner
deftly points out.

QUESTION: Do Pop Artists influence each other?
ANSWER: It's too early to say anything on that.
QUESTION: This is not a Kennedy press conference.[51]

Digressing momentarily from the topic of appropriated language, it is
important to observe here that Warhol's willingness to offer more than
"yes" or "no" once he was in the midst of this interview is indicative of a

pattern evident in many of his interviews. The impression is one of initial nervousness followed by a gradually more relaxed demeanor.[52] Behind this pattern was a deep fear of public speaking that went back many years. Warhol's college classmate Bennard B. Perlman recalled that when as a student the artist had to speak in front of the class, "invariably he would utter a few sentences and then freeze, unable to continue. It was a painful experience for all of us."[53] Warhol himself was perfectly frank about his at-times-immobilizing stage fright, describing in the 1966 *Cavalier* interview how "I've been on some radio and television shows, but I usually bomb out," or, in another, of 1977, that "I was on Merv Griffin a couple of times, and I was so nervous I couldn't even get a word in."[54] The "yes" and "no" formula, as well as other appropriated responses, allowed him, among other things, to overcome his terror.

Once Warhol found a formula that worked in this way, he was apt to repeat it (repetition being, of course, an important feature of his visual art). We see the "yes" and "no" answer formula, for example, in an interview, reprinted here, that was included in his 1967 book *Andy Warhol's Index (Book)* (a collaborative project put together largely by his associates).[55] And we find him relying on this formula at live appearances, too. In the fall of 1967, the *New York Post* reported this story about a speaking engagement at Drew University:

> The students who crowded into the Madison, N. J. campus gymnasium expected Warhol to talk on pop art and film making. Instead, Warhol showed a half-hour film and answered questions with a yes, or no.
> "We paid for Andy Warhol and we didn't get two words out of him," [Thomas] McMullen [president of the student association] said.[56]

What they did get was a demonstration instead of an explanation: rather than speaking about filmmaking, Warhol showed a film; his disappointing "yes" and "no" answers were (as in the 1962 interview) an *illustration* of pop art rather than a *discussion* of it. The event was a performance, as were so many of the published interviews, or the equally notorious instances

during this time when Warhol sent a surrogate, Allen Midgette, to lecture in his place.[57] Warhol saw the interview as being what social scientists call a "speech event" — an occurrence that follows a set of rules for how speech is used. However, going one step further, in collaboration with the media, he turned the "speech event" into an artistic act.[58]

When he asked Allen Midgette to speak in place of him, Warhol drew upon a by-then-old Hollywood tradition, that of using the double for public appearances, a practice in which Greta Garbo, in particular, was known to engage. What's more, this practice was not always concealed; a 1929 story in *Photoplay* actually was about one of the women who acted as Garbo's double.[59]

The business of Hollywood that had created the phenomenon of the actress's double also led to the idea, prevalent during the 1950s, that the actress was a "machine" of the film studio. In his notorious quip that he wanted to "be a machine," appearing in the November 1963 issue of *Artnews*, Warhol may well have been playing on the way, to take one example, that Debbie Reynolds was characterized as a cold and calculating machine, or, to take another, that Marilyn Monroe insisted that an "actor is not a machine, no matter how much they want to say you are. . . . This is supposed to be an art form, not just a manufacturing establishment."[60] By recognizing how words such as "machine" actually circulated in the media, we can better comprehend the significance of Warhol's own use of these words, which in the past all too often have been interpreted at face value (and this is nowhere more true than of his claim that he wanted to be a machine).[61]

Warhol uttered stereotypical movie-star-like comments, one subcategory of his appropriated language, to the same effect as the "yes" and "no" responses. With these comments, he created verbal equivalences to his paintings of Marilyn Monroe, Elizabeth Taylor, and other Hollywood celebrities. In such cases, he enjoyed a kind of transposition of the context, so that his words sounded like something we might find in *Photoplay* even when they were spoken to a reporter from the *New York Times*. For a 1965 *Times* article, he claimed (as he often did in the mid-1960s) that he was

abandoning painting to devote himself entirely to film, and then quipped: "I've had an offer from Hollywood, you know, and I'm seriously thinking of accepting it."[62] In the same vein, two years later he told an interviewer "the only goal I have is to have a swimming pool in Hollywood."[63] Later still, in 1986, he used the term "photo opportunity," also derived from the world of celebrity—which by this date was *his* world—in such a way that he not only exposed his own appropriation of it, but also, in the process, its pretentiousness. When the interviewer, British art critic Matthew Collings, declared that Warhol's then-new book of snapshot-type photographs, *America*, was "very patriotic," Warhol replied "[t]hat's just photo opportunity." Collings then asked what Warhol meant by this term. Here is Warhol's explanation:

> I don't know. Everybody uses that phrase. It means just being in a photo or something. When somebody says, "It's a photo opportunity," you just stand there and they take your picture. It's actually just having your picture taken.[64]

Warhol borrowed his words from famous artists as much as from other kinds of celebrities. In the *New York Times* story in which he stated that he would now devote himself to film, he called himself a "retired artist,"[65] an idea taken from Marcel Duchamp, who had in the mid-1920s contributed to circulating a rumor that he had decided to quit making art and would instead focus his creative energies on chess-playing. Some of Warhol's other quips probably came from Duchamp too, including his provocative labeling of art as business, and of business as art, which echoes Duchamp's statement that painting "today is a Wall Street affair. When you make a business out of being a revolutionary, what are you? A crook."[66]

Another visual artist whose words Warhol duplicated and manipulated was Jasper Johns. Johns had explained that the reason he painted compositions based on the American flag and on targets was because they were "both things which are seen and not looked at, not examined." This well-known statement would seem to be the source for Warhol's response when

asked whether the subject matter of his *Last Supper* paintings (1986), based on Leonardo da Vinci's famous mural, had a particular meaning for him: "It's something that you see all the time. You don't think about it."[67] Just as Duchamp and Johns had been inspirations for Warhol's visual imagery, so were they inspirations for his words. As we have seen throughout this discussion, the visual and the verbal are the weft and warp of a seamless fabric that is Warhol's art.

Perhaps the most interesting of all Warhol's verbal borrowings are the ones he took from writings about his art. When he claimed to have done something a particular way because it was "easy," he was reiterating a word used by art historian Peter Selz in an early and especially blistering assessment of pop art. In Selz's analysis, pop art lacks commitment, is cool and complacent, and, finally, is "easy." He repeats the word "easy" several times: pop art is "easy to assimilate," is "as easy to consume as it is to produce," and is "easy to market."[68] Rather than attempting to disprove Selz's accusation, Warhol simply used it himself. In 1965, he explained to the poet and art critic John Ashbery that while his real interest at the moment was in film, perhaps he would not give up painting after all: "[w]hy should I give up something that's so easy?"[69] Conversely, a few years later, in an interview for *Mademoiselle*—and on numerous subsequent occasions—he claimed that he liked making films better than making paintings, because *they* were "easier."[70]

Warhol himself left behind the evidence of his practice of stealing the words others wrote about him. In his 1975 book, *The Philosophy of Andy Warhol*, he explained:

> I . . . constantly think of new ways to present the same thing to interviewers, which is [a] . . . reason I now read the reviews—I go through them and see if anybody says anything to us or about us we can use.[71]

Once we understand Warhol's techniques of communicating in interviews, through the evidence he offered, including referring to himself in the

plural, and by looking at the sources of his language, we can better appreciate his mastery at interviewing, his transformation of the interview into a text that can be analyzed in the way literature is analyzed, and his vision of the interview as both a parallel to, and a component of, his art. Although other artists used the interview format to make art (Salvador Dalí and photographer Philippe Halsman's 1954 book, *Dalí's Mustache: A Photographic Interview*, is a good instance), no other artist before or since has come even close to putting such extraordinary energy into this activity, and none has accomplished so much with it. Warhol managed to give new—and often multiple—meanings to the most prosaic and over-circulated of words. In Warhol's interviews, even the phrase "I don't know" resonates with significance. Are these interviews art? When looked at in the larger context of Warhol's body of work in every medium, I think the answer would have to be yes.[72]

Preface by the Author

There was probably no cultural figure more frequently interviewed in the late 20th century than Andy Warhol. His persona was synonymous with media and everywhere he went, the press followed. Quips became Andyisms; sentences became truisms. For a man who was notoriously reluctant, he is one of the most quoted icons of our time.

This book began with a trip to a local bookstore in the spring of 2002. I was leafing through a compilation of essays about Warhol released by *October* magazine and the last piece in the book was an interview with Andy by the art critic Benjamin Buchloh from 1985. It seemed that the more pointed Buchloh's questions became, the more elusive Andy's answers were. Buchloh would hit harder and Warhol would get slipperier, repeating things he'd said many times before as if Buchloh's questions were irrelevant. In the end, I realized that by saying so little, Warhol was inverting the traditional form of the interview; I ended up knowing much more about Buchloh than I did about Warhol.

I was intrigued and turned to the Internet, where I found one or two interviews which confirmed what I had learned with the Buchloh piece. Although snippets and allusions to them seemed to be everywhere, almost none of Andy's interviews were reprinted in the vast body of literature that had formed around him. Following the leads from stray lines in bibliographies and footnotes, I began combing bookstores and eBay to track down the original pieces. As they started coming in, I realized the potential for a fascinating book. Once the flow started, a torrent followed and by the time my collecting was over, I had close to 200 interviews.

What I soon learned was that these 200 interviews represented only a fraction of what was floating around in various media. Every time I'd mention to someone that I was collecting interviews, they would tell me of a new or obscure one that was their favorite; I heard about daytime television appearances from the late '60s that changed young minds; odd film walk-ons; one-line zingers printed in obscure fanzines; people e-mailed me

interviews that they had done with Warhol years before; to this day, I'm still uncovering new ones.

What constitutes a Warhol interview? After all, there are as many wonderful interviews with Andy as interlocutor; *Interview* magazine is full of them, as are the many hours of *Andy Warhol TV*. In this volume, for the most part, I selected pieces in which Warhol was the subject. Future volumes could be published with other forms of Warhol "interviews" and would make for fascinating, but decidedly different, reading.

Many of the interviews in this book come from Andy's *Time Capsules* at the Warhol Archive in Pittsburgh. But the problem is that only a fraction of the *Time Capsules* have been opened and cataloged. One can speculate that there are dozens of interviews still tucked away in unopened boxes at the Warhol Museum. The Warholian landscape is a constantly shifting one; a decade from now, a second or third volume might be necessary to document in full this aspect of Andy Warhol. I quickly realized that the *collected* Warhol interviews were an impossibility at this time. Instead, I opted to edit a volume *of selected* interviews, choosing what I considered to be the best of what's available today.

But to a man for whom everything was equal, is it possible to select "the best"? I believe so. After reading so many of Warhol's interviews, I got a sense of when he was engaged in the conversation and when he was just going though the motions. Discernible patterns began to make themselves apparent and I soon became adept at feeling when Andy was "on" and when he was "off" (although these are relative categories when dealing with Warhol; his "off" was our "on" . . .). Also, several interviews have long been acknowledged as "classics"; many of these have been included in this volume.

I have tried to present as much as possible, Warhol in all his dimensions over the twenty-five years when he was in the public eye. There are pieces focusing on all areas of his vast oeuvre and voracious life: Andy as painter, filmmaker, publisher, promoter, performer, printmaker, photographer, author, and videographer; there are interviews about Andy's opinions of other artists; what it was like to go shopping with him; how he felt about New York; how he felt about being a Catholic.

While I have tried to be even-handed chronologically, more than half the interviews are from the 1960s, which I and many others consider to be Warhol's most important period; so important, in fact, that there are no fewer than a half-dozen interviews from 1966 alone, a landmark year for Warhol.

I have not edited any of the interviews, nor have I included any revised versions of pieces. Several times interviewers offered to give me unedited, full-length tape transcriptions instead of the published pieces, but each time they decided against it, believing that the interview they did at the time was the better piece.

The introductions were done, when possible, in collaboration with the interviewers. I had many extensive phone conversations and face-to-face meetings with them in order to get a sense of what it was like to interview Andy. Each interviewer was sent a copy of their interview's introduction to make certain that the facts were accurate and that each person was represented fairly.

I have included original introductions when they seemed specific to the circumstances of the interviews. In other cases, I have excerpted only parts pertinent to the interviews. In a few instances—where the introduction gave rote biographical or editorial content—I have reprinted the interview without the introduction.

I have added footnotes where I felt that a general readership would need them; if Warhol or an interlocutor made an unfamiliar or obscure reference, I researched and annotated it. I have tried to keep the number of these references to a bare minimum, assuming that a reader will approach this book with a familiarity of Warhol and his circle. For those requiring additional information, there is a plethora of biographies, monographs, and websites dedicated to the life and art of Andy Warhol.

I only met Andy once, in 1986 at a party for Keith Haring and Kenny Scharf that he hosted at the Whitney. Absolut Vodka sponsored the party. As it was winding down, I staggered up to Andy, drunk out of my mind, to thank him. As I extended my hand to him, he shrunk away from me. Or at least that's how I remembered it. I felt foolish.

After an encounter with the words of the words of Andy Warhol, one's relationship to language is never the same: long-held assumptions of place, time, and self are all up for grabs. Although Warhol was known for his surfaces, what we are left with is an unusually strong sense of interiority. In the end, Warhol's mirror reflects on us; as such, this book is really about us and who we are as filtered through the apparition of Andy Warhol.

Kennneth Goldsmith
New York City
November 2003

The information provided at the beginning of each interview is as follows: the title of the piece; the name of the interviewer (if known); the date of the interview (if known); and the name and date of the publication the interview appeared in (if known and/or if any). Introductory notes by the current editor are in italic font and signed "KG"; introductions that were originally published with the interview, when used, whether in full or in part, are in roman.

For the sake of authenticity and overall texture, all interviews presented here are formatted as originally published unless otherwise noted.

THE SIXTIES

THE SIXTIES

1 "Pop Art? Is It Art?
A Revealing Interview with Andy Warhol"

Art Voices, December 1962

The fall of 1962 was the season of Pop and an explosive time for Andy Warhol. While he had gained notoriety in Los Angeles that summer showing his Campbell's soup can paintings for the first time, he was still without representation from a major New York gallery. This changed when he was unexpectedly offered a November solo show at the prominent Stable Gallery where he exhibited silkscreened paintings of Marilyn Monroe, soup cans, dollar bills, and Coke bottles. The show, which was lauded by the art world, subsequently sold out, making Warhol a leader of the fledgling movement.

Warhol's show coincided with his inclusion in the group exhibition "New Realists" at the established Sidney Janis Gallery, which was the most talked-about art show of the season. The show—a pivotal moment for the New York art world—represented a changing of the guard. The Janis Gallery, which had made its name in the 1950s presenting the previous generation of Abstract Expressionist painters, suddenly switched its alliance, showing new artists like Roy Lichtenstein, James Rosenquist, and Claes Oldenburg for the first time. The style, as yet still unnamed, was dubbed "Pop Art" a few weeks later on December 13 at a symposium of critics, collectors, dealers, and artists at the Museum of Modern Art.

The following interview from a small art journal picks up on the zeitgeist *of the moment with the tag line "Love is not sweeping the nation, Pop Art is." In this interview, Warhol introduces many of the strategies that he would use with remarkable consistency over the following 25 years: elusiveness, passivity, and mirroring.*

An excerpt from the interview's introduction sets the stage: "We visited Warhol in his studio and found the young man to be a true original—fey, wry, impossible to engage in serious conversation. He is a lark. We said let us interview you as spokesman for Pop Art, and he said no, let me interview

you. We said no, let us interview you. Well, he said, only if I may answer
your questions with Yes and No. We sat on a sofa, surrounded by new can-
vases of Marilyn Monroe and Troy Donahue (the latter is Warhol's favorite
movie star only he has never seen him on the silver screen). Movie, base-
ball and physical culture magazines were strewn about. Bookshelves,
barren of books, held cans of beer, fruit juice, cola bottles. Jukebox pop
tunes played incessantly so we yelled our first question above "Many a tear
has to fall, but it's all in the game."[1]

—KG

QUESTION: What is Pop Art?

ANSWER: Yes.

QUESTION: Good way to interview, isn't it?

ANSWER: Yes.

QUESTION: Is Pop Art a satiric comment on American life?

ANSWER: No.

QUESTION: Are Marilyn and Troy significant to you?

ANSWER: Yes.

QUESTION: Why? Are they your favorite movie stars?

ANSWER: Yes.

QUESTION: Do you feel you pump life into dead clichés?

ANSWER: No.

QUESTION: Does Pop Art have anything to do with Surrealism?

1. These lyrics refer to Tommy Edwards' 1958 #1 pop hit, "It's All In The Game."

ANSWER: Not for me.

QUESTION: That's more than one word. Sick of our one-word game?

ANSWER: Yes.

QUESTION: Do billboards influence you?

ANSWER: I think they're beautiful.

QUESTION: Do Pop Artists defy abstract expressionism?

ANSWER: No, I love it.

QUESTION: Do Pop Artists influence each other?

ANSWER: It's too early to say anything on that.

QUESTION: This is not a Kennedy press conference. Is Pop Art a school?

ANSWER: I don't know if there is a school yet.

QUESTION: How close is Pop Art to "Happenings?"

ANSWER: I don't know.

QUESTION: What is Pop Art trying to say?

ANSWER: I don't know.

QUESTION: What do your rows of Campbell soup cans signify?

ANSWER: They're things I had when I was a child.

QUESTION: What does Coca Cola mean to you?

ANSWER: Pop.

2 "Warhol Interviews Bourdon"

DAVID BOURDON
1962–63
Unpublished manuscript from the Andy Warhol Archives,
Pittsburgh

Art critic David Bourdon conducted this interview during the Christmas hol-idays following the heady Fall 1962 season. The two had originally met at a party on the Upper East Side in the late 1950s when Warhol was at the peak of his career as a successful commercial illustrator, before turning to Pop Art. Both collected art and they began going to galleries together. In the early '60s, after not having seen each other for some time, Bourdon happened to pick up an art magazine and read that a new artist named Andy Warhol was going to be showing some paintings of soup cans. He called his old friend in disbelief and asked if, in fact, he was the same Andy Warhol that he had known as a top commercial artist. Warhol confirmed this and over the next few years Bourdon became one of Warhol's staunch supporters and confidants.

As part of Warhol's inner circle, Bourdon was involved in many Factory activities, from helping silkscreen silver Elvis paintings to sitting for a three-minute screen test, eating a banana as slowly as he could. With Warhol's help, Bourdon went on to become an art critic for the Village Voice *in 1964. In 1966 he was hired as* Life *magazine's art critic, thus exposing Pop to a national audience. Bourdon's support of Warhol continued for the rest of his life, culminating in his authoritative art-critical text,* Warhol, *published in 1989. David Bourdon died in 1998.*

All notations and corrections found on the original manuscript have been retained by the present editor.

—KG

Interview begun 12/24/62, completed 1/14/63
Draft dated 4/22/63

WARHOL: Am I really doing anything new?

BOURDON: You are doing something new in making exclusive use of second-hand images. In transliterating newspaper or magazine ads to canvas, and in employing silk screens of photographs, you have consistently used preconceived images.

W: I thought you were about to say I was stealing from somebody and I was about to terminate the interview.

B: Of course you have found a new use for the preconceived image. Different artists could use the same preconceived images in many different ways.

W: I just like to see things used and re-used. It appeals to my American sense of thrift.

B: A few years ago, Meyer Schapiro[1] wrote that paintings and sculptures are the last handmade, personal objects within our culture. Everything else is being mass-produced. He said the object of art, more than ever, was the occasion of spontaneity or intense feeling. It seems to me that your objective is entirely opposite. There is very little that is either personal or spontaneous in your work, hardly anything in fact that testifies to your being present at the creation of your paintings. You appear to be a one-man Rubens-workshop, turning out single-handedly the work of a dozen apprentices.

W: But why should I be original? Why can't I be non-original?

B: It was often said of your early work that you were utilizing the techniques and vision of commercial art, that you were a copyist of ads. This did seem to be true of your paintings of Campbell's Soup and Coca-Cola. Your paintings did not depict the objects themselves, but the illustrations of them. You

1 Meyer Schapiro. Art historian and critic, 1904–1996.

were still exercising the techniques of art in your selection of subject, in your layout, and in your rendering. This was especially true of your big black Coke painting, and in your *Fox-Trot* floor-painting, both about six feet in height, where the enormous scale did not leave enough room for the entire image. In *Coca-Cola* the trademark ran off the right side of the canvas, and in *Fox-Trot*, step number seven occurred off the canvas.

In these works, you were taking what you wanted stylistically from commercial art, elaborating and commenting on a technique and vision that was second-hand to begin with. I believe you are a Social Realist in reverse, because you are satirizing the methods of commercial art as well as the American Scene.

W: You sound like that man on the *Times* who considers my paintings to be sociological commentary. I just happen to like ordinary things. When I paint them, I don't try to make them extraordinary. I just try to paint them ordinary-ordinary. Sociological critics are waste makers.

B: But for all your copying, the paintings come out differently than the model, because you have changed the shape, size and color.

W: But I haven't tried to change a thing! You must mean my unfinished paint-by-number paintings. (The only reason I didn't finish them is that they bored me; I knew how they were going to come out.) Whoever buys them can fill in the rest themselves. I've copied the numbers exactly.

B: You don't mean to say that otherwise you have copied the picture *exactly*. It's so identifiable as your work. The flower stems in your still-life have an awkward grace that is typical of your work.

W: I haven't changed a thing. It's an exact copy.

B: (Then your hand has slipped.) It's impossible to make an exact copy of any painting, even one of your own. The copyist can't help but contribute a new element, or a new emphasis, either manual or psychological.

W: That's why I've had to resort to silk screens, stencils and other kinds of automatic reproduction. And still the human element creeps in! A smudge

here, a bad silk screening there, an unintended crop because I've run out of canvas—and suddenly someone accusing me of arty lay-out! I'm anti-smudge. It's too human. I'm for mechanical art. When I took up silk screening, it was to more fully exploit the preconceived image through the commercial techniques of multiple reproduction.

B: How does it differ from print-making—serigraphs, lithographs and so on?

W: Oh, does it? I just think of them as printed paintings. I don't see any relationship to printmaking but I suppose, when I finish a series, I ought to slash the screen to prevent possible forgeries. If somebody faked my art, I couldn't identify it.

B: I have always been most impressed by your multiple-image paintings, especially your paintings of movie stars, like Marilyn and Elvis.

W: So many people seem to prefer my silver-screenings of movie stars to the rest of my work. It must be the subject matter that attracts them, because my death and violence paintings are just as good.

B: The two paintings of Marilyn Monroe, hung side by side in your show at the Stable Gallery, were two of the most moving modern paintings I have seen. I was surprised by the differing effect they had on me. Their format was identical; each had been silk screened with fifty identical portraits of Marilyn. The black-and-white painting was the more tragic. In the central area, the silk screens had been printed with great care, and the portraits had the crispness and reality of a newsreel, or one of Marilyn's own movies. But around the edges, especially on the right, the black lost intensity, becoming almost grey, so that the portraits seemed to fade away to some ethereal place. Yet the portraits were still legible, and it was like the persistence of memory after something is gone, or the anticipation of forgetting something before it is gone.

The colored portrait was much different in tone: it was brassy, strident, bordering on vulgarity. You used very acrid colors: lemon yellow, bright orange, chartreuse, red. It was like overworked Technicolor. Through mis-printing (presumably intentional as well as accidental), you somehow

achieved fifty different expressions. In one portrait the green eye shadow would be printed too low, so that she looked sulky and wicked. In another, the red lips would be off-register like the *rotogravure* in the Sunday tabloids, where it is usual for the cover girl to have her lips printed on her cheek or chin. Sometimes the mouth was pursed, sometimes it was opened in hedonistic joy. Marilyn was given expressions that were never caught on film. (It was possible to believe that in your painting we had seen the entire spectrum of Marilyn's personality.)

W: Can you talk like that about my soup cans?

B: Your six-foot-high soup cans remind me of red-and-white Rothkos. You both seem preoccupied with minimizing the elements of art.

W: But he's much more minimal than I am. His image is really empty.

B: But I see a comparison in that, like him, you seem to be attempting monumentality in your painting. Your images, immobilized and frozen, have a quality of grandeur about them.

W: I didn't know anybody was monumental any more. Rothko's paintings are full of movement . . . all that shimmering and hovering. How can they be monumental? I've always thought they were big empty spaces.

B: His paintings are like vacuum cleaners, swallowing up the space in front of them.

W: . . . and mine are vacuous.

B: Whereas Rothko's paintings are subtle nuances of a single idea, yours are brutal repetitions of a single idea.

W: (I don't think there's any connection between my work and Rothko's.) Too many people who say my work is vacuous are judging it either from a reduced illustration or even as an abstract idea. They say, "Who's interested in a can of soup? We know what it looks like." But so often they think I've changed something. "Oh, look at the pretty fleur-de-lis!" You'd think most women wouldn't have a soup can on their shelf that didn't have a fleur-de-

lis on the label. Nobody really looks at anything; it's too hard. I think someone should see my paintings in person before he says they're vacuous.

B: Campbell's Soup must be just as familiar as the Mona Lisa. The Mona Lisa is seldom looked at as art, because it has become the *symbol* of art. And the soup label isn't looked at, because it isn't expected to be art.

W: You know, people have been comparing my soup cans to the Mona Lisa for so long now. "How can you call this art?" they say. "You can't paint as well as what's-his-name . . . and your model isn't as pretty to begin with."

B: Perhaps the people who make that comparison are exhibiting an unusual perceptivity to line and shape, because there is a similarity of form between your soup cans and the Mona Lisa. Do you have a picture of the Mona Lisa handy?

W: Just this paint-by-number diagram which I decided not to copy. Why doesn't she have any eyebrows? Have they left out the numbers?

B: Let's set it up next to a soup can. As you can see, the neckline of her dress has the same contour as the bottom of the soup can. The outline of her head and throat areas are almost identical to the outline of the can. Her smile has the same curve as the can and falls in the center of the flesh area, corresponding the place occupied by the gold medallion on your soup label.

W: I've heard that she's smiling because she's pregnant.

B: And I've heard that your soup can is a symbol of the womb, expressing your deep-seated desire to return to the foetal state. That's another similarity to be thought about. You haven't been consciously influenced by Leonardo, have you?

W: No, I don't think so.

B: I would like to know if you were ever consciously influenced by Stuart Davis, not only in your style of painting, but in your choice of subject matter as well. Do you know that he did a big mural—the largest single canvas ever painted—for the H. J. Heinz Co. in Pittsburgh?

W: But *I'm* from Pittsburgh. He's from Philadelphia.

B: And he included in this mural a scrambled "1957," to represent both the year it was painted and Heinz's "57 Varieties."

W: Fifty-seven varieties! Why didn't I think of that? Campbell's Soup comes in only thirty-three flavors. The H. J. Heinz Co. probably sends Stuart Davis all "57 Varieties" every year, besides having paid him for the mural. Do you know the Campbell Soup Co. has not sent me a *single* can of soup? And I've bought every flavor. I even shop around for discontinued flavors. If you ever run across Mock Turtle, save it for me. It used to be my favorite, but I must have been the only one buying it, because they discontinued it. Soups are like paintings, don't you think? Imagine some smart collector buying up Mock Turtle when it was available and cheap and now selling it for hundreds of dollars a can! (I suppose it'd be smart now to start collecting Cheddar Cheese soup.)

B: To get back to Stuart Davis, would you say that he is one of the fathers of Pop Art? Are you familiar with his "imitation" collage, done in 1921, of the Lucky Strike package? The Museum of Modern Art has it. The lettering and emblems of the Lucky Strike Green package have been arranged in cubist design. I believe it is one of the earliest paintings in which he made extensive use of words and letters, labels and signs.

W: You mean to say this artist who's now painting Camels *isn't* the father of Pop Art?

B: (Davis has for a long time been incorporating typographical elements into his paintings.) By "imitating" rather than using the actual labels of such things as cigarette packages, Davis freed himself from the limitations of the size of the objects. Seeking bigness and boldness, he had no patience for the watchmaker's skill that Schwitters practiced in fitting together little bits of paper from cigarette packages, ticket stubs, and so on.

W: Maybe Davis doesn't smoke or save his ticket stubs.

B: If it were not for Stuart Davis, who felt he had to "hand-paint" his col-

lages in order to achieve the large scale he wanted, some Pop Artists might find themselves still involved with *decoupage* pasting mechanically reproduced objects, actual size, to a background.

W: But some are!

B: The giant scale of your work has made it necessary for you, like Davis, to dispense with the use of actual artifacts. I find it interesting that Davis has acknowledged among his influences, both Leger, whom he once described as "the most American painter painting today" . . .

W: Oh yes, the comic strip painter.

B: . . . and Seurat.

W: I'm seeing dots before my eyes. Where does Seurat fit in?

B: I think Pop Artists ought to slap a paternity suit on Seurat.

W: Oh, not now. Pop Art has more fathers than Shirley Temple had in her movies. I don't want to know who the father of this movement is. In those Shirley Temple movies, I was so disappointed whenever Shirley found her father. It ruined everything. She had been having such a good time, tap dancing with the local Kiwanis Club or the newspaper men in the city room.

B: I'm just looking for a tidy parallel in art history. I think we have one if we let Monet father Abstract Expressionism and Seurat father Pop Art. The neo-impressionists found their predecessors careless and romantic. They demanded a return to form and structure. Seurat sought to make his subjects monumental and permanent. But his attitude toward his subjects shows an almost inhuman detachment. He chose "impure" and ordinary subject matter and he was able to monumentalize these subjects, distilling their ordinariness, until his paintings achieved the kind of grandeur and lifelessness that we expect to be reserved for "noble" Poussinist subjects. Seurat drew every single detail from the most banal scenes of his time, but he withdrew all life from them. Just like a Pop Artist, he wanted to purge art of human passion and avoid all the hazards of a sensuous paint surface.

W: But why do you want to make Seurat the father of Pop Art? Don't you remember the Monet retrospective at the Museum of Modern Art and what *that* did to Abstract Expressionism? The galleries had been full of Abstract Expressionists and Impressionists. And then, it was as if somebody said, "Why, look at Monet, that sweet old man, he was doing all these wild things before you were born." And collectors stopped buying the new painters. What happened to all those Abstract Impressionists? Do you want the same thing to happen to Pop Art?

B: But it's unlikely we'll have another Seurat show.

W: There'll be another fire, if there is. Anyway, you've dropped so many names, how can you remember what you're talking about? Stuart Davis, Rothko, Monet, Mona Lisa.

B: Some critics have compared you to Henri Rousseau and Norman Rockwell.

W: I guess I've been influenced by everybody. But that's good. That's pop.

B: You said you wanted my candid opinions.

W: But that was before I knew what you were going to say! You have such definite opinions about things, it won't do for an interview. Let's get a ghost to do our interview. Then we won't have to do any more thinking.

B: (That sounds good.) Are ghost-interviews pop?

GRS:[2] Yes, they're pop.

2 Gene R. Swenson. Art critic and collector, 1934–1969. (See Swenson's interview with Warhol, "What is Pop Art?," 1963, p. 15.)

3 "What Is Pop Art? Answers from 8 Painters, Part I"

G. R. SWENSON
ARTnews, November 1963

This widely quoted interview gives the first in-depth public glimpse of Andy Warhol in the heady early days of his Pop Art career. Several Warhol bon mots are printed for the first time, most notably "I think everybody should be a machine."

However, the interview's legacy has proven troublesome. According to Warhol biographer David Boudon:

Swenson and Warhol were good friends, but the artist was in one of his uncooperative moods, prompting the critic to conceal his tape recorder during the interview[1]. Some of the more "intellectual" sounding quotes attributed to Warhol may have been doctored by Swenson, particularly the remarks concerning the *Hudson Review,* a literary quarterly that Warhol was not known to read.

Swenson's discussion with Warhol was one of eight interviews with as many artists published under the title "What Is Pop Art?" in the November 1963 and February 1964 issues of *Art News.* Seven of Swenson's eight interviews were reprinted in *Pop Art Redefined* (London: Thames and Hudson, 1969) by John Russell and Suzi Gablik. Through careless editing, the last eight paragraphs of Swenson's interview with painter Tom Wesselmann . . . are appended to Swenson's interview with Warhol. As a result of this production goof, several of Wesselmann's remarks are erroneously attributed to

1 The hidden mircophone technique would be used to great effect later in the decade in "Cab Ride with Andy Warhol" by Frederick Ted Castle, 1967, p. 150.

Warhol. . . . Because of the *Pop Art Redefined* catalog, the phony
Warhol quotes are continually perpetuated. (Bourdon, 163)

In this interview, Swenson asks Warhol to discuss the origins of his Death
& Disaster *series. Warhol answers: "It was Christmas or Labor Day—a hol-
iday—and every time you turned on the radio they said something like, '4 mil-
lion are going to die in traffic accidents'. . . . With tragic irony, Gene Swenson
died at age thirty-five in a traffic collision in August 1969. He and his mother
were driving along an interstate highway in western Kansas—they were
second in a line of cars when, ahead of them, a tractor-trailer suddenly jack-
knifed, killing everybody in the first three automobiles." (Bourdon, 163)*

—KG

Someone said that Brecht wanted everybody to think alike. I want every-
body to think alike. But Brecht wanted to do it through Communism, in a
way. Russia is doing it under government. It's happening here all by itself
without being under a strict government; so if it's working without trying,
why can't it work without being Communist? Everybody looks alike and
acts alike, and we're getting more and more that way.

I think everybody should be a machine.

I think everybody should like everybody.

Is that what Pop Art is all about?

Yes. It's liking things.

And liking things is like being a machine?

Yes, because you do the same thing every time. You do it over and over again.

And you approve of that?

Yes, because it's all fantasy. It's hard to be creative and it's also hard not to
think what you do is creative or hard not to be called creative because

everybody is always talking about that and individuality. Everybody's always being creative. And it's so funny when you say things aren't, like the shoe I would draw for an advertisement was called a "creation" but the drawing of it was not. But I guess I believe in both ways. All these people who aren't very good should be really good. Everybody is too good now, really. Like, how many actors are there? There are millions of actors. They're all pretty good. And how many painters are there? Millions of painters and all pretty good. How can you say one style is better than another? You ought to be able to be an Abstract-Expressionist next week, or a Pop artist, or a realist, without feeling you've given up something. I think the artists who aren't very good should become like everybody else so that people would like things that aren't very good. It's already happening. All you have to do is read the magazines and the catalogues. It's this style or that style, this or that image of man—but that really doesn't make any difference. Some artists get left out that way, and why should they?

Is Pop Art a fad?

Yes, it's a fad, but I don't see what difference it makes. I just heard a rumor that G. quit working, that she's given up art altogether. And everyone is saying how awful it is that A. gave up his style and is doing it in a different way. I don't think so at all. If an artist can't do any more, then he should just quit; and an artist ought to be able to change his style without feeling bad. I heard that Lichtenstein said he might not be painting comic strips a year or two from now—I think that would be so great, to be able to change styles. And I think that's what's going to happen, that's going to be the whole new scene. That's probably one reason I'm using silk screens now. I think somebody should be able to do all my paintings for me. I haven't been able to make every image clear and simple and the same as the first one. I think it would be so great if more people took up silk screens so that no one would know whether my picture was mine or somebody else's.

It would turn art history upside down?

Yes.

Is that your aim?

No. The reason I'm painting this way is that I want to be a machine, and I feel that whatever I do and do machine-like is what I want to do.

Was commercial art more machine-like?

No, it wasn't. I was getting paid for it, and did anything they told me to do. If they told me to draw a shoe, I'd do it, and if they told me to correct it, I would—I'd do anything they told me to do, correct it and do it right. I'd have to invent and now I don't; after all that "correction," those commercial drawings would have feelings, they would have a style. The attitude of those who hired me had feeling or something to it; they knew what they wanted, they insisted; sometimes they got very emotional. The process of doing work in commercial art was machine-like, but the attitude had feeling to it.

Why did you start painting soup cans?

Because I used to drink it. I used to have the same lunch every day, for twenty years, I guess, the same thing over and over again. Someone said my life has dominated me; I liked that idea. I used to want to live at the Waldorf Towers and have soup and a sandwich, like that scene in the restaurant in *Naked Lunch.* . . .

We went to see *Dr. No* at Forty-second Street. It's a fantastic movie, so cool. We walked outside and somebody threw a cherry bomb right in front of us, in this big crowd. And there was blood, I saw blood on people and all over. I felt like I was bleeding all over. I saw in the paper last week that there are more people throwing them—it's just part of the scene—and hurting people. My show in Paris is going to be called "Death in America." I'll show the electric-chair pictures and the dogs in Birmingham and car wrecks and some suicide pictures.

Why did you start these "Death" pictures?

I believe in it. Did you see the *Enquirer* this week? It had "The Wreck that Made Cops Cry"—a head cut in half, the arms and hands just lying there.

It's sick, but I'm sure it happens all the time. I've met a lot of cops recently. They take pictures of everything, only it's almost impossible to get pictures from them.

When did you start with the "Death" series?

I guess it was the big plane crash picture, the front page of a newspaper: 129 DIE. I was also painting the *Marilyns*. I realized that everything I was doing must have been Death. It was Christmas or Labor Day—a holiday— and every time you turned on the radio they said something like, "4 million are going to die." That started it. But when you see a gruesome picture over and over again, it doesn't really have any effect.

But you're still doing "Elizabeth Taylor" pictures.

I started those a long time ago, when she was so sick and everybody said she was going to die. Now I'm doing them all over, putting bright colors on her lips and eyes.

My next series will be pornographic pictures. They will look blank; when you turn on the black lights, then you see them—big breasts and. . . . If a cop came in, you could just flick out the lights or turn on the regular lights— how could you say that was pornography? But I'm still just practicing with these yet. Segal did a sculpture of two people making love, but he cut it all up, I guess because he thought it was too pornographic to be art. Actually it was very beautiful, perhaps a little too good, or he may feel a little protec- tive about art. When you read Genêt you get all hot, and that makes some people say this is not art. The thing I like about it is that it makes you forget about style and that sort of thing; style isn't really important.

Is "Pop" a bad name?

The name sounds so awful. Dada must have something to do with Pop— it's so funny, the names are really synonyms. Does anyone know what they're supposed to mean or have to do with, those names? Johns and Rauschenberg—Neo-Dada for all these years, and everyone calling them derivative and unable to transform the things they use—are now called

progenitors of Pop. It's funny the way things change. I think John Cage has been very influential, and Merce Cunningham, too, maybe. Did you see that article in the Hudson Review ["The End of the Renaissance?," Summer, 1963]? It was about Cage and that whole crowd, but with a lot of big words like radical empiricism and teleology. Who knows? Maybe Jap[2] and Bob[3] were Neo-Dada and aren't anymore. History books are being rewritten all the time. It doesn't matter what you do. Everybody just goes on thinking the same thing, and every year it gets more and more alike. Those who talk about individuality the most are the ones who most object to deviation, and in a few years it may be the other way around. Some day everybody will think just what they want to think, and then everybody will probably be thinking alike; that seems to be what is happening.

2 Jasper Johns. Artist, b. 1930.
3 Robert Rauschenberg. Artist, b. 1925.

4 "Andy Warhol Interviewed by a Poet"

JOHN GIORNO
1963
Unpublished Manuscript from the Andy Warhol Archives,
Pittsburgh

Poet John Giorno first met Warhol in November 1962 at Eleanor Ward's Stable Gallery during Andy's first Pop show there. A friendship between the two ensued which ultimately led to Giorno starring in Warhol's first film, Sleep *(1963), a six-hour film of Giorno sleeping. In 2002, Giorno told a British newspaper "I was a kid in my early 20s, working as a stockbroker. I was living this life where I would see Andy every night, get drunk and go into work with a hangover every morning. The stock market opened at 10 and closed at three. By quarter to three I would be waiting at the door, dying to get home so I could have a nap before I met Andy. I slept all the time—when he called to ask what I was doing he would say, 'Let me guess, sleeping?' "[1] The premiere of* Sleep *took place on January 17, 1964 at the Gramercy Arts Theater as a benefit screening for the Film-Makers' Cooperative. The screening was attended by only nine people, two of whom left during the first hour.*

—KG

Andy and I made the "Andy Warhol Interviewed by a Poet" in June and July 1963, as a parody, a fake interview, about nothing and for nothing. Stupid and trashy, and dumb, not intended for anything, with no agenda; a response to the serious, self-serving art world. We did it in taxis, when Andy came by my place at 255 East 74th Street to pick me up to go somewhere, and in his place on Lexington Avenue and 89th Street, and in the Firehouse Factory, and any-

1 Catherine Morrison, "My 15 Minutes." *The Guardian*, 14 Feb. 2002.

where. Whenever Andy said something that sounded like it fit in an interview, I scribbled down the words. I made up the questions to fit the answers. They were typed up separately. A dysfunctional interview, and in the style of a Tennessee Williams play. "Oh, just put it together any way," said Andy. "It doesn't matter." It was never published. We had a good time doing it, laughing and loving and resting in the play of each others' minds. There was no bad or good. Everything was totally great.

—John Giorno

Place: The former locker room of the old No. 13 Hook & Ladder.

POET. (*winningly*) How long have you been a painter?

ANDY. When I was nine years old I had St. Vitus Dance. I painted a picture of Hedy Lamarr from a Maybelline ad. It was no good, and I threw it away. I realized I couldn't paint.

POET. That is a revealing fact. Your first painting was of a movie star. What is your capacity? Are you a fast worker?

ANDY. I can make a picture in five minutes, but sometimes I run into so much trouble. I have to do them over and over. Or I don't have enough turpentine, and everything is sticky. I did fifty Elvises one day. Half my California show. The roof of the firehouse leaked, and they were all ruined. I had to do them all over.

POET. How come you weren't in the Modern Museum show this year?

ANDY. I was crushed. But it doesn't matter.

POET. How come?

ANDY. (*coughing*) They had Marisol and Bob Indiana, and I guess they thought three from one gallery would be too much. I was so hurt.

POET. What do you think of Abstract Expressionism?

ANDY. Art is dead.

POET. Why Is Art dead?

ANDY. Nobody thinks. Nobody uses imagination anymore. Imagination is finished.

POET. What do you think of Larry[2]?

ANDY. He's the daddy of "Pop Art." He's so chic.

POET. What is "Pop Art"?

ANDY. "Pop . . . Art" . . . is . . . use . . . of . . . the . . . popular . . . image.

POET. Is "Pop Art" a fade? [*sic*]

ANDY. Yes. "Pop Art" is a fade. [*sic*] I am a "Pop Artist."

POET. Would you like to go with Marlborough[3]?

ANDY. Oh, yes. They are international, and I hear they give you a private secretary. That would be good for my career.

POET. Did you get any free soup from the Campbell soup people?

ANDY. No! Not even a word. Isn't that amazing? If it had been Heinz, Drew Heinz would have sent me cases of soup every week.

POET. What do you think of the nude figure in American painting?

ANDY. Oh, Art is too hard.

POET. What's that can of paint on the floor? It looks like house paint.

ANDY. It is. I mean it's the black paint I use.

2 Larry Rivers. Artist, 1923–2002.
3 Marlborough Gallery, New York City.

POET. Don't you use tubes like other artists?

ANDY. (*crossly*) Ohhhh, no.

POET. What pigments do you use?

ANDY. A silver spray can, plastic paint . . . and varnoline.

POET. What's varnoline?

ANDY. I clean my screens and brushes with it. I am having so much trouble. I am allergic to varnoline. I break out in red blotches and vile sores. I'm going to have to stop painting.

POET. Did you just become allergic to it?

ANDY. Yes. In the last two, three weeks.

POET. And you have been using varnoline for two years?

ANDY. Yes.

POET. Don't you think it is psychosomatic?

ANDY. No . . . Yes . . . I don't know.

POET. Well, if you weren't allergic to it for two years, I think it was caused by a mental disorder.

ANDY. (*confused*) I guess so. It gets in your blood. Varnoline is poisonous. That's what causes the. . . .

POET. Where do you have your silk screens made?

ANDY. Mr. Golden.

POET. Is that where Rauschenberg has his made?

ANDY. (*huffily*) Yes . . . Oh, don't put that in your interview.

POET. Tell me what you do when you're not painting.

ANDY. I believe in living. I didn't before. I spent fourth of July in the country, and I had forgot about living. It was so beautiful. I started going to Sam Ronny's Health Club on Broadway and West 73 Street, every day for four hours. I get massaged, box, swim under water . . . I want to be pencil thin . . . I want to like myself . . . What else? I am making a movie about sleep.

POET. Sleep! What about sleep?

ANDY. A movie of John Giorno sleeping for eight hours.

POET. How fascinating. Could you be more explicit?

ANDY. It's just John sleeping for eight hours. His nose and his mouth. His chest breathing. Occasionally, he moves. His face. Oh, it's so beautiful.

POET. When can I see it?

ANDY. I don't know.

POET. Tell me more about your painting.

ANDY. I am going to stop painting. I want my paintings to sell for $25,000.

POET. What a good idea. What are you working on now?

ANDY. Death.

POET. (*transfixed*) Hmmmm.

ANDY. The girl who jumped off the Empire Building, a girl who jumped out of a window of Bellevue, the electric chair, car crashes, race riots.

POET. Where do you get your photographs?

ANDY. My friends clip them out of newspapers for me.

POET. Do you think Marisol has affairs with people?

ANDY. Nobody knows.

POET. When can I see your death pictures?

ANDY. In November. I'm having a show in Paris[4] . . . (*with despair*) I haven't done them yet. I will have to do all of them in one day. Tomorrow . . . I don't know why I'm having a Paris show. I don't believe in Europe.

POET. How do you think Oldenburg compares with Marisol?

ANDY. (*impatiently*) Ohhhh . . . You can't ask me questions like that.

POET. Would you like to meet Elizabeth Taylor?

ANDY. (*ecstatic*) Ohhhh, Elizabeth Taylor, ohhhh. She's so glamorous.

POET. Tell me more about your painting.

ANDY. It's magic. It's magic that makes them.

The End

4 Galerie Ileana Sonnabend, Paris, January–February, 1964.

5 "Pop Goes the Artist"

RUTH HIRSCHMAN (NOW RUTH SEYMOUR)
Fall 1963
Transcription of KPFK radio broadcast, published in
Annual Annual, 1965, The Pacifica Foundation,
Berkeley, Ca.

In September of 1963, following the filming of Sleep, *Warhol made a cross-country car trip to Los Angeles for his second show at the Ferus Gallery. He was accompanied by the actor Taylor Mead, the artist Wynn Chamberlain, and Warhol's assistant, poet Gerard Malanga. Warhol's stay in Los Angeles was packed with parties and openings. He was invited to a party at Dennis Hopper's house and was introduced to stars such as Troy Donahue and Sal Mineo; he attended the opening of Marcel Duchamp's retrospective at the Pasadena Art Museum; and he made a movie during his stay,* Tarzan and Jane Regained . . . Sort of, *starring Mead and the New York underground filmmaker Naomi Levine.*

The Ferus show featured portraits of Elvis Presley in the main gallery, which were printed on one continuous roll of canvas and left to gallerist Irving Blum to cut and stretch at will. Although Warhol's reputation was quickly growing and the Pop phenomenon had spread to the West Coast, the paintings appeared too machine-made for the general public and were coolly received; subsequently, nothing sold. Andy later pointed out that they were money hanging on the wall but, at the time, people couldn't see it.

A few days after the opening, KPFK Arts Director Ruth Seymour (then Ruth Hirschman) interviewed Warhol and Mead at Pacifica's North Hollywood studios. Seymour, who joined KPFK at the end of 1961, regularly interviewed artists and intellectuals coming through Los Angeles, such as filmmaker Jean Renoir, poet Charles Bukowski, and author Erskine Caldwell. In the early '60s, KPFK was the only radio station of its kind in Southern California. Seymour was responsible for the station's arts coverage:

"I made the decisions about what arts programs went on the air and chose what I thought was important and timely." Her interview with Warhol and Mead lasted about half an hour.

The day the interview was scheduled, Seymour showed up with her five-year-old daughter in tow, who was too ill to go to school. "I can't tell you the look on their faces when I drove up with this sick little girl," Seymour recalls. "They were not pleased, to say the least. It was clear that they were going to be interviewed by this suburban mom: la vie famille vs. the two gay, decadent avant-gardists." Seymour settled her daughter into a corner of the studio with crayons and a coloring book and set to work.

The interview began roughly, with Warhol incorrectly giving Youngstown, Ohio as his place of birth. Seymour felt that "Warhol and Mead weren't pre-pared to take me seriously. They were impressed that I was good-looking, smart and plugged into the 'scene' (probably in that order). Andy and Taylor were all about that."

As they spoke at length, the dynamic shifted. "Taylor was the one who melted first. You could see him changing and you could see him thinking, 'Oh, she's interesting,'" Seymour remembers. "Andy was a much more guarded person; you couldn't tell very much about his reaction to things. But as the interview progressed, he warmed up and we began playing with each other. It became a friendly exchange and, by the end, we were having fun with each other. And when it was over, they both felt awful about my little daughter and I could see they felt guilty, especially since she'd behaved beau-tifully throughout the interview. She was too sick to do much of anything else, and their belated solicitousness hardly registered with her, but they made a real effort to make up for a bad beginning."

—KG

RUTH HIRSCHMAN: Where are you from, Andy?

ANDY WARHOL: Youngstown, Ohio.

R.H.: Ohio. Were you brought up there?

A.W.: Yes.

R.H.: Most of your life spent in Ohio?

A.W.: No.

R.H.: Where was it?

A.W.: Philadelphia.

R.H.: Were you painting at that time?

A.W.: Yes.

R.H.: How long have you been painting?

A.W.: I was ah . . . ah . . . oh, I just copied all the Maybelline ads.

R.H.: Way back then.

A.W.: Yes.

R.H.: Right.

A.W.: And they were of movie stars . . . Hedy Lamarr and Joan Crawford.

R.H.: When you were doing these things was there any movement known as Pop Art?

A.W.: Just in the grade school.

R.H.: Kind of underground.

A.W.: Underground Pop Art.

R.H.: Right. When did you hit the Pop Art scene?

A.W.: The skids, so to speak. Uh—two years ago.

R.H.: Was it in New York?

A.W.: Yes.

R.H.: One of the things that I've heard most discussion about, especially in relation to your work, is the question where do you get your themes from? The Campbell's soup show showed here, and now, of course, the Elvis Presley show; and watching people move around the Ferus Gallery, especially art instructors from colleges who are trying to explain it to their students, and they usually talk in terms of social significance—this is the—this is an aspect of our culture that he's painting—would you go along with that? Do you consciously think of like "What is the symbol of our culture?" when you did the Campbell soup show?

A.W.: Uh, no.

R.H.: You don't?

A.W.: No.

R.H.: Are they simply objects that move you?

A.W.: Yes.

R.H.: And they're chosen at random.

A.W.: Yes.

R.H.: Do you think they are particularly American?

A.W.: Uh, what they are, they're the only things I know.

R.H.: When I saw your show, I don't know whether you were aware of it, I don't know whether you were in town—the Campbell soup show—there was a gallery two doors down, and they had six Campbell's soup cans in the window with a little sign and it said "Don't be fooled, buy the real thing here, two for 33¢."

A.W.: Oh, I would have bought those.

TAYLOR MEAD: Yes, in fact, he was going into sculpture and we were going to go into a supermarket and put fixative on one of the displays in the supermarket and transport it to a museum or something.

R.H.: One of the things I find kind of interesting is that almost all Pop painters seem to come from the Midwest. Or am I wrong about that?

A.W.: Well, no. I think California—doesn't California have a lot?

R.H.: California has some, but I know Oldenburg's from Chicago, I think Lichtenstein is from the Midwest, too.

A.W.: And Taylor Mead is, too.

T.M.: I'm not a Pop Artist, I'm a romantic.

R.H.: Is there a difference?

T.M.: I'm an old silent movie star.

R.H.: Is there a difference?

A.W.: No.

T.M.: Yes. I'm pure and simple and Andy's complex and satirical.

R.H.: Are you satirical, Andy?

A.W.: No, I'm simple.

R.H.: You're simple. Well, he says he's simple, too. Maybe he's the real romantic.

T.M.: Maybe.

A.W.: No, I'm quasi-romantic, at least.

R.H.: When you—for example, when you did the Elvis Presley show, I forget, how long ago was that done?

A.W.: Well, it took me five minutes to do.

R.H.: Yeah.

A.W.: I mean, well, about an hour. It was done a month ago.

R.H.: Has it ever been shown before?

A.W.: No.

R.H.: This is the first showing.

A.W.: Yeah.

R.H.: Now, when you say like, it takes about an hour—do you spend most of your time painting?

A.W.: No.

R.H.: You don't. What do you do? Besides, I know you've made a movie and you're going to make another one.

A.W.: I don't know.

R.H.: You just live.

A.W.: Right. No, I don't live.

R.H.: Do you want to qualify that statement?

A.W.: No.

T.M.: He spends the rest of the time playing Elvis Presley records, and listening to them.

R.H.: Do you think Pop Art could survive, let's say, without P.R. people?

A.W.: Oh, yeah.

R.H.: You do?

A.W.: Well, because I think the people who come to the exhibition understand it more. They don't have to think. And they just sort of see the things and they like them and they understand them easier. And I think people are getting to a point where they don't want to think, and this is easier.

R.H.: I gather that you find something positive in this.

A.W.: Well, yeah.

R.H.: Right. I wish you'd just go on and explain a little bit why.

A.W.: I don't know, I don't know —

R.H.: Well, I was wondering, I had — I brought my daughter to two or three Pop Art exhibitions and had no difficulty at all with her understanding the stuff, or with her being bored. She wasn't, she had a ball at the galleries. Maybe that comes close to something that you mean.

A.W.: Yeah, yeah.

R.H.: That it's just, you just dig it.

A.W.: Yeah.

R.H.: You don't have to. . . .

T.M.: I don't, really, I don't see how a child could dig it any more than digging average pictures in books. I think it almost requires a very sophisticated audience. 'Cause I think it's sort of a transvaluation of the advertising values that sort of inundate the country. . . .

R.H.: Well you see it, then, as satiric. You see that a can. . . .

T.M.: I see it as something the country richly deserves. And it, actually the advertising, has so swamped America that now the Pop Artist . . . we have to find some value in it because it's just — you know, we have to take it and find something in it that's groovy or just be smothered by it, and the Pop Artist is doing that. They're saying "We're going to dig it no matter what," you know.

R.H.: I think this is interesting. That's what we get so often. In other words, Pop Art is a verbal art in a way. It's very easy for you or me to talk about it in terms of its meaning, and we can make a very meaningful case for it. But when we ask Andy, he doesn't want to make a meaningful case for it and that's what intrigues me.

T.M.: Yeah, but he was in advertising, though, and he's evolved.

R.H.: Were you in advertising professionally?

A.W.: Yes.

R.H.: And do you feel that this has any carry-through?

A.W.: Why, no, it's just that I liked what I was doing before and I like what I'm doing now.

R.H.: But you don't consider the two the same thing?

A.W.: Uh, no.

R.H.: Would you go along with what Taylor said? We've been . . .

A.W.: No. . . .

R.H.: . . . been so swamped with it that this is where we now find a meaning?

A.W.: No.

T.M.: Well, actually,—there's so much of it that actually you can now pick out things in it that really amount to, uh, to art. Like we just drove across the country and both of us would say "Oh what a great Coca-Cola sign or what a great restaurant sign that is" and it's really amazing that as a result of Pop Art you can really see something in the average sign of value.

A.W.: Yeah.

R.H.: I think this is true. I don't think that anybody who saw the Campbell's soup show can ever walk into a supermarket and look at a can of Campbell's soup the same way again.

T.M.: The Pop Artist has isolated a way of looking at what surrounds us; I think, just like the person who paints a sylvan scene has isolated the countryside somehow.

R.H.: Do you think that it's like a comment on what we have to say about the way we live now?

T.M.: Yeah, definitely.

R.H.: Pop Art makes that comment?

T.M.: Yeah, very much.

R.H.: Does it make it on a value basis? Is it saying it in terms of like, this is what we get, Campbell's soup, rather than a vision of truth or beauty or that Campbell's soup contains a vision of truth and beauty?

A.W. & T.M.: Both, yeah, both.

R.H.: Then you don't see it as a negative comment?

T.M.: (*Laughing*) Some days I do.

R.H.: Andy, do you like the things that you paint?

A.W.: Yes, I do.

R.H.: In other words, there's a reason, like you were more drawn to Campbell's soup, for example, than you would be to another artifact.

A.W.: Why, I ate Campbell's soup, well, I had a soup and a sandwich for 20 years.

R.H.: Right.

T.M.: Yes, you see, he's inundated by it and it has to burst out in some aesthetic or intellectual or sophisticated or satirical direction, like he's done Elizabeth Taylor and Elvis Presley. It's obvious what he's working with are the most . . .

A.W.: Oh, but there's. . . .

T.M.: . . . most Pop of all the Pop things that are in the country.

A.W.: But I'm working on death now. And that's not satirical.

T.M.: Yeah, but the way you're working on it is in its most cliché, Pop, form really.

A.W.: Oh,. . . .

R.H.: Will we be giving it away if we ask you another question about that?

A.W.: No.

R.H.: You say you're working on death.

A.W.: Yeah.

R.H.: How?

A.W.: Oh, well, just people jumping out of windows and landing and being killed by cars and taking poison and, uh, that's all.

R.H.: Are they different people or what—

A.W.: No, just newspaper pictures and electric chairs and. . . .

T.M.: Hearses.

A.W.: And hearses.

T.M.: Great piles of flowers.

A.W.: Oh, flowers.

T.M.: . . . graves from florists' shops.

R.H.: Do people come up to you and talk to you about your work?

A.W.: No.

R.H.: They don't?

A.W.: Mm-mm.

R.H.: Why is that?

A.W.: I don't know.

T.M.: It's all there, there's nothing to talk about.

A.W.: Yeah. It's really nothing, so it really has nothing to say.

R.H.: When you finish a show, like the Elvis Presley one, you say it takes

like about an hour, I assume it takes longer, just you know, physically, it would, it might take longer to do it but you would say that all the time in between is a kind of preparation for coming to something like that?

A.W.: No, it's just being mechanical.

R.H.: Do you regard it as a part of your life, you know, not the ultra-romantic concepts of the artist living at his highest moment in the creative act?

A.W.: Mmmm. No, yeah—No.

T.M.: No, more working at the machine—going to work at the factory.

A.W.: Yeah.

R.H.: Is it any different to you from, for example, any other of the things that you might do during the day like taking a bath or having a sandwich?

A.W.: No, it's the same.

R.H.: It is the same.

A.W.: Yeah.

R.H.: Uh, I want to, if I haven't introduced him before, I want to introduce Taylor Mead, who's—

T.M.: Where, where, where!

R.H.: Tell me Taylor, does that go for you, too?

T.M.: What?

R.H.: Is, is acting for you—

T.M.: When that little sound goes off, I am on.

R.H.: You're on!

T.M.: I don't know. Now I've been getting sort of probably used to it and so I don't know when I'm on and when I'm off. Now I'm becoming a star and so . . . I'm on 24 hours a day. And it's great.

R.H.: But for you it's a different kind of thing, I take it then, like it's not taking a bath or eating a sandwich. It's a kind of. . . .

T.M.: Well, I think ideally, maybe it should be, but actually the critics say I can do no wrong anyway. But no, there is a slight heightening specially for the camera. You're *on*, working differently than on stage. But you find this out so quickly that eventually you don't know that you're on; I don't think, too much.

R.H.: Taylor, do you see any counter-relationship between Pop Art and the work that Andy is doing and the films being produced by the New American Cinema now?

T.M.: There must be a relation because I get along so well with the Pop Artists. That's the only way I could judge, because I dig them—we dig each other mutually.

R.H.: Are you working in essentially the same area, like, you know, isolating the American symbols?

T.M.: No. No, we're not isolating anything. The movies I've made we just walk—uh, like Andy says he walks into his art, we walk into our movies. But also we have such a tremendous respect for the old silent films that, there, a certain amount of romanticism and exaggeration wanders into it. Like a movie—like just the titles of some of the movies I make, like "Queen of Sheba Meets the Atom Man" or. . . .

A.W.: Yeah, but then that becomes a symbol, too. Like taking Tarzan and all that. Tarzan is one, and the President and. . . .

T.M.: Yeah, but we aren't doing Tarzan exactly as Lex Barker or Weismuller would do it. If that were a Pop Art Tarzan we would have the exact—it would be a TV Tarzan. We'd have the exact leotards.

R.H.: Wouldn't you have. . . .

T.M.: No! I have—the only Tarzan outfit I could find was—belonged to— was an 8-year-old's zebra swimming trunks that we had to rip all to shreds and which barely makes it over my privates.

R.H.: What is the film called?

T.M.: *Tarzan Sort Of.*

R.H.: *Tarzan Sort Of?*

T.M.: Yes.

R.H.: Maybe that's the difference—Pop Art is Tarzan.

T.M.: Mixed with Taylor Mead because half the time I just couldn't put on my trunks. We were at, we were either at a high-toned party or in the weight lifting area, or, the manager of the weight lifting area got very upset, very prurient.

R.H.: Do you feel that the films from the New American Cinema are social comments?

T.M.: Oh, definitely. They're brutal. Brutally satirical and completely thumbing their nose at Hollywood and TV and everything that's present. They're not thumbing their noses at the way that Hollywood used to work, in which there were idea men and you'd reel off a film in a day and you had a ball doing it. And if, like nowadays, if a workman three studios over hammers in a nail while an actor is doing a great scene even though that's barely picked up they'll re-shoot the whole scene without any regard to whether the actor was functioning on the screen or what. They don't care about that. All they care about is a cold, technical thing with no sounds and the decor is all perfect—no dust on the decor.

R.H.: The word "underground." Do you use that word in terms of the New American Cinema?

T.M.: It shouldn't be because the New York Film Festival proved this, that it's ready to—the people who go to the foreign movie houses are all ready for the New American Cinema. Easily. And it's, uh, well, any appellation like even avant-garde or even New American Cinema, anything that isolates a movement is unfortunate, I think, because all kinds of people like the movie I made in Venice, California, *Passion of the Seaside Slum,* that was shown to every type of audience and they just . . . the impact was tremendous and yet

it was put together spontaneously and according to the semi-rules of this new cinema.

R.H.: I might just mention here for the sake of the audience, I think three of Taylor's earliest films were made in Venice, California. Am I right?

T.M.: Well, no, two were made in 'Frisco and two or three were made here in L.A. *Senseless, To L.A. With Lust,* and *Passion of the Seaside Slums.*

R.H.: What is *Senseless?*

T.M.: *Senseless* is floating a raft—it's in New York, I guess.

R.H.: I think the film which has been, which has shown most in Los Angeles, and it's been available if you care to see it, and it probably will be available again, is *Flower Thief.*[1]

T.M.: Yes, *The Flower Thief* is available and *Lemon Hearts.* There are both many prints of them from the Film-Makers' Cooperative in New York City.

R.H.: Andy, what's the title of the film that you've made?

A.W.: Uh, it's an eight-hour movie on sleeping.

R.H.: Do you want to tell us a little about it?

A.W.: Well, nothing really happens. Just somebody sleeping for eight hours.

R.H.: And you focus a camera on him and . . .

A.W.: Yeah.

R.H.: . . . and shoot straight?

A.W.: No, I just put the motor on and the motor just goes on and shoots and it's mostly all finished. It's practically—it is finished.

1 *The Flower Thief* (1962). Directed by Ron Rice.

R.H.: Are you going to have it reviewed the way the last Cage concert was, with all the reviewers going from 11 to 12?[2]

A.W.: It's been reviewed.

R.H.: Oh, it has been reviewed.

A.W.: Yes. Jonas Mekas reviewed it.

R.H.: In *The Voice*.

A.W.: Oh, well, it's a movie where you can come in at any time. And you can walk around and dance and sing.

T.M.: I'm doing the music for it.

R.H.: Is there a close tie-up in New York between Pop painting and film making?

T.M.: Well, not exactly except all the painters are sort of also interested, many of them are also interested in making movies and we often get them in the movies. And the scene, the art scene I guess in New York is very interrelated, the movies and the people and everything . . .

A.W.: Oh, yeah?

T.M.: . . . are all very congenial.

R.H.: Tell me, does this scene include the theater, or is the theater in terms of this new movement finished?

T.M.: Yeah, the whole concept of repeating and repeating on the stage — well, no, there is a—'cause it was mostly in dance, really, in music—in happenings.

R.H.: In other words, things which are fairly fluid seem to be—

2 In September of 1963, John Cage organized the first complete performance of Erik Satie's "Vexations" at the Pocket Theatre in New York City. Ten pianists worked in two-hour shifts. The concert lasted 18 hours and 40 minutes.

T.M.: It seems mostly to be only stage work that just happens one night.

R.H.: You mean happenings?

T.M.: But shows that go on and on are just, the temperament of the people is just not too suited for it, I don't think. Because these are Beat people, really.

R.H.: Is there any tie-up between this and let's say Cage, John Cage's music?

A.W.: Yeah, I think so.

T.M.: He's a pedantic idea of what you have to free. I mean, he might help people to free themselves, but as for doing something interesting or something really stimulating, no, he's just. . . .

A.W.: I think he's really marvelous, but I think that younger kids are really. . . .

T.M.: He's an artist for technicians, for freeing you technically maybe, to wig out on anything you feel like, bongos or piano wires or alarm clocks or things. . . .

A.W.: But he, he really is great. . . .

T.M.: But as for making it cohesive. . . .

R.H.: Do you feel that it has to be made cohesive?

T.M.: I think it's more fun to. It's more fun to have an hour concert than something that people wander in just to see—well, I don't know, it's fun both ways, but I'd like it, I like it, I'm very theatrical, I like a theatrical evening really, that gives you a great overall feeling that really charges you.

R.H.: Do you feel that you need a center?

T.M.: Well, with Cage or those other people you come in and maybe you're intellectually piqued, you know, but you aren't stirred emotionally and overwhelmed.

A.W.: I would grant him, you know, a lot on purely experimental intellectual "freeing the other artists" basis.

R.H.: But you don't feel that he's a romantic, do you?

A.W.: No.

R.H.: Andy, why do you repeat your images?

A.W.: I don't know.

R.H.: When you come on to Andy that way, he turns off. Like, there are lots of Campbell's soup cans. Is each one, to you, different?

A.W.: Uh, no.

R.H.: They're all the same?

T.M.: Oh, no, sometimes they're chicken soup, sometimes they're beef broth —

R.H.: I went around counting at the Ferus which were selling, and I found out something interesting. I think you had trouble with one brand. The chicken soups were not going. I thought that was very curious.

T.M.: I think there are a lot of vegetarians out here.

R.H.: . . . things like that went right away.

A.W.: No, I just think people do the same thing every day and that's what life is. Whatever you do is just the same thing.

T.M.: Well, that certainly is American life. Since half the people are doing everything they do all eight hours a day at least. It's repeat, repeat, repeat, repeat and the countryside is repeat, repeat, repeat, repeat, so why not in art, repeat, repeat. One Elvis, why not twenty?

R.H.: Andy, you don't act, do you?

A.W.: No.

R.H.: When you did this film, you directed it?

A.W.: No.

R.H.: What did you do, then? Were you the man that was sleeping?

A.W.: Oh, you mean we're talking about the other—not the *Tarzan* movie.

R.H.: No, I'm talking now about—oh, by the way, does your film have a title?

A.W.: Uh, no.

R.H.: Will it?

A.W.: No.

T.M.: *Sleep*, I guess it is.

A.W.: No, it won't have any title at all. It just starts, you know, like when people call up and say "What time does the movie start?" you can just say "Any time."

R.H.: I imagine that one of the interesting things about this film is that I would suspect that there is not a repetitive moment in your film. I have a feeling that probably the human face changes.

T.M.: Well, there won't be when I get to the. . . .

R.H.: I mean even visually. Fixing a camera on a man who's asleep, I wonder whether his face does change perceptibly.

A.W.: It doesn't change for a long time.

R.H.: It doesn't?

A.W.: Some scenes, yes, they sort of last for a long time.

R.H.: By the way, I'm sort of curious, how did you find the subject who. . . .

A.W.: Well, it took a long time. He was just somebody who likes to sleep.

R.H.: And he would do it without. . . .

A.W.: Well, yeah, I had a key and I just came in and it never bothered him.

R.H.: And he was aware that this was going to happen?

A.W.: Yeah, but it didn't matter because he just—I guess he has a problem.

R.H.: Maybe he doesn't have any.

T.M.: Yeah, he's wealthy, he doesn't need movie contracts.

R.H.: He went right on.

A.W.: Yeah.

R.H.: Right. Are you going to edit it?

A.W.: It's half edited—it's mostly edited—yeah.

R.H.: How do you decide, well, if you take this. . . .

T.M.: The editing is just splicing, is all.

R.H.: Are you going to take something out, or, I wonder how you edit a film like that. Like, if the idea is to do eight hours of a man sleeping do you take anything out for a particular reason?

A.W.: No, no, just the little holes in the camera, you know, the film, that you have to cut out.

R.H.: Right. Otherwise it'll be straight?

A.W.: Yeah.

R.H.: Taylor, does this appeal to you as a way of making films?

T.M.: If I do the sound track it does.

R.H.: But you won't do. . . .

T.M.: But to see it silent, it, uh, you have to be able to come and go—

A.W.: It won't be silent. Taylor's going to do the music.

T.M.: I'm going to do a spontaneous sound track, I think. With using

pianos or whatever's available in the studio, and everything. My radio, and everything.

R.H.: Then hopefully it'll be available to the New York Film Cooperative, and a group that wants to get them can apply for them there.

T.M.: Yeah.

R.H.: Right. Thanks very much, Andy Warhol and Taylor Mead.

6 "Andy Warhol: Interviewed by Gerard Malanga"

GERARD MALANGA
1963
Kulchur 16, Winter 1964–65

Poet Gerard Malanga was Andy Warhol's primary studio assistant at the Factory during the 1960s. They met at a party in June of 1963 and Malanga began working for Warhol shortly thereafter. He had previously been employed as a silkscreener in a tie manufacturing plant and brought that knowledge to the Factory just as Warhol was moving toward a more mechanical means of painting.

The Factory environment rubbed off on Malanga and he began a series of interviews with Warhol based on Warholian concepts, the first of which was this interview published in the small but influential 1960s literary magazine Kulchur. *(The other interviews from this series, "Interview With Andy Warhol on EMPIRE" [1964] and "Andy Warhol on Automation: An Interview with Gerard Malanga" [1968] follow.)*

As Malanga recalls, "It was just a very casual thing. I had this idea to sit down and do a questionnaire-type of interview with Andy. We sat in chairs opposite each other and I had a notebook in my hand. Because of his monosyllabic answers, it was very easy to transcribe, just write down what he was saying. Basically I was taking dictation."

The questions Malanga asked were taken from an employment questionnaire that he found. "I changed a few questions here and there and repeated certain questions for a more Warholian effect. Andy was interested in a readymade situation so I thought this method of interviewing was very applicable."

—KG

Q. What is your name and address?

A. My name is Andy Warhol. I live on Lexington Avenue in New York. Actually I spend most of my time at "the factory" on East 47th Street.

Q. Where were you last employed?

A. I. Miller Shoe Salon.

Q. What is your profession?

A. Factory owner.

Q. Do you have a secret profession?

A. Commercial artist.

Q. Do you have a secret profession?

A. Yes.

Q. If so, what?

A. I can't think of it.

Q. Why aren't you doing what you should be doing?

A. Because I'm making films.

Q. Are you allowed to do what you should by circumstances?

A. No.

Q. What is beyond your control?

A. What's that mean?

Q. Why should anyone hire you?

A. Because I'm dependable.

Q. Does society owe you anything?

A. Yes.

Q. If you are happy doing what you do, should you be paid for it?

A. Yes.

Q. If so, why?

A. Because it will make me more happy.

Q. And how much?

A. As much as I want.

Q. Are you human?

A. No.

Q. Why do you answer what you answer?

A. Because I'm sensitive.

Q. If you are unhappy, should you be paid for this?

A. Yes.

Q. Who should not be allowed to be paid?

A. Talented people.

Q. Why?

A. Because they can do it so easy.

Q. If you were very stupid, could you still be doing what you are doing?

A. Yes.

Q. If so, why do you do it?

A. Because I'm not very smart.

Q. If not, should you be compensated for this?

A. Yes.

Q. Should very stupid people be compensated?

A. Yes.

Q. Does your physique affect what you do?

A. Yes.

Q. How?

A. Because, sometimes, when I put on some weight from eating too much I get depressed.

Q. What do you need?

A. Nothing.

Q. Where should what you need come from?

A. From God.

Q. What are you?

A. A man.

Q. What do you know?

A. Nothing.

Q. Are you glad you know this?

A. Yes.

Q. Does it pay?

A. Yes.

Q. How much?

A. Nothing.

Q. Should it pay?

A. Yes.

Q. What would you like to forget?

A. Everything.

Q. Who are you glad you are?

A. I don't know.

Q. How does this affect our educational standards?

A. It doesn't.

Q. Is it more wonderful than awful to know the right people?

A. Yes.

Q. Why?

A. Because they're right.

Q. Who do you know?

A. Almost no one.

Q. Are you sure you know them?

A. I'm not sure of anything.

Q. Of what are you certain?

A. I'm not certain of anything.

Q. Could you be hired on this basis?

A. It's not what I'm not certain of, it's what I can do that counts, I suppose.

Q. How can you help?

A. I can help by doing everything right.

Q. Whom do you want to help?

A. Those whom I know that deserve help.

Q. Is there any necessary connection between wanting to help and a potential value of helping?

A. No.

Q. Why not?

A. Because wanting to help does not necessarily lead to actually helping; therefore no potential value can exist.

Q. Do your answers to the above make you useful to people?

A. It's not that I am made useful to people, it's those people who are made useful to me.

Q. Do your answers to the above make you some kind of Communist?

A. No. But I've been referred to as a Platonist.

Q. Please tell me about yourself.

A. I already have.

7 "Interview with Andy Warhol on *EMPIRE*"

GERARD MALANGA

1964

Unpublished manuscript from the Andy Warhol Archives,
Pittsburgh

In his 1966 interview for the film USA: Artists, *Andy Warhol said "I mean,
you should just tell me the words and I can just repeat them because I can't,
uh . . . I'm so empty today. I can't think of anything. Why don't you just tell
me the words and they'll just come out of my mouth."*[1]

*The following two "interviews" are just that: invented dialogues by
Warhol's assistant, poet Gerard Malanga, in the spirit of Andy Warhol. Both
"interviews" were done with Warhol's knowledge and consent. "Interview
with Andy Warhol on* EMPIRE" *appears in print here for the first time;
"Andy Warhol on Automation: An Interview with Gerard Malanga," was
published in the literary magazine* Chelsea *in 1968.*

*Warhol's career leaves a legacy of authorized impersonations, most
famously when, in the fall of 1967, Factory denizen and seasoned actor Allen
Midgette was hired by Warhol to do a series of college lectures impersonating
Andy Warhol. Warhol himself found these engagements difficult and tedious.
The students, expecting someone dynamic and glamorous, were often disap-
pointed when the tight-lipped, shy Warhol appeared. Midgette on the other
hand—charismatically donning his silver wig and dark sunglasses—was a
smash hit with the students. The stunt went off without a hitch for some time,
but the gig finally ended when a suspicious newspaper reporter called the
Factory and Warhol spilled the beans. Andy Warhol—as himself—subse-
quently had to return to the colleges to make up for the impersonations.*

*In the summer of 1964, Warhol, Jonas Mekas, Gerard Malanga, Henry
Geldzahler, and John Palmer convened in an office on the 44th floor of the*

[1] "USA Artists: Andy Warhol and Roy Lichtenstein," Lane Slate (1966), p. 79.

Time-Life Building in midtown and filmed Empire, *an eight-hour movie of the Empire State Building at night. The shooting began at 6 p.m. and completed close to 1 a.m.*

The majority of the questions and answers from "Interview with Andy Warhol on EMPIRE" *were taken from an Empire State Building publicity brochure. The "interview" was written in the weeks following the filming of* EMPIRE, *not at 4:30 in the morning, following the shooting of* EMPIRE, *as Malanga falsely states in his introduction.*

—KG

(The following interview was recorded with Andy Warhol at 4:30 A.M. on the 43rd floor of the Time-Life Building, just 30 minutes after the completion of the shooting of the 8-hour "underground" movie, *EMPIRE, in the summer of 1964.*)

GERARD MALANGA: *Could you tell me how you felt as you were being taken up into the building?*

ANDY WARHOL: The actual elevator ride to the top of the Empire State Building took as little as one minute, but a visit to Empire State is an experience that each visitor will remember all his life.

My thrills began the moment I stepped aboard a modern express elevator which whisked me to the 86th floor Observatory at a speed of 1,200 feet per minute. A special elevator took me to the 102nd story peak.

GM: *What did you see once you reached the top?*

AW: Once atop the Empire State Building, the most spectacular view in the world was spread at my feet. From the outdoor terraces or the glass-enclosed, heated Observatory on the 86th floor (1,050 feet or 320 meters), other buildings are dwarfed by this engineering marvel.

The view is even more amazing from the circular, glass-enclosed Observatory on the 102nd floor (1,250 feet or 381 meters). Here I was often at cloud level nearly a quarter of a mile above the streets.

I could distinguish landmarks as far away as 25 miles and was able to gaze as far as 50 miles into five states . . . Massachusetts, Connecticut, Pennsylvania, New Jersey, and New York.

GM: *What were some of New York's landmarks that you were able to see from atop Empire State?*

AW: To the north the RCA Building stands out against the 840 acres of Central Park. The Hudson River to the left leads to upper New York State and New England. The Bronx is in the background.

From the northwest corner of the 86th floor Observatory, visitors look into Times Square (center) and the bustling piers along the Hudson River, where giant ships from all over the world tie up.

Looking northwest from the top of Empire State, the visitor looks down on such landmarks as the United Nations Building (center) on the bank of the East River and the Chrysler Building (left). The Borough of Queens is in the background.

By night, New York becomes a honeycomb of light, dazzling and unbelievable in its beauty. This view from the northwest corner of the 86th floor observatory looks down into Times Square and the heart of the theatre district.

GM: *What do you know about Empire State's TV Tower?*

AW: At the 102nd story level of the Empire State Building—on a space the size of a pitcher's mound—a 22-story, 222-feet, 60-ton mast-like structure stretches upward to a height of 1,472 feet into the clouds. It is the world's most powerful and far-reaching TV tower. From here all seven of the New York area's television stations transmit their programs to a four-state sector in which 15 million persons live and own more than 5,200,000 TV sets. Programs transmitted from the Empire State Building, in other words, reach an area in which one of every ten persons in the United States lives.

GM: *Andy, can you brief me on some of Empire State's vital statistics in comparison with other structures of similar nature?*

AW: The internationally known Empire State Building is the world's tallest building. Comparative statistics show that the 1,472-feet-high Empire State Building towers over such other international structures as the 984-feet-high Eiffel Tower, the 555-feet-high Washington Monument, the 480-feet-high Pyramid of Cheops, and the 179-feet-high Leaning Tower of Pisa.

GM: *What can you tell me about Empire State's huge floodlights?*

AW: The spectacular lighting of the tower portions of the Empire State Building allows the world-famous silhouette of the world's tallest building to occupy the same dominant position on the horizon of nighttime New York as it does during the day. Basic light source for this gigantic flood-lighting task is a 1,000-watt, iodine-quartz lamp which is in the same family of lamps as those used to illuminate missile launching pads at Cape Kennedy. The floodlights, which are distinguished for their high intensity, long throw, and fine beam control capabilities, are strategically located on various setbacks of the building so as to do the best job of illumination without interfering with the famous nighttime view from the Observatory.

GM: *Before the floodlights were installed to coincide with the World's Fair, was there a time when Empire State had four powerful beacons?*

AW: Yes; you are quite correct. Visible from the Observatory are the four Freedom Lights, the world's most powerful beacons, which have made the Empire State Building the tallest lighthouse in the world . . . a landmark to sea and air travelers alike. A bronze plaque inscribed with famed author MacKinley Kantor's 168-word tribute to the Freedom Lights is located on the western terrace of the 86th floor Observatory.

GM: *What about Empire State's interior decoration?*

AW: "The Eight Wonders of the World," the eight original art works in the lobby of the Empire State Building, which were created by artist Roy Sparkia and his wife Renee Nemerov, have become a prime additional attraction at Empire State since their unveiling in 1963. Employing a new technique which permits the artist to paint with light as well as color, the

subjects include the Seven Wonders of the Ancient World as well as the Eighth Wonder of the Modern World . . . the Empire State Building.

GM: *Can you tell me about the exterior of the Empire State?*

AW: Not only the highest building in the world, Empire State is also one of the most beautiful. The exterior is of Indiana limestone trimmed with sparkling strips of stainless steel which run from the sixth floor all the way to the top. Whether seen in sunlight or moonlight, the effect is magnificent.

Marble in the cathedral-like lobby was imported from four different countries, France, Italy, Belgium, and Germany. Experts combed these countries to get the most beautiful marble, and in one case, the contents of an entire quarry were exhausted to insure matching blocks of exactly the right color and graining.

GM: *Do you feel that Empire State is a popular subject?*

AW: The Empire State Building has been featured in many movies, Broadway plays and several big-hit musicals. Hardly a day passes that it isn't mentioned in one television program or the other. It's been included, too, in popular songs—and many, many books.

GM: *Who are some of Empire State's celebrated visitors?*

AW: Each year the Empire State Building plays host to many Heads of State or dignitaries and celebrities. Had you been here on the right days in the past, you might have seen Queen Elizabeth II and Prince Philip of England, or the King and Queen of Thailand, or Princess Birgitta and Desiree of Sweden, or Queen Frederika of Greece or even your favorite movie actor.

GM: *Oh, by the way, that reminds me, who is your favorite movie actor?*

AW: My favorite movie actor is Troy Donahue.

GM: *In closing, do you know what others think of Empire State?*

AW: Of the many publications that have commented on Empire State, the following superfluous praise has been said (I hope I get the quotes right.):

"Empire State . . . one of USA's 7 engineering wonders." —*Time Magazine*

"The unbelievable Empire State Building." —*Reader's Digest*

". . . see New York from the top of Empire State. There's nothing like it" —Dorothy Kilgallen

"From Empire State you can see 50 miles." —*Allentown Sunday Call Chronicle*

"No visitor should miss Empire State." —*New York Times*

"Empire State's best view is at night." —*Glasgow* (Scotland) *News*

"Empire State's view is breathtaking." —Britain's Queen Mother

"New York's most visited building." —NBC

*erard Malanga with Andy Warhol's
1964. Malanga made up both the
ving researched various industrial
's famous quote "I think everybody
on's interview in this volume, "What*

—KG

uth on automation is coming a lot sooner than most people realize?

A. I have always considered that the substitution of the internal combustion engine for automation marked a very important and exciting milestone in the progress of mankind.

Q. But what is the truth about automation?

A. You don't have to think a lot.

Q. How do you feel about the 35,000 or more U.S. workers who are losing their jobs to machines?

A. I don't feel sorry for them. It will give them more time to relax.

Q. Do you feel that automation has been responsible for the nation-wide coin shortage?

A. Possibly: but I hope for the coin extinction.

Q. What does the computer mean to you?

A. The computer is just another machine.

Q. Do you feel that the alternative to automation is economic suicide?

A. Absolutely not.

Q. You have said many times in the past that you, yourself, would like to be a machine. Does this mean that you sense what you are doing and are able to take over operations to correct any mistakes or initiate the next step?

A. Yes. The power of man has grown in every sphere except over himself. Never in the field of action have events seemed so harshly to dwarf personalities. Rarely in history have brutal facts so dominated thought or has such a widespread individual virtue found so dim a collective focus. The fearful question confronts us, have our problems got beyond our control? Undoubtedly, we are passing through a phase where this may be so: but this will change with the rise of automation, because mankind will understand eras and how they really open and close.

Q. Purists speak of cybernation, in which a master machine is used to run other machines, as in a factory. Using this definition would you then say that you are a Purist?

A. Not yet.

Q. Would you like to replace human effort?

A. Yes.

Q. Why?

A. Because human effort is too hard.

Q. Close-tolerance "silk-screening" involves highly skilled technicians. What would happen, let's say, if you had the chance to acquire taped programmed machines with digital signals to guide the intricate silk-screen printing which is ordinarily done by me?

A. Everything would be done with more efficiency.

Q. Would you say that I have a property right to my job? I mean I own my job for life?

A. No.

Q. If my job vanishes into a technological limbo, won't another open up somewhere in this "factory"?

A. Possibly. It's all a matter of doing something else.

Q. Will I make more?

A. Yes.

Q. How will you meet the challenge of automation?

A. By becoming part of it.

Q. What will you do with all this leisure time created for you by automation?

A. Sit back and relax.

Q. Will you devote yourself to life-enhancing hobbies?

A. No.

Q. What does human judgment mean to you?

A. Human judgment doesn't mean anything to me. Human judgment cannot exist in the world of automation. "Problems" must be "solved." Without judgment there can be no problems.

Q. Are you patient with little solutions and try to get as many as you can so they'll add up to something?

A. What I try to do is to avoid solving problems. Problems are too hard and too many. I don't think accumulating solutions really add up to something. They only create more problems that must be solved.

Q. Do you, then, feel that we're moving into a period, most probably a

permanent period, where the main characteristic of the world will be change?

A. Change is the same without being different. We live in a world where we do not notice change: therefore what does change only enhances itself a little more each day.

Q. Dissect the meaning of automation.

A. Automation is a way of making things easy. Automation just gives you something to do.

9 "An Interview with Andy Warhol"

DAVID EHRENSTEIN
March 3, 1965
Film Culture, Spring 1966

In 1965, David Ehrenstein, a recent high school graduate, found him-
self attending numerous underground film screenings in New York City. He
was beginning to write film criticism and frequently met and conversed with
Warhol at screenings of Andy's films. On the suggestion of Film Culture
editor Jonas Mekas, Ehrenstein was given a chance to interview Warhol. He
decided to take a three-tiered approach: "I went over to the Factory one day
just to hang out to get a feel for what was going on there. I then came
back the next day to do the interview; and went back a third to hang out
some more."

On the day of the interview, the Factory was in full, mid-week swing:
Screen Tests were being filmed of the poet Ted Berrigan and the painter
Joe Brainard; a 45 rpm version of The Rolling Stones' "Time Is On My
Side" was blasting out of the stereo; and all day long various people came
and went trying to pitch Warhol projects, including a young French-Cana-
dian named "Rock" who had unsuccessfully tried several times to take his
life ("Rock" became the star of Warhol's film Suicide *[1965] mentioned in*
the interview. The film, which consists of close-ups of "Rock's" scarred wrists
along with his descriptions of his various suicide attempts, was never shown
due to legal threats by it's subject).

The interview took place during the entire day, as Ehrenstein followed
Warhol around the Factory, turning on the tape recorder at various times
to catch snippets of conversation. "What I wanted to do was to be there
in the Factory and ask him questions in the course of whatever happened
to be going on at the moment."

Warhol's enthusiasm in this interview for the just-opened film Sylvia *is*
of note due to his interest in the film's star, Carroll Baker. Baker's

impersonation of Jean Harlow in Harlow *(1965) had helped inspire Warhol's first sound movie,* Harlot *(1965), starring Mario Montez seductively devouring several bananas. Carroll Baker subsequently starred in Warhol's* Bad *(1976), directed by Jed Johnson.*

—KG

DAVID EHRENSTEIN: What was the first movie you ever saw or remember seeing and what did you like about it?

ANDY WARHOL: Uh *Three Girls Grow Up*[1], and I liked it because I was so young.

DE: Who was that with?

AW: Deanna Durbin[2].

DE: What was that?

AW: Gloria Jean[3].

DE: What did you like about Gloria Jean?

AW: Uh she just sang so nice.

DE: What recent movies have you enjoyed and why?

AW: I saw uh *Sylvia*[4]; that was the best movie last week and the best movie this week was uh, *Joy House*[5].

DE: What did you like about *Sylvia*?

1 *Three Smart Girls Grow Up* (1939). Directed by Henry Koster.
2 Deanna Durbin. Actress, b. 1921.
3 Gloria Jean. Actress, b. 1927.
4 *Sylvia* (1965). Directed by Gordon Douglas.
5 *Joy House* (USA release, 1965). Made in 1964 as *Les Félins* (France). Directed by Réne Clement. Starring Alain Delon and Jane Fonda.

AW: Uh so much happened in it.

DE: Like what in particular?

AW: It starts with her very young and she grows up and she just lives a lot and dies a lot.

DE: Any outstanding things in *Sylvia* that might relate to your films?

AW: Uh they're better than mine.

DE: Really? Why?

AW: So much happens in them.

DE: What about the stars?

AW: Stars are so good.

DE: You'd like to do a film with Carroll Baker?[6]

AW: Uh no.

DE: Why not?

AW: Uh she has too much acting ability for me.

DE: People with acting ability are not the kind you need?

AW: No. I want real people.

DE: What films in particular do you like? Westerns? Gangster films? Musicals?

AW: Oh, like them all.

DE: How did you get started making movies?

AW: Uh I don't know. What movie did you see last week, Ted?

6 Carroll Baker. Actress, b. 1931.

TED BERRIGAN:[7] We saw *Sylvia*.

AW: Really?

TB: I saw *Sylvia* in Times Square.

AW: Oh, really? What did you think about *Sylvia*?

TB: I was stunned.

AW: Really? I was stunned too.

TB: We sat in the first row.

AW: Oh, really? I sat in about the seventh. Oh, Ted, do you want to do a picture?

TB: O.K..

AW: All you have to do is uh no, let's do one without eating the banana uh yeah, that's an old movie just a sit-down movie.

DE: You're making a movie now? What do you do, going about making one?

AW: Uh nothing. Oh, pull that chair in so it' s more out in the open. Move it over, uh yeah, over there ... Yeah, just right there that's great Oh, I know. We're going to have to do something about that chair.

DE: What are you going to ask Ted to do?

AW: Uh. Just pretend he's not doing anything.

DE: Who in the New American Cinema do you admire?

AW: Jaaaacck Smiiiitttth.

DE: You really like Jack Smith?[8]

7 Ted Berrigan. Poet, 1934-1983.
8 Jack Smith. Filmmaker, 1932-1989.

AW: When I was little, I always thought he was my best director I mean, just the only person I would ever try to copy, and just so ter- rific and now since I'm grown up, I just think that he makes the best movies.

DE: What in particular do you like about his movies?

AW: He's the only one I know who uses color . backwards.

DE: Why did you go into sound?

AW: It's well, it's the only thing to do. I mean, if you're going to make movies, you've got to have sound.

DE: Well, why did you make movies without sound before then?

AW: It was the only kind of camera I had.

DE: What about color?

AW: My first color movie will be called *Suicide*. It was last week's a movie, but we're shooting it this week.

DE: And that will be with?

AW: With Rock. Oh, Gerry, will you go get the film for the color movie? Can you get the checkbook and yeah, and I'll write you a check.

DE: Do you know exactly how many movies you've made?

AW: Uh, no; well, we did a movie a week.

DE: How do you keep track of them all — or don't you?

AW: Uh, we don't keep track of them.

DE: Do you consider yourself a documentary film-maker?

AW: I don't know.

DE: Which of your films are you most satisfied with?

AW: *Screen Test* and *Couch*.

DE: Why?

AW: I don't know why. Why do you like them, Gerry?

GERARD MALANGA: Because sitting in the couch this morning, it made me feel like it was a human being. It was a whole living thing in itself, the couch.

DE: What about *Screen Test*?

GM: Uh no comment.

DE: Uh, could we ask him about the movie?

AW: Oh, yeah. Ted Berrigan?

DE: Ted Berrigan, what about the movie you just did?

TB: What about it?

DE: Did you like what you did?

TB: Sure, it was wonderful.

DE: You said tears were coming into your eyes.

TB: I was looking at the light to see what it looks like and ... It was all really wonderful; I just loved myself every second. I looked at the camera and the light made it look like a big blue flower. And so I looked at it until the flower effect wore off and then I looked at the light for a few minutes until it came on again.

DE: Which of your films are you least satisfied with?

AW: Well, the other one that didn't come out was John And Ivy, but only

because the film the look of it or something. There were a lot of complicated things happening.

DE: What do you hope to do in films?

AW: Well, just find interesting things and film them. We can ask Joe some thing, he's very good. Joe, is this the first movie you ever making?

JOE BRAINARD:[9] I did movies with Ron Padgett.[10] Ron Padgett makes movies.

AW: Oh, where are they?

TB: He has them.

AW: Oh, really? Could you bring that chair over here?

DE: The New American Cinema seems very much immersed in the 30's and the early 40's. What about you?

AW: The early 10's. That was about when movies were just starting.

DE: Do you like Edison?

AW: I like Edison. Oh, do I like Edison!

DE: Has Edison been a big influence on you?

AW:. Oh, yes.

DE: What new plans do you have? Anything new from what you've been doing?

AW: Musicals.

DE: Who will write the music?

AW: We don't know yet. The first musical will be tap dancing.

9 Joe Brainard. Visual artist and poet, 1942-1994.
10 Ron Padgett. Poet, b. 1942.

DE: Do you have any regrets?

AW: No.

10 "Pop Goes the Videotape: An Underground Interview with Andy Warhol"

RICHARD EKSTRACT

1965

Tape Recording, September–October 1965

*In the summer of 1965, Andy Warhol acquired his first video recording equip-
ment. "The idea was for me to show it to my 'rich friends' (it sold for around
five thousand dollars) and sort of get them to buy one," wrote Warhol in
POPism. "I remember videotaping Billy [Name] giving Edie [Sedgwick] a
haircut on the fire escape. It was the new toy for a week or so." (POPism, 119)*

The deal for the equipment was arranged by Richard Ekstract, publisher of
Tape Recording, *a fanzine devoted to the then-new art of home audio taping.
Ekstract contacted Warhol in 1964 to ask him to be a judge in a contest called
"Pop Sounds" put together by* Tape Recording, *which was seeking the audio
equivalent to Pop Art. Unfortunately, most of the submissions received were
gags and the contest was cancelled. However, soon after, Warhol started
calling Ekstract for advice on audio and video equipment, and subsequently
Ekstract became Warhol's tech guru for the better part of the 1960s.*

*In early 1965, Norelco came out with the first affordable video recorder.
"Andy called me up and said he had been making these underground movies
and asked for a loaner on this Norelco video recorder for both a black & white
and a color camera," recalled Ekstract. "I thought it would be good publicity
for Norelco to lend him one and have a world premiere underground party
for him."*

*Ekstract had heard that there was an unused train tunnel beneath the
Waldorf-Astoria Hotel and thought the location would be an ideal setting for
the premiere of Warhol's videos made with the new equipment. The party was
held on Friday, October 29, 1965. Entering through a hole in the street,
denizens of the New York underground mixed with Park Avenue housewives,
all dodging rats and roaches. The party was a success but the exact content*

*of the tapes—recorded on an obsolete one-inch format which makes playback
virtually impossible today—remains unknown.*

*In conjunction with the party, Tape Recording ran the following interview
with Warhol featured on the cover of the September–October 1965 issue of the
magazine. The interview was conducted at the 47th St. Factory by Ekstract with
Robert Angus, the editor of Tape Recording. The piece was unedited except for
Ekstract's amending of technical facts that Warhol himself was unclear about.*

—KG

If you think recording sound is fun (and it is), just think of the tremendous
possibilities available when you can tape sound and pictures with the same
recorder. That day was brought much closer to tape enthusiasts this
summer when Ampex, Matsushita and Sony introduced home video tape
recorders in the $1000 price range. The race is now on to produce video
tape units for $500 or less. When that happens tape recording will surely
be America's number one hobby.

To test the new medium, *TAPE RECORDING* magazine approached
tape enthusiast and home moviemaker Andy Warhol to produce some
experimental home video tapes. Warhol, for the uninitiated, is an artist
who rose to sudden fame a few years ago when the Pop Art movement
swept America. His paintings of such common objects as Campbell Soup
cans and Brillo boxes became the rage in art circles and now hang in many
of the most prominent homes and museums both here and abroad.

About two years ago, Warhol began experimenting with 16mm movies.
He was welcomed by the members of the "Underground Movie" camp
who make experimental films in the hope of extending the art of motion
pictures to new and exciting visual art forms.

Warhol made his reputation in the Underground film movement with
films such as "Sleep," eight hours of film of one person sleeping. Another
of his epics was "Empire," eight hours of film recording the Empire State
building. Warhol and his group have now made underground movies on
home video tape to give *TAPE RECORDING*'s readers a preview of the

techniques involved in the new medium. Thus we embarked on an adventure which is continuing even as this is being written.

Warhol used a Norelco slant-track video recorder which retails for $3950 and operates in the same manner as its lower priced counterparts. With the recorder, Norelco supplied a remote control television camera with a zoom lens. For special applications, he also used a Concord model MTC 11 hand-held video camera with a Canon zoom lens. Video tape was supplied by Reeves Soundcraft. The rotary head recorder operates at a tape speed of 7½ ips and uses one inch wide video tape.

TAPE RECORDING: How did you get involved in making Underground movies?

WARHOL: I was going to Hollywood. That's how it all happened.

TAPE RECORDING: You mean. . . .

WARHOL: Hollywood is the movie capital of the world so I bought a movie camera to take along. A 16mm Bolex. I was with Taylor Mead, a famous Underground movie star. My first movie was called "Taylor Mead in Hollywood."

TAPE RECORDING: What did you shoot?

WARHOL: Anything and everything. I was just learning to use the camera.

TAPE RECORDING: How did Underground movies get their start?

WARHOL: I don't know. Lots of people were making these movies and Jonas Mekas organized a co-op, the Cinémathèque, to exhibit them.

TAPE RECORDING: What was your next film?

WARHOL: Next came my "Sleep" movie.

TAPE RECORDING: What were you trying to show?

WARHOL: It started with someone sleeping and it just got longer and

longer and longer. Actually, I did shoot all the hours for this movie, but I faked the final film to get a better design.

TAPE RECORDING: You mean. . . .

WARHOL: Yes, it's the same 100 feet of film spliced together for eight hours. I'd like to do this movie again someday with someone like Brigitte Bardot and just let the camera watch her sleep for eight hours.

TAPE RECORDING: Sounds like fun.

WARHOL: Yes, but frightfully expensive.

TAPE RECORDING: How much do these "longies" cost?

WARHOL: Thousands of dollars.

TAPE RECORDING: Do you get any income from Underground movies?

WARHOL: No.

TAPE RECORDING: Pretty expensive hobby.

WARHOL: All my painting money goes into it.

TAPE RECORDING: Did you make any sound movies?

WARHOL: Yes, I bought an Arricon sound camera with a 1200 foot reel. But the optical sound wasn't very good. The sound on video tape is much better.

TAPE RECORDING: Home videotaping is such a new medium. How does it feel to be pioneering in it?

WARHOL: Like Alice in Wonderland.

TAPE RECORDING: What do you see as the essential difference between film and videotape?

WARHOL: Immediate playback. When you make movies you have to wait and wait and wait.

TAPE RECORDING: How about lighting?

WARHOL: You don't need any for video. Just a light bulb. It's so scary. The tape machine is so easy to use. Anyone can do it.

TAPE RECORDING: Do you prefer tape to film?

WARHOL: Oh, yes.

TAPE RECORDING: How long did it take you to become proficient with the video tape recorder?

WARHOL: A few hours. All you really have to master is the picture rectifier which compensates for the light in the room. Once you know that, it's just a matter of keeping your heads clean.

TAPE RECORDING: How will video tape affect home movies?

WARHOL: It will replace home movies. Its the machine we're going to use to do our 31-day movie.

TAPE RECORDING: What?

WARHOL: It's the story of Christ.

TAPE RECORDING: How much will it cost?

WARHOL: A lot.

TAPE RECORDING: Do you consider yourself just like the average tape or film hobbyist?

WARHOL: Oh, yes. Anybody can do what I do.

TAPE RECORDING: Have you recorded from a television set with the video recorder?

WARHOL: Yes. This is so great. We've done it both direct and from the screen. Even the pictures from the screen are terrific. Someone put his arm in front of the screen to change channels while we were taping and the

effect was very dimensional. We found you can position someone in front of a TV set and have it going while you're recording. If you have close-ups on the TV screen, you can cut back and forth and get great effects.

TAPE RECORDING: That's interesting. Have you been trying to do things with tape that you can't do with film?

WARHOL: Yes. We like to take advantage of static. We sometimes stop the tape to get a second image coming through. As you turn off the tape it runs for several seconds and you get this static image. It's weird. So fascinating.

TAPE RECORDING: How do you insure getting the pictures on tape that you want?

WARHOL: Simple. You make a test on your TV monitor. If the test is good you know your result will be good.

TAPE RECORDING: Is it that easy out-of-doors, too?

WARHOL: Yes. We took the recorder onto our fire escape to shoot street scenes.

TAPE RECORDING: What did you get?

WARHOL: People looking at us.

TAPE RECORDING: Can you edit video tape?

WARHOL: No.

TAPE RECORDING: Does this bother you?

WARHOL: No. We never edited our films before because we wanted to keep the same look and the same mood. You lose this when you try to re-create a scene days later after you've gotten back the processed film. Therefore, we just accepted whatever we got. Now with videotape, we can do instant retakes and maintain our spontaneity and mood. It's terrific. It has been a great help.

TAPE RECORDING: While taping, how do you get your actors to give you their most in front of the camera?

WARHOL: I don't ask for the most.

TAPE RECORDING: How about filters? Have you used any standard lens filters as you would in motion picture photography?

WARHOL: We tried a red filter, a polarizing filter and a green filter, I think. The red filter helps change the contrast by lightening all reds as well as reducing contrast. Even though video tape and film have different response curves, the effect of filters is very similar on tape to the effect on black and white film.

TAPE RECORDING: How about lenses?

WARHOL: As with motion picture photography, the better the lens, the more potential you have for good picture making. We used the Norelco VE2612 turret zoom lens, the standard lens on the Concord MTC-11 and a Canon zoom lens, TU, C16. We got acceptable results with all three. The Norelco lens was the best, however.

TAPE RECORDING: Does sound present any particular problems in making videotapes?

WARHOL: Really good, synchronized sound is one of the most exciting things about home videotapes. There is no "double-system" sound or editing needed. It's built right in. The only thing to be careful about is the position of the microphone. A little experimenting before taping is all that's needed.

TAPE RECORDING: How important is sound to your Underground videotapes?

WARHOL: It's important to us because the people we're working with have something to say.

TAPE RECORDING: What's the most fun you've had with your video recorder?

WARHOL: Oh, it's so great at parties. It's just terrific. People love to see themselves on tape and they really behave normally because the equipment is so unobtrusive.

TAPE RECORDING: What kind of comments do you get from people at these parties?

WARHOL: Ooh. Aah. Ooh. Aah.

TAPE RECORDING: Anything else?

WARHOL: Aah. Ooh.

TAPE RECORDING: What else can people do with their home video recorders?

WARHOL: Make the best pornography movies. It's going to be so great.

TAPE RECORDING: You think Mr. and Mrs. America will. . . .

WARHOL: Yes. And they'll have their friends in to show them.

TAPE RECORDING: Any other things you like about the video recorder?

WARHOL: Oh, yes. You can spy on people with it, too. I believe in television. It's going to take over from movies.

TAPE RECORDING: Have you any last advice for home movie makers?

WARHOL: Get a video recorder.

11 "USA Artists: Andy Warhol and Roy Lichtenstein"

LANE SLATE
Produced by NET, 1966; 30 min. 16mm, b/w

In this split-bill black-and-white film appearance with Roy Lichtenstein, Warhol makes one of his most cold and contentious appearances on film. The first fifteen minutes of the half-hour documentary feature a cheerful Lichtenstein in his studio talking about a special iridescent plastic background that changes character as the position of the viewer changes. The second half of the film features a distant, emotionless Warhol who reluctantly answers questions fired at him by an aggressive and skeptical off-screen interlocutor. Warhol remains tight-lipped as he sits on a stool in front of a silver Elvis painting. The camera frequently zooms close-up on Warhol's face, framed by a broken pair of dark sunglasses; his fingers cover his lips, causing him to mumble hesitant and barely audible responses.

The Warhol interview is not continuous; rather it is interspersed throughout Factory vignettes: Warhol working on a silkscreen print, creating a floating sculpture, and relaxing with friends while the narrator's voiceover attempts to explain Warhol's art. Clips of Warhol films are shown and quotes from other Factory habitués intersperse the Warhol segments, all accompanied by a "groovy" soundtrack. The film finishes with footage of the Velvet Underground and The Exploding Plastic Inevitable.

USA Artists: Andy Warhol and Roy Lichtenstein was one of a nine-part series made for NET (National Educational Television, the precursor to PBS) by director Lane Slate. It included profiles on contemporary artists of the era such as Claes Oldenburg, Roy Lichtenstein, Jim Dine, Jasper Johns, Jack Tworkov, and Robert Rauschenberg, among others. Lane Slate died in 1990.

The interview was transcribed by the current editor.

—KG

Q: Andy, you've said casually, "Since I don't believe in painting any more"

WARHOL: Uhhh . . . Well, ah . . . I don't believe in painting because I hate objects and, uh . . . ah . . . I hate to go to museums and see pictures on the wall because they look so important and they don't really mean anything . . . I think.

Q: People think of you as the perfect Pop artist without really knowing what that means or, I think, really knowing what your work is about. I'd like to try to talk some more about the paintings and the things you did earlier because . . . there's something that I think needs to be explained for the public, which has, at this point, a certain impression of you . . . and I'm not sure that it's the one that you would want them to have, although I don't think it matters to you very much. Is that true?

WARHOL: What?

Q: Does it matter to you that people feel one way or another to you? I mean, you have the kind of reputation now, which is a little bit apart from what you really are, I think. Does it matter to you that this is so, that they feel one way rather than another about you?

WARHOL: Uh, oh . . . I don't really understand. What do you mean? Uh . . . this is like sitting, um, at the World's Fair and riding one of those Ford machines where the voice is behind it. It's so exciting not to think anything. I mean, you should just tell me the words and I can just repeat them because I can't, uh . . . I can't . . . I'm so empty today. I can't think of anything. Why don't you just tell me the words and they'll just come out of my mouth.

Q: No, don't worry about it because. . . .

WARHOL: . . . no, no . . . I think it would be so nice.

Q: You'll loosen up after a while.

WARHOL: Well, no. It's not that. It's just that I can't, ummm . . . I have a cold and I can't, uh, think of anything. It would be so nice if you told me a sentence and I just could repeat it.

Q: Well, let me just ask you a question you could answer. . . .

WARHOL: No, no. But you repeat the answers too.

Q: All right. Well, I don't know the answers. . . .

WARHOL: Oh, well . . . you'll . . . you'll be. . . .

Q: Okay. Before you started to silkscreen, you made a number of paintings and you made comic strips, right?

WARHOL: Uh . . . I guess I made comic strips, uh . . . before I did . . . before I did . . . uh . . . the silkscreen things.

Q: And you made some other paintings of things that were not done mechanically. What were they?

WARHOL: I made, uh . . . I guess they were ads . . . from magazines.

Q: And then you made, uh. . . .

WARHOL: And then I made, uh. . . .

Q: Things like. . . .

WARHOL: Things like. . . .

Q: Uh. . . .

WARHOL: Uh. . . .

Q: A lot of people might be inclined, it seems to me, to put you down because they could say that your work has a certain distance: it's mechanical and you don't really make it and all of those things. And yet, like anyone else, when you start to talk about it, the things you say are about really caring; I mean, you want people's lives to be better.

WARHOL: Uh . . . Uhhhhhh . . . Yeah, well I guess I really don't, uhhh . . . It's too hard to care and I guess I . . . Well, I care . . . I still care but it would be so much easier not to care.

Q: In other words, are you saying that you are involved in this idea of making people more conscious of their lives but you don't really want to get into their lives deeply. . . .

WARHOL: Uh . . . Oh, yes . . . yeah. I don't want to get too involved.

Q: I think that this is a very important thing about all of your work: the idea of your own distance that you keep from it. Is this because of this feeling that you don't want to get that close to it?

WARHOL: Uh . . . yes. I don't want to get too close to it.

Q: You never, in any of your work, have ever really said anything that tells anyone anything about you. You don't want that to happen, do you?

WARHOL: Uh . . . well, there's not very much to say, you know, about me.

Q: But you've done some extraordinary things. I think that for me the high point was the opening of the exhibition at the Institute of Contemporary Art in Philadelphia[1] when so many people came that they had to take all the pictures down and thousands of people jammed in there and there were no pictures to speak of, just you. And you had the real character of a celebrity there, the kind of celebrity you really haven't had in America now. Do you realize that?

WARHOL: Oh, oh. It was so riveting and glamorous.

Q: Well, Andy, do you have any thoughts at all about the fact that so many people like the idea of just being able to watch you sitting in a chair or standing on a balcony?

WARHOL: Oh, uh . . . but that won't last very long.

Q: You don't think so?

1 *Andy Warhol*, exhibition, Institute of Contemporary Art, Philadelphia, October 7 through November 21, 1965.

WARHOL: No . . . um, no, because just sitting there, um . . . doesn't really mean anything. But, what I really want to do is, I guess, do some movies and, uh, sort of tape what we've done and sort of combine them together or something like that.

Q: When you began, you made your films very simply without moving the camera and now you've tended to make them more and more complicated. You're getting into sound now. What are you trying to do now?

WARHOL: Uh . . . well, I just, uh . . . well, I got tired of just setting the camera up because it just, uh . . . means repeating the same idea over again so I'm changing, um . . . I'm trying to see what else the camera can do. And I'm mostly concerned with, uh . . . doing bad camerawork and, uh . . . ah . . . and we're trying to make it so bad but doing it well. Where, um . . . where the most important thing is happening you seem to miss it all the time or showing as many scratches as you can in a film or all the dirt you can get on the film, uh . . . or zoom badly, where you zoom and you hit . . . uh . . . miss the most important thing. And, uh . . . your camera jiggles, ah . . . so that everybody knows that you're watching a film. Because everybody else can do . . . I don't know, it's so easy to do movies, I mean you can, uh . . . uh . . . just shoot and every picture comes out right. So that's what I'm working on right now.

Q: I want to change the subject again. I would like to ask you to say something about the new sculpture.

WARHOL: Uh . . . oh, the new thing I'm working on is sculpture because, uh . . . uh . . . uh . . . since I didn't want to paint any more and I thought that I could give that up and do movies and then I thought that there must be a way that I had to finish it off and I thought the only way is to make a painting that floats and I asked Billy Kluver[2] to help me make a painting

2 Billy Kluver. Engineer, 1927-2004. In 1966 he co-founded Experiments in Art and Technology, a not-for-profit service organization for artists and engineers.

that floats and he thought, um, about it and he came up with the, uh . . . silver . . . since he knew I liked silver, he got all these silver things that I'm working on now and the idea is to, ah . . . fill them with helium and let them out of your window and they'll float away and that's one less object. And, and, well, it's the way of finishing off painting and, um. . . .

Q: So you think that this will finish off painting and then. . . .

WARHOL: For me, yes. . . .

Q: For you. So you feel that instead of having a painting, which is an inert object hanging on the wall, that what we really need is to have things which involve people more directly?

WARHOL: Oh . . . ah . . . well, we started . . . we're sponsoring a new band, it's called the Velvet Underground. And, um, and we're trying to, ah . . . well, since I don't really believe in painting any more I thought it would be a nice way of combining, uh . . . and we have this chance to combine music and art and films all together and we're sort of working on that and, uh . . . the whole thing is being auditioned tomorrow at nine o'clock. And if it works out it might be very glamorous.

Q: What sort of thing do you intend to do with the band?

WARHOL: Ah, well, it would be kind of the biggest discothèque in the world and we'll have twenty-one screens and, I don't know, three or four bands.

12 "Andy Warhol: My True Story"

GRETCHEN BERG
Summer 1966
The East Village Other, November 1, 1966

Often quoted from but rarely reprinted in full, this interview is considered the most important that Andy Warhol gave in the 1960s: so important, in fact, that when the U.S. Post Office issued its Warhol stamp in 2002, the quote on the stamp's selvage originated here: "If you want to know all about Andy Warhol, just look at the surface: of my paintings and films and me, and there I am. There's nothing behind it."

Twenty-three-year-old Gretchen Berg—the daughter of prominent film historian Herman G. Weinberg[1]—was introduced to Andy Warhol by film critic Sheldon Renan[2] who had visited the 47th Street Factory. Renan was so impressed that he phoned Berg to tell her that she should go and meet Warhol.

Berg had previously known about Warhol through her film-world connections. She recalls: "We had heard that there was this new artist who was making these unusual films so I saw a few of them—Empire, Sleep, and Kiss—at The Film-Makers' Cinémathèque on 41st Street. At the time, we weren't quite sure who he was or what he was doing." Soon after Renan's call, Berg approached Warhol at a screening and requested an interview with him. Warhol replied that he was interested but warned her that he didn't usually say anything.

Undeterred, Berg proceeded to interview Warhol at the Factory during the summer of 1966. Upon her arrival, she "found a very nice, very reserved man" who was amused to speak to a "polite and serious young woman." The face-to-face interviews, which were done partly on a reel-to-reel Norelco tape recorder she had borrowed from her father, and partly from memory, were written down afterward.

1 Herman G. Weinberg. Film critic, subtitler and historian, 1908–1983.
2 Sheldon Renan. Film critic and director, b. 1941.

The conversations took place over the course of three to four weeks—generally between 2:00 and 6:00 in the afternoon—and are a compendium of loose talk and observations. As Berg remembers, "The questions were meant to relax him, banish fear or hesitation and put him into a kind of dream state so that he would speak his innermost thoughts. They were made to provoke him to talk about this or that, to suggest things; they were remarks rather than questions. The piece was meant to be a kind of word collage to give the reader the feeling of being in the Factory on a hot summer day."

Berg came with a few pre-prepared questions, but she quickly discarded her script and let the conversation take its own course. She was captivated by Warhol and wanted her piece to reflect this quality. "Andy was such a powerful presence; he had an enormously magnetic personality. Talking to him, one became as though one was being hypnotized. It seemed to me that everything flowed in one stream to the point that the questions I asked became irrelevant." Hence, she began to think of her interactions with Warhol as "mediations" rather than as interviews.

In a particularly chilling passage, Warhol refers to Valerie Solanas, who shot him in June of 1968, about two years after this interview was done: "People try to trap us sometimes: a girl called up here and offered me a film script called Up Your Ass and I thought the title was so wonderful and I'm so friendly that I invited her to come up with it, but it was so dirty that I think she must have been a lady cop. I don't know if she was genuine or not but we haven't seen her since and I'm not surprised. I guess she thought that was the perfect thing for Andy Warhol."

During Berg's visits, the Factory was full of its many famous inhabitants including Jackie Curtis, Gerard Malanga, Rene Ricard, International Velvet, and Eric Emerson. Also present was a Harvard student named Danny Williams[3] who, during these conversations, fell asleep on a couch holding a lit cigarette and set the piece of furniture ablaze. Berg recalls

3 Danny Williams, who did the lights/sound for the Exploding Plastic Inevitable, mysteriously disappeared in 1967 off the coast of Cape Cod, leaving his clothes by the side of his car. His body was never found.

Warhol trying to rouse Williams as Stravinksy's "Petrushka" played over the stereo in the loft.

The piece was edited over the course of several days. "There were a few things that do not appear in the final interview: for instance, we had a conversation about my photography portfolio. I removed it because it wouldn't have fit in but I included almost everything else."

When the interview was finished, Berg didn't know what to do with it. She lived on St. Mark's Place in the East Village with her boyfriend and decided by chance to stop into the nearby offices of The East Village Other, *who accepted the piece on the spot. Berg remembers their response: "Oh yeah, Andy. Cool."*

—KG

ANDY WARHOL—I'd prefer to remain a mystery, I never like to give my background and, anyway, I make it all up different every time I'm asked. It's not just that it's part of my image not to tell everything, it's just that I forget what I said the day before and I have to make it all up over again. I don't think I have an image, anyway, favorable or unfavorable. I'm influenced by other painters, everyone is in art: all the American artists have influenced me; two of my favorites are Andrew Wyeth and John Sloan; oh, I love them, I think they're great. Life and living influence me more than particular people. People in general influence me; I hate just objects, they have no interest for me at all, so when I paint I just make more and more of these objects, without any feeling for them. All the publicity I've gotten . . . it's so funny, really . . . it's not that they don't understand me, I think everyone understands everyone, non-communication is not a problem, it's just that I feel I'm understood and am not bothered by any of the things that're written on me: I don't read much about myself, anyway, I just look at the pictures in the articles, it doesn't matter what they say about me; I just read the textures of the words.

I see everything that way, the surface of things, a kind of mental Braille,

I just pass my hands over the surface of things. I think of myself as an American artist; I like it here, I think it's so great. It's fantastic. I'd like to work in Europe but I wouldn't do the same things, I'd do different things. I feel I represent the U.S. in my art but I'm not a social critic: I just paint those objects in my paintings because those are the things I know best. I'm not trying to criticize the U.S. in any way, not trying to show up any ugliness at all: I'm just a pure artist, I guess. But I can't say if I take myself very seriously as an artist: I just hadn't thought about it. I don't know how they consider me in print, though.

I don't paint any more, I gave it up about a year ago and just do movies now. I could do two things at the same time but movies are more exciting. Painting was just a phase I went through. But I'm doing some floating sculpture now: silver rectangles that I blow up and that float. Not like Alexander Calder mobiles, these don't touch anything, they just float free. They just had a retrospective exhibition of my work that they made me go to and it was fun: the people crowded in so much to see me or my paintings that they had to take the pictures off the walls before they could get us out. They were very enthusiastic, I guess. I don't feel I'm representing the main sex symbols of our time in some of my pictures, such as Marilyn Monroe or Elizabeth Taylor, I just see Monroe as just another person. As for whether it's symbolical to paint Monroe in such violent colors: it's beauty, and she's beautiful and if something's beautiful, it's pretty colors, that's all. Or something. The Monroe picture was part of a death series I was doing, of people who had died by different ways. There was no profound reason for doing a death series, no "victims of their time"; there was no reason for doing it at all, just a surface reason. I delight in the world; I get great joy out of it, but I'm not sensuous. I've heard it said that my paintings are as much a part of the fashionable world as clothes and cars: I guess it's starting that way and soon all the fashionable things will all be the same: this is only the beginning, it'll get better and everything will be useful decoration. I don't think there's anything wrong with being fashionable or successful; as for me being successful, well . . . uhhh . . . it just gives you something to do, you know. For instance, I'm trying to do a business here

at the Factory and a lot of people just come up and sit around and do nothing, I just can't have that, because of my work.

It didn't take me a long time to become successful, I was doing very well as a commercial artist, in fact, I was doing better there than with the paintings and movies which haven't done anything. It didn't surprise me when I made it; it's just work . . . it's just work. I never thought about becoming famous, it doesn't matter . . . I feel exactly the same way now I did before . . . I'm not the exhibitionist the articles try to make me out as but I'm not that much of a hard-working man, either: it looks like I'm working harder than I am here because all the paintings are copied from my one original by my assistants, like a factory would do it, because we're turning out a painting every day and a sculpture every day and a movie every day. Several people could do the work that I do just as well because it's very simple to do: the pattern's right there. After all, there're a lot of painters and draughtsmen who just paint and draw a little and give it to someone else to finish. There're five Pop artists who are all doing the same kind of work but in different directions: I'm one, Tom Wesselman, whose work I admire very much, is another. I don't regard myself as the leader of Pop Art or a better painter than the others.

I never wanted to be a painter; I wanted to be a tap-dancer. I don't even know if I'm an example of the new trend in American art because there's so much being done here and it's so good and so great here, it's hard to tell where the trend is. I don't think I'm looked up to by a large segment of young people, though kids seem to like my work, but I'm not their leader, or anything like that. I think that when I and my assistants attract a lot of attention wherever we go it's because my assistants look so great and it's them that the people are really staring at, but I don't think I'm the cause of the excitement.

We make films and paintings and sculpture just to keep off the streets. When I did the cover for the *TV Guide*, that was just to pay the rent at the Factory. I'm not being modest, it's just that those who help me are so good and the camera when it turns on just focuses on the actors who do what they're supposed to do and they do it so well. It's not that I don't like to speak

about myself, it's that there really isn't anything to say about me. I don't talk very much or say very much in interviews; I'm really not saying anything now. If you want to know all about Andy Warhol, just look at the surface: of my paintings and films and me, and there I am. There's nothing behind it. I don't feel my position as an accepted artist is precarious in any way, the changing trends in art don't frighten me, it really just doesn't make any difference; if you feel you have nothing to lose, then there's nothing to be afraid of and I have nothing to lose. It doesn't make any difference that I'm accepted by a fashionable crowd: it's magic if it happens and if it doesn't, it doesn't matter. I could be just as suddenly forgotten. It doesn't mean that much. I always had this philosophy of: "It really doesn't matter." It's an Eastern philosophy more than Western. It's too hard to think about things. I think people should think less anyway. I'm not trying to educate people to see things or feel things in my paintings; there's no form of education in them at all.

I made my earliest films using, for several hours, just one actor on the screen doing the same thing: eating or sleeping or smoking; I did this because people usually just go to the movies to see only the star, to eat him up, so here at last is a chance to look only at the star for as long as you like, no matter what he does and to eat him up all you want to. It was also easier to make.

I don't think Pop Art is on the way out, people are still going to it and buying it but I can't tell you what Pop Art is: it's too involved; it's just taking the outside and putting it on the inside or taking the inside and putting it on the outside, bringing the ordinary objects into the home. Pop Art is for everyone. I don't think art should be only for the select few, I think it should be for the mass of American people and they usually accept art anyway. I think Pop Art is a legitimate form of art like any other, Impressionism, etc. It's not just a put-on. I'm not the High Priest of Pop Art, that is, Popular art, I'm just one of the workers in it. I'm neither bothered by what is written about me or what people may think of me reading it.

I just went to high school, college didn't mean anything to me.

The two girls I used most in my films, Baby Jane Holzer and Edie Sedg-

wick, are not representatives of current trends in women or fashion or any-
thing, they're just used because they're remarkable in themselves. *Esquire*
asked me in a questionnaire who would I like to have play me and I answered
Edie Sedgwick because she does everything better than I do. It was just a
surface question, so I gave them a surface answer. People say Edie looks like
me, but that wasn't my idea at all: it was her own idea and I was so surprised:
she has blonde short hair, but she never wears dark glasses. . . .

I'm not more intelligent than I appear . . . I never have time to think
about the real Andy Warhol, we're just so busy here . . . not working, busy
playing because work is play when it's something you like.

My philosophy is: every day's a new day. I don't worry about art or life:
I mean, the war and the bomb worry me but usually, there's not much you
can do about them. I've represented it in some of my films and I'm going
to try and do more, such as *The Life of Juanita Castro*, the point of which
is, it depends on how you want to look at it. Money doesn't worry me,
either, though I sometimes wonder where is it? Somebody's got it all! I
won't let my films be shown for free. I'm working principally with Ronald
Tavel, a playwright, who's written about ten movies for me; he writes the
script and I sort of give him an idea of what I want and now he's doing the
films as off-Broadway plays.

I don't really feel all these people with me every day at the Factory are
just hanging around me, I'm more hanging around *them*. (Oh, those are
great pants, where did you get them? Oh, I think they're so great.) I haven't
built up a defense against questions that try to go below the surface, I don't
feel I'm bothered that much by people. I feel I'm very much a part of my
times, of my culture, as much a part of it as rockets and television. I like
American films best, I think they're so great, they're so clear, they're so true,
their surfaces are great. I like what they have to say: they really don't have
much to say, so that's why they're so good. I feel the less something has to say
the more perfect it is. There's more to think about in European films.

I think we're a vacuum here at the Factory: it's great. I like being a
vacuum; it leaves me alone to work. We are bothered, though, we have
cops coming up here all the time, they think we're doing awful things and

we aren't. People try to trap us sometimes: a girl called up here and offered me a film script called *Up Your Ass* and I thought the title was so wonderful and I'm so friendly that I invited her to come up with it, but it was so dirty that I think she must have been a lady cop. I don't know if she was genuine or not but we haven't seen her since and I'm not surprised. I guess she thought that was the perfect thing for Andy Warhol. I don't resent situations like that but I'm not interested in subjects like that, that's not what I'm pushing, here in America. I'm just doing work. Doing things. Keeping busy. I think that's the best thing in life: keeping busy.

My first films using the stationary objects were also made to help the audiences get more acquainted with themselves. Usually, when you go to the movies, you sit in a fantasy world, but when you see something that disturbs you, you get more involved with the people next to you. Movies are doing a little more than you can do with plays and concerts where you just have to sit there and I think television will do more than the movies. You could do more things watching my movies than with other kinds of movies: you could eat and drink and smoke and cough and look away and then look back and they'd still be there. It's not the ideal movie, it's just my kind of movie. My films are complete in themselves, all 16mm, black and white, me doing my own photography, and the 70-minute ones have optical sound which is rather bad which we will change when we get a regular sound tape-recorder. I find editing too tiring myself. Lab facilities are much too tacky and uncertain, the way they are now. They're experimental films; I call them that because I don't know what I'm doing. I'm interested in audience reaction to my films: my films now will be experiments, in a certain way, on testing their reactions. I like the film-makers of the New American Underground Cinema, I think they're terrific. An Underground Movie is a movie you make and show underground, like at the Film-Makers' Cinémathèque on 41st St. I like all kinds of films except animated films, I don't know why, except cartoons. Art and film have nothing to do with each other, film is just something you photograph, not to show painting on. I just don't like it but that doesn't mean it's wrong. Kenneth Anger's *Scorpio Rising* interested me, it's a strange film . . . it could have

been better with a regular sound track, such as my *Vinyl*, which dealt with somewhat the same subject but was a sadism-masochism film. *Scorpio* was real but *Vinyl* was real, and not real, it was just a mood.

I don't have strong feelings about sadism and masochism, I don't have strong feelings on anything. I just use whatever happens around me for my material. I don't collect photographs or articles for reference material, I don't believe in it. I used to collect magazine photographs for my paintings, though.

The world fascinates me. It's so nice, whatever it is. I approve of what everybody does: it must be right because somebody said it was right. I wouldn't judge anybody. I thought Kennedy was great but I wasn't shocked at his death: it was just something that happened. (Why do you look like a cowboy today, with that neckerchief?) It isn't for me to judge it. I was going to make a film on the assassination but I never did. I'm very passive. I accept things. I'm just watching, observing the world. Slavko Vorkapich[4] was just telling you how to make movies his way, that's why I sold my ticket after going to the Museum of Modern Art to his first lecture.

I plan to do some more films soon, in 35mm: perhaps an autobiography of myself. My newest film is *The Bed*, from a play by Bob Heide that played at the Caffé Cino, in which we'll use a split screen, one side static of two people in bed and the other, moving, of the lives of these two for two years. All my films are artificial but then everything is sort of artificial, I don't know where the artificial stops and the real starts. The artificial fascinates me, the bright and shiny.

I don't know what will happen to me in ten years . . . the only goal I have is to have a swimming pool in Hollywood. I think it's great, I like its artificial quality. New York is like Paris and Los Angeles is so American, so new and different and everything is bigger and prettier and simpler and flat. That's the way I like to see the world. (Gerard, you should get a haircut, that style doesn't suit you at all.) It's not that I've always been looking for a kind of Los Angeles paradise; I wouldn't be taken over

4 Slavko Vorkapich. Film Director, 1892–1976.

by Hollywood, I'd just do what I always like to do. Or something. (Oh, hi, David.)

My Hustler was shot by me, and Charles Wein directed the actors while we were shooting. It's about an aging queen trying to hold on to a young hustler and his two rivals, another hustler and a girl; the actors were all doing what they did in real life, they followed their own professions on the screen. (Hello, Barbara.) I've been called: "Complex, naive, subtle and sophisticated"—all in one article! They were just being mean. Those are contradictory statements but I'm not full of contradictions. I just don't have any strong opinions on anything. (Hi, Randy.) It's true that I don't have anything to say and that I'm not smart enough to reconstruct the same things every day, so I just don't say anything. I don't think it matters how I'm appreciated, on many levels or on just one. The death series I did was divided into two parts: the first on famous deaths and the second on people nobody ever heard of and I thought that people should think about them sometimes: the girl who jumped off the Empire State Building or the ladies who ate the poisoned tuna fish and people getting killed in car crashes. It's not that I feel sorry for them, it's just that people go by and it doesn't really matter to them that someone unknown was killed so I thought it would be nice for these unknown people to be remembered by those who, ordinarily, wouldn't think of them. (Oh, hi, Paul.) I wouldn't have stopped Monroe from killing herself, for instance: I think everyone should do whatever they want to do and if that made her happier, then that's what she should have done. (There's something burning here, I think. Don't you smell something?) In the Flint heads I did of Jacqueline Kennedy in the death series, it was just to show her face and the passage of time from the time the bullet struck John Kennedy to the time she buried him. Or something. The United States has a habit of making heroes out of anything and anybody, which is so great. You could do anything here. Or do nothing. But I always think you should do something. Fight for it, fight, fight. (There *is* something burning here! Danny, will you please get up? You're on fire! Really, Danny, we're not kidding now. *Now* will you get up? I mean, really, Danny, it's not funny. It's not even necessary. I *knew* I smelt something burning!) That was one of my assistants; they're not

all painters, they do everything: Danny Williams used to work as a sound man for the film-making team of Robert Drew and Don Alan Pennebaker, Paul Morrissey is a film-maker and Gerard Malanga, a poet. We're going into show business now, we have a rock and roll group called The Velvet Underground, they practice at the Factory. I'm in their act, I just walk on in one scene. But anybody who comes by here is welcome, it's just that we're *trying* to do some *work* here. . . . !

I think the youth of today are terrific; they're much older and they know more about things than they used to. When teen-agers are accused of doing wrong things, most of the time, they're not even doing wrong things, it was just other people who thought they were bad. The movies I'll be doing will be for younger people; I'd like to portray them in my films, too. I just tore out an article about the funeral of one of the motorcycle gang leaders where they all turned up on their motorcycles and I thought it was so great that I'm going to make a film of it one day. It was fantastic . . . they're the modern outlaws . . . I don't even know what they do . . . what do they do?

I think American women are all so beautiful, I like the way they look, they're terrific. The California Look is great but when you get back to New York you're so glad to be back because they're stranger looking here but they're more beautiful even, the New York Look. I read an article on me once that described my machine-method of silkscreen copying and painting: "What a bold and audacious solution, what depths of the man are revealed in this solution!" What does *that* mean? My paintings never turn out the way I expect them to but I'm never surprised. I think America is terrific but I could work anywhere—anywhere I could afford to live. When I read magazines I just look at the pictures and the words, I don't usually read it. There's no meaning to the words, I just feel the shapes with my eye and if you look at something long enough, I've discovered, the meaning goes away. . . . The film I'm working on now is a 70–minute aria with the Puerto Rican female impersonator, Mario Montez, called *Mr. Stompanato*. I think the questions usually asked me in interviews should be more clever and brighter, they should try to find out more about me. But I think newspaper reporting is the only way to write because it tells what's

happening and doesn't give anyone's opinion. I always like to know "what's happening."

There's nothing really to understand in my work. I make experimental films and everyone thinks those are the kind where you see how much dirt you can get on the film, or when you zoom forward, the camera keeps getting the wrong face or it jiggles all the time: but it's so easy to make movies, you can just shoot and every picture really comes out right. I didn't want to paint any more so I thought that the way to finish off painting for me would be to have a painting that floats, so I invented the floating silver rectangles that you fill up with helium and let out of your window . . . I like silver . . . and now we have a band, the Velvet Underground, who will belong to the biggest discotheque in the world, where painting and music and sculpture can be combined and that's what I'm doing now.

Interviews are like sitting in those Ford machines at the World's Fair that toured you around while someone spoke a commentary; I always feel that my words are coming from behind me, not from me. The interviewer should just tell me the words he wants me to say and I'll repeat them after him. I think that would be so great because I'm so empty I just can't think of anything to say.

I still care about people but it would be so much easier not to care . . . it's too hard to care . . . I don't want to get too involved in other people's lives . . . I don't want to get too close . . . I don't like to touch things . . . that's why my work is so distant from myself . . .[5]

5 The last two paragraphs of this interview are almost identical to what Warhol says in Lane Slate's filmed interview, "USA Artists: Andy Warhol and Roy Lichtenstein" (1966), p.79.

13 "Inside Andy Warhol"

STERLING MCILHENNY AND PETER RAY
Cavalier, September, 1966

To conduct the interview that follows, we took our tape recorder to the "Factory," as Warhol calls his studio, which is located on the fourth floor of a rickety loft building in Manhattan's east forties. The interior of the Factory—walls, ceiling, and floor—and everything in it, is painted silver or covered with a veneer of Reynolds Wrap—which produces a curiously timeless, abstract feeling. About the only furniture, aside from a few props left over from moviemaking, is a couple of pieces in the 1930s "moderne" style—a Lucite-and-glass china cabinet and the semi-circular couch on which we conducted the interview. In the center of the Factory six or seven youths, male and female—all sporting tight pants and long hair—were languidly frugging to the Beatles' latest album blasting from a loudspeaker.

A few minutes after we arrived, the silver door to the Factory opened and Andy Warhol stepped in to offer us an inanimate handshake. Except for his hair, which, like the interior of the Factory, seems to sport an applied silver color, Warhol creates a completely unobtrusive presence. He is pale and slight. He uses few gestures, speaks softly, sometimes almost inaudibly, and wears dark glasses indoors and out. It is almost impossible to tell whether the aura of bland self-concealment that surrounds him is a mask assumed to create a paradox or, true paradox, is simply the real man himself.

This interview may be read as a Pop Art psychodrama. The cast of characters includes, besides the subject, a number of Assistants to the Artist, who, abandoning the Beatles, draped themselves around our couch.

Before we could get our tape recorder warmed up, Andy Warhol produced his own transistorized set and placed the microphone before us.

—Sterling McIlhenny and Peter Ray

WARHOL: Have you ever been taped before?

CAVALIER: No. At any rate not as a part of the underground movement.

WARHOL: We should make a video tape of this interview and at the same we could look at it.

CAVALIER: This is a very interesting looking place, although the Reynolds Wrap seems to be coming loose here and there. Is there any particular meaning behind everything being painted silver?

WARHOL: Well, you might say I have a fondness for silver, or even gold for that matter.

CAVALIER: The gold seems to be well hidden. Where did you get this cellophane-wrapped couch?

WARHOL: It just arrived one day. Apparently someone made a mistake in the address and had it delivered here.

CAVALIER: You didn't tell them it was a mistake?

WARHOL: No. We didn't want them to have to move something that heavy again after they'd already brought it here.

CAVALIER: About when did the Pop Art movement begin?

WARHOL: I guess about five years ago.

CAVALIER: Salvador Dalí has been quoted as saying that he is the father of Pop Art. Have you any comment on that?

WARHOL: I don't know. He's certainly been around a long time. But it's hard to understand what he is saying most of the time.

CAVALIER: What were the first Pop Art things you did?

WARHOL: I did comic strips and ads. A great many artists were working on different ideas at the same time. Things just fell together to create the Pop Art movement.

CAVALIER: Why did you start with comic strips? Were you interested in them as an entertainment medium or, as some intellectuals regard them, a kind of illustrated modern mythology?

WARHOL: I don't know. Just as comic strips, that's all. They were things I knew and they are relatively easy to draw or, better still, to trace. I also did movie stars—Marilyn Monroe, Elizabeth Taylor, Troy Donahue—during my "death" period. Marilyn Monroe died then. I felt that Elizabeth Taylor was going to die, too, after her operation. I thought that there were a lot of people who were going to die—like Troy Donahue.

CAVALIER: Why did you think Troy Donahue was going to die?

WARHOL: I don't know. He just looked like it. I concentrated on a series of Marilyn Monroe. She fascinated me as she did the rest of America. I did about forty paintings of her. Most of them are in gallery shows and private collections. But I still have some of them myself.

CAVALIER: Are they all different?

WARHOL: Most of them are. I used photographs. I made multiple-color silk screen paintings—like my comic strip technique. Why don't you ask my assistant Gerry Malanga some questions? He did a lot of my paintings.

CAVALIER: Mr. Warhol, what's your role in making the paintings?

WARHOL: I just selected the subjects, things that I didn't have to change much.

CAVALIER: With such a lack of involvement in your own work, what value if any could your painting hold for you?

WARHOL: Oh, I don't know . . . [*At this point a lanky, wavy-haired young man dressed in short pants, sandals, and sun glasses appeared in the silver entrance to the Factory.*] Oh! Ondine does some of my Pop Art work. Come here, Ondine, we're being taped. Just a few words.

ONDINE: I have to go to the bathroom first.

WARHOL: Oh, no, come here first.

CAVALIER: Do you have any feeling at all about the images you create?

WARHOL: Ondine, you're not going to the bathroom.

CAVALIER: By the way, you have a great mirror in there. It's very narcissistic.

WARHOL: Really? Where is it? I don't remember.

CAVALIER: Behind the door. It gives you a two-way view of yourself using the toilet. But let's get back to art. Most of the things you paint are simply exact re-creations—rather than interpretations—of perfectly ordinary things: Brillo boxes, dollar bills, matchbook covers. Some are recognizable as art only because they are displayed in a gallery instead of a supermarket. When you paint these objects do you have a specific audience in mind?

WARHOL: No.

CAVALIER: What is your feeling then? Do you want anyone to react to them, or do you paint them just to please yourself?

WARHOL: It gives me something to do.

CAVALIER: As opposed to what? Nothing to do?

WARHOL: Yes.

CAVALIER: There must be more rewarding things to do than printing dozens of Brillo labels by hand. It must take a great deal of time and effort.

WARHOL: It doesn't take long, especially when you have a lot of people helping you.

CAVALIER: Do you expect people to regard them as works of art?

WARHOL: No, we don't have any feeling about them at all, even when we are doing them. It just keeps us busy. It's something to pass the time.

[*Ondine comes out of the bathroom.*]

WARHOL: Oh, Ondine—don't disappear again. Please.

CAVALIER: Why is Ondine emptying a bucket of water into the toilet?

WARHOL: It's very important. The toilet doesn't work very well.

CAVALIER: To return to the fine arts: Why do people buy your art?

WARHOL: I don't know.

CAVALIER: Isn't there a slight chance that you're trying to find out just how far the public will follow your artistic experiments?

WARHOL: No. It just gives me something to do.

CAVALIER: Have you ever met anyone who has bought your work?

WARHOL: Just one—and they keep sending it back without paying for it. Usually for personal reasons.

CAVALIER: What do you mean? That they've hung it wrong or you don't like it?

WARHOL: No. They just keep sending it back. It's not the price. They can afford the money. Oh! Ondine. Please say a few words. Come on.

ONDINE: When shall I ever get to bed?

WARHOL: Just sit right here next to me.

ONDINE: (*To Cavalier*): Hello. How are you? What's that (*indicating microphone*)?

CAVALIER: That's Warhol's—this is ours (*microphone*)—the real taping.

ONDINE: Then I'll talk into Warhol's.

WARHOL: Ondine was the subject of my six-and-a-half-hour movie *Sleep*. He was the only thing on camera for the entire film.

CAVALIER: Ondine, then, is living, walking subject matter.

WARHOL: Well, walking, yes.

ONDINE: I am just walking; I have a terrible cold. I haven't been able to sleep in almost three days.

CAVALIER: Is Ondine a Pop artist?

WARHOL: No, but he does some sculpture. What would you say, Ondine?

ONDINE: I hope people never will buy anything that I do. I never want to be popularly accepted. For instance, I won't appear in any movies other than Andy Warhol's, and they aren't popularly accepted.

CAVALIER: Does he pay you?

ONDINE: Of course not. I do it for love.

CAVALIER: Why, again, Mr. Warhol, do think people go out and buy a Brillo box painted by you when they can just as well buy the real thing for a few cents, if they regard this as art?

WARHOL: They could get SOS, the rust-free soap pads. Ondine, what kind do you use?

ONDINE: I use any kind that will give my complexion that fresh scrubbed look. Sunkist like a lemon.

WARHOL: I thought your mouth was Sunkist.

ONDINE: My *mouth*? Oh, no. That's a dew drop.

WARHOL: Somebody get Ondine a glass of water.

CAVALIER: Ondine, do you like other people's Pop Art?

ONDINE: I don't know other people's Pop Art. I only know Andy's.

CAVALIER: That's hard to believe. Mr. Warhol, have you, like many other artists today, ever been in analysis, or taken any hallucinogenic drugs?

WARHOL: No, I think I face everything straight on.

CAVALIER: Do you think this is reflected in your painting?

WARHOL: I think it is. Ondine, do you like the magic book I gave you? Are you a witch, Ondine?

ONDINE: Yes, I do like the book but I couldn't be a witch, I'm not from the Bronx.

CAVALIER: Do you have to be from the Bronx to be a witch?

ONDINE: All the witches I've met are from the Bronx.

CAVALIER: Mr. Warhol, did you study art?

WARHOL: No, I never did, but Ondine did in high school.

ONDINE: Yes, but I only paint myself. White. With water-soluble paint. I was at Henry Geldzahler's and he was painting the bathroom. I got some paint on myself and decided to take my clothes off and paint myself all over. Then he took the brush away from me.

CAVALIER: Mr. Warhol, you just said that you hadn't studied painting. Has there been a strong influence in your work?

WARHOL: Marc Chagall. I love his work very much. I never had any thought of copying his art, but I did feel that I could express my ideas as he has.

CAVALIER: When did you start painting?

WARHOL: About four or five years ago.

CAVALIER: What about the time prior to that?

WARHOL: Before that time I was very young.

CAVALIER: Yes. I'm sure you were. Are you interested in what the critics say about your work?

WARHOL: No, just Henry Geldzahler. He's a good friend—a fan. And I

want him to care. Whatever anyone else says has no value to me concerning my work. I don't need approval. I have confidence in what I'm doing.

CAVALIER: What is the future of Pop Art?

WARHOL: It's finished.

CAVALIER: What will you do?

WARHOL: I'll become more involved in my movies. I haven't done any painting since May of last year.

CAVALIER: Have you made any money from your paintings?

WARHOL: Yes. But it just covers the cost of making movies. I don't pay any of the people who act in them or help conceive the ideas, but film and processing cost a lot, and the rent of the Factory and the props.

CAVALIER: Could you tell us something about your movies?

WARHOL: It would take too long. There are over forty of them.

CAVALIER: *Film Culture* magazine has said that your "Underground" movies are a "meditation on the objective world, in a sense . . . a cinema of happiness." Some of your films, however, are about rather bizarre aspects of the objective world. For example, *Eat* is forty-five silent minutes of a man eating a mushroom, *Empire* is eight solid hours of the world's tallest building. *Blow Job* has been described as one half hour of "a passionate matter handled with restraint and good taste." One of your newest sound films, *Vinyl*, has a couple of scenes of what the Victorian English referred to as "buggery," a subject which, by any name, is still regarded rather gravely by polite society. In view of such controversial subjects, have you ever encountered any trouble showing your films?

WARHOL: In the past there has been at least one bad scene I can recall— a police raid. But I think they've about gotten over this by now.

CAVALIER: When did you first start making movies?

WARHOL: About two years ago. I just suddenly came up with the thought that making movies would be something interesting to do, and I went out and bought a Bolex 16mm camera. I made my first movie in California, on a trip to Los Angeles. I went there with Taylor Mead, an Underground movie star. We stayed in a different place every day. We took some shots in a men's room out at North Beach and we used one of the old Hollywood mansions for some of the inside shots. The movie we were shooting was *Tarzan and Jane Regained . . . Sort of.* Taylor Mead called it his most anti-Hollywood film.

CAVALIER: Where do you show them?

WARHOL: They were showing one at the Cinémathèque the other night. And they play at the Astor Playhouse.

CAVALIER: Is there any relation between your paintings and your movies?

WARHOL: No, but there will be. Henry Geldzahler said I could combine my movies and my paintings.

CAVALIER: What do you mean?

WARHOL: I don't think I should go into details right now.

CAVALIER: Who besides Ondine has played in your films?

WARHOL: Baby Jane used to. Edie Sedgwick is our new superstar.

CAVALIER: Where do you make your movies?

WARHOL: Nearly all of the indoor shots can be done here in the Factory, as the props are very stark, almost severe. The outdoor shots are done wherever we feel like doing them. In the beginning when we first started with film we went about it in the traditional way technically. They were cut and edited as any other films are. We've given that up now. We feel we're beyond that.

CAVALIER: Not long ago you were experimenting with video tape. In fact you said you might do all your future work with tape.

WARHOL: Well, yes, we were working with some equipment from the Norelco people. It was all here at the Factory and as you can see, it's gone now. They made a promotional thing of it including an underground party on the railroad tracks underneath the Waldorf Astoria, down where the tracks run towards Grand Central Station. It was climaxed by the filming of a dueling scene. Video tape has its advantages, such as immediate playback and you can get by with very little light. It allows for instant retakes and with this you can maintain the particular mood that has been created for a scene.

CAVALIER: You must have some sort of crew for making these movies.

WARHOL: Well, I do, and then there are two secretaries for correspondence and answering the phone and changing records on the phonograph.

CAVALIER: What movie are you doing now?

WARHOL: We are doing a movie called *Breathe*, and after that we'll do a movie a week, but they'll be straight movies.

CAVALIER: What do you mean by "straight" movies?

WARHOL: I can't define it—let's just say something that's not vacuous.

CAVALIER: Do you have any particular person in mind for these movies?

WARHOL: Edie Sedgwick will be in all of them.

CAVALIER: In 1964, when she was named "Girl of the Year," Baby Jane appeared in many of your movies. Do you think her parts in your films had anything to do with her other successes?

WARHOL: Oh, yes. She really hadn't done anything until she joined our group.

CAVALIER: How did that come about?

ONDINE: (*interrupting*) She just appeared here one afternoon. She was swept in by a group of fairies and then decided to come back every now and then.

CAVALIER: Do you have fun making your movies?

WARHOL: Oh, yes, I enjoy it.

CAVALIER: Even the one showing Ondine sleeping for over six hours?

WARHOL: Well, I've never watched all of that one. I just fed film into the camera and made sure it was taking the pan shots and other shots that I wanted. In the end, though, we only used 100 feet of the film we shot, running it over and over again for eight hours. We don't edit any of the films. What I sometimes do is use two reels of the three reels we may have shot.

CAVALIER: Do you want a lot of people to see your films?

WARHOL: I don't know. If they're paying to see them. By the way, they can be rented. There's a catalog, and the cost is nominal: one dollar per minute. A 30–minute film can be rented for $30. *Sleep* rents for $100, at a special rate, and you can get all eight hours of *Empire* for $120.

CAVALIER: A lot of people have said that these are pretty boring films.

WARHOL: They might be. I think the more recent ones with sound are much better.

CAVALIER: You say you are not going to continue painting in order to concentrate on movie-making. Is there any one particular reason for this?

WARHOL: I decided to concentrate entirely on films when I met the most fantastic man in the world, Huntington Hartford[1]. He is very enthused about what we are trying to do. He has offered us the use of his Paradise Island in the Bahamas to make our next film.

CAVALIER: Knowing the kind of conservative art that is shown in Mr.

1 Huntington Hartford. American arts patron and an heir to the A. & P. supermarket fortune. In 1964, he commissioned architect Edward Durell Stone's modernist building at 2 Columbus Circle, which housed Hartford's Gallery of Modern Art.

Hartford's Gallery of Modern Art, it is hard to imagine him taking part in such an avant-garde venture.

WARHOL: Well, along with everyone else he is very excited about this project. It's to be our first full-length picture. By that I mean it will have a large cast and a complete crew of technicians and a carefully prepared script.

CAVALIER: What will distinguish this from your other films besides the large cast and crew?

WARHOL: We plan to make money from it. Not just enough to cover the rent here at the Factory and the cost of processing film but a good deal of money.

CAVALIER: Can you tell us something about this film?

WARHOL: It will be *Jane Eyre*. Chuck Wein is writing the shooting script. We know we want a total running time of one hour and forty minutes and that Edie Sedgwick will be the star. Why don't you ask Chuck some questions?

CAVALIER: How do you do, Mr. Wein? How did you get involved with Andy Warhol?

CHUCK WEIN: It was an accident. I was at a party with Edie and Andy asked me if I'd like to write a movie for him. I said yes. So far I've done *Poor Little Rich Girl, Party, It Isn't Just Another Afternoon*, and some others.

CAVALIER: Mr. Warhol, why did you pick Chuck as a script writer?

WARHOL: When I met him at the party I couldn't think of anything else to say.

CAVALIER: The average person may not know much about art, but if he follows the gossip columns and watches the "night" shows on television, he knows something about you. For example, recently a photograph appeared in the society sections of the New York papers of you and Edie Sedgwick at a "Mod Ball" at the Rainbow Room in Rockefeller Center. You have become a real social phenomenon, in a peculiar sense.

WARHOL: The part about the parties I attend is probably overplayed. Most of them are well covered by the press. That accounts for my name appearing so often. I've been on some radio and television shows, but I usually bomb out. I've given up saying anything.

CAVALIER: Anything?

WARHOL: Just about.

14 Untitled Interview

ROBERT REILLY
Unpublished manuscript
from the Andy Warhol Archives, Pittsburgh
Spring 1966

In the mid-60s, the Factory was a popular hangout for college students. By the spring of 1965, Edie Sedgwick and her Cambridge crowd had already colonized the Factory, opening the floodgates to wanna-be superstars from the Ivy Leagues. One of these was Robert Reilly, a Yale undergrad majoring in political science, who thought that interviewing Andy Warhol for a student newspaper would be a keen way of meeting Warhol face-to-face. He telephoned and an interview at the Silver Factory was arranged.

The finished interview was intended to be in the Yale Record, America's oldest college humor magazine, founded in 1872, which then ran monthly. Reilly had never written for the Record and made a blind submission after the interview was completed. For the piece, Reilly took on the moniker "Old Owl," the Record's mascot. The interview was never published, but the plan worked: afterward, Reilly became a regular visitor to the Factory.

—KG

Andy: This is the basic form that the interview in the Record will take. Please try to mail your ad to me (801 Yale Station, New Haven, Connecticut 06520) soon. The deadline for it is the end of next week. The date we're trying for is May 15 (for films and the Velvets), in case you have to put this information in the ad. Oh, by the way, maybe a friend, I, and some girls will be at your discothèque next Friday or Saturday.

—Bob Reilly

ANDY: Hi. You just missed all the girls.

OLD OWL: What girls?

ANDY: From my fan clubs. They were all down here a few minutes ago.

OLD OWL: That sounds nice. *Time* magazine once described your art as "vulgar." You know, the soup cans, Brillo boxes, rows of Marilyn Monroes. Any comments?

ANDY: Yes.

OLD OWL: Yes, your art is vulgar?

ANDY: Yeah.

OLD OWL: Oh. Do you think what you do is really art?

ANDY: *(No comment)*

OLD OWL: Some critics say that Pop makes the symbol of the thing more real than the thing itself. Is this true?

ANDY: *(No comment)*

OLD OWL: What type of people buy your paintings?

ANDY: Uh, you're not supposed to talk about that. Let's just talk about boots and Chinese food.

OLD OWL: All right. Why do you wear boots?

ANDY: To make me taller. But tin cans are better.

OLD OWL: On your shoes you mean?

ANDY: Oh no. *Inside* your shoes, like the boy in *Life*. Your boots are so nice, but they have round toes and small heels. I have Cuban heels.

OLD OWL: Why else do you wear boots? Besides to be taller?

ANDY: To make me taller?

OLD OWL: Yes.

ANDY: Well, I'm a sadist.

OLD OWL: What do boots have to do with being sadistic?

ANDY: Ah, well, you can step on people.

OLD OWL: Oh, really?

ANDY: Have you ever been stepped on? It's fascinating.

OLD OWL: I'll have to try it sometime.

ANDY: Oh, your boots are so big. They're very steppable.

OLD OWL: That's why I wear them.

ANDY: But you just wear them on Saturday when you come down to New York. You couldn't wear them at school.

OLD OWL: You don't know Yale, Andy. Tell me, for the press, where is Yale University?

ANDY: I'm so dumb. I don't know where anything is. You said you were from New Haven so it must be New Haven.

OLD OWL: What did you think about Ginsberg's praise of pot?

ANDY: I think people should do what they want to do. Oh, I didn't know you *chain*-smoked. Wow.

OLD OWL: Do you want a cigarette?

ANDY: No. I don't know how to smoke. I never sleep, either.

OLD OWL: Tell me, why in the car last week was everyone cutting down Bob Dylan? I mean, he's got a very good voice for the songs he sings.

ANDY: Oh, it's not that. It's just that he is so mean.

OLD OWL: Don't you think Dylan's got a right to be mean if he wants to, though?

ANDY: But to everyone?

OLD OWL: I suppose. Can you drive?

ANDY: Yes, but I hit a taxi once, and I've been too nervous ever since. No one was in the cab, but I smashed the whole side of it in. My mind wanders too much to drive. I've always wondered how people could drive cars. I can never remember what to do.

OLD OWL: What is your favorite type of beer?

ANDY: Beer? Well, beer always tastes like piss.

OLD OWL: Does it? How do you know?

ANDY: Uh . . . haven't you ever tasted piss?

OLD OWL: No.

ANDY: Really? Well, now you know. Paul said all Chinese food tastes like shit.

OLD OWL: You said you were always afraid of doing things when you were young. . . .

ANDY: We've been seen by one of my friends. Hold it. This is David Bourdon who, ah,. . . .

DAVID BOURDON: I'm writing your autobiography.

ANDY: Oh.

OLD OWL: Why do you dye your hair silver? I'm really curious.

ANDY: Uh, when I was young I always wanted to look older, and now I'm looking older I want to look younger. So, uh . . . Edie's hair was dyed silver, and therefore I copied my hair because I wanted to look like Edie because I always wanted to look like a girl.

OLD OWL: Oh, really? Why?

ANDY: Uh, girls are prettier. . . . Oh, Edie starts everything—leather, the boots, everything. I think girls and boys in leather are gorgeous, probably even prettier than. . . .

OLD OWL: What do you think about girls' dresses?

ANDY: Uh, well, I don't really believe in clothes. I really feel the body is so beautiful. I photographed a naked girl the other day for the book, and she was very beautiful. Oh, she wasn't really beautiful but her body was just so much prettier without clothes on. And I think people would rather look at themselves more and take care of themselves more. I think the people in California are good because, well, they're more naked.

OLD OWL: But some people are ugly, don't you think?

ANDY: Uh, yeah, but beauty is sort of beauty to different people. And my kind of beauty might be different from your kind of beauty.

OLD OWL: Will you pass me the ale?

DANNY: Pass you the yale? Yes, we'll pass you the yale.

ANDY: Oh, David, you weren't home when I called.

DAVID: I was out marching, marching for peace.

ANDY: Oh really? I was supposed to be there. How come you weren't marching in the parade?

OLD OWL: Didn't you read our Vietnam issue? You're not a pacifist, are you?

ANDY: What's that?

OLD OWL: It's somebody who doesn't like Vietnam.

ANDY: Oh, no!!!!!

OLD OWL: Well, why were you marching?

ANDY: But, I. . . .

OLD OWL: Why did you *want* to march?

ANDY: Uh, oh, uh . . . somebody said that we had to, or something. I don't know. Do you think the Chinese will take over when, uh, if, uh. . . . What will happen to the Chinese in Chinatown when the Chinese take over?

OLD OWL: They'd move to Cuba. What do *you* think would happen to them?

ANDY: China will own Cuba, and so, I mean . . . would they be Chinese Americans, or, or, uh, uh. . . . Somehow it doesn't matter if they're Russians or Germans because somehow you can't tell. If they were American Chinese, you know, they'd look Chinese, or they'd have to be— what? Chinese or Chinese Americans? I don't know. Would you like some Chinese soup?

OLD OWL: Yes, I'd love some Chinese soup. Thank you. Where did you get that shirt?

ANDY: Got it on Saint Mark's Place in one of those fancy stores near the Saint Mark's Baths. Haven't you ever gone to the baths?

OLD OWL: No.

ANDY: Really, oh, you say it so fast like, uh, it's something awful.

OLD OWL: Yes, well, isn't it?

ANDY: I don't know. I've never been. Did you know that Edie took Suzanne to the Four Seasons? I'm going to do a record, for Columbia, I think.

OLD OWL: Singing?

ANDY: Oh no. Just sort of talking along.

OLD OWL: Is there much money now in what you're doing?

ANDY: Well, I don't know. I'm not doing paintings any more. But I think I'll glue together some of the parts of old studies I did and sell them as whole paintings to get the money. I do a lot of stuff—not art—just to get some money. Like this portable discothèque thing soon. That's so we can do the good stuff, painting, movies. Oh, David, the Village police were so funny, really. There was one guy in a beard, just sitting around, looking for people to recognize him.

DAVID: I read some place that they had them grow long hair and go around with several days' growth of beard.

OLD OWL: Fascinating.

PAUL: Let's look at fortune cookies. Oh, there's one for our Yalie. "Beware of men in *blue* suits."

ANDY: Wow. He's doing that interview for that dreadful magazine. They're going to write awful things about us.

DANNY: Are you still missing a card?

ANDY: What card? I don't know.

DANNY: You woke up in Marmene. You recall what you said after you woke up? It was very weird. I thought you were serious or something. I guess you had been dreaming about it, someone telling your fortune. Do you remember?

ANDY: No.

DANNY: I guess you were dreaming about someone telling your fortune. You said in this very anxious voice, "There's still a card missing." And something else to do with fortune-telling, and then you like woke up.

ANDY: No. When was this?

DANNY: In Marmene, when you were sleeping in a motel.

ANDY: I wasn't sleeping in a motel.

DANNY: Yes, you were.

OLD OWL: Well, I think I'd better go now. Thank you, Andy, for an informative interview.

15 "Andy Warhol Interviews *Bay Times* Reporter"

JOSEPH FREEMAN
October 30, 1965
Bay Times, Sheepshead Bay High School, Brooklyn,
New York, April 1, 1966
Andy Warhol's Index (Book), 1967

In 1967, Andy Warhol published Andy Warhol's Index (Book) (Random House/Black Star Books: New York). It was a portrait of Warhol's scene at the Factory and included photographs of Andy and his friends, pop-up pages, a silver balloon, and a flexidisc with sounds from tape recordings Warhol had made of Nico talking to poet Rene Ricard. Also included were the following three interviews: one done for a high school student newspaper in Brooklyn, another with a German reporter at the Factory, and a third focusing exclusively on Warhol's film Chelsea Girls.

Billy Name, who was in charge of the book's production, recalled: "I originally called the book Andy Warhol's Index. The idea was to publish an index of films which viewers should see (all of Andy Warhol's films) as opposed to the Catholic Church 'index' of films to be avoided as censored by the church (many of the operators at the Factory were Catholic). Random House objected, saying the project was supposed to be a 'book.' So I changed the title to Andy Warhol's Index (Book)."

Name was also in charge of selecting texts for the book. "None of the interviews contained in Andy Warhol's Index (Book) were done for this project; I selected them from our folder of interviews about the Factory which had already appeared elsewhere in print, in order to have some literary-text content in the book along with all the photo images I had at my disposal. The reason these interviews were chosen for the book is because they appeared to contain a substantial amount of text, thereby fulfilling the 'need' for

reading matter in the book. We had several interviews on file and the ones I chose seemed to be the most 'charming,' ridiculous, or the most like 'Warhol Factory stuff' (as opposed to New York Times *or* Art in America *stuff).*"

Joseph Freeman was a student at Brooklyn's Sheepshead Bay High School when he interviewed Warhol. The experience had such a marked effect on him that, according to Name, "After interviewing Warhol, Freeman was asked by Andy to work at the Factory as Andy's paid assistant. He did what Gerard Malanga had previously done; helping with silkscreening paintings, screen cleanup and general gopher." The Bay Times *is still published twice a year by Sheepshead Bay High School.*

—KG

"Do you think pop art is. . . ."

"No."

"What?"

"No."

"Do you think pop art is. . . ."

"No . . . no, I don't."

"Why did you leave commercial art?"

"Uhhh, because I was making too much money at it."

"Is your present work more self-satisfying?"

"Uhhh, no."

"OK, if you say so. Are you drawing for yourself to express your individuality more fully or because you are so well paid?"

"Uhhh . . . well, Gerard does all my paintings."

"What was the purpose of making a 4 ½ hour film of Robert Indiana eating two mushrooms?"

"How do you know it was two mushrooms? It was only one mushroom."

"Well, in the article I read it said it was two mushrooms."

"Oh, it was one mushroom."

"What was the purpose of it?"

"Well, it took him that long to eat one mushroom."

"I mean, why did you have to film it?"

"Uhhh, I don't know. He was there and he was eating a mushroom."

"About how much time do you spend on your painting?"

"No time. . . . What color are your eyes?"

"I think they're blue but my mother says they change a lot."

"They look . . . they look brown."

"Yeah, that's what she says. She says at night they look brown."

"Well, why'd you say they were blue?"

"Because that's the color I've known all my life. She says they're blue."

"Really?"

"Yeah, they're blue."

"They're brown."

"They're blue."

"They're brown."

"Yeah, I mean, you know, it's not my fault. I just thought they were blue."

"They're so black. The middle part is so black. . . . What kind of paintings do you paint?"

"You know, my mother and father just bought me an easel and a . . . uh . . . uh . . . what's that thing called?"

"A brush?"

"Yeah, a brush. And a palette and a sketch box, and I didn't paint anything yet."

"Why don't you put some paint on the floor, and then put the canvas . . . do you have a room . . . your own room?"

"Yeah."

"Well, take the canvas that they gave you and put it in the doorway, and then put paint in front of the doorway, and then somebody will step in the paint and on the canvas. And then you won't have to do anything."

"But that wouldn't be my own work."

"It would be pretty colors."

"Yeah, it would be pretty colors but that's not exactly what I wanted to do."

"What did you want me to do?"

"I like shapes."

"You could have a shape on your foot."

"Maybe I could put a rubber stamp on my foot."

"Yeah, it would be fantastic."

16 "An Interview with Andy at the Balloon Farm"

UNKNOWN GERMAN REPORTER
1966-67
Andy Warhol's Index (Book), 1967

The origin of this interview with a German reporter is murky. Billy Name: "I used the interview without permission (as with all included contents), and do not recall the name of the reporter or his publication." The interview was orig-inally set in two typefaces, with the German reporter's words in a gothic type-face and Andy's in a clean sans-serif. "I used the two-different-type set-up in the book to accent the stylization of cultures and for design and flavor pur-poses," says Name. The interview is reproduced here without the original typographical treatment.

The Balloon Farm, a nightclub on St. Mark's Place in the East Village, was originally called The Dom. Warhol presented the Exploding Plastic Inevitable there in April of 1966. In the late summer of 1966, Bob Dylan's manager, Albert Grossman and a partner took over the Dom and renamed it the Balloon Farm.

—KG

GERMAN REPORTER: —You know this is the second evening I am here and first you weren't here and now you, I finally got you. And what I felt is a feeling of composition of many things which are seemingly disconnected, yet then made a whole, and is that what you want to do right here as we just talk about the discoteque [*sic*], a match between the dance floor, the music, the film, etc.?

ANDY: —Different people getting together (*indistinct*)

GERMAN REPORTER: —And to get these people who have a kind of sen-sual impulses from what they are getting here.

ANDY:—Yeah.

GERMAN REPORTER:—How does that fit into the other work you are doing? Because, you are called a pop-artist, which I know means very little, because what does "pop" mean after all. It's something totally new and we can put anything into it that we want. How would you yourself put into it—how would you define who you are and what you want to do?

ANDY:—It keeps me busy.

GERMAN REPORTER:—It keeps you busy, but you are working, you are a craftsman, an artist, and you have a studio, you are making films. Now, for instance, let's talk film-making. You are making so-called "underground" films, also another word. But what does it depict, and what do you want to depict in the films you are making?

ANDY:—I haven't thought about it yet.

GERMAN REPORTER:—You are a difficult subject to interview, because. . . .

ANDY:—I told you, I don't say much.

GERMAN REPORTER:—Yah, I know. I know. Talk is very little, doing is everything.

ANDY:—Yes.

GERMAN REPORTER:—You don't want to talk at all..

ANDY:—Eh. No.

GERMAN REPORTER:—You said that you were willing to talk to me. And obviously, since you were nice enough to say, well, okay, we'll talk, that I would ask you questions, and that the questions would be more or less that I would like a definition of Andy Warhol, because I wouldn't want to define you, I would rather have a definition of you about yourself and the role you think you are playing among young people, because they are flocking to you.

They are adoring you. They love you. I know that because I have talked to many. This is what interests me and it interests me what it does to you.

ANDY:—Nothing.

GERMAN REPORTER:—You just want to go back to your—I mean you are going around sitting here and you're sitting there watching—going back to your factory and so on—that is your own private life and nobody else's business.

ANDY:—What do you mean?

GERMAN REPORTER:—A lot has been written about you. And was this without your cooperation?

ANDY:—Eh, yah.

GERMAN REPORTER:—You mean, people have just seen what you have done and observed and, therefore, Andy Warhol was formed for them?

ANDY:—Yah.

GERMAN REPORTER:—Since when do you have the discoteque [sic]? How did this occur to you that you would open this at all?

ANDY:—It happened all by itself.

GERMAN REPORTER:—Really?

ANDY:—Yah.

GERMAN REPORTER:—It just happened. All these things are really, I mean, they happened? And your relationship to people who are coming here—I talked to Nico and to Ingrid and so on. I have a feeling that it is all happening. They are just there. I mean they drink coffee, then eat a piece of salami and then they go on stage and then they come back and you are here or you are not here and so all this kind of logical things where it is very difficult to find the logic, and why should it?

ANDY:—No, no. There isn't any.

GERMAN REPORTER:—But there is a connection between here and when you go to your factory and work there. . . .

ANDY:—No. . . .

GERMAN REPORTER:—There is a connection. . . .

ANDY:—No.

GERMAN REPORTER:—And, what are you working on now, if you care to say?

ANDY:—I wouldn't.

GERMAN REPORTER:—You wouldn't.

ANDY:—No, I'm not working on anything.

GERMAN REPORTER:—Not on films?

ANDY:—Eh, well, we're starting tomorrow again.

GERMAN REPORTER:—Isn't there something that Nico is in where you make people enter and come?

ANDY:—Yah, but we did that three weeks ago.

GERMAN REPORTER:—What is the subject?

ANDY:—There's no subject.

GERMAN REPORTER:—There's no subject. It's a short. . . .

ANDY:—No.

GERMAN REPORTER:—Long. . . .

ANDY:—About 70 minutes long.

GERMAN REPORTER:—And, are they talented girls? I mean. . . .

ANDY:—They're young.

GERMAN REPORTER:—They're future . . .

ANDY:—Yes.

GERMAN REPORTER:— . . . but only within the framework of what you are doing, or do you think one day they will go away and become film. . . .

ANDY:—Yah.

GERMAN REPORTER:—Yes, you would like that?

ANDY:—Oh, sure. Yes.

GERMAN REPORTER:—Does your life go in rounds always? Would you describe any direction? I mean, I could. It bores me to tears, but I could describe the direction.

ANDY:—No.

GERMAN REPORTER:—You would not.

ANDY:—You tell me.

GERMAN REPORTER:—Well, I cannot tell you. I mean, I can tell you what my life's direction is—it's misdirection, but it is one. But you wouldn't even say it's a misdirection.

ANDY:—No.

GERMAN REPORTER:—Are you satisfied? Are you happy?

ANDY:—Oh yeah. Yeah.

GERMAN REPORTER:—Have you any inkling, do you know why you are happy?

ANDY:—(*No reply*)

17 "My Favorite Superstar: Notes on My Epic, *Chelsea Girls*"

GERARD MALANGA
1966
Arts, February 1967
Andy Warhol's Index (Book), 1967

Chelsea Girls, *a three-and-a-half-hour split-screen film, was Warhol's most successful 1960s movie and a breakthrough film for the underground genre. As David Bourdon succinctly stated, "The word around town was that underground cinema had finally found its* Sound of Music *in* Chelsea Girls" *(Bourdon, 249). After opening at the Film-Makers' Cinématèque, it moved to the Cinema Rendezvous on December 1, 1966, making it the first underground film to get a two-week run in a midtown Manhattan art theater. Extraordinary national press combined with word-of-mouth praise led to a series of sold-out screenings in New York and before long, it was playing in theatres across the country.*

The film was not conceived as a whole; rather, it is a compilation of various reels that Warhol had been shooting during the summer of 1966. The final film consists of twelve different reels of film—eight in black-and-white and four in color—juxtaposed side by side on a single screen; it documents the life of Warhol's female associates (Nico, Brigid Polk, International Velvet), many of whom lived in The Chelsea Hotel on West 23rd Street in New York City. Although screenwriter Ronald Tavel had written two scripts for the film, most of it was improvised. The superstars played themselves, often acting outrageously for the camera, blurring the line between documentary and fiction, giving mainstream America a glimpse into the mid-60s underground New York lifestyle.

—KG

SPLIT SCREEN:

I use the split screen because there's two movies going at one time. Mmmm-gousch. Am I coming through clear and clear? Right now we are at the Mad Hatter enjoying a peaceful breakfast. . . . Oh, I use the double screen to keep the audience . . . no, to capture the audience's attention like they have two things going at one time . . . once. So they would put audience uptight and get them confused. I keep double screens—I don't know—why do I keep double screens? Well, there's many things going on—to capture the audi-ence's attention. Am I coming through clear and clear? So people can freak out on two things at once. To have two things going at once to have two things going at once . . . to have two things going at once.

Why do I use color and black & white? Color and black and white? That clashes. Great—I mean color and black and white over another. I mean a color movie over a black and white movie or a black & white movie over a color movie. I mean, it's just so fantastic it looks like Poltergeists over Polter-geists in different colors and patterns and intricate divisions and, uhh—what was that word? I just had it on the tip of my tongue but I forgot it . . . I forgot the word. When it comes up, I'll let you know.

SUPERSTARS:

I use superstars in my movies so they can be superstars, portray their sponta-neous—uhh—talents on the screen. I don't know. Who is my favorite super-star? My favorite superstar is Ingrid Superstar. Isn't your favorite superstar Ingrid Superstar, or do you like International Velvet? My favorite superstar is Ingrid Superstar because, because, because she's just her. She's a real person; she's not phony. She's just her. She's a real person. She says and does what-ever she happens to feel like doing and saying at the time. And the only time she acts phony is when she feels like being a phony. She's 5'8"; she weighs 116; she has big brown eyes; brownish-blondish hair (the blonde is in the front of her head); and she's slim, wears about size 9/10 dress; and she's got a crooked mouth and a stray dog face sometimes and she keeps on going up and down

through life's euphorics. Hahaha, mmm-gousch. Fried eggs and my fried eggs—oh, no, you mean my runny eggs. Oh no I don't have runny eggs.

Oh, wow—she's got such a high ego right now, man. Like it's zooming and flying up to the galaxies.

Oh, about Ingrid and the Chelsea Girls? *She was nothing but a piece of trash—she looked like a piece of trash, but she looks so much better right now. She feels so much better right now, too, since she stopped and switched. But she had Red Cheek Apple juice . . . Red Cheek Apple juice. . . . She used to do with what she had—Red Cheek Apple Juice.*

I think the Chelsea Girls *is a different type movie from the others I've seen.*

Q: Why do you let your camera run for the time it runs?

A: Well, this way I can catch people being themselves instead of setting up a scene and shooting it and letting people act out parts that were written because it's better to act naturally than act like someone else because you really get a better picture of people being themselves instead of trying to act like they're themselves.

Q: Why did you use 10 minutes of script in the movie?

A: Well, the whole thing could be summed up in just 10 minutes of script, in fact in just a few words. Should I sum it up? Why is *Chelsea Girls* art? Well, first of all, it was made by an artist, and, second, that would come out as art. Also, *Chelsea Girls* is an experimental film which deals in human emotion and human life, which anything to do with the human person, I feel is all right.

Q: Are all the people degenerates in the movie?

A: Not all the people—just 99.9% of them. Who did I like best in the movie? I liked Pope Ondine best. Ingrid in the movie I think is very funny.

Q: What was the greatest influence on your work?

A: People themselves and their ideas. Actually, there are no other films similar except *Who's Afraid of Virginia Woolf?* and *Tom Jones.* If I were going

to make *Chelsea Girls* in the South, first of all, I think I'd call it *Southern Belles*. And as Pope Ondine I'd probably use Gugliana Magaduna, and as Ingrid, Babette La Rod. As the fat pill pusher and dope addict I would probably use my father. I would probably use the Hud of Dothan Motor Inn in Dothan, Alabama. It's the swingingest hotel in the South. Not necessarily a lot of degenerates—a lot of bands stay there, a lot of whores, wrestlers, and a lot of people like that. You might say it's all the degenerates, yes. Uhhh. I think drugs wouldn't be such a good subject to use in South Alabama, really. Liquor, since South Alabama's completely dry. Yes, I do come from the South. These other Yankees don't know that I'm from the South, so they don't bother me, but the South has a feeling toward the human person that the North doesn't have and its many more of a humane person living in the North.

Q: Do you have a lot of Southern themes in your paintings?

A: Yes, of course. I have a lot of Southern themes in my paintings. Flowers and Liz Taylor and bananas, which all the monkeys down there eat. Yes, I have used negroes in my painting. The negroes are a vital part of the South. In fact, if it weren't for the colored people in the South, my father's refrigerator factory would close down.

Q: Do you advocate everybody using drugs?

A: Certainly I would advocate everybody using drugs, but only the drugs that are given by prescription.

18 "Andy Out West"

JIM PALTRIDGE
1966
The Daily Californian, October 10, 1967

In the spring of 1966, Michael Kalmen and Jim Paltridge, both students at the University of California at Berkeley, attended a showing of Andy Warhol movies. They were so impressed that, out of the blue, they decided to call Andy in New York and invite him to attend a party that they were going to be throwing in the Bay Area. Kalmen left a message with Warhol's answering service telling him that "Clark Kent" had called. A few days later, Kalmen received a call·back from Warhol, claiming to be on LSD; whereupon Warhol began reading him tourist brochure descriptions of Bryce Canyon at length. Finally, they began conversing and Kalmen told Warhol of his impending plans to move to Los Angeles to pursue a career in screenwriting. Warhol informed him that he and his performance troupe, The Exploding Plastic Inevitable — which included Factory regulars as well as the rock band The Velvet Underground — were going to be in Los Angeles playing a month-long gig at a club called The Trip.

When Kalmen arrived in Los Angeles, he called Warhol, who was staying at an imitation-medieval stone structure in the Hollywood Hills called The Castle, where many rock stars put up their entourages at $500 a week. The Trip suddenly closed during their run, thus stranding the band at The Castle without a car. Jim Paltridge, on his way to Mexico, met Kalmen in L.A. and the two of them, both with cars, became default drivers for Warhol during this tense and bored time. Kalmen recalled the ennui at The Castle: "I opened the front door — the house was empty of furniture — and I looked into the living room. There was Mary Woronov, spinning around and around to Ike and Tina Turner's 'River Deep Mountain High.' Nico was out in the garden feeding rabbits." Visitors to the Castle found the atmosphere eerie and extremely uptight as Lou Reed was looking for a way out of his con-

tract with Warhol. During their visit, Andy had a show of his silver pillows
at Los Angeles's Ferus Gallery. It was his third show there.

Paltridge was the Arts & Entertainment editor for The Daily Californian,
a UC Berkeley campus daily with a readership of 40,000, and decided that he
would chronicle his and Kalmen's experience for the paper. Kalmen recalled:
"We were in the Andy Warhol group, but not of the Andy Warhol group," thus
giving Paltridge enough editorial objectivity to accomplish his goal.

Paltridge found Warhol charming. "He was a lot of fun to be with. There
wasn't a lot he wanted to talk about. He didn't want to be interviewed but if
you wanted to hang out, that was fine." During their time together, Andy was
carrying his tape recorder everywhere and frequently gave it to Kalmen,
saying "It doesn't matter what you record. Just record everything."

During their stay at The Castle, the group received a call from Bill
Graham, proprietor of the Fillmore West concert hall in San Francisco,
inviting them to perform, where this interview concludes. Kalmen says "It was
the only offer they had and took Graham up on his offer." According to
Warhol biographer Victor Bockris, "By then tempers were so frayed that the
hardcore New York contingent could no longer hide their contempt for the
West Coast scene, typified by Reed's description of it as a 'tedious untalented
lie,' and the grating sarcasm of [Paul] Morrissey asking [Bill] Graham why
the West Coast bands didn't take heroin since 'that's what all really good
musicians take.' . . . Graham exploded, screaming 'You disgusting germs!
Here we are trying to clean everything up and you come out here with your
disgusting minds and whips!' " (Bockris, 251).

Kalmen's attempt at screenwriting failed and the pair ended up back in
San Francisco where, a few months later, they were invited by Warhol to
attend the Bay Area premiere of Chelsea Girls. After the movie was over, they
went back to the hotel where the group was staying. Kalmen remembers: "It
was pandemonium. People were running through the halls naked and there
were pills galore. Andy was usually washing out his socks but he had a great
big bag of pharmaceutical-type pills: libriums, valiums, uppers, downers."

In 1968, after Warhol was shot by Valerie Solanas, Kalmen sent him a
telegram in the hospital, but afterward, they didn't see Andy with the same

intensity as they had in 1966. However, Warhol later told Jim Paltridge that his interview was one of the best articles about him that he had ever read.

Michael Kalmen passed away in June of 2003.

—KG

From the marble bathroom floor up: black boots, black suede leather pants, black belt with a steel buckle, dark blue tee-shirt with small white and red stripes, very light bubble-gum pink face, dark prescription glasses, silver-rinsed hair. Action: a thin hand with the same bubblegum pink skin holds a cordless electric razor that shaves a few silver whiskers from the chin of Andy Warhol, pop artist, sunshine superman, underground movie-maker, and serene king teenybopper. Andy goes into the bedroom and takes a black suede leather motorcycle jacket and a copy of *Vogue* off the bed. Andy Warhol's bed is very messy. Fashion magazines, *Los Angeles Times, Variety*, photographs are under and in it, taking their rightful place in Andy's sleeping and waking hours. Andy goes down a long spiral staircase.

Andy is in Los Angeles with the Velvet Underground, an ensemble that consists of the Velvets proper,—drums, electric guitars, electric violin—Nico, beautiful, strange Scandinavian presence who played Nico in "La Doce Vita," and Gerard and Mary, the Whip Dancers.

At night: on stage, the Velvets, Nico, the Whip Dancers (whips, black belts, pelvises, Gerard with and without shirt and beads), strobe lights, Andy's movies are the parts of a giant hypnotic machine called the Exploding Plastic Inevitable. This machine spins an endless cable of steel sound. Johnny Cale may or may not be an Indian, has a tall thin face, long black hair parted in the middle, has an electric violin under his chin, plays tall, thin and very shrill sounds on it. Gerard kneels in front of the strobe light, writhes, offers his whip. Mary writhes, twists her whip around Gerard, cracks her whip, bumps, grinds, grinds her Levi covered pelvis. The black leather belt with a steel buckle sits right on top of her hips, and it too bumps, it grinds, exceeding fine.

Andy's movies! Above the static-writhing dancers, teenyboppers, Velvets, whippers, are three or four screens with Nico writ large, staring, crying, Gerard

lifting weights, huge kisses, grainy white and black pictures of Edie Sedgwick feeling Gerard's muscles, languid whipping, terrifying fast whipping.

Mary has her whip twisted around Gerard in the strobe lights, starlets and studlets in fluffy sweaters, up-tight teenies are dancing, and Nico, blond on blond in a white wool pants suit steps into the spotlight and says, "The song is, 'I'm Not a Young Man Anymore.' "

Scene: One o'clock in the afternoon, Hollywood Hills. Andy is coming down the spiral staircase of this big Hollywood-Spanish castle where the Velvets are staying. The Velvets have already risen, eaten, and are passing the time, listening to electronic music, writing poems, dispersing to various parts of the castle and grounds, reading, bopping. There is plenty of time to pass because the Trip, the Sunset Strip nightclub where the Velvets are appearing, has been closed. No one seems to know why. Andy is having a grapefruit and a diet pill for breakfast. Paul, a kind of business manager, arranger, treasurer for the Exploding Plastic Inevitable, is talking on the phone on one of the frequent interminable business calls. He hangs up.

Paul: The education TV station in Boston wants you to introduce their series of campy movies. They offered five hundred dollars for you alone, but I told them you'd charge fifteen hundred. It'll take a day. They'll pay transportation and hotel.

ANDY: (*drawling slightly, the tone color of his voice like the silvered color of his hair*) Oh, did you see Nico on television yesterday? She was beautiful.

PAUL: What shall I tell the man from Boston when he calls back?

ANDY: Oh. I have to have Nico or one of the Velvets on with me. Tell him I'll have Nico with me.

PAUL: Five hundred for Nico?

ANDY: Yeah, she'll talk for me.

MARY (*whip dancer*): Some aluminum company sent you this, this ad. They want you to do something to it or even just sign it, and they'll pay two thousand. (*The ad then lies all day on the table, unsigned. The next day it was under the two volumes of the Los Angeles telephone directory, then somebody threw it away.*)

The phone rings. Paul answers it.

PAUL: (*hands over the receiver*) Andy, it's long distance from Montreal.

ANDY: Who is in Montreal, Paul?

PAUL: Somebody wants to know if you want to go to a champagne and strawberry Montreal.

ANDY: Oh, wow, everybody is always calling me up to ask me to parties somewhere.

PAUL: (*into the phone*) I'm sorry, but Mr. Warhol never goes anywhere without Nico and the Velvets. You'd have to fly all ten of us out there . . . yeah . . . well, thanks anyway.

JIM: Andy, I have a car. Do you want to go somewhere?

ANDY: Oh, wow, you have a car! Oh, I want to go somewhere.

JIM: Do you want to see the Kienholz exhibit at the L.A. County Museum?

ANDY: (*vaguely*) Oh, yeah.

JIM: Do you want to go to Forest Lawn?

ANDY: (*looking more vaguely at the smog*) What is there to see at Forest Lawn?

JIM: Alan Ladd's grave.

ANDY: (*wicked smile*) Oh, really?

Television cameramen arrive and professionally examine the lighting conditions in the vast throne room of the castle, which is bare except for a velvet throne.

ANDY: Where's Nico?

VELVET: She was looking at the rabbits about half an hour ago.

VELVET: I think she's in the garden.

Scene: Castle roof, three o'clock in the afternoon. Light blue sky above, smog below. Andy is sitting between Gerard—blue Levis, light blue shirt with ruffled sleeves, dark blue beads, hunting knife—and Nico—straight almost white blond hair, white pants suit, shy smile. The Velvets are arranged in the background, Johnny Cale with a cheap violin (not his). In the far background, Patrick, ex-child star, ex-protégé of Lenny Bruce, seventeen, permanent resident of the castle, emerges from his net hammock, comes out into sunlight and writhes in a lace shawl.

TV REPORTER: (*who looks like a TV reporter with a razor haircut, blue shirt and summer suit*) We're talking today with Andy Warhol, the famous pop artist and underground movie-maker. Mr. Warhol is in Los Angeles with his show, the Exploding Plastic Inevitable, featuring Nico, the Velvet Underground, and Mary Woronov and Gerard Malanga, Whip Dancers. Mr. Warhol, how did you get the idea for your show?

ANDY: (*faint, pleasant smile*)

NICO: (*shyly, her protuberant lower lip glistening*) He likes us.

GERARD: (*holding the knife up to his lips*) The Velvets. The Velvet Underground.

TV REPORTER: Andy, what kind of a following do you and your friends have?

ANDY: (*looking at Nico, his thin bubble-gum pink fingers caressing his lips*)

GERARD: You mean who is following us?

ANDY: (*softly, amused*) The F.B.I.?

TV REPORTER: Andy, as a kind of leader of youth (*Andy smiles*), do you feel any responsibility toward them?

ANDY: Oh . . . I. . . .

GERARD: I don't think anyone is following us, and if they are. . . . Well, we just do what we like, and if someone wants to follow, I guess it's not our responsibility.

TV REPORTER: Thank you.

Everyone goes down the spiral staircase again.

JIM: Paul, I've got a car, do you want to go somewhere?

PAUL: (*twisting his head around to Jim*) Thanks, but I've got to see if the Trip is going to open again tonight.

Jim: (twisting his head around to Andy) Andy, do you want to go somewhere?

ANDY: Oh, yeah, I want to go to the Ferus.

Scene: Santa Monica Avenue, dark blue station wagon. In the back seat, Gerard, Andy, Somebody. In the front seat, Jim (at the wheel), and Clark Kent ("of the Daily Planet"). *Andy is reading the* Los Angeles Times.

CLARK: Andy, did you ever get a copy of the review in the *Sunday Times*?

ANDY: Oh, that terrible one?

CLARK: I thought you'd like a real terrible review like that.

ANDY: Oh, sometimes I do. I think people will come if there is a really terrible one.

Clark: We went to see the Kienholz exhibit yesterday. Have you seen it?

ANDY: No.

CLARK: Do you want to go today?

ANDY: Oh, I don't think I really like him.

JIM: Why don't you?

ANDY: I don't know, he seems kind of moral to me.

CLARK: Why?

ANDY: I don't think he really likes the things he does like he doesn't really like—greasy hamburgers. He has a painting of mine. We traded. I gave him, really beautiful painting, but I don't remember what I got. I think I sold it.

CLARK: The L.A. County Museum has one of yours.

JIM: Yeah, it's the only good thing in the place.

ANDY: Oh, really, which one?

JIM: One of the *Disasters*, the fireman carrying out the child.

ANDY: Oh, really, a silver one?

CLARK: No, a black and white one.

GERARD: I really like that one, it's so perverse.

 Silence

JIM: Were there any stars at the opening of the show at the Trip?

ANDY: Oh, yeah, it was really exciting. Jennifer Jones was there and I met her.

GERARD: Sonny and Cher were there too, but Cher left early.

ANDY: Oh, she's so conservative. Sonny liked it. I wish the Beach Boys had come.

SOMEBODY: Andy, you're a purist.

ANDY: Oh, wow!

JIM: Where's the Ferus?

SOMEBODY: It's on La Cienega.

Silence

GERARD: If the Trip doesn't open tonight, can we have a movie-star party tonight?

ANDY: Oh, that would be really great. Ask Jack when we get back. He knows movie-stars. So does Severin.

Musical Interlude: The car radio, which is always on, is playing the Lovin' Spoonful. Did you ever have to make up your mind? Did you ever have to finally decide? Your ambiguity shines in the bright blue, smoggy air. The sun shines on the car, the radio is on. Hollywood is very same. Its sameness makes driving static, like driving around inside a polyethylene beach ball.

SOMEBODY: Andy, do you like Los Angeles?

ANDY: Oh, yeah, life is so simple here.

> *Andy, his entourage, and his world float across Hollywood like a grand, benign ascension balloon. They drift toward a convocation of balloons at the Ferus Gallery on La Cienega.*

Scene: Ferus Gallery. A room with white walls and ceiling. On one wall a large black and silver photograph of Andy Warhol with his fingers resting lightly on his lips. On the opposite wall a large black and white photograph showing an inflated silver pillow escaping from an upper window of Andy's art Factory in New York. In one corner is a green tank of helium. On the ceiling are two dozen of the same silver pillows. There are several slightly deflated silver pillows on the floor. Andy comes in with half a Heath Bar in his hand.

ANDY: Hi, did we get any mail?

GIRL: Yeah, I think there's a letter for you.

The entourage begins playing with the silver pillows.

ANDY: Do you have a pair of pliers?

GIRL: Yeah, I think there are some here. . . . No, I guess not. I'll go next door and see if they have some.

She goes next door and is gone for about ten minutes. She comes back.

GIRL: They didn't have any.

CLARK: Andy, do you want me to go up to Liberace's gallery and see if they have some?

ANDY: Oh, that would be really great.

Liberace's gallery doesn't have any pliers, so the whole entourage goes out to look for some. In half an hour they are all back and one of them has two pair. Andy reaches into the pocket of his black suede leather jacket and pulls out a yellow package of Juicy Fruit gum. He puts this into another pocket, reaches into the first pocket and pulls out a package of lead fishing weights. He pulls down one of the silver pillows and attaches some of the lead fishing weights to it with the pliers. The silver pillow floats back up to the ceiling.

ANDY: I wish they would just float in the middle.

The room is quiet. Andy and the entourage are putting lead fishing weights on the silver pillows, pushing them off so that they hit the ceiling and bounce back, and just float in the middle. The room is quiet and light from the bright blue smoggy sky outside. The silver pillows are floating around bumping into each other without making any sound. Andy and his entourage feel like they are becoming lighter. They feel like soon they will be floating too, right in the middle of the Ferus Gallery on La Cienega, bumping into each other without making a sound, right between the big black and silver photograph of Andy Warhol and the black and white photograph of an escaping silver pillow. Andy puts lead fishing weights on the last silver pillow and pushes it away. It moves slowly through the air, then floats motionless.

ANDY: Oh, wow! I'd like an ice cream cone.

Scene: Hotel Beresford, San Francisco. Andy dressed as before, but with a plain blue and white striped tee-shirt. He is washing a pair of black socks. Another pair hangs drying on the towel rack, as does the dark blue tee-shirt with small white and red stripes. Someone knocks on the door and Andy goes to open the door. Jim comes in.

ANDY: Oh, hi, I'm washing some socks.

JIM: Why don't you just throw them away when they get dirty?

ANDY: I like to keep them, they might be valuable some day.

JIM: When did you get here?

ANDY: Oh, the day before yesterday. Oh, wow, it was just like a movie-star's arrival at the airport.

JIM: Dial the Velvets come up too?

ANDY: No, just Gerard.

JIM: Well, what do you want to do tonight?

ANDY: I don't know. What do you want to do?

JIM: Have you had dinner yet?

ANDY: No, but I can just take a diet pill and not get hungry.

JIM: Well, let's go to Chinatown and have a Chinese dinner.

ANDY: Oh, that would be really great.

 The phone rings and it is Paul calling from The Castle. Andy talks to him and Jim lies on the bed looking at a huge mass of photographs of Andy, the Velvets, Nico, Edie Sedgwick and other friends and superstars. Andy says goodbye and hangs up.

ANDY: Is it cold outside?

JIM: Oh, it might get a little chilly later on.

ANDY: Should I wear a sweater or my jacket?

JIM: I don't know.

ANDY: Do you think my jacket would look funny?

JIM: I don't know. It's up to you.

ANDY: Oh, no. It's up to you to decide.

JIM: Well, wear the jacket then.

ANDY: Shall I take the tape recorder?

JIM: Why?

ANDY: Oh, I might want to record something.

> They go out into the hall. Andy locks the door and they go down the elevator and out the front doors.

ANDY: Are we going to have a good time tonight?

JIM: Probably not.

ANDY: (*wicked smile*) Oh, really? We got thrown out of the last hotel we were in. We were all registered and then the manager saw us and didn't like Gerard's beads, so he said we could stay only one night.

JIM: What did you do today?

ANDY: Oh, I just watched television. Oh, wow! There's a candy store. Can we buy some candy?

JIM: Sure.

ANDY: What kind of candy do you like?

JIM: I don't think I really want any. Chocolate makes me sneeze.

ANDY: Oh, really? That's really great.

> They go into an *Awful Fresh McFarland* candy store. Andy looks at all

the different kinds of candy. The saleslady makes small talk, cuts off pieces of candy to taste.

ANDY: Oh, it all looks so good. What kind shall I get?

JIM: Oh, I don't really care. That kind looks good.

ANDY: All right, I'll take a half a pound of that kind and a half pound of this kind.

SALESLADY: That will be a dollar twenty-nine.

Andy reaches into a pocket of his black suede leather motorcycle jacket and pulls out a yellow package of Juicy Fruit gum. He reaches in again and pulls out some bills. He gives the money to the saleslady and gets his change and the candy. They go out.

ANDY: Would you like some gum?

JIM: I always accept gum from strangers.

ANDY: (*wicked smile*) Oh, really? I guess I shouldn't eat so much candy. It's probably not good for me. I think I like to buy it more than I like to eat it.

JIM: Why don't you just buy it and throw it away?

ANDY: Oh, what a really great idea.

Andy and Jim go into the Far East Restaurant on Grant Street. The waiter motions them to a table and gives them menus.

WAITER: Do you want a drink before you order?

ANDY: Do you want a drink?

JIM: Yes, I think I'll have a martini.

ANDY: Do you have some really dry sherry?

WAITER: Yes.

ANDY: I'll have a little glass of sherry, and make that a double martini for him.

JIM: Are you trying to get me drunk?

ANDY: Oh, yeah.

JIM: I'm not sure that it's worth the expense. I usually just drink and drink and stay sober until I pass out.

ANDY: Oh, I like people who can really hold their liquor.

> They look at the menus. Andy takes a sip of his sherry. Jim drinks his double martini.

ANDY: Oh, everything looks so good. Oh, wow, they have ginger beef. Can we have some ginger beef?

JIM: Yes, and let's have some oyster sauce beef and sweet-and-sour spareribs.

ANDY: Is that the kind with pineapple?

JIM: Yes.

ANDY: Oh, wow, I love pineapple.

WAITER: You gentlemen like to order now, or you want another drink?

ANDY: Bring him another double martini.

JIM: It's useless, Andy.

ANDY: I already feel a little drunk.

> The waiter comes with the double martini. They order dinner and drink their drinks. Dinner comes and they eat.

ANDY: Oh, this is really good. I just love ginger.

JIM: We always used to come here when my parents and their friends would go out. They used to get tight and build a pagoda out of the teapots.

ANDY: Oh, the Chinese food here is much better than the Chinese food in New York. It's really the best food I've ever had.

JIM: Do you want some coffee?

ANDY: Don't you want another drink?

JIM: No, I'll just have some coffee.

ANDY: Could we have some coffee and the check?

JIM: What did you do with the candy?

ANDY: Oh, I threw it away.

The waiter comes with the coffee and the check. Andy and Jim drink their coffee and Andy looks at the check. He reaches into one of the pockets of his black suede motorcycle jacket and pulls out a bill. The waiter picks the bill and the check up, smiles widely, bows and retreats. Andy and Jim get up and go out.

JIM: You left him an enormous tip. Are you depressed?

ANDY: Oh, no. He was so nice and the dinner was really great.

JIM: Do you want to go to LiPo's?

ANDY: What LiPo's?

JIM: It's an evil bar.

ANDY: Oh, really? Do you like to go to evil bars?

JIM: Not really. It just looks like an evil bar in a 1946 movie about shot-down Yanks in Shanghai during the war. That's why I like it.

ANDY: Are you evil?

JIM: No, I think I just like to look at evil.

ANDY: *(wicked smile)* Oh, really?

Andy and Jim go into LiPo's. It is decorated in a garish style that reminds one of an evil Shanghai bar in a 1946 movie about shot-down Yanks. There is a gilded Buddha at one end of the bar and a Scopitone at the other end.

ANDY: Oh, wow, it's so Ana Mae Wong.

JIM: Don't you think it's really neat?

BARTENDER: Could I see I.D. please?

Jim takes out his driver's license, Andy takes out an old green passport. The bartender looks at Jim's license then at Andy's passport.

BARTENDER: Ooooh! You old. You surprise me, you no look 38. You look very young.

JIM: Could we have two Burgermeisters?

ANDY: Oh, they have a Scopitone. Can we play it?

JIM: Yes, that's why I brought you here, so you could play the Scopitone.

ANDY: Oh, really? What does it have?

JIM: Bobby Vee.

ANDY: Bobby Vee? Oh, I just love Bobby Vee.

They play Bobby Vee on the Scopitone. Jim drinks his beer. Andy talks about the Velvets and about Clark Kent "of the Daily Planet" (his real name is Michael Kalmen, but he introduced himself to Andy as Clark Kent and now everybody calls him that) and doesn't drink his beer. Jim finally drinks Andy's beer. Andy and Jim get up and go out. They start looking in shop windows.

ANDY: Look what beautiful cuff-links they have.

JIM: Do you really think so?

ANDY: Oh, yeah. Oh, wow, look at those great switchblades. I have a thing about knives.

JIM: Why?

ANDY: Oh. I guess I used to have a knife. I wonder if they have some cheap perfume? Can I buy you some, cheap perfume?

JIM: No, I don't think I want any.

ANDY: Really? I'll see if they have some.

 Andy goes into the shop.

ANDY: Do you have some cheap perfume?

SHOPKEEPER: No. Sorry we have no perfume.

ANDY: Oh, you really have some great knives.

SHOPKEEPER: Thank you, sir.

 Andy and Jim go out, and go past another shop. They stop and look in the window.

ANDY: Those are really nice beetle pins. If I bought you a beetle pin, would you wear it?

JIM: Probably.

 Andy goes into the shop and buys a beetle pin. He gives it to Jim who puts it in his pocket. They go on to another store and look in the window.

ANDY: Would you like me to buy you a wedding ring?

JIM: No, I don't think so.

ANDY: Why not? You may need it.

JIM: Would you like a cigarette?

ANDY: Oh, no thanks.

JIM: Don't you ever smoke?

ANDY: I used to smoke cigars once because I had some friends that smoked cigars.

JIM: Why don't you smoke?

Andy: Oh, I guess I'm afraid I'd burn myself up.

Scene: Fillmore Auditorium, San Francisco. Jim comes up the stairs to the ballroom. In the lobby are Mary Woronov, whip dancer in black Levis, big black belt with a steel buckle, black shirt; Nico in a dark shirt, wide belt and red arid white striped bell-bottom Levis; Maureen (a Velvet) in regular Levis and a paisley blouse; the Somebody in bellbottom Levis, monkey-fur jacket and a gold ring in his ear. Teenyboppers, lots of teenyboppers; hairdressers-on-leave and their dates, smart hippies and sloppy hippies: Junior League members, looking uncomfortable in their phosphorescent all-vinyl pants suits are all milling about in the lobby. Jim goes up to Mary, Nico, Maureen and Somebody.

JIM: Hi, where's Andy?

MARY: He's up on the balcony. Do you have a cigarette?

JIM: Sure.

MAUREEN: Oh, could I have one too?

JIM: Sure.

 Jim goes up to the balcony where Andy and Paul are setting up the movie projectors. The alternate band is leaving the stand.

JIM: Hi.

ANDY: Oh, hi. Oh, I tried to call you last night. We were over in Berkeley.

JIM: I was out. How did you like Berkeley?

ANDY: Oh, it was really great. We just sat and looked at the people.

PAUL: We can start if we can find Nico.

JIM: She's down in the lobby with Mary and Maureen.

 Paul goes off to round up the Velvets. Andy starts one of the projectors. Giant picture of Nico eating a candy bar. Andy turns on another pro-jector. Giant picture of Edie Sedgwick in black bra and panties sitting on

a unmade bed with a handsome boy wearing jockey shorts. "What do you mean, Andy?" asks Edie's voice over the loudspeaker. The Velvets set up their equipment. Nico comes out on the stage.

NICO: The song is "I'll Be Your Mirror."

Mary and Gerard are writhing together with their whips. The static din takes on a shrill steel sound as Johnny Cale scrapes the electric viola tucked under his long face. On the balcony a crowd forms around Andy. Four boys in electric paisley shirts and tight red pants are seeking his favor. Jim whispers something in Andy's ear. Andy reaches in one of the pockets of his black suede leather motorcycle jacket and pulls out a yellow package of Juicy Fruit gum. He gives a piece to Jim. Lou, the lead singer, sings "Shiny, shiny, shiny, shiny boots of leather." Gerard takes off his blue shirt with ruffled sleeves, his greasy, curly blond hair falls over his face, he kneels in front of the strobe light with his arms outstretched. Severin appears on the balcony dressed in black rubber trousers, white shirt, tie and frock coat. A woman in a white vinyl coat pushes toward Andy, with a news photographer behind her. Jim whispers something in Andy's ear. Blue flash.

San Francisco Chronicle: *large black and white picture of Andy Warhol in black suede leather motorcycle jacket, black turtleneck shirt, silvered hair, faint, shy, wicked smile. Oo, wow!*

19 "Cab Ride with Andy Warhol"

FREDERICK TED CASTLE
June 1967
ArtNews, February 1968

In May of 1967, Warhol and his entourage headed to the Cannes Film Festival for a screening of Chelsea Girls. *The French were great Warhol fans, going so far as to call him "a prime witness of our era" (Bockris, 269). However, because of the controversy surrounding the film, Cannes officials decided not to show it, upsetting Warhol and increasing his dislike for French film and, in particular, the more recent work of Jean-Luc Godard. Following Cannes, Warhol headed to Paris for the premiere of* Chelsea Girls. *After a short stop in London, Warhol was back in New York. The day he arrived, he jumped on a plane to Boston for a Velvet Underground concert.*

The day after he returned from Boston, Warhol went to Max's Kansas City, where superstar Ivy Nicholson was making a scene, screaming and throwing food. Horrified, Andy bolted from the restaurant and hailed a cab. The driver happened to be Frederick Ted Castle, an art critic and writer, who had a hidden tape recorder in his cab. Castle recorded this conversation and published it in a column called "Occurrences" in ArtNews *nine months later.*

Soon after, Castle wrote an experimental novel called Gilbert Green *(Kingston, New York: McPherson & Company, 1986), upon which the protagonist, Gilbert Green, is to some extent based on Andy Warhol. "I made Gilbert Green into an amalgam of myself and Andy Warhol and what I imagined a great artist and poet might do in those unsettled times [1968]."*

—KG

I first met Andy Warhol on St. Valentine's Eve in 1967. I was working as a cab driver and he hailed my cab. I am not usually a very talkative driver

but I had just seen *The Chelsea Girls* and I wanted to tell him that I was glad he made it. I did and we got to talking. He asked me if my writing was abstract. I had never thought about it that way before but I decided that it must be. The next day I wrote a series of two prose poems about the movies called A *Valentine to Andy Warhol.* In the next few months we got to know each other somewhat better. I wrote a useless movie script for him and I saw a lot of movies at his Factory. One day he suggested that since I was a cab driver I ought to install a tape recorder in the cab and record other people's conversation and transcribe it. He even went so far as to wonder why everyone didn't write that way. At the time he was getting ready to publish his novel about Ondine which had taken 24 hours to record and two years to transcribe[1]. I find the work of transcription practically unbearable myself, but I did agree that it would be interesting to make some tapes. Without happening to tell Warhol that I was going to do it, I went ahead and for three weeks I kept a record of things mentioned in my presence. One night while I was doing this experiment. Andy Warhol hailed my cab again, and this is exactly what we said to each other during a cab ride back in June.

WARHOL: Oh it's so good to see you, yes. . . .

CASTLE: Did you have a nice time in France?

WARHOL: Oh, we, sort of. . . .

CASTLE: Not really.

WARHOL: Huh? How did you know?

CASTLE: I don't know, just. . . .

WARHOL: The only two nice things we did, we had dinner with Brigitte Bardot twice. . . .

1 *a, a novel* (New York: Grove Press, 1968).

CASTLE: Is she a nice girl?

WARHOL: Yes, she's really beautiful.

CASTLE: I mean is she pleasant to be with?

WARHOL: Oh yeah, yes she is, she's really very . . . very sweet, really sweet.

CASTLE: Some of these people really aren't, you know.

WARHOL: Oh, no, no, no, she's really magic. And uh. . . . You smell like you've been drinking.

CASTLE: Well, I had a beer a little while back, it's been an incredibly dull night.

WARHOL: Oh really? Oh it's not dull at Max's!

CASTLE: It isn't?

WARHOL: No. Ivy was . . . Ivy was, uh, uh . . . do you know where you're going?

CASTLE: Yeah I do, really. I'm, uh, confused by running into you.

WARHOL: Oh. . . .

CASTLE: These things don't happen.

WARHOL: I know, isn't it funny? So Ivy was, you know, she called me up and said uh, you know, uh I'm going to Mexico right now and you know can you give me some money I'm getting a divorce and I'm coming back and marrying you and I said what? you know and I decided that you know everything is going wrong and I decided that we're going to get organized and really do things right and try to you know and nobody can sit at the factory they have to sweep or clean up or if they don't they have to leave and and so you know everything goes wrong. I lost my the or somebody stole the un, um, our microphone, so. . . .

CASTLE: What a drag!

WARHOL: So, I, oh, I don't know, it someplace, it's either, I misput it somewhere or something, it's around someplace or somebody took it, I mean, so it took me five hours and I wore myself out before we shot the movie and then um I've decided to really be straight with Ivy and tell her that you know she's crazy you know like you know let's not go on and it's fun and blah so I you know so I just told her that and so we I was taking everybody to dinner at Max's and we got there and here she was throwing her, you know, she just happened to see us and she began throwing her food and you know carrying on and so she just turned her back and I ran out because I didn't you know like I didn't want there to be a scene and the other kids had already stayed and were sort of ordering so I guess they had to stay on but, but that's not going to be the end of it because she's really just going to. . . .

CASTLE: Are you still taking pictures of her?

WARHOL: Well, yeah, we wanted to finish it, we wanted to shoot her babies and her but I think now maybe we'll just call it quits and uh. But I mean then you know. . . . Well, I don't know what she wants, you know, I mean I really don't. I can't figure out what she really, really wants.

CASTLE: It's very hard to know what women want. I think that usually you might as well decide . . . they hardly care. . . .

WARHOL: I mean I hardly ever see her, I haven't seen her for four weeks . . . I really haven't. . . .

CASTLE: I think they really usually want somebody to decide what they want for them you know, and then they get all screwed up because nobody does. . . .

WARHOL: Oh. . . . What have you been doing?

CASTLE: Oh, let's see, writing . . .

WARHOL: Oh that's good.

CASTLE: . . . walking around . . . working . . . not much actually I mean you know nothing new and exciting . . . how long were you away?

WARHOL: Oh, about three weeks and then we came back three days ago and we had to go to Boston so we came back from Boston yesterday. . . .

CASTLE: How do they like the film up in Boston?

WARHOL: Well, uh, the Velvets were playing up there and then somehow we got this television she I mean Nico and I got this television show with Al Capp. . . .

CASTLE: That's supposed to be a fairly good show.

WARHOL: Oh yes! He was very nice to us, yes. Jimmy Breslin was on and I had always liked him and to meet him it was great to meet him.

CASTLE: Oh and you and Nico and Jimmy Breslin and Al Capp, wow!

WARHOL: Yes and he was very nice to us. You know usually everybody said that he probably would have been just so evil but uh he's really nice! He really liked us, it was so strange! And then they had a love-in in the park yesterday . . . and we stayed there and it was sort of fun and then the Velvets worked at the Tea Party. . . .

CASTLE: What's that?

WARHOL: The Tea Party there and they're sort of a psychedelic . . . well, Boston is really like San Francisco it's getting so big you know and uh, New York can't seem to do the same thing that Boston and San Francisco do. . . .

CASTLE: It's not the same type of . . . I mean everything's very commercial here, you know?

WARHOL: Yeah but I mean. . . .

CASTLE: There isn't so much sort of extracurricular dedication for it.

WARHOL: Oh, yes, well, I guess so. That must be it. Then they're both school towns, you know, so it just means uh. . . .

CASTLE: A lot of kids who're not just children, exactly, not just sort of

being trained to be some sort of office person—people who are actually in operation. . . . The last few months we've had quite a few people from Boston at our house, I don't know why that is. . . .

WARHOL: Oh really? Oh. . . .

CASTLE: You know, people call up and say so and so blah-blah and so then they come by and uh really it's uh things seem to be happening there, nothing actually is happening there I think in both San Francisco and Boston it's always sort of a mirage. . . . Everything looks great, you know, but nothing's actually going on. You know what I mean by that?

WARHOL: Yeah. Well I'm sort of wondering you know like now everybody you know they want to freak out so they just put on funny clothes and stuff like that—then they become like everybody else.

CASTLE: Very true.

WARHOL: And then I don't understand what all that means. You know like and then it seems like they become like everybody else it's like and then with drugs you know it's really more plastic or more, you know, I mean somebody could take over, you know, and begin telling people what to do! And that's probably what they want!

CASTLE: Well Leary is doing his best, I suppose.

WARHOL: Well, I guess so, you know but then I don't know.

CASTLE: You know what I mean? And he started in Boston and now he's here if he's not in jail. . . . What do you think about making a movie about yourself?

WARHOL: Oh. Who would play it?

CASTLE: Ha-ha!

WARHOL: We did one, we did *The Andy Warhol Story* with Rene Ricard, you know, he was the most awful person I, but it didn't come out. Somehow. I'll show it to you.

CASTLE: What?

WARHOL: We did one with Rene Ricard, I don't know if you know him, he's really sort of awful. . . .

CASTLE: I don't know him.

WARHOL: And uh. . . .

CASTLE: Actually trying to play you, so to speak?

WARHOL: Yes, and then Edie was playing me or something like that, but it just wasn't, it was when I was moving the camera and stuff like that but then we had used him earlier that evening and then by the time we did that he was so tired that it just wasn't clever or anything, everything was wrong, sort of, uh. . . . Wow, everything is so boring in Europe!

CASTLE: Yeah, I know what you mean.

WARHOL: It's so great here.

CASTLE: Everything is very attractive and very boring at the same time in Europe. . . .

WARHOL: Yes.

CASTLE: There's so much that's very pleasant about it you know the food is good and all that sort of thing, you know. . . .

WARHOL: Yes, oh, yeah. It's fantastic, yeah.

CASTLE: But wow . . . I haven't been to Europe in five years now, I feel like going again.

WARHOL: Oh. Well, Paris is different now because they really are, well, Americans don't go there any more and uh you know they have four drug stores, you know, called drug stores, and a lot of English new shops, it's really getting very scary. Because I guess they have to accept you know the Americans and uh, and they still don't want to and you know we heard de Gaulle speak for three hours, and uh. . . .

CASTLE: Did you hear that?

WARHOL: Oh yes, yeah, I don't know what he was saying but he just he. . . .

CASTLE: What?

WARHOL: He had a lot of style and it was sort of great.

CASTLE: I like de Gaulle a lot.

WARHOL: But I mean it was just like, uh, you know, they still, they're missing something, they still think they're still—you know, they've lost it. They still want to hold on to something you know they don't want to change and it's funny, you know, it really is so peculiar. Because they really want to be something and or. . . .

CASTLE: Somebody's writing or editing a book about Jean-Luc Godard.

WARHOL: Oh really?

CASTLE: Asked me to write a chapter about it and I've been writing away and I've got about twelve pages of the most insane bullshit I've ever read.

WARHOL: Oh we saw the last one, well he did two, we didn't see the last one, we saw *Made in USA* and it's so bad!

CASTLE: Was it made in USA?

WARHOL: No, it was called *Made in USA*.

CASTLE: But it wasn't made in USA.

WARHOL: Oh, it was so bad! I mean it was—well, maybe I didn't think it was so bad, but everybody with me were, you know, got me so nervous that they made it, like you know they all walked out but you know it was really boring and Anna Karina looks terribly ugly, and oh. The only thing I liked about it that I thought was interesting was that he does them so fast and he keeps the same people you know it's like actually a diary. And that's what I really like maybe about his movies. . . .

CASTLE: You know, I def . . . I do like his movies.

WARHOL: And he gets girls that look like her, and, then, uh. . . .

CASTLE: But also he's not afraid to say things, to have people say things, you know?

WARHOL: Oh, yeah, but when you see *Made in USA* it really is bad. It really is so boring.

CASTLE: Well that could be . . . *Alphaville* I didn't like at all. . . .

WARHOL: Oh, I didn't like that either, it was terrible.

CASTLE: Terrible.

WARHOL: But *Masculine-Feminine* I really liked, I didn't want to like it but I did. I really did. And it was just easy and. . . .

CASTLE: It was going to be so bad and then it really wasn't.

WARHOL: Yes. Well, this one now, there're more gun shots. Everybody is shooting, you know I mean it started somewhere where. . . .

CASTLE: He's always been fascinated with that. . . .

WARHOL: *Masculine-Feminine* had a couple but this one was, he's always. . . .

CASTLE: Even his old pictures have people pointing a gun at somebody.

WARHOL: Yeah, but they didn't shoot as many times as they did this time. This time they really shot, you know, they really, they killed everybody.

CASTLE: He's always been fascinated with the way in American films suddenly you know two people confront each other and one pulls out a gun and that's that.

WARHOL: But it's sort of interesting that. . . .

CASTLE: But he doesn't understand it, actually, you know.

WARHOL: But now it's even, it's just so much, it's fantastic.

CASTLE: Well. . . .

WARHOL: And uh really now it's so screwed-up.

CASTLE: What's that? [a brochure]

WARHOL: Oh, uh, oh, why don't you take it. He drives me insane that guy.

CASTLE: I was just looking at this.

WARHOL: He bugs people's apartments, you know, he bugs everything.

CASTLE: Oh, this is one of these sex things. . . .

WARHOL: No, this is a guy who bugs things, no, he's a, he really is scary. He's a, oh he wanted to be our manager somewhere but uh and then uh he was so sneaky about it like he's uh you know bug things or something, you know, and it was just so scary.

CASTLE: He'd record stuff?

WARHOL: Yeah, he sells bugging machines and stuff like that and uh he was just scaring me and it was just . . . oh . . . thanks.

CASTLE: Thank you very much.

WARHOL: Oh, come up and see us since we're back.

CASTLE: Yeah, all right.

WARHOL: We're going to work hard.

CASTLE: Back to the ordinary schedule?

WARHOL: Oh, oh, yes, yeah. We're working, working very hard. I hope Ivy isn't waiting for me.

CASTLE: It's too early. Good night.

WARHOL: Good night. Oh, thanks.

20 "Andy Warhol"

JOSEPH GELMIS
Spring, 1969
The Film Director as Superstar, 1970

Newsday *film critic Joseph Gelmis had conducted two short interviews with Andy Warhol before this more in-depth session from 1969. Upon returning to the Union Square West Factory, Gelmis was struck by the elaborate security precautions that were taken following Warhol's shooting by Valerie Solanis the year before. "I remembered that there was a fake wall in front of you when you got off the elevator to guide you and a turnstile to slow you down so that without having a guard there, you actually went through a maze-like process to get access to Warhol. The first thing you saw was Cecil B. DeMille's stuffed harlequin great dane standing there. It stopped you dead in your tracks." When he finally did gain entry, Gelmis found Warhol absorbed in television.*

Gelmis's newspaper reporter slant was reflected in the nature of his questions to Warhol: "I took the everyman approach with him as opposed to somebody who was asking more elliptical, insider or antagonistic questions. Warhol responded appropriately, giving me disarmingly pragmatic and simple answers."

This piece was published in a book of Gelmis's interviews with prominent directors of the day, The Film Director as Superstar *(Garden City, New York: Doubleday, 1970), including Stanley Kubrick and Francis Ford Coppola. Gelmis recalls how different his experience with Warhol was: "Most directors I interviewed were starved for people to ask them questions about the creative process or what their practice meant. Warhol was interesting for a totally different reason because he hadn't a clue about the filmmaking process. I must have interviewed 5,000 filmmakers in the course of 30 years and he was unique in his non-narrative approach. He was admitting that they were coming out of a non-technical, filming-what-happens kind of approach, and in doing so, putting on film what nobody else had achieved up to that point."*

In his original introduction to the interview, Gelmis wrote: "He is a listener and observer who absorbs and absorbs and absorbs. Ordinarily, he is like a somnambulist, with very gentle, doe-like eyes, slack, melancholy mouth, straight, platinum-dyed hair, soft, courteous voice. He is a listless conversationalist, totally passive. In the following interview, which was conducted at his 'factory' in a Union Square loft, the only time that Warhol became at all animated was when he started to discuss the 'beavers' he had seen earlier in the day. In talking to others who came and went during the afternoon, he spoke in the same monotone and drifted around in a kind of vague torpor."

The interview lasted approximately half an hour and is printed verbatim.

—KG

GELMIS: Why are you making movies? Why did you give up painting?

WARHOL: Because movies are easier to do.

G: Easier than signing Campbell Soup cans?

W: Yeah. Well, because you just turn the camera on. And then, if you go into commercial filming, it's even easier because people do it all for you. They really do. The camera person is really the person that usually makes the movie.

G: Do you really think that Lester and Penn and Kubrick and Nichols let their cameramen do all the work?

W: Yeah.

G: There's an element of confession and of autobiography in almost everything you film. The people who act for you seem to be constantly confessing. What's your fascination with the confessional?

W: They're just people who talk a lot.

G: Where do you get your actors? Where did Ingrid Superstar and Viva and Ultra Violet and Mario Montez come from?

W: Just around, I guess. They were just the ones who wanted to be in a movie. So that's how we used them.

G: Have you since gotten many more people interested?

W: No. It's very hard. Those people just sort of happen. You can't look for them.

G: How much of your films is fiction and how much of it is real? Is this what they'd be doing whether you had the camera turned on them or not? Would Ondine do what he did and said in *Chelsea Girls*?

W: Yes. He does better things now. I wish I were filming it now.

G: How do you see your role in getting him to do what he does?

W: I don't do anything. That's what I don't understand.

G: What's your role, your function, in directing a Warhol film?

W: I don't know. I'm trying to figure it out.

G: It's been suggested that your stars are all compulsive exhibitionists and that your films are therapy. What do you think?

W: Have you seen any *beavers*? They're where girls take off their clothes completely. And they're always alone on a bed. Every girl is always on a bed. And then they sort of fuck the camera.

G: They wriggle around and exhibit themselves?

W: Yeah. You can see them in theaters in New York. The girls are completely nude and you can see everything. They're really great.

G: If they aren't prohibited by the state obscenity law, what's preventing other filmmakers from doing the same thing?

W: Nothing.

G: So why haven't you done it? Or have you?

W: We're getting there. *Lonesome Cowboys* has two fucking scenes. There's hard-ons and the actors go down on each other in *Fuck*[1]. That's a movie we made when I got out of the hospital after I was shot. It's been shown at the Museum of Modem Art.

G: Have you actually made a beaver yet?

W: Not really. We go in for artier films for popular consumption, but we're getting there. Like, sometimes people say we've influenced so many other filmmakers. But the only people we've really influenced is that beaver crowd.

The beavers are so great. They don't even have to make prints. They have so many girls showing up to act in them. It's cheaper just to make originals than to have prints made. It's always on a bed. It's really terrific.

G: How did you learn to make movies?

W: I bought a 16-mm camera and took a trip to California four or five years ago. We were going to Hollywood, so that's what made me think of buying a camera.

G: Did you bring along a tape recorder or shoot silent first?

W: Silent. I was just learning how to use a camera. I'm still learning how to use a camera. We haven't made a *movie* yet.

G: What have you been doing until now?

W: Just photographing what happens.

G: Is it preparation for something you're planning in the back of your mind?

W: No. Things always happen, so you never know what's going to happen. You can't really prepare for anything.

1 *Fuck* (also known as *Blue Movie*), 1968. Andy Warhol: "I'd always wanted to do a movie that was pure fucking, nothing else, the way 'Eat' had been just eating and 'Sleep' had been just sleeping. So in October '68 I shot a movie of Viva having sex with Louis Waldon. I called it just 'Fuck'." (*POPism*, 294)

G: When did you make your first movie, or non-movie? How do you refer to them, incidentally, if you don't call them movies?

W: Depending on the time, we have short ones and long ones.

G: But are they called movies, or what? You say you haven't made any movies up until now.

W: I think movies are the kind of things Hollywood does. We haven't been able to do that. Because you need a lot of money to do that. So we're working it out our way.

G: Why was *Chelsea Girls* half in color and half in black and white?

W: I don't know. We got a little more money, I guess.

G: Is money still the chief consideration for why things are done the way they are in your movies?

W: Yeah. We have to make our movies look the way they do because if you can make them look better bad, at least they have a *look* to them. But as soon as you try to make a better movie look good without money, you just can't do it.

G: It looks shoddy?

W: Yeah.

G: When people went to see *Faces*[2] many were disappointed because they thought it would be a slick Hollywood movie but it was grainy 16 mm enlarged to 35 mm and it wasn't carefully lit.

W: It was very slick when I looked at it. I saw it in *Life* magazine and it was cropped. If it were shown in a square it would have been awful. But it was shown in a nice super-oblong.

G: Do you experiment much with various projection shapes yourself?

2 *Faces* (1968), directed by John Cassavetes.

W: Well, you get used to cutting off things. It makes the movie more mysterious and glamorous.

G: Why did you make a movie like *Sleep* about a guy who sleeps for eight hours?

W: This person I knew slept a lot.

G: During the day?

W: No, at night.

G: Doesn't everybody? Don't you?

W: Not when you turn the camera and the lights on and everybody's making noise.

G: You just set the camera on a tripod and had operators spelling each other behind the camera for eight hours?

W: Yeah. Well, it didn't turn out the way we wanted it to because I did it in three-minute things. So now we do it in thirty-five-minute things.

G: Were you using a simpler camera then?

W: Yeah. We use an Arriflex and a Nagra tape thing now.

G: Have you made a 35-mm film yet?

W: No. I guess we'll do that some day. It's expensive.

G: *Sleep* was shown silent, wasn't it?

W: Yeah. The first time we showed it, we had a radio on in the theater. Instead of recording a sound track, we just put a radio next to it and every day put on a new station. And if a person were bored with the movie, he could just listen to the radio. People listen to radios.

G: You've said you like television a lot, too. Any special programs?

W: I like it all.

G: Why?

W: There's just so much to see. You can change all the stations. As soon as it gets a big picture, it'll be even more exciting. Everybody should have two television sets. So you can watch two at a time. Every time you see the President, he has three.

G: Can you really pay attention to two sets at once? Or is it just images and sensations, anyway?

W: I put two things on the screen in *Chelsea Girls* so you could look at one picture if you were bored with the other.

G: How do you feel about the interruptions of the commercials on television?

W: I like them cutting in every few minutes because it really makes everything more entertaining. I can't figure out what's happening in those shows anyway. They're so abstract. I can't understand how ordinary people like them. They don't have many plots. They don't do anything. It's just a lot of pictures, cowboys, cops, cigarettes, kids, war, all cutting in and out of each other without stopping. Like the pictures we make.

G: How many pictures have you made so far?

W: I dunno. It depends on how you count. We have small ones and big ones and sometimes we make two from one or one out of two older pictures. We stopped making so many now. We thought we'd wait a while to see what happens.

G: You recently made a one-minute television commercial for Schrafft's.

W: Yeah, well, that just took a minute to do.

G: But it took more than a minute to put that minute together, didn't it?

W: No, it just took a minute.

G: What about the use of videotape? You've said you're enthusiastic about using tape. Why?

W: Oh, it's like instant pictures. You can see it right back. You can combine things together that you can't do in films. You have to send films out to be processed.

G: Can you imagine yourself making a full script sometime, written out in advance?

W: Yeah, if anybody asked us to do it, we'd do it.

G: You did make a western, or at least you made a movie, *Lonesome Cowboys*, on location in Arizona.

W: Yeah, that was with Viva. We asked them to make up something, but they were still themselves. They were in cowboy hats.

G: You were supposed to go on a tour of colleges last year and you sent someone else in a wig who pretended to be you on the stage introducing the films.

W: We went to about fifty colleges last year.

G: Is it true that you sent a stand-in to the college lectures?

W: I only did it because I thought it was what they wanted. It was more entertaining.

G: You're really anxious to entertain?

W: Oh, sure. That's what we're trying to do now. The cowboy movie is more entertaining than the early ones.

G: Is there a market for your films in colleges?

W: Yeah, that's where we get most of our films shown. I think movies are becoming novels and it's terrific that people like Norman Mailer and Susan Sontag are doing movies now too. That's the new novel. Nobody's going to read any more. It's easier to make movies. The kind of movies that we're doing are like paperbacks. They're cheaper than big books. The kids at college don't have to read any more. They can look at movies, or make them.

G: What was the reaction of the college audiences to your films last year?

W: We showed them so much they didn't know whether they liked them or not.

G: Is that the reaction of most people?

W: When people go to a show today they're never involved any more. A movie like *Sleep* gets them involved again. They get involved with themselves and they create their own entertainment.

G: Your audience is forced to do the work themselves?

W: It becomes fun.

G: Do you mean people who don't like your films or are bored by them just aren't working hard enough?

W: I don't know. But it's a lot of fun.

G: Most of your films have little or no editing. You keep the camera in one spot and keep shooting until the reels run out. Your characters enter and leave the frame. But there's no cutting, just reels spliced together. Why?

W: The reason we did that was because whatever anybody did was always good. So you can't say one was better than the other. You get more involved and time goes by quicker if you stay with one scene.

G: Have you changed your opinions about the need for editing?

W: Well, now we really believe in entertainment, and that's a different scene.

G: You've said "I like boring things." How can entertainment be boring?

W: When you just sit and look out of a window, that's enjoyable.

G: Why? Because you can't figure out what's going to happen, what's going to be passing in front of you?

W: It takes up time.

G: Are you serious?

W: Yeah. Really. You see people looking out of their windows all the time. I do.

G: Mostly it's people who are stuck where they have to be, like an old person or a housewife waiting for the kid to get out of school or the husband to come home from work. And they're usually bored.

W: No. I don't think so. If you're not looking out of a window, you're sitting in a shop looking at the street.

G: Your films are just a way of taking up time?

W: Yeah.

21 "We're Still All Just Experimenting"

ROGER NETZER AND CURTIS ROBERTS
Fall 1969
The Gunnery News, December 6, 1969

*In the fall of 1969, Roger Netzer and Curtis Roberts, both high school jun-
iors at The Gunnery School for Boys, decided to interview Andy Warhol for
the school newspaper as part of a series of interviews with prominent figures
of the day. Other subjects included Harrison Salisbury, Paul Goodman,
Arthur Miller, William Styron, and William Buckley.*

*Curtis Roberts recalls setting up the interview: "I remember looking up
the phone number for Andy Warhol Films on Union Square in the New York
City phone book. We just went ahead and called, armed with the confidence
that teenagers can have. Anyway, we were treated politely, called back at the
designated date and time, and the interview went off without a hitch."*

*They found Warhol an unusual interviewee. "The other interviewees were
so different than Warhol because they tended to be fairly long-winded and
self-regarding; they weren't giving the one-word answers that Andy gave,"
recalls Roger Netzer. "In fact, I was a little exasperated because I wasn't
accustomed to this. With Andy you had to stay on your toes because there
were all these blanks that you had to fill." One of these moments shows up
in the following interview when Netzer asks Warhol, "Do you like chives?"
out of frustration because Andy wasn't giving him the serious, pompous
answers that Netzer had come to expect. "I happened to be in a kitchen
looking at a bunch of chives, so I just sprung that question." In doing so,
Netzer found himself under the Warholian spell and suddenly, Andy's
responses didn't seem so odd.*

*Very little editing occurred, but after the interview was complete, Netzer
and Roberts were shocked at how short the transcript was. Their solution was
to typographically increase the spacing between the questions and responses
just to fill a page. The terseness of the interview left Netzer with a feeling*

that, in fact, the interview could be improved upon. He called the Factory a year later requesting to redo the piece, but was told that Andy was satisfied with the interview as it stood. "I was unhappy with it in retrospect because, at the time, I didn't appreciate how great he was in the original piece," says Netzer. "Over the course of the next year, I had really come to admire him and wanted to go back and do a proper interview, but in fact, the one we did was the proper interview."

—KG

"I don't like any of them yet," Andy Warhol, underground filmmaker and Pop artist, said about his movies this week in a *News* exclusive telephone interview.

Mr. Warhol, whose latest film, *Blue Movie*, was recently seized by the New York Police as "pornography," conversed with the *News* for nearly half an hour, ranging in his discussion from censors ("we believe in them") to the critics' panning of his novel *a* ("we think they're right").

In addition, Mr. Warhol disclosed his hitherto unannounced plans to marry a girl named Jane Ford, and his present writing project, a twenty-six-act play called *B*.

Blonde on a Bummer and *New Girl in the Village* will be Mr. Warhol's next films, the director announced, then went on to ask, "Do you know any people who want to be in the film?"

Mr. Warhol named flying as the next artistic medium in which he'd like to work. "It's the only way," he explained.

He also revealed his admiration for "all the Hollywood people" and "the kind of movies I can't really make."

Asked about the price of one of his books, Mr. Warhol said he didn't know, but added, "It has two prices. They always have two prices to everything."

This is a recorded interview. Is that okay?

Oh, sure.

Oh, great. What film are you working on?

We're working on a couple of things. One of them's called ah, "Blonde Bummer," and ah, "New Girl in the Village."

Where are you filming?

Huh?

Where are you filming?

Oh, we're . . . we're going to do it in, ah, California, and in the Village.

Are you going to have people who've appeared in your films before?

Yeah, but we're going to try and use new people. Do you know any people who want to be in the film?

Yeah. There're lots of people here who'd like to be in your film.

We need someone named John Modern.

John Modern!?

Yeah, Modern.

We can change our names or something. Could we change our names?

Oh, yeah.

Okay. What present films or film-makers do you admire?

Well, I like all the Hollywood people.

Excuse me?

I like all the Hollywood people, the kind of movies I can't really make. Like ah-h-h . . . Like ah-h-h. . . . What are some Hollywood movies?

Oh. All sorts of things. Guess Who's Coming to Dinner . . . All sorts of crap. Do you like any specific directors in Hollywood?

Um-m-m-m. . . .

Mr. Warhol, could you speak a little louder? You'll have to talk a little louder.

Um-m-m-m. U-m-m-m-m.

I'm sorry, Mr. Warhol, could you speak a little louder?

Oh, we have a newspaper. Would you be interested in writing for our newspaper?

Yes. We'd really be interested.

Really? It's called *Interview*. Would you give me? — ah, what's your address? Oh, you gave me the address already.

Yes.

Oh, we'll send you a copy. Maybe you could write for it.

Great.

Ah, ah, what else did you want to find out?

Do you have any special theory of film?

Serious?

Theory.

Huh?

Theory.

Steery?

T-h-e-o-r-y.

Oh, theory?!

Yes.

No.

You don't? Do you have any opinion about who the most important under-ground film-maker in America would be?

Ah, oh, Hitchcock.

Okay. About critics. Whose critical opinion, if anyone's, do you value?

Huh?

Do you value anyone's critical opinion?

Ah, the movie reviews.

Anyone particular?

No.

I'm sorry, Mr. Warhol, could you speak just a little louder? . . . About censors and things. What do you—

We believe in them.

You do? How did you feel when Blue Movie *was seized?*

What?

How did you feel when Blue Movie *was seized?*

Oh, we didn't think about it at all.

Are you going to plan any legal action against the people who did it?

No.

Okay. Are you writing anything now?

Oh yes, uh-huh.

What are you writing?

Oh, we're writing, er, a twenty-six-act play.

Oh, really.

We'd like to perform it in New York.

Would you like to tell us anything about it?

Oh, it's just er, it's just called, ah, "B."

Oh. I see. Do you have any reaction about the critics' reaction to your novel? Because some people gave it some pretty horrendous reviews. Do you feel anything about that?

No. We think they're right.

Okay. I'm sorry to ask again, Mr. Warhol, but can you speak just a little bit louder?

We think they're right.

Okay, thank you. Do you have any sort of opinion about prep schools in general? Because this is a prep school.

Oh no, I think they're really . . . ah . . . terrific. All the kids are always so pretty.

Okay. Is there any sort of art form that you haven't worked in yet that you'd sort of like to?

Flying.

Yeah. Why would you like to fly?

Oh it's its the only way.

You haven't done it before?

Huh?

You haven't done it before?

Oh, no.

Er, how do you feel about Les Levine?[1]

Who?

Les Levine.

Oh, I've, I've never heard of him.

Oh, you haven't?

No.

I've forgotten where it was, but there was an article comparing you to Les Levine.

Oh, really?

Yeah, it was in the Times *or something.*

Oh.

Something Like "The Battle of Andy Warhol and Plastic Man."

Oh, no, I haven't—I've never seen that article.

Okay. Is it true that Warhol is an anagram of Harlow?

Huh?

Is it true that Warhol is an anagram of Harlow? That's what someone told us.

What?

That Warhol is an anagram of Harlow. You know.

No, I don't—What? Huh?

You know.

1 Les Levine. Artist, born 1935.

Is underground. . . .

Is anagram.

Anagram.

Yeah.

Of Harlow.

Yeah.

Oh. Yes.

Okay. Um, let's see. How do you feel about The Kinks?

The Kinks?

Yeah.

Oh, they're terrific.

Well, that's really great. Thank you. Are there any painters in the Pop school that you admire?

No, I like them all.

What are you reading now?

Ah, just newspapers.

Do you have a favorite writer?

No, I like the ones that don't use by-lines.

Oh. We don't use by-lines in the Gunnery News.

Oh, really?

No. Well, actually we do sometimes. But it doesn't flatter really. Do you plan on marrying in the near future?

Oh, yes.

Ah, who are you planning to marry?

Ah, a girl named Jane Ford.

Oh, really. Well, that's nice. Can we do a Gunnery News *exclusive on it?*

Oh, sure.

When will that be then?

Ah, soon. Hello?

What is your attitude toward amphetamines?

Well, I don't know. I mean, you know. Most of the people we know don't take that sort of thing.

Someone read somewhere that you hooked all your superstars on speed so you could dominate them.

That's not true. People on speed tend to dominate *you.*

So you could give them the speed and they'd be dependent on you. You see? What religion are you, Mr. Warhol?

Well, I believe in all religions. That's the kind I am.

You used to be a commercial artist, didn't you? I mean, you know.

Oh, yes. Uh-huh. And I still am.

Yeah. But did anything, you know—?

Huh?

Any sudden thing make you change your style?

No.

Which of your movies did you like the most?

Ah-h-h.

Did you like any of them?

Ah, not yet.

When do you expect to?

Well, I don't know.

Oh.

We're still all just experimenting.

Yeah. Do you like chives?

What?

Do you like chives?

Huh?

Do you like chives?

Chives?

Yes.

Chives?

Yes.

What are chives? You mean those things you put in—

Cream cheese.

Huh?

Cream cheese?

Oh yes, I see.

Neat. Didn't you start the DOM?

Yes.

How's that doing?

Well, they took it away from us a long time ago.

Oh, they did? It's still running, though, isn't it?

Oh yeah, it is.

How's your novel doing?

Oh, it's in paperback now.

Oh, is it?

Yeah.

Is it selling pretty well?

Yeah.

How about that book you did, the one that had all the foldouts and things?

A.h-h-h-h, well, I guess it's still doing well.

Um. How much did that sell for?

Well, I don't know. It had two prices. They always have two prices to everything.

Did you like that pretty well?

Ah, oh yeah, it was pretty.

Do you do any lecture tours at all, sir?

What?

Do you do any lecturing?

No, we stopped. We just did one couple of days ago in Houston, but we don't do too many.

Because we have a film course at the school and they were planning to ask you. But I guess—well, do you charge an awful lot?

Gee, I don't know how much we charge. Paul's (Paul Morrissey) the person to talk to.

Would you be at all interested in lecturing at a prep school?

Oh, yes.

You would?

What?

At a prep school?

Oh, maybe, yeah, why don't you write to us?

Sure.

Oh, I have to go.

The paper comes out rather soon and we'll send you a copy.

Okay.

Thank you, sir.

All right, 'bye.

'Bye.

THE SEVENTIES

THE SEVENTIES

22 "Andy Warhol, Movieman: 'It's Hard to Be Your Own Script' "

LETITIA KENT
Vogue, March 1, 1970

"Warhol's *Kitchen* may really be the best film made about the twentieth century and is almost unendurable to watch. The camera is locked into position at an irritating middle distance, Edie Sedgwick and some other people are sitting around the table; Edie has the sniffles and keeps blowing her nose and this other guy keeps opening and closing the door of the refrigerator. They talk and you can't understand a word. You almost can't bear it, but . . . when in the future they want to know about the riots in our cities, this may be the movie that tells them."

—Norman Mailer, in an interview
with Vincent Canby, *The New York Times*, October 27, 1968

On a recent afternoon, I visited Andy Warhol in his New York Factory and found him languishing there on a Paris park bench. At forty-one or forty-two ("I never like to give my age"), Warhol is spectral, corpse-pale. Sitting there, sealed in a zipped-up leather jacket, scarcely moving, he resembled a perhaps living George Segal sculpture. Only his attaché case sputtered. *It* was alive. And so, in fact, was and is Warhol.

He arrived in New York from Pennsylvania in the early 'fifties. He had been a fruit peddler, a window dresser, and an art student. He became a commercial artist, a Pop painter, an underground moviemaker, and a novelist. In all but the last, he was spectacularly successful. Warhol's giant shoe ads won a medal. His Pop paintings sold to the best collectors and museums. His underground movies were widely imitated and some, like *Chelsea Girls*, made a mint. His novel was remaindered.

Presently, he invited me to join him on the park bench. We talked about his movies.

WARHOL: I can't bear to let all this beautiful talk go by. *(He opened his attaché case and took out an enormous microphone.)* Everybody says . . . fantastic things. People are always putting it down as an invasion of privacy, but I think everyone should be bugged all the time . . . bugged and photographed.

KENT: *(taping him taping her)*: How did you become a filmmaker?

WARHOL *(breathlessly)*: I just suddenly came up with the thought that movies would be something interesting to do, and I went out and bought a Bolex sixteen millimeter camera and went to Hollywood. I went there with Taylor Mead, one of the first Underground movie stars. The movie we shot was called *Tarzan and Jane Regained . . . Sort of.*

Tarzan, my first movie, is more like my later ones because it tells a story in several scenes. In my other early movies there is just one scene with one star performing a very simple function—like the Empire State Building standing there all day.

KENT: Were your early films an extension of your still-portrait variations— like the multiple Marilyn Monroes?

WARHOL *(hesitating)*: Y-e-s. But I don't paint any more. I gave it up two years ago. I think painting is old-fashioned. In my early films, I wanted to "paint" in a new medium.

In *Empire,* the point was to make a moving picture still-life of the Empire State Building. It lasts for eight hours. The light changes, but the object remains stationary. The image is square and it's projected on a wall . . . like a painting. *Empire* is a—uh—pornographic movie. When the light goes on in the Empire State Building, it's supposed to represent. . . . *(He smiled.)*

Eat and *Henry Geldzahler* are moving-picture portraits. In *Eat,* Robert Indiana munches a mushroom for half an hour, and in *Henry Geldzahler,* Henry smokes a cigar for forty-five minutes. A newer way of doing a portrait would be to make a one-minute looped videotape of a person that you could play over and over again . . . for as long as you like. . . .

As soon as videotape machines are improved—isn't planned obsolescence terrible?—I'd like to do television. *(He spoke in a slightly awed tone.)*

I've always *believed* in television. A television day is like a twenty-four-hour movie. The commercials don't really break up the continuity. The programs change yet somehow remain the same . . . or something. Critics complain that our movies are slow. Well, each segment of the *Peyton Place* series runs for half an hour and nothing really happens.

KENT: Do your films ever have scripts and plots?

WARHOL (*smiling*): Sometimes. Half a page, a paragraph. But, mainly, the stars improvise their own dialogue. Somehow, we attract people who can turn themselves on in front of the camera. In this sense, they're *really* superstars. It's much harder, you know, to *be* your own script than to memorize someone else's. Anyhow, scripts bore me. It's much more exciting not to know what's going to happen. . . .

I don't think plot is important. If you see a movie, say, of two people talking, you can watch it over and over again without being bored. You get involved — you miss things — you come back to it — you see new things. But you can't see the same movie over again if it has a plot because you already know the ending.

KENT: But isn't improvisational movie making a matter of luck, depending upon the resources of the people who are doing the improvising?

WARHOL (*fervidly, as if his own voice had revealed a mystery*): *Everyone* is rich. Everyone and everything is interesting. Years ago, people used to sit looking out of their windows at the street. Or on a park bench. They would stay for hours without being bored although nothing much was going on. This is my favorite theme in moviemaking — just watching something happening for two hours or so.

KENT: As if the camera were a kind of visual tape recorder?

WARHOL: Yes.

KENT: But you do have a star system. When we watch the kooky characters in *Lonesome Cowboys*, we're also aware that they're Taylor Mead and Viva.

WARHOL: I still think it's nice to care about people. And Hollywood movies are uncaring. But I don't really believe in the star system. If one of our stars doesn't show up, we substitute someone else. (*He shrugged.*) They do that in television. Joan Crawford filled in for her daughter on a soap opera. I saw a program about Hollywood's search for a star to play Scarlett O'Hara in *Gone With the Wind*. They showed forty stars, each playing the same role differently. They all had something. It was so exciting.

KENT: Richard Schickel[1] said that you are firmly rooted, technically and aesthetically, to a point in film history around 1904–05: "Like the primitives, all Warhol does is borrow a real setting, place amateur actors in front of it, and instruct them to improvise dialogue and action based on a rough outline." Is that really the way you work?

WARHOL (*staring at Kent without animosity*): I guess so. When we decided to make *Blue Movie*, we first got Viva and Louis Waldon. Then we found an apartment. We had a crew of three. After all the things were plugged in, I turned on the camera and we moved it around. Viva and Louis did — uh — what they were — doing, and never paid any attention to us or to the camera. It was — uh — over in three hours and we all packed up and went home.

KENT: What's the point of making a three-hour film? Is it a kind of disposable item?

WARHOL: Well, if we want to, we can shoot the same movie over again. In the case of *Blue Movie*, we could do it over again, leaving out the — uh — objectionable parts.

KENT (*feigning nonchalance*): Oh, yes. *Blue Movie* has recently been declared "hard-core pornography."

WARHOL (*with a slightly put-on smile*): It's soft-core pornography. We used a misty color. What's pornography anyway? The muscle magazines are called pornography, but they're really not. They teach you how to have good

1 Richard Shickel. American film critic and author. Born 1933.

bodies. They're the fashion magazines of Forty-second Street—that more people read. I think movies should appeal to prurient interests. I mean, the way things are going now—people are alienated from one another. Movies should—uh—arouse you. Hollywood films are just planned-out commercials. *Blue Movie* was real. But it wasn't done as pornography—it was an exercise, an experiment. But I really do think movies should arouse you, should get you excited about people, should be prurient.

KENT: Was it camp to say on the program note that *Blue Movie* is "a film about the Viet Nam war and what we can do about it?"

WARHOL (*still smiling*): Oh, no. It really is. The movie is about uh— love—not destruction.

KENT: Then, is the moral: "Stay home and make love—not war?"

WARHOL: Not exactly. It's caring about people. *Blue Movie* cared about Viva and Louis. But after seeing Agnes Varda's movie *Lions Love,* I realize I didn't care enough. Varda made Viva look and sound so beautiful—better than we could.

KENT: Are you implying that the techniques used in the Varda film are beyond your means?

WARHOL: Yes. People forget that we turn out a movie in one day. *Blue Movie* was shot in three hours at a cost of $2,000. Critics put our movies down because of their technical defects—poor sound or wrong film—but I think they're more entertaining than many Hollywood films that cost millions. I *believe* in entertainment, don't you?

KENT: You once said that you wanted to make bad movies.

WARHOL (*practicing another put on*): Anybody can make a good movie, but if you consciously try to do a bad movie, that's like making a *good* bad movie.

KENT: There is an element of sexual ambiguity in your films.

WARHOL (*in an Andy Hardy voice*): I just like everybody and I believe in everything.

KENT: You also once said that you wished you were a machine.

WARHOL (*looking away*): Life hurts so much. If we could become more mechanical, we would be hurt less—if we could be programmed to do our jobs happily and efficiently.

KENT: But earlier, you said that we should be aroused from our alienation by prurient means.

WARHOL (*meeting her eyes*): Prurience is part of the machine. It keeps you happy. It keeps you running.

KENT: How do you evaluate yourself as a movie maker? Are you an innovator or are you, as Schickel suggests, a throwback?

WARHOL (*forbearingly*): Uh—a throwback, I guess. We just keep busy. Everything we've been doing is simply an experiment—our movies are like rushes. We haven't really finished a complete film—everything is part of something else.

KENT (*aggressively*): Isn't it a cop-out, an evasion of responsibility, to characterize as an "experiment" films that are commercially exhibited?

WARHOL (*without looking at Kent and with the barest hint of a smile*): In that case, the paying customers are the experiment.

Without seeming to stir, he closed the attaché case.

23 "A Conversation with Andy Warhol"

GERARD MALANGA

The Print Collector's Newsletter, January-February 1971

I was introduced to Andy Warhol the first week in June, 1963, at a party given by the film makers Willard Maas and Marie Menken. I recall Andy's silver hair, white skin, dark shades, and outright nervousness. I had just curtailed my formal education at Wagner College and was desperately in need of a job. Andy was in need of an assistant to help with production of his silkscreen paintings.

I began working for Andy at what was then his studio, a condemned hook and ladder company located on 87th Street between Lexington and Third Avenues. The city had sold the building to a real estate agent at an auction, and Andy was renting the entire building for $150 a month until such time as he would be asked to vacate the premises.

We began working almost immediately on the silk-screening of a portrait of Elizabeth Taylor on a canvas that had been prepared with a background of silver spray paint. The job was not too difficult, but became messy later when the screen had to be cleaned with varnolene.

We printed four or five 40 x 40 in. canvases, after which we returned to Andy's home which was two blocks away where I scrutinized Andy's photograph collection while "Sally Goes Round the Roses" spun. The photos were an odd assortment of car crashes, people being tortured, candid and posed movie stars, and nature lovers. I realized that the photos were the actual subject matter Andy reproduced in his silk-screens. From these photos, Andy was taking what he wanted stylistically from the media and from commercial art, elaborating and commenting on a technique and vision that was to begin with secondhand. He was a Social Realist in reverse; he was satirizing the methods of commercial art as well as the American Scene. But instead of satirizing the products themselves, he had satirized the "artful" way they were presented.

Andy has always been an education for me. He had many pitfalls to over-
come with his art, and on many occasions we resolved these problems. It was
always impossible to make an exact copy of his paintings. It was always acci-
dental, a new element or a new emphasis, either manual or psychological,
would crop up in the work. Andy wanted to keep the human element out of
his art, and to avoid it he had to resort to silk screens, stencils, and other kinds
of automatic reproduction. But still the Art would always manage to find a
way of creeping in. A smudge here, a bad silkscreening there; an unintended
cropping. Andy was always antismudge. To smudge is human. He wanted to
blot out blots. When we took up screenprinting, it was not to get away from
the preconceived image, but to more fully exploit it through the commercial
techniques of multiple reproduction. Unlike Rauschenberg, Andy never
destroyed his screens after they were used, and for this reason he has always
been worried about the possibility of a forgery. If somebody faked his art, he
could never hope to identify it.

Andy has always felt his work to be vacuous, but at the same time he felt
he couldn't tell how someone would react to one of his paintings until the
person actually saw it. He thought someone had to see his painting in
person to realize how vacuous it really was. Too many people who say it's
vacuous have never experienced the vacuousness of it at all. They are
judging it either as a reduced illustration or just an abstract idea. They say
who's interested in a can of soup? We know what it looks like because we
eat it. Or, we've seen pictures of it in the magazines. So Andy reproduces
a can of soup as it appears in an advertisement, and then they think he's
changed something. People just don't know how vacuous something is
until they see a copy of it. Maybe somebody will have to imitate his work
before it looks as vacuous as it really is.

Having struck out on my own, after a seven-year apprenticeship, I have
discovered now that I am able to make use of what I've learned from Andy
in my own daily living, and also the way I see things. The following interview
with Andy is not an interview at all, but a review of what we've been feeling
about art during the past seven years.

—Gerard Malanga

MALANGA: *Andy—when did you make your first print?*

WARHOL: Don't you remember, Gerard!? It was the print in three colors of the portrait of Elizabeth Taylor.* Actually I didn't silk screen it myself. Leo (Castelli) had it printed up in a limited edition signed by me. It was in the format of a poster and unlike the current *Campbell Soup Can* and *Flower* portfolios. If I remember correctly, I felt that if everyone couldn't afford a painting the printed poster would be available.

MALANGA: *What was the motive behind repeating the same image more than once on a painting?*

WARHOL: I don't really know or remember. I think, at the time, I started repeating the same image because I liked the way the repetition changed the same image. Also, I felt at the time, as I do now, that people can look at and absorb more than one image at a time.

MALANGA: *Gathering from what you've said I feel that the idea of the repetitive image ties up with the split-screen experiments incorporated into the film* Chelsea Girls.

WARHOL: Correct, but that was a divine accident. The idea of the split/image in *Chelsea Girls* only came about because we had so much footage to edit, and I wasn't into editing at the time, and the film would have been too long to project in its original form time-wise. By projecting two reels simultaneously, we were able to cut down the running-projecting

* *Documenting Andy Warhol's graphic work is difficult as he has consistently employed the graphic media to make things other than prints. No documentation was kept on Warhol's early graphics as many of these works were only considered prints after the fact. For example, the first* Flowers *print was a photo offset poster, signed but not numbered, for a 1964 exhibition at the Castelli Gallery in New York. The Elizabeth Taylor print Warhol refers to here was not his first print. Warhol's first signed and numbered print was probably* Cooking Pot *(1962). The print was made from an engraving of a newspaper advertisement and was signed on the verso with an embossed blind stamp of the artist's signature and numbered in pencil in an edition of 60. It was included in the portfolio* International Avant Garde, Volume V, *published by the Galleria Schwarz in Milan.* —Editor [PCN]

time in half, avoiding the tedious job of having to edit such a long film. After seeing the film projected in the split/screen format, I realized that people could take in more than one story or situation at a time.

MALANGA: *How random is your randomness in choosing the images you work with for the paintings?*

WARHOL: Ah—what do you mean? I don't choose images randomly, but make a careful selection through elimination. This was the same approach we used with *Chelsea Girls*, although we did eliminate two to four 35-minute reels. As for the paintings, the images I've used have all been seen before via the media. I guess they're media images. Always from reportage photographs or from old books, or from four for a quarter photo machines.

MALANGA: *Do you feel you've changed the media?*

WARHOL: No. I don't change the media, nor do I distinguish between my art and the media. I just repeat the media by utilizing the media for my work. I believe media *is* art.

MALANGA: *At what point did you stop painting and start using screens to print your paintings?*

WARHOL: Around 1962, though the backgrounds to the paintings have always been painted by hand before the silk screen is applied. Silhouette-shapes of the actual image were painted in by isolating the rest of an area on the canvas by means of masking tape. Afterwards, when the paint dried, the masking tape would be removed and the silk screen would be placed on top of the painted silhouette shape, sometimes slightly off register. I wasn't too careful about making a perfect register. I used to be concerned about this, but it would never come out perfectly registered anyway, because it was hard to see through the silk screen once I'd screened one image and moved it over to the next piece of canvas, so I would approximate the area upon which the silk screen would be placed, and nearly 100% of the time the image would reproduce an almost perfect register.

MALANGA: *What distinguishes your prints from your paintings?*

WARHOL: I suppose you could call the paintings prints, but the material used for the paintings was canvas. The prints, if they were silk-screened by us, were always done on paper. Anyone can do them. Why, even now, there's this boy in Cologne who has printed up slightly smaller versions of my *Marilyn Monroe* paintings and the *Cow* wallpaper prints. But his versions are also done on paper and with more color combinations.

MALANGA: *Is there a relationship between your prints and your involvement with film?*

WARHOL: At the time I wasn't aware of any relationship. They were for me at that time and still are two distinct expressions. But you did point out to me the similarity in the repetition of images in both media. I'm speaking here in regard to the early films, like *Sleep* and *Empire*.

MALANGA: *Yes, I remember holding up to the light a clip from* Sleep *and taking notice how each frame was exactly the same; each frame was static because the film was static in its actual projection. What percentage of influence do the people who work with you have over your final work?*

WARHOL: I don't know. I always get my ideas from people. Sometimes I change the idea to suit a certain project I'm working on at the time. Sometimes I don't change the idea. Or sometimes I don't use the idea right away, but may remember it and use it for something later on. I love ideas.

MALANGA: *Do you reuse the same screens for later printings and editions?*

WARHOL: The screens I used for the *Flower* and *Campbell Soup Can* paintings were never reused for the *Flower* and *Campbell Soup Can* portfolios. First of all, they were never the same size. Second, the portfolios were never hand-screened by me. They were always manufactured. I chose the different colors for them.

MALANGA: *Why do you use a rubber stamp?*

WARHOL: I don't always use a rubber stamp for my signature; but I turned towards the idea of a rubber stamp signature because I wanted to get away from style. I feel an artist's signature is part of style, and I don't believe in style. I don't want my art to have a style.

MALANGA: *Do you think of yourself as media?*

WARHOL: No one escapes the media. Media influences everyone. It's a very powerful weapon. George Orwell prophesied the potency of the media when he spoke of "Big Brother is watching you" in his visionary novel *1984.*

MALANGA: *What plans have you for the near future?*

WARHOL: To do nothing.

24 "Around Barnett Newman"

JEANNE SIEGEL
ArtNews, October 1971

In 1971, art critic Jeanne Siegel asked eleven artists about their relationship to the Abstract Expressionist painter Barnett Newman. These interviews coincided with a retrospective of Newman's work held the same year at the Museum of Modern Art in New York. As Reva Wolf states in her introduction to the present book, "Each artist dutifully spoke about what he perceived to be the significance of Newman's work. Warhol spoke about the art, too, making light of Newman's reductive abstract compositions of vertical lines. However, what seemed to really grip him was Newman's social life."

When Warhol arrived on the art scene, the Abstract Expressionist painters had a firm grip on the New York art world. In POPism, Warhol made clear his dislike of the macho scene centered around the Cedar Bar: ". . . even Barnett Newman, who was so elegant, always in a suit and monocle, was tough enough to get into politics when he made a kind of symbolic run for mayor of New York in the thirties. The toughness was part of a tradition, it went with their agonized, anguished art." (POPism, 13)[1]

Like Warhol, Newman was a latecomer to the art scene. He made what he considered to be his first painting at age 43. His exhibitions throughout the fifties were failures, and it wasn't until 1963 that he began to receive attention—at which point, of course, he was overshadowed by the Pop artists grabbing the spotlight.

Wolf continues: "In this passage, to the extent that there is discussion about art, it is covered over by what appears to be banal chitchat about parties. Still, under this cloak of banality, Warhol loosely concealed a surprising poignancy, which is exposed once we realize that Newman had died in 1970,

1 In 1933, Newman had offered himself as a last-minute candidate for election as New York City mayor against Fiorello LaGuardia, on a program advocating better arts education and more cultural resources in New York.

not long before this interview occurred. At this point, it becomes clear that being 'at another party' was Warhol's idea of Newman's afterlife, and that there was a pathos in his words."

ANDY WARHOL: The only way I knew Barney was, I think, Barney went to more parties than I did. I just don't know how he got around—I mean he'd go off to the next party. And it's just so unbelievable; why, I just think he's at another party. Don't you think he's just at another party? Maybe he didn't have to work a lot if he just painted one line, so he had time for parties.

And then I heard about all these studios he used to have, like fifteen studios; one for every painting. Every time I'd go by a building they'd say, well, Barney has a studio there. He had one in Carnegie Hall and about three or four downtown. He did a painting in the studio and then he'd leave one painting up forever. Isn't that true, Fred? Didn't Barney have a studio for every painting he ever painted? That was the most mysterious thing about him—that's what I thought was so great.

JEANNE SIEGEL: Was Barnett Newman a success when you first became aware of him?

ANDY WARHOL: I thought he was famous ever since the first time I met him. But then somebody said he wasn't famous until just recently. I liked the thing that's down in Houston next to the Rothko Chapel. I think that's so beautiful. We used to go down to Houston so I saw it. The whole idea was so great. It was so simple near the church. I liked it in the setting.

JEANNE SIEGEL: Did you like his other, simpler sculptures, such as "Here III"?

ANDY WARHOL: Frankly, I never understood how he got away with it.

JEANNE SIEGEL: Did Newman ever come to your studio, to see your work?

ANDY WARHOL: No, I don't think so. The last time I saw Barney it was at the Eugene Schwartzes[1]. Do you know them? They had a Barney Newman and then they had another Barney Newman, and I thought it was a copy done by that girl who copies paintings. I was going to ask him and then I didn't ask him and then he was standing right next to it so it must be real. They wouldn't have hung a copy if Barney was there.

JEANNE SIEGEL: Did you talk to him?

ANDY WARHOL: Oh, yes. He was always so sweet. He always asked me how I was. He was really kind.

1 Eugene M. Schwartz. Art collector, 1927–1995.

25 "Who Is This Man Andy Warhol?"

GEORGE GRUSKIN
SCOPE, March 16, 1973

Most people approaching Andy Warhol for an interview were, at the very least, curious; most were intrigued; and nearly all were fans. But George Gruskin and the editorial staff of the South African publication SCOPE set out to prove Andy Warhol to be the fraud that they assumed him to be. However, Warhol magnificently deflects Gruskin's hostility in this interview to the point where, near the end of the interview, Gruskin remarks: "I am very impressed by your modesty. So many people who achieved fame or wealth tend to be a little stuffy"; Warhol had won him over.

The early '70s were transitional times for Andy Warhol as he moved from '60s Pop artist to '70s jet-set entrepreneur. Victor Bockris says: "Andy was crossing over from the art world into the world of fashion. The change was reflected by a new look. Gone were his black leather jackets, replaced by velvet jackets, chic European-designed suits, ties and expensive high-heeled boots, though always worn with blue jeans. 'Everyone's back to beautiful clothes,' he told Truman Capote. 'The hippie look is really gone'." (Bockris, 347)

Other events shaped the era: his mother, who had long lived with Warhol in New York, died in 1972; his '60s painting prices soared at auction; his portrait commissions business took off (costing $25,000, with additional canvases of the same image in different colors costing $5,000 each); he made a well-publicized return to painting with his Mao paintings; and his filmmaking continued at a furious pace with Trash, Women in Revolt, Heat, *and* L'Amour*—to name a few—made between 1970 and 1972.*

This interview was conducted at the Factory at 33 Union Square West.

—KG

He is, without doubt, one of the strangest men who ever lived. He is also one of the most successful.

His name is Andy Warhol—pop artist, mad moviemaker, and genuine, Grade-A triple distilled 20th century freak; the weirdest wonder-child of all in an age noted for its glorification of presumptuous parvenus.

Warhol first hit the big time with his new "art" form—full-colour portraits of Campbells soup cans, perfect copies down to the last details. From there he moved on to even greater things: life-size replicas of Brillo soap pad cartons for which he asked—and got R200[1] apiece.

In anywhere else but America Warhol would have been dismissed as the insignificant upstart he was. But in a nation dedicated to the perpetuation of the transient he could only come out tops. Which, of course, he did.

The "beautiful people" clasped him to their collective bosom and he became a major cult figure. Little matter that he behaved like a spaced-out speed freak: he was different, he was "in."

Then, in the mid-sixties, Andy Warhol turned his tin-pan talents to film making and the trendy bores of the arty film world fell over themselves in their indecent haste to see what Andy baby had to offer the modern cinema.

Not much. Most of his movie work is amateurish and vulgar. Ultimately, a Warhol film is a stupefying bore.

One of his major "epics"—*Empire State Building*—lasts for eight hours. To film this masterpiece Warhol trained his camera on the skyscraper in question and let the machine run by itself. The camera angle was not changed. Another of his films, *Sleep*, also lasts eight hours. It shows a man sleeping. Nothing else.

In *Harlot*, Warhol places two men and two women on a couch. One of the women ate bananas, one after the other, while the other three players sat and watched him do so. There was no dialogue and the film lasted for 70 minutes.

For *13 Beautiful Women*, Warhol used the services of 13 females. Each of the women was required not to say anything. Each was simply asked to stare into the camera lens. The film runs for an hour.

1 South African Rand.

Such is the soaring genius of Andy Warhol, the anemic little [*word missing*] who operates from the top floor of a disused New York warehouse he calls the "Superstar Factory."

Little is known of his private life. He lives in a six-roomed apartment on 90th Street. His mother, a Czech, lives with him. So does his current playmate, a person of indeterminate sex who answers to the exotic title of Silva Thins.

Warhol has always preferred to keep himself out of the limelight. Recently, however, he allowed David Bailey, the internationally famous London photographer, to film a documentary on his work. Bailey's documentary, which contains some rather remarkable sequences, was due to be shown on Britain's ITV network late in January. But Mr. Ross McWhirter, author of the *Guinness Book of Records*, took advance exception to what had been touted as "the most dismissive shocker to be shown on British TV screens" and obtained a court injunction banning the film. The ban has since been lifted.

The four-hour show reveals, among other things:

—A fat woman stripping to the waist, daubing her breasts with ink, and then sloshing them against a canvas.
—A naked man sitting in a bath while a woman tries to persuade him to accompany her (and her rock band) to bed.
—A girl and a Hell's Angel discussing sex on a motor-cycle traveling at 90km/h.

The immediate outcome of all this inevitable fanfare was, of course, an upsurge of public interest in Andy Warhol and his work. Less than a week after the show, Warhol had raised more than R20,000 to finance three new films he has on the cards, and his most recent work, *Trash*, is currently playing to packed houses on the West End.

South Africans are unlikely to ever see a Warhol movie in this country, and in lieu of this sad gap in your cultural upbringing, we offer instead this interview between George Gruskin and the great man himself. It must surely rank as one of the strangest ever recorded. . . .

GRUSKIN: You are one of the most famous Americans of modern times and I would like to find out a number of things about you. I don't want to produce a story similar to the one Clifford [*word missing*] wrote about another famous American, so I have to ask you a number of questions.

WARHOL: OK.

G: Apart from your artistic and movie-making activities I am interested in your private life, your hobbies and avocations. In other words: your life and life-style.

W: Well, we're finishing two films. One is called *Don't Worry*, the other one *Heat*. One is going to the Dallas Film Festival, the other to Cannes, I guess. We are also writing a musical for couturier Yves St. Laurent, called *Vicious*.

G: Are you writing the music?

W: No. I'm working on the story. We are trying to get Lerner and Loewe to do the music, but if they're not willing, we'll settle for the "Velvet Underground."

G: What else is doing?

W: We are also trying something with situation comedies for TV.

G: Are you writing, directing or producing?

W: No. We are just getting people together. We're trying to do something with Silva Thins. Come on, Silva Thins.

Enter Silva Thins. He/she sits beside Warhol.

W: Silva Thins will play in *Vicious*, which is a movie about a girl who is in love with a boy who is turning into a girl. And so she is now getting ready for the part.

G (*To Silva Thins*): So for all intents and purposes you are a girl.

SILVA THINS: No.

W: She is a mosaic.

G: A mosaic?

W: A collage of the sexes. He is not sure yet what he is.

G: AC–DC (bisexual), in other words?

W: No, not AC–DC. He doesn't wear girl's clothes, but he wears lipstick.

G: If we can leave show business for a moment, I would like to ask you a few personal questions. What sort of private life do you lead?

W: I live with a drag-queen. I think that is enough. You know what a drag-queen is?

G: Of course. (A transvestite man who looks like a beautiful woman.) But you used to live with your mother, didn't you?

W: Oh yes, she is around somewhere.

G: You live in a town-house?

W: No, I live in a house in town.

G: If I may pry into very personal matters: how do you live? How does your day start? What time do you get up in the morning? Are you a night owl or a day bird? Or perhaps your routine is irregular?

W: That is the right word.

G: In other words, you live an irregular life. After all, if you did not want this life-style you would be in a nine to five job.

W: I believe in the nine to five jobs.

G: But you just said that you do not have a regular schedule.

W: I try to.

G: Oh, I see. So at what time do you get up in the morning?

W: At 8 a.m.

G: What do you do next? Exercise? Jog?

W: No.

G: So you find it a bit difficult to get going, right?

W: Yes.

G: What do you have for breakfast?

W: Just a cup of tea.

G: Nothing but tea?

W: And some vitamin pills.

G: How do you drink your tea, with lemon or with milk?

W: I like it with milk.

G: You drink only one cup?

W: One cup.

G: What comes then?

W: I talk on the telephone.

G: Business calls?

W: No. I tape them.

G: Why?

W: Just . . . just . . . (*he shrugs*).

SILVA THINS: Let's order some ice-cream! . . . (*he/she disappears*).

G: Are you fond of ice-cream?

W: I was until I saw how they made it. They put a lot of sugar in it.

G: And you object to sugar?

W: Well, there was one restaurant where I ate most of my ice-cream, and

yesterday it was mentioned in the paper among 400 restaurants in which inspectors found rat droppings in the kitchen. Can you imagine eating ice-cream at a place like that?

SILVA THINS: Why don't we tell him about my idea for a play?

W: Oh yes. Silva Thins has a good idea. We would organise a party on a Broadway stage. It would be like a play but actually it would be just a party to which we would invite different people every day.

G: Are you considering doing it?

W: Oh yeah!

G: Getting back to the phone calls: how long do you usually talk on the telephone in the morning?

W: Till the phone stops ringing. Then I try to get down to the studio. At about 2pm.

G: How do you come to the studio? Do you drive?

W: I take a taxi.

G: You don't keep a car?

W: We have a Volkswagen Kombi. That is our limousine.

G: Getting back to the telephone conversations: are they business, personal or perhaps a mixture of both?

W: They are with the same people and about the same things every day.

G: Can we assume then, that there is no clear dividing line between your business and your private life?

W: Right! But isn't this true for everybody? I cannot really understand how anyone can say he has a private life! After all, a man is always working.

G: What I meant is that people have friends with whom they play golf or tennis.

W: But that is also a part of work, isn't it?

G: Can you tell me about your friends?

W: I always think that everybody is my friend.

G: Yes, but still, who do you get together with: artists, writers, actors . . . what kind of crowd?

W: Just anybody who has my number.

G: By the time you arrive here at the Factory, you have probably got through a lot of telephone conversations.

W: Yes, and then I have to hurry back home to give my mother a pill.

G: What kind of pill? Why do you have to administer it personally?

W: It is some old-age pill . . . a stroke pill. If I don't give it to her, she would probably just throw it under the bed.

G: Doesn't she believe in medicine?

W: No. And I think she is right!

G: How old is your mother?

W: She is over 65.

G: In other words, she is a "senior citizen."

W: That's right. She can go to the movies free in those theatres for senior citizens.

G: How about the Warhol films? Does she go to see them?

W: She doesn't even know I make movies.

G: Well, if she knew and if she saw one of your films, do you think she would be shocked or embarrassed?

W: She likes to take to the bottle once in a while.

G: I heard she was a devout Catholic and. . . .

W: You can be a devout Catholic and still take to the bottle.

G: Oh yes, of course, but what I meant was that if she went to see some of your more shaky films, would she be shocked?

W: She doesn't go out.

G: I see. Does she read English?

W: She watches TV.

G: Your mother was born in Czechoslovakia. What language do you speak to each other?

W: I don't talk to her much. I just make her take the pills.

G: But does she speak English? I read somewhere that she doesn't.

W: She does.

G: And you speak English with her.

W: Yes.

G: Do you speak any Czech?

W: No.

G: Who takes care of the household?

W: There is a lady who comes.

G: She does the cooking and cleaning?

W: No. I do all that.

G: You? I've never heard or [word missing] this about you.

W: Nobody ever asked.

G: So you can cook?

W: No, I can't.

G: What do you cook?

W: Brown rice. You just mix it with water, its very easy.

G: Do you have any favourite dishes?

W: Chicken soup.

G: But you can't make that.

W: Sometimes I do.

G: I would assume that most of time you go to restaurants.

W: Sometimes. I eat before I go to a restaurant.

G: Are New York restaurants giving you too little to eat?

W: No. It is just my eating habit.

G: Are you too shy to eat in public?

W: You can't talk when you eat. And restaurants are dirty.

G: Do you do the cleaning at home?

W: Some. I vacuum. My new art form is vacuum cleaning. Or washing dishes.

G: Is the end-result of your activity the "art" or is it the very process of doing it?

W: The doing of it. But I will eventually exhibit the results.

G: Incidentally, I saw an autographed picture of Greta Garbo at the Studio. Did she dedicate that to you? Do you know Garbo?

W: No, I just picked it up in an antique shop. I don't know her personally, but I ran into her several times on the street.

G: Did you talk to her?

W: No, I just followed her in the rain. It's much more fun that way. When it rains, she is out on the streets.

G: Did you try to talk to her?

W: No. It is more exciting this way.

G: Do you go to the movies frequently?

W: Yes.

G: Several times a week?

W: I watch two TV sets at a time.

G: Colour or black-and-white?

W: Both.

G: Do you also listen to both simultaneously?

W: Sometimes I do. I also talk on the telephone at the same time.

G: Do you go to the theatre?

W: No.

G: Do you read a lot?

W: No.

G: Do you read newspapers?

W: I watch the news on television.

G: When you do read, what papers, what topics?

W: I read the gossip columns . . . like *Woman's Wear Daily* (the American fashion "Bible").

G: Are you interested in women's wear?

W: Yes.

G: In what way?

W: I am getting into fashions.

G: What will be your specific area: designing, manufacturing, distributing or what?

W: Reflecting.

G: An interviewer once asked what you liked best and then quoted you as having said "money." Is that true?

W: I said "money for everybody."

G: From what I can see, you are not too concerned about making money.

W: Just to pay the bills.

G: I am very impressed by your modesty. So many people who achieved fame or wealth tend to he a little stuffy. I wonder whether your modesty is based on a certain philosophy or outlook.

W: Yeah! I have some missing marbles!

G: What do you mean by that?

W: Some of my marbles are missing. That's my philosophy.

G: Can you elaborate a little bit on this?

W: Everybody knows about missing marbles.

G: Yes, but what does it mean in your particular case?

W: Well, it means that something is missing . . . the marbles.

G: I see. What you mean to say is that whatever makes people act stuffy and overplay their roles is somehow missing from your psychological make-up.

W: Yeah.

G: Although you were born in this country, you do not strike me as a typical American. Your personality strikes me more as Continental.

W: There are a lot of people like that here. This is such a great country because it is all mixed up. When you are away from America and then come back to New York, you are happy to see it again, even though it is so dirty. But that is its character, somehow.

G: Do you travel extensively?

W: Not much. But it is always nice to come back to dirty New York.

G: People are very rough on each other here. Even taking a taxi can be an experience.

W: Oh yes. I used to be afraid of taxi drivers when they screamed. But I think they expect you to scream back. They scream and then you scream and then they scream again. I think this is just the way people talk, they don't mean it. The trouble is that you read it in the papers that now when you talk back to some people, they really kill you! They just take a knife and stab you!

G: That brings me to an interesting question. Do people recognise you in the streets?

W: No. If I go to Bloomingdale's department store or some thing, somebody just says "Oh, there is Andy Warhol," and somebody else says "Oh, that's nothing, we see him here all the time; he is nobody."

You see people are only glamorous if you don't see them. Like the movies used to make people years ago. There is something about people on screen that makes them so special; when you see them in person, they are so different and the whole illusion is gone.

G: What is your favourite pastime?

W: I like watching *Pantomime Quiz*. Do you ever watch that?

G: No. Is that a TV show?

W: Yeah.

G: Is it your favourite?

W: No, it's not. *Love of Life,* a soap opera, is my favourite.

G: How long have you been watching it?

W: Oh, for the last 15 years.

G: Regularly, every day?

W: Uhu.

G: Are there any other things you like to do, like reading certain poets or listening to certain music?

W: No.

G: Once you said that never again would you paint another picture; is this still correct?

W: No, I do portraits.

G: Is this a commercial thing?

W: No, it actually helps us to pay for the movies.

G: Have you painted any famous people?

W: One of the Rothschilds.

G: Which branch of the family?

W: French.

G: Can you give me the first name?

W: Not at the moment.

G: Any other famous people?

W: Dennis Hopper. He made the movie *Easy Rider.*

G: How about photography?

W: I just use a Kodak Instamatic or a Polaroid camera.

G: Professionally or just as a hobby?

W: *Vogue* wants me to be their society editor.

G: And how did you react to this proposal?

W: I really want to do it!

G: But wouldn't you have to attend far more parties than you would care for?

W: No. I would just talk to the people on the telephone.

G: Do you enjoy talking to society people?

W: Anybody can be [word missing]

G: In other words [word missing] be not strictly what is called "society" but also the "beautiful people"?

W: High society and low society.

G: You once said that blue jeans are just as fashionable when shabby as when they are new. You also referred to the way everybody in China wears the same kind of clothes. You said you liked it. So it seems you are more interested in fashion than people realise.

W: Old blue jeans here cost more than the new ones.

G: Are they genuine old ones or artificially made to look old?

W: They are actually worn ones.

G: This is an interesting phenomenon. What brought this attitude about? After all, a few years ago it was new clothes that were elegant and worn clothes were certainly not desirable.

W: Well, it's just like when you are in a good restaurant where a lot of stars

eat, and when a star goes to the bathroom, you always wonder about using the john after some big star. I think it is the same thing with used blue jeans.

G: Do you go to fancy restaurants?

W: No. I just go where anybody invites me.

G: You don't go on your own?

W: Yeah.

G: Why is that?

W: I am afraid to go out.

G: Are you worried to walk about the streets?

W: Yeah.

G: What makes you uneasy? Are you afraid of the crowds, or of big places, or muggings, or what?

W: I think it's all of these.

G: If I may change the subject to those charming and very often beautiful young ladies who appear in your films. They are often referred to as super-stars. Did you invent that expression?

W: No.

G: But it certainly did come out of your films.

W: Maybe.

G: What do these women mean to you? How often do they influence your life, apart from the fact that they act in your films?

W: Well, they are not that beautiful!

G: Some of them are. And they have certain qualities most women don't possess.

W: No, they just "turn on" for the camera. They are not that way when the camera is not on. They are just like a TV set that can be turned on and off . . . I don't know . . . they don't listen to anything I say, anyway! They don't listen when we put on the camera.

G: So how do you direct the movie?

W: I don't! They do.

G: Back to your private life: do you take part in any sports? Tennis, golf, swimming?

W: No. But I vacuum!

G: Vacuum clean?

W: Yes, and I wash dishes! That's my sport!

G: But wouldn't you pass it up if you could?

W: Oh no, I really love it! I would really like to vacuum the Vatican! Do you think you could help me to get a chance to vacuum the Vatican?

G: Well, actually, my influence at the Vatican is rather limited. . . .

W: Or perhaps that great place near Munich that used to be the royal castle of the Bavarian King! Do they have carpets there? Well, it's probably not very dirty in Europe, anyway!

G: How often do you vacuum these days?

W: Well, I did it every day for a month at Finch College, but I don't do it anymore.

G: But you wash dishes every day?

W: Yes, that I do.

G: You live on 90th Street. How large is your apartment?

W: About six rooms.

G: What is your furnishing like? Is it interesting?

W: No, it's a dump!

G: Maybe what you call a dump, others wouldn't.

W: No, all the plumbing broke down and all the hot water pipes had to be replaced.

G: You mean there is no hot water?

W: There is now, but there wasn't for four months. The walls were broken open and they are still fixing them.

G: Is it a big building?

W: A small building, three storeys.

G: How can it be that Andy Warhol, a famous man, lives in such a building?

W: I am trying to move out.

G: Where to?

W: I wanted to buy a house on Long Island, but they didn't want me in the neighbourhood. They returned the deposit I made.

G: Why didn't they want you?

W: I don't know.

G: How do you feel about politics? Do you have any strong convictions?

W: Just like everybody else.

G: Can we have some particulars? Or would you rather stay aloof . . ?

W: Aloof.

G: Are you trying to incorporate ideas of philosophy, of politics and outlook into your art?

W: I guess so.

G: Would you tell me what this philosophy and outlook is?

W: No.

G: But I must assume that as an artist—and here I mean filmmaker as well as a graphic artist—you are using your skill for the betterment of the world, for the benefit of mankind. Am I correct?

W: I am trying to.

G: Could you tell me then something about the inter-relationship between your art and your philosophy? How are your ideals translated into art?

W: Giving people a few laughs.

G: What do you mean by that?

W: Nothing. Just entertainment.

G: There is another area I would like to discuss with you; namely your family life, love-life, romantic involvement. Your sex life, to put it bluntly.

W: I don't have any.

G: That's strange. Are you devoted so much to your art and movie-making that you have no time left?

W: That is right.

G: Do you hope to have time for it eventually?

W: No.

G: You don't hope and you don't expect?

W: No.

G: In 1968 an attempt was made on your life and you came rather close to

death. (One of Warhol's actresses walked into his studio and shot him. He was critically ill for weeks.) Such an experience always leaves a deep mark on people. What was the effect on you?

W: It was just as if I was watching another movie.

G: You suffered very serious injuries. You had to stay in hospital for three months. Did you recover completely from a physical point of view? Or do you still have some complaints?

W: I do.

G: Would I be tactless if I asked what is troubling you still?

W: A few pains.

G: Where do you have the pains?

W: All over.

G: Does it affect your work?

W: No.

G: Any plans for the near future, apart from the films and musical?

W: None.

G: Any comment on life in general?

W: No.

G: Any advice to young artists?

W: No.

G: Last question: you told me earlier that you lived with a "drag queen." Is that person Silva Thins?

W: Yeah, Silva Thins.

G: He was not in drag (female attire) he was wearing that zoot-suit. Does he look good in drag?

W: Oh yeah, you should see him.

G: I hope I will. Thank you for your time.

(Above) **STRANDED ON SUNSET:**
Andy Warhol with the Velvet Underground & Nico, during their short-lived stint at The Trip, Hollywood, 1966. From left to right: Nico, Andy, Maureen Tucker, Lou Reed, Sterling Morrison, John Cale. Credit: © by Gerard Malanga

(Right) **115 LB. WEAKLING:**
Andy Warhol as he appears in Piero Heliczer's underground film classic, *Joan of Arc*, 1966. Credit: © by Gerard Malanga

WITH LOVE FROM ANDY "PIE" AND GERRY "PIE"

(Above) **PORTRAIT OF THE ARTIST AS A YOUNG MAN:** Opening sequence to a film by Gerard Malanga, 1964-65. Credit: © by Gerard Malanga

(Below) **MATINEE IDOL:** Gerard Malanga. The Factory, East 47th Street, New York City, 1966. Credit: © 2004 by Gretchen Berg

(Above) **WITH LOVE FROM ANDY "PIE" AND GERRY "PIE,"** Photobooth Assemblage by Gerard Malanga, December 1963. Credit: © by Gerard Malanga

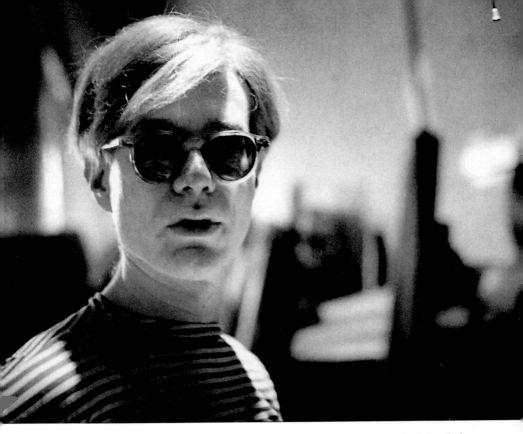

(*Above*) **A DAY IN THE LIFE:** Andy Warhol. The Factory, East 47th Street, New York City, 1966. Credit: © 2004 by Gretchen Berg

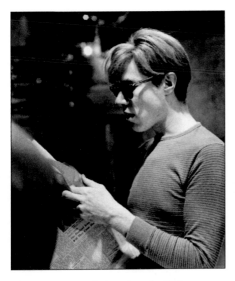

(*Above*) Andy Warhol reading the *Village Voice*. The Factory, East 47th Street, New York City, 1966. Credit: © 2004 by Gretchen Berg

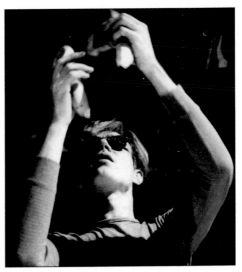

(*Above*) Andy Warhol hanging bananas for a film scene about to be shot. The Factory, East 47th Street, New York City, 1966. Credit: © 2004 by Gretchen Berg

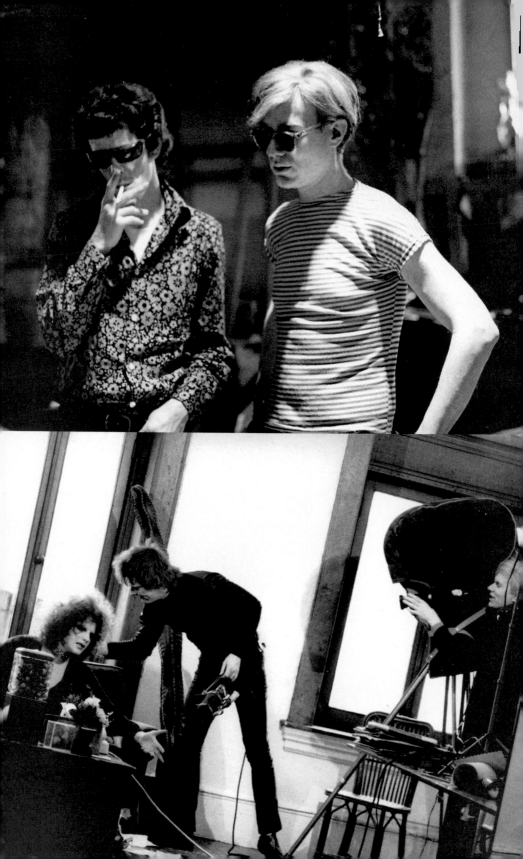

(Above) **IVY BOYS:** Andy Warhol and two unidentified friends. The Factory, East 47th Street, New York City, 1966. Credit: © 2004 by Gretchen Berg

(Above) **FIT TO PRINT:** Andy Warhol at the New York Film Festival during a trip to Stan Vanderbeek's studio, talking with Mrs. Vanderbeek, 1967. Credit: © 2004 by Gretchen Berg

(Above) **MAN WITH CAMERA:** Andy Warhol and Paul Morrissey during the filming of *Women in Revolt*, The Factory, 33 Union Square West, New York City, 1972. Credit: © 2004 by Gretchen Berg

(Above) **BLOW UP:** Andy Warhol, Paul Morrissey and Jane Forth (poster of Dallesandro in background). The Factory, 33 Union Square West, New York City, 1972. Credit: © 2004 by Gretchen Berg

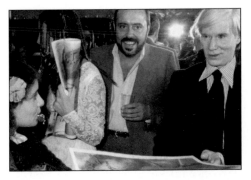

(Top of opposite page) **CREATIVE CAPITAL:** Andy Warhol and Lou Reed. The Factory, East 47th Street, New York City, 1966. Credit: © 2004 by Gretchen Berg

(Bottom of opposite page) **WOMEN IN REVOLT:** Andy Warhol mans the camera, while Paul Morrissey directs Jackie Curtis. The Factory, 33 Union Square West, New York City, 1972. Credit: © 2004 by Gretchen Berg

(Above) **ANOTHER OPENING:** Warhol and Elio Fiorucci, the Italian fashion guru, at the opening of Fiorucci's Rodeo Drive store in Beverly Hills. Andy is signing and giving away free copies of *Interview* magazine to fans. September 1978. Credit: © by Edo Bertoglio

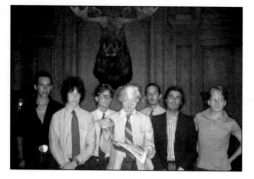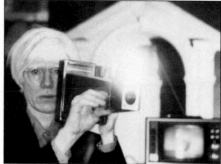

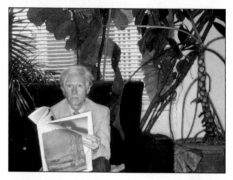

(Above) **THE FACTORY "BOYS."** From left to right: Richard Cramer, Jamie Frankfurt, Vincent Fremont, Andy Warhol, Fred Hughes, Bob Colacello, Chris Hemphill. Union Square Factory, July 1977. Credit: © by Edo Bertoglio

(Top right) **SAY CHEESE:** Andy poses with his Big Shot Polaroid camera, Union Square Factory, 1978. Credit: © by Edo Bertoglio

(Right, 2nd from top) **HOT OFF THE PRESS:** Andy examines the August '77 issue of *Interview* magazine, Union Square Factory, July 1977. Credit: © by Edo Bertoglio

(Right, 3rd from top) **GOOD TIMES:** Marisa Berenson swipes Andy's camera during a party in Venice, California. Credit: © by Edo Bertoglio

(Below) **I'LL BE YOUR MIRROR:** Andy and right-hand man Bob Colacello at Fiorucci's Rodeo Drive store opening in Beverly Hills, 1978. Credit: © by Edo Bertoglio

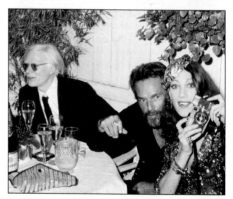

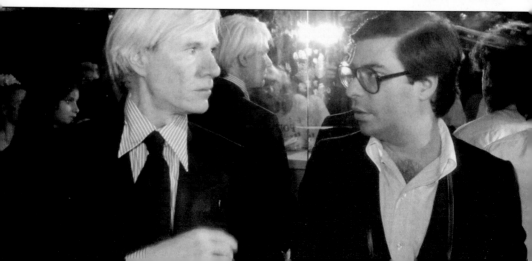

(*Above*) **I TOOK A PICTURE OF HIM, HE TOOK A PICTURE OF ME:** The resultant portrait from the Man Ray Interview. *Man Ray*, 1978. Silkscreen ink on synthetic polymer paint on canvas. Credit: © 2004 by Andy Warhol Foundation for the Visual Arts / ARS, New York

(*Above*) **CLASS OF '79:** The "in" crowd poses before a Delia Doherty fashion show in a Soho loft. Back row, sitting left to right: unidentified man (with hat and moustache), Tom Sullivan (moustache and floral shirt), unidentified man (hands in lap). Back row, standing, left to right: Linda Hutton (actress), Ned Smyth (artist), Jed Johnson (Factory), Andy Warhol, Robin Geddes (Factory), Grace Jones, Jean-Paul Goude (art director), Francis Scavullo (photographer), Sean Byrnes (Scavullo's assistant).Front Row, kneeling, left to right: photographers Robert Mapplethorpe, Marcus Leatherdale. 1979. Credit: © by Edo Bertoglio

(*Below*) **THE LIFE OF THE PARTY:** At a Studio 54 party for Christopher Makos (left corner) and Shelly Fremont (holding wine glass), 1979. Credit: © by Edo Bertoglio

(*Below*) **"A MEETING BETWEEN TWO GREAT ICONS OF GAY LIBERATION."** William S. Burroughs and Andy Warhol dine at 65 Irving Place for their Blueboy interview, February 1980. Credit: © by Victor Bockris, 2004

(Right) **HANGING ON THE TELEPHONE.** The Factory, 860 Broadway, New York City, August 11, 1981. Photographed by Barry Blinderman during the time of his interview about Andy's prints. Credit: Barry Blinderman

(Right, 2nd from top) **WE CAN BE HEROES:** Andy in front of his diamond-dusted portrait of Joseph Beuys.Factory, 860 Broadway, New York City, August 11, 1981. Credit: Barry Blinderman

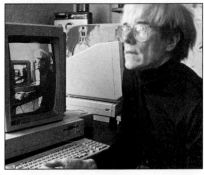

(Right, 3rd from top) **I THINK EVERYONE SHOULD BE A MACHINE:** Andy works on a self-portrait during the AmigaWorld, 32nd Street Factory, 1985. Credit: © 2004 by Edward Judice

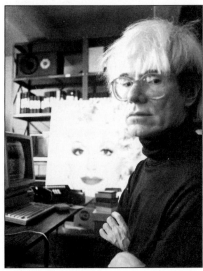

(Right, bottom) **COVER GIRL:** Andy takes a break from his digital study of Dolly Parton during the AmigaWorld interview, 32nd Street Factory, 1985. Credit: © 2004 byEdward Judice.

(Below) **HALL OF MIRRORS:** The finished self-portrait done on the early Commodore computer, assisted by Glenn Suokko. Self Portrait by Andy Warhol, digital proof, 1985. Collection Glenn Suokko. Credit: © 2004 by Andy Warhol Foundation for the Visual Arts / ARS, New York

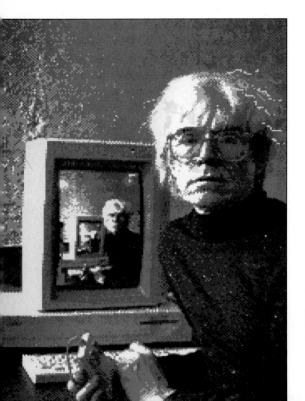

26 "Andy Warhol's Life, Loves, Art and Wavemaking"

BESS WINAKOR
1975
Chicago Sun-Times, Sunday, September 28, 1975

In September of 1975, Andy Warhol embarked on an eight-city cross-country tour to promote his new book THE Philosophy of Andy Warhol: From A to B and Back Again *(New York: Harcourt Brace & Company, 1975). Bob Colacello, who was part of Warhol's entourage, describes the mob scene at a typical book signing:*

> The majority were clean-cut and preppy, with a good number of smart suburban housewives, loaded down with Warhol posters and catalogues, knowing these items would be more valuable once signed by Andy. . . . They wanted him to sign their hands, their arms, their foreheads, their clothes, and their money. They brought cases of *real* Campbell's soup cans for him to autograph, old Velvet Underground records, paperback copies of *a,* early issues of *Interview,* Liz and Marilyn posters from the sixties. (*Holy Terror,* 310)

In each city, Andy gave at least a half-dozen interviews to local journalists. Below is a typical interview given to a Chicago Sun-Times *staff writer. According to Bob Colacello, "Andy considered these interviews torture, especially when he was asked the question he hated most, 'Are you rich?' As 'business art' was one of the prime credos of his* Philosophy, *variations of that question came up in almost every city. Andy always answered 'No,' or pointed to the paint spots on his shoes and made a funny face" (Holy Terror, 310).*

—KG

[. . .] The other day Warhol, who is 47 and has been painting for 25 years was in town promoting his new book *THE Philosophy of Andy Warhol (From A to B and Back Again)*. He autographed books in store windows, signed real Campbell soup cans and Brillo boxes and praised the city's esthetics and Mayor Daley.

He is thin but not frail-looking in his blue jeans. His hair, white-blond in front is almost black at the nape of his neck. He appears to be interested in everything, especially work. A talk with Andy Warhol sounds like something out of his *Interview* magazine, with a few more ambiguities.

Q. Are you really Andy Warhol or are you a figment of my imagination?

A. I guess I am.

Q. You make yourself to be something of a vacuum in your book. Is that an honest appraisal or is it a gimmick or put-on to sell the book?

A. No. I guess I've always been that way. When I was shot it made me feel that way more.

Q. What does life mean to you?

A. I don't know. I wish I knew.

Q. Did getting shot change you in any way?

A. Yeah. I don't see imaginative people any more.

Q. Doesn't that eliminate a lot of people?

A. Yeah, a lot of freaks.

Q. What do you think of the women's liberation movement?

A. I think it's great.

Q. Why?

A. I think men and women are the same.

Q. In what way?

A. They do the same things.

Q. If you could do anything, what would it be?

A. Nothing special. (*He laughs a sniffing, almost inaudible laugh.*) There's nothing I really want to do. Just keep our outfits running, and turn our magazine into a glossy.

Q. Do you consider yourself the bellwether of America, as one critic recently called you?

A. No. That was the first time I heard that word. What does it mean?

Q.I think of it as a sign of what's happening.

A. Oh, no. I think I'm always ten years behind.

Q. Did you ever imagine when you painted your first soup can, that it would become art?

A. No. It's like anything. You just work. If it happens, it happens. If it doesn't, it doesn't.

Q. Does your success surprise you, or did you expect it?

A. Oh, no, it surprised me.

Q. How does it feel for wave-making Andy Warhol to also be part of the establishment? Your *Mao* is at the Art Institute in Chicago.

A. You mean, the term "underground" and all that stuff? Somebody just said that. I always worked. You know, it's a business. Gee, we missed seeing the Picasso sculpture. Have you seen that? Chicago is so rich. How did they get so rich? It's more rich than any other city I've been to. It's just unbelievable, the buildings are so beautiful. They look so great, I guess maybe because there are just a few around or something.

Q. Have you ever been here before?

A. No, just at the airport about 10 times.

Q. Do you do a portrait of anyone who asks you to or do you prefer celebrities?

A. Usually anyone who asks.

Q. How long does it take?

A. A month or so.

Q. You must be a millionaire by now. How do you spend your money?

A. Just keeping our office going. The magazine doesn't make any money.

Q. Do you have any luxuries?

A. Two dachshunds. Archie Bunker and Amos.

Q. How do you live? How big is your home?

A. About eight rooms, six rooms. Very small. Six or seven rooms.

Q. How are they decorated?

A. Just with junk. Paper and boxes. Things I bring home and leave around and never pick up. Old interviews, magazines.

Q. Do you live alone or live with somebody?

A. I live alone.

Q. Is your furniture modern or is it old?

A. I like old American furniture. It's sort of big and ugly furniture, from 1830.

Q. How much of your own art do you have on hand?

A. None. Just some rejected portraits.

Q. Who rejected them?

A. Oh, I don't know. People who just haven't picked them up, or people that didn't like the way they looked, or something.

Q. Who didn't like the way they looked?

A. Nobody that's really well-known. I'm surprised that people don't reject them because I never paint the colors their eyes are and stuff. I just make them up. Maybe that's why they reject some of them.

Q. Who is your favorite celebrity?

A. Jack Ford.

Q. Why?

A. He was just very nice to us. He invited us to the White House.

Q. Whom do you admire?

A. Mostly everybody.

Q. How did you get into making movies?

A. It sounds dumb, but I was taking a trip cross-country in 1964, having exhibitions in California. So I brought a 16-millimeter camera and we took one of the underground stars, Taylor Mead. We shot cross-country. In California, we were staying at John Houseman's place. And they thought it was funny. We thought it was funny.

Q. Why, after your asexual paintings or commercial objects, did you go into films that some people say are pornographic?

A. They weren't actually pornographic. They're comedies. Sex wasn't the most important thing in the movies. People made up their own lines. My favorite is *Chelsea Girls*, I guess, because there were two things happening at the same time, two stories going on in different rooms of the hotel.

Q. Did you try to make boredom chic with some of your early movies like *Empire?*

A. No. What I was trying to do is make comedy in the audience. People always have a better time, have more fun together than watching what is on the screen.

Q. What is your next movie?

A. It's called *Bad*. Carroll Baker is interested. We've been working on it for a whole year. We were supposed to start shooting in August with Peggy Cass. We still like her. There are two roles in it for Peggy and Carroll.

Q. What's the plot?

A. It's just a normal family in Brooklyn. (*Sniffling laughter.*)

Q. Oh, what's normal?

A. That's the plot.

Q. By whose definition?

A. Pat Hackett, one of the girls who has worked in our office for about six or seven years, wrote the script.

Q. Do you consider the people and the plots in your movies normal?

A. Oh, no! The last two movies—*Dracula* and *Frankenstein*—were horror movies. This is a horror movie, too, I guess.

Q. Did you do the films with sex and drugs and so on to shock people?

A. No, they were what the kids were doing in New York, I guess.

Q. What do you mean by "the kids"?

A. Oh, you know, the actors we used.

Q. Do you find sex boring—and why or why not?

A. I think it's too much work.

Q. What are your sexual inclinations these days? Do you prefer men or women?

A. I don't think about it.

Q. What is love?

A. I don't really believe in love. I sort of believe in liking.

Q. And what is that?

A. Just thinking about things.

Q. Were you ever in love—with anything or anybody?

A. No.

Q. Do you like yourself?

A. I don't have time to think about it.

Q. Now that's contradictory. You say liking is thinking about things.

A. Yeah, I like myself. I'm just too busy all the time, just working. I like work and work is what I do—a lot.

Q. You say sex is too much work?

A. It is for me. I guess the people who work at sex like it. They do it well.

Q. What do you do best?

A. I guess I paint best. I've done it longer than the other things, like making movies.

Q. What are you doing this tour?

A. It was a chance to get out to California. I think California is great. It's just great the way people live.

Q. So why don't you move? Why do you stay in New York?

A. I was going to, and then they had the earthquake and I sort of changed my mind. (*Sniffling laughter.*)

Q. Do you like conceptual art?

A. Yeah, I do. You know, they're digging holes in the ground or something like that. You have to see it from an airplane.

Q. Do you like to be interviewed?

A. No.

Q. Why?

A. I just think people should be doing two things at one time, you know. They either should be watching television and getting interviewed, or eating. Like on talk shows, I think the people who do news should also be having breakfast or getting their nails done or something.

Q. Why?

A. Just doing two things at one time, you can get two things done.

27 "Factory Diary: Letter to Man Ray"

1976
Color, sound, ½" reel-to-reel videotape
The Andy Warhol Archives, Pittsburgh

The legendary artist Man Ray figured prominently throughout Warhol's career. In the elegant art deco sitting room of his Upper East Side town house, Man Ray's painting, Peinture Feminine, *occupied a prominent place between a Cy Twombly abstraction and an early Roy Lichtenstein. In 1981, photographer Christopher Makos photographed Andy Warhol in drag, which directly referenced Man Ray's portrait of Macel Duchamp in drag posing as Rrose Sélavy, done in the early 1920s. And Warhol's massive 1978 painting series entitled* Shadows *took its cues from Ray's* Interrogation of Shadows *(1919).*

On November 30, 1973, Andy Warhol shot a series of Polaroids of Man Ray in his Paris apartment as preliminary studies for a painted portrait. In the piece below, Andy recounts the day's events in minute detail. Present in the apartment were Man Ray and his wife; Warhol and his associate Fred Hughes; and the Italian art dealer Luciano Anselmino and his assistant Dino.

On an audiotape made of the session, we hear Andy request that Man Ray keep his hands away from his face, put his cigar in his mouth, and remove his glasses for the portrait. With opera playing softly in the background, Man Ray asks technical questions about the camera while the Polaroid whizzes and clicks. As the session winds up, Fred Hughes asks Man Ray to sign his name on a piece of paper, in case Warhol decides to silkscreen it onto the finished painting (in the final portrait the signature was not included).

Warhol was introduced to Man Ray by Anselmino, a Turin-based art dealer who also represented Ray. He had commissioned Warhol to do an edition of one hundred prints of the Man Ray portrait. When Andy went to Italy to sign the prints, Anselmino wanted to commission a larger body of work, which led to Warhol's notorious series of black and Hispanic men in drag, Ladies and Gentlemen *(1975).*

This piece was transcribed by the present editor with Greg Pierce and Geralyn Huxley from the Andy Warhol Museum. It is printed here in full for the first time.

—KG

WARHOL: "What am I to talk about? Talk about what? Nobody told me what to talk about."

[pause]

"Oh, um . . . You mean writing a letter to Man Ray?"

"Oh."

"Uh . . . Man Ray was this wonderful person that uh . . . that uh . . . Luciano . . . Luciano Anselmino introduced me to. And he was uh . . . really cute. And uh . . . the only thing I can really remember is . . . is a toilet. Because on his toilet he had uh . . . this stocking and uh . . . it was just so great because it was . . . it was the only toilet I ever knew that had a covering on it. And uh . . . the . . . his place was so cold but he was so rich and uh . . . and it looked like a little tenement but it was next door to the richest house in Paris.

"And he was really cute. He took a picture of me and I took a picture of him and then he took another picture of me and I took another picture of him and he took another picture of me and I took another picture of him and he took another picture of me and I took another picture of him and he took another picture of me and then I took the one of him and then I took one of Dino and then Dino took one of me and then I took one of Dino again and then Dino took another one of me and Man Ray. And then Man Ray took one of me and Dino. And then Dino took another one of Man Ray and me. And then I took one of Luchia . . . Luciano. And then Luciano took one of me and Man Ray. And then Man Ray took one uh . . . of me and Dino and Luciano. And I think his wife got in this time. And then . . . then he took a picture of Fred Hughes. And then he took a picture of me again. And I took another Polaroid of him. And then we had the Super X . . . the camera 70 . . . Super 70–X uh. . . . And then I took one of

um . . . uh . . . And then I took another picture of Man Ray and then I took another one of Man Ray and then I took another one of Man Ray. Then I took another with my uh . . . uh . . . with my funny camera. What's it called? The funny camera? It's called the uh . . . the portrait camera. And so I took another one of Man Ray and I took another one of Man Ray and I took another one of Man Ray. And then I think he signed one . . . one of them. And then I took another one of Man Ray. I took another picture of Man Ray, another Polaroid portrait of Man Ray and another Polaroid portrait of Man Ray, another Polaroid portrait of Man Ray and then another Polaroid portrait of Man Ray and then I took another Polaroid portrait of Man Ray and then I took another Polaroid portrait of Man Ray. And then I took another portrait. And then I think he took another portrait of me and then he signed that one for me and I put it in my sss . . . in my Brownie shopping bag. And then I had to go back and look at the toilet seat again because it was the best thing in the apartment. And uh . . . if Luciano really loved me he would get me the toilet seat.

"We're now pausing for identification."

[pause]

"Okay. Here we go again. It's. . . . And then I remembered. I uh . . . dropped my camera and then I had to pick it up again and then I thought, well, gee, you know, Man Ray, I mean I only loved him because of his name, to be very truthful. That was the only . . . I thought his name was the best thing about him. Until I met him. And uh. . . . He had the best name. Well, I was . . . I . . . I just thought and I'd met him once uh . . . I think he wrote a book. And he . . . he . . . he uh . . . he said he was from Philadelphia and he made up his name and then I really was so disappointed because I found out his name was uh . . . Schwartz and uh . . . and uh. . . . now they tell me his name is Rabinovitz. And uh. . . . And so then I took another picture of him. And I took another picture of him. And I think I took another picture of him. I took another one and another one and another one. Then I had to change my roll of cam . . . film because that was eight in . . . eight in a roll so then I put it in, pulled out the black thing and then I took another picture of him and another picture and

another picture and then I put a light bulb in and another picture and another picture and another picture and another picture and another picture and another picture and then I put. . . . That was eight pictures. And then I had to change my camera again and I took a SX-70 and then I put a whole roll in and I got ten . . . ten pictures out of that and then he put a cigar in his mouth, because Luciano handed him a cigar and he liked to smoke cigars. I think they were friends because Luciano brought him the best cigars and uh . . . in town. And actually the cigar was bigger than he was because he'd . . . he'd gotten very . . . very bent over. And . . . or maybe very uh. . . . He looked like he was always far out but uh . . . I think it was just because he was bent over. And then I gave him uh . . . I put another . . . I took ten of the uh . . . SX-70s and then I took uh . . . changed it to the portrait camera and uh . . . I had him smoke the cigar and then I took four more pictures and put some more light bulbs in and then I took . . . I took four more pictures and uh . . . put some more light bulbs in and then I put in some more. And then Dino was taking some more pictures and uh. . . . That was really fun. And uh . . . and Man Ray had the most beautiful uh . . . wife. God. And uh . . . he was so adorable. And uh. . . ."

"And uh. . . . We uh. . . ."

28 "Interview: Andy Warhol"

GLENN O'BRIEN
June, 1977
High Times, August 24, 1977

This interview was conducted at the third "Factory" at 860 Broadway, probably in early June 1977. I was the editor in chief of Andy Warhol's *Interview* from 1970 to the end of 1973, when I left to go to work for *Rolling Stone*. After a strange and brief tenure there I spent a year in Chicago working for *Playboy*. I returned to New York in 1976 and renewed my friendships at the Factory. I was working as articles editor at *High Times* at this time and I proposed a cover story on Andy. He was happy to accept.

The interview took place over about 90 minutes—the time of one tape. I had thoughts about some of the things I wanted to ask, like if he was the richest artist, but mostly the interview was improvised. Andy was on that day and there was no need to go any further. I don't like the *Playboy* Interview approach of spending days on an interview and piecing a text together from hours of tape; ours was a normal, real time conversation. I guess it's Aristotelian, real time and naturalistic.

We talked in the panelled "Board Room" while staffers came and went, including Fred Hughes, Catherine Guinness, Bob Colacello and Ronnie Cutrone. We were interrupted now and then by the normal course of Factory business and paused the tape, but Andy didn't take any phone calls. He would just answer questions from the crew as they stuck their heads in. That was a more normal way of doing it for him, rather than quietly concentrating, one on one, which would have made him nervous. When he couldn't think of an answer he might ask one of his employees the question, but that's part of Andy's sense of humor.

I cut out a few things for length, but the interview was done in the accurate, warts-and-all style that we developed at *Interview*. We didn't try to turn

things into "good writing" but wanted to keep the flavor of a real conversation and the genuine voices of the participants.

Andy was very happy with the interview. I think he liked the questions, but most importantly, he thought he sounded smart and funny. Shortly afterward he asked me to come back to *Interview* and write a music column. I did and began writing the *Glenn O'Brien's Beat* column which ran for 12 years.

—Glenn O'Brien

O'BRIEN: What was your first work of art?

WARHOL: I used to cut out paper dolls.

O'BRIEN: How old were you?

WARHOL: Seven.

O'BRIEN: Did you get good grades in art in school?

WARHOL: Yeah, I did. The teachers liked me. In grade school they make you copy pictures from books. I think the first one was Robert Louis Stevenson.

O'BRIEN: His was your first portrait?

WARHOL: Maybe.

O'BRIEN: Were you in an art club?

WARHOL: No. But if you showed any talent or anything in grade school, they used to give us these things: "If you can draw this," where you'd copy the picture and send it away. . . .

O'BRIEN: Famous Artist's School?

WARHOL: Uh, yeah.

O'BRIEN: Did you send them away?

WARHOL: No, the teachers used to.

O'BRIEN: Did they say you had natural talent?

WARHOL: Something like that. Unnatural talent.

HIGH TIMES: Were you arty in high school?

WARHOL: I was always sick, so I was always going to summer school and trying to catch up. I had one art class.

O'BRIEN: What did you do for fun when you were a teenager?

WARHOL: I didn't do anything for fun, oh, I think maybe once I went down to see a Frank Sinatra personal appearance with Tommy Dorsey. You had to take a streetcar to get there.

O'BRIEN: Did you work after school?

WARHOL: Yeah, I sold fruit.

O'BRIEN: At a fruit stand?

WARHOL: No, on a fruit truck.

O'BRIEN: So, how did you decide to become an artist and move to New York?

WARHOL: I went to Carnegie Tech. Phillip Pearlstein was going to New York during a semester break, so I took a shopping bag and we took a bus. We took our portfolios and showed them around New York to see if we could get jobs. The lady from *Glamour*, Tina Fredericks, said that when I got out of school she'd give me a job. So I got out and came back. That was my first job.

O'BRIEN: A free-lance job?

WARHOL: Yes. She gave me a shoe to do.

O'BRIEN: What was your ambition in those days? To be an illustrator or to be a fine artist?

WARHOL: I didn't have any ambition.

O'BRIEN: What was your first work that really pleased you as an artist?

WARHOL: I don't remember. I did get some prizes in school. It wasn't my best work. One time after summer vacation I did some fruit truck pictures. I won five dollars.

O'BRIEN: Who was the first artist to influence you?

WARHOL: It must have been Walt Disney. I cut out Walt Disney dolls. It was actually Snow White that influenced me.

O'BRIEN: Did you go to the movies a lot?

WARHOL: Yeah, on Saturday morning. If I took the neighbor's baby I got to go to the movies free.

O'BRIEN: When you went to art school at Carnegie Tech, what artists influenced you?

WARHOL: Carol Blanchard, she used to do ladies falling out of bed. She did Lord and Taylor ads, and she was in the Carnegie International Show.

O'BRIEN: Were you up on your art history?

WARHOL: Oh, yeah. We had a wonderful teacher named Balcolm Green. He gave slide lectures.

O'BRIEN: Who were your favorite movie stars in those days?

WARHOL: Ray McDonald[1] and his sidekick. What's her name?

O'BRIEN: Who is Ray McDonald?

WARHOL: A dancer. And he had a wonderful girl partner. And Abbott and Costello, the Andrews Sisters, Lucille Ball, Edward G. Robinson, Paulette Goddard, Alexis Smith, Linda Darnell, Ann Sothern, Zachary Scott, Vida Ann Borg and Roy Rogers. Every one of them.

1 Ray McDonald (1921–1959) and his wife Peggy Ryan (b. 1924) appeared together in *Shamrock Hill* (1949), *There's a Girl in My Heart* (1949) and *All Ashore* (1953). They toured stages and nightclubs; Ray popped up on TV variety shows as well.

O'BRIEN: Is there anyone you wanted to be like when you grew up?

WARHOL: Uh, who was Charlie McCarthy's father? Edgar Bergen.

O'BRIEN: Were you interested in any politics?

WARHOL: I listened to the speeches on the radio—Truman's.

O'BRIEN: Were you impressed by him?

WARHOL: No.

O'BRIEN: What were your favorite radio shows?

WARHOL: "Let's Pretend" and "Jack Armstrong, All American Boy"; all the good ones. "Little Orphan Annie."

O'BRIEN: Did you like comic strips?

WARHOL: Yeah, "The Katzenjammer Kidz."

O'BRIEN: Did you ever do cartoons?

WARHOL: No. I could never think of a good person to draw.

O'BRIEN: Do you think there are any great undiscovered artists?

WARHOL: Uh, yeah, there are. But it's more important to make money now.

O'BRIEN: What advice would you give to a young person who wanted to become an artist today?

WARHOL: I'd just tell them not to be one. They should get into photography or television or something like that.

O'BRIEN: Do you think the art world is dead?

WARHOL: Oh, yeah. Being a wallpainter or a housepainter is better. You make more money as a housepainter. Ten dollars an hour.

O'BRIEN: Who do you think is the world's greatest living artist?

WARHOL: I still think Walt Disney is.

O'BRIEN: He's dead.

WARHOL: I know, but they still have him in plastic, don't they?

O'BRIEN: He's frozen.

WARHOL: But I really like them all. Rauschenberg and Twombly and Paul Klee. Dead ones too? And I like American primitive painters. I just like everyone, every group. Grant Wood, Ray Johnson.

O'BRIEN: Who is the richest artist in the world?

WARHOL: I'll bet there are a lot of artists that nobody hears about who just make more money than anybody. The people that do all the sculptures and paintings for big building construction. We never hear about them, but they make more money than anybody.

O'BRIEN: What about Dalí?

WARHOL: I don't think getting your name around means that you make a lot of money.

O'BRIEN: Do you think you or Dalí is more famous?

WARHOL: There's Calder too. Miro is still alive.

O'BRIEN: Have you made a million on art?

WARHOL: It depends on the expenses.

O'BRIEN: Has your work gone up in price a lot compared to what you made on it originally?

WARHOL: No, I try to keep it down. I turn out so much. But I stopped for a while.

O'BRIEN: To raise the prices?

WARHOL: No, I just can't think of anything to do. I get so tired of painting. I've been trying to give it up all the time, if we could just make a

living out of movies or the newspaper business or something. It's so boring, painting the same picture over and over.

O'BRIEN: Where do you get your ideas for paintings these days?

WARHOL: I do mostly portraits. So it's just people's faces, not really any ideas.

O'BRIEN: But lately you've done flowers and skulls.

WARHOL: We've been in Italy so much, and everybody's always asking me if I'm a Communist because I've done Mao. So now I'm doing hammers and sickles for Communism, and skulls for Fascism.

O'BRIEN: Did Mao ever see your portrait of him?

WARHOL: I don't know. One of the big ones was shown in Washington at the Corcoran Gallery, and the director there told us that a delegation of Chinese was taking a tour of the place. They found out there was a big Mao hanging there, so they went in through the back of the museum so they wouldn't see Mao. I guess they were worried about liking it or not liking it. It's all so different for them. We invited the Chinese ambassador to the Factory, but he never came.

O'BRIEN: Who do you think is the best business artist in the world?

WARHOL: Cristo. He just finished this $2 million project for a foundation. But I'm sure the government's going to find something wrong with the foundation. It seems so easy. That's more like a business. It's like producing something, a big $2–million project. Someone will come along and do a movie like that, a $4–million art movie nobody has to really like.

O'BRIEN: But Cristo makes money.

WARHOL: No, he works on a foundation thing. You don't get paid, you just take out expenses and things.

O'BRIEN: Do you think that's what's going to happen to art? It's going to be all foundations and subsidies?

WARHOL: Yeah, that sounds like a nice new way. It's the easiest thing. There are a lot of people working on it; and it's up for only two weeks.

O'BRIEN: Do, you think Picasso was a business artist?

WARHOL: Yeah, I guess so. He knew what he was doing.

O'BRIEN: But who do you think invented the idea?

WARHOL: I think Americans after the war. It was the galleries. Somewhere along the line, someone did it with Picasso, where it started to be more of a product.

O'BRIEN: Do you think Picasso was conscious of his prices and his marketing?

WARHOL: Oh, yeah.

O'BRIEN: Do you think artists of the future will form companies or go public and sell stock?

WARHOL: No, but I'm opening a restaurant called the Andymat. We're going to sell turkeys. But I can't use that word any more.

O'BRIEN: Why?

WARHOL: Well, I like them. But whenever I call something that, people think I'm putting it down.

O'BRIEN: Do you think that there are any art movements now?

WARHOL: No.

O'BRIEN: Do you think there will ever be any more art movements?

WARHOL: Oh, yeah. I always thought they were going to come from California. But I just came back from Macon, Georgia, and I was surprised. They have so many performers down there. It's such a wonderful town. You can see why they have so many famous performers.

O'BRIEN: Do you think social realism is business art?

WARHOL: What kind is that?

O'BRIEN: You know, Diego Rivera, post-office murals, WPA art.

WARHOL: Yeah, they should really do more with it. It's amazing that they don't do enough with it. You never see anybody painting up offices. You know who has a wonderful dining room? Bill Copley got all those kids who graffiti the subway, and he hired four of them to do his dining room. It's really wonderful.

O'BRIEN: Do you think those kids should get grants to decorate subways?

WARHOL: Yeah. But when you go to Tehran the graffiti is so beautiful. It's not so beautiful here. Their writing is much more beautiful than ours. All the writing is great, even the signs.

O'BRIEN: You once said that your work was decorative. Do you still think that?

WARHOL: Oh, yeah. But Emile de Antonio thinks it's Marxist. It's really funny.

O'BRIEN: Did you ever read Marx?

WARHOL: Marx who? The only Marx I knew was the toy company.

O'BRIEN: Do you ever think about politics?

WARHOL: No.

O'BRIEN: Did you ever vote?

WARHOL: I went to vote once, but I got too scared. I couldn't decide who to vote for.

O'BRIEN: Are you a Republican or a Democrat?

WARHOL: Neither.

O'BRIEN: You only do things for the Democrats. You did a Nixon print for the McGovern campaign. You did the Carter cover on the *New York Times* magazine.

WARHOL: I did Rockefeller's portrait.

O'BRIEN: You gave prints to Bella Abzug?

WARHOL: I just do anything anybody asks me to do.

O'BRIEN: What's your favorite painting of all your work?

WARHOL: I guess the soup can.

O'BRIEN: What's your favorite color?

WARHOL: Black.

O'BRIEN: What do you think of danger-oriented conceptual artists like Vito Acconci and Chris Burden?

WARHOL: I think Chris Burden is terrific. I really do. I went to the gallery, and he was up in the ceiling, so I didn't meet him, but I saw him.

O'BRIEN: Where did you get the idea of using photo silkscreens?

WARHOL: I started when I was printing money. I had to draw it, and it came out looking too much like a drawing, so I thought wouldn't it be a great idea to have it printed. Somebody said you could just put it on silkscreens. So when I went down to the silkscreener I just found out that you could reproduce photographs. The man that made the screens was a really nice guy named Mr. Golden. I think the first photograph I did was a ballplayer. It was a way of showing action or something.

O'BRIEN: So once you found that process, where did you get your ideas for images?

WARHOL: Oh, just reading the magazines and picking up the ideas from there.

O'BRIEN: Did you really do the Campbell's soup cans because you had it for lunch every day?

WARHOL: Oh yeah, I had Campbell's soup every day for lunch for about 20 years. And a sandwich.

O'BRIEN: How did you get the idea to make Brillo boxes?

WARHOL: I did all the cans in a row on a canvas, and then I got a box made to do them on a box, and then it looked funny because it didn't look real. I have one of the boxes here. I did the cans on the box, but it came out looking funny. I had the boxes already made up. They were brown and looked just like boxes, so I thought it would be so great to just do an ordinary box.

O'BRIEN: Did you ever hear from Campbell's or Brillo or any of the manufacturers whose products you painted?

WARHOL: Brillo liked it, but Campbell's Soup, they were really upset and they were going to do something about it, and then it went by so quickly and I guess there really wasn't anything they could do. But actually when I lived in Pittsburgh, the Heinz factory was there, and I used to go visit the Heinz factory a lot. They used to give pickle pins. I should have done Heinz soup. I did the Heinz Ketchup box instead.

O'BRIEN: What was your first big break?

WARHOL: My first big break was when John Giorno pushed me down the stairs. No, actually my first big break was meeting Emile de Antonio who now lives across the street. He laughed a lot and that encouraged me.

O'BRIEN: In your book you say "Some people have deep-rooted and long-standing art fantasies and really stick with them." Do you think that goes for you?

WARHOL: I really don't have any fantasies at all. But art fantasies, that sounds really terrific. Do you spell that with a *ph*?

O'BRIEN: You used an *f*. How did the Factory get the name *Factory*?

WARHOL: Billy Name named it. It was in an office building. I guess it was really a factory. There was a lot of machinery there and a heavy floor. They must have made shoes there or something.

O'BRIEN: Who were the first people that worked for you?

WARHOL: Gerard Malanga was the first one. He was writing poetry in between helping me do things. Actually it was Billy Name that brought people to the studio. He began putting silver all over, and he needed some people to help him.

O'BRIEN: Was he working for you?

WARHOL: No, he wasn't actually working for me. He wanted a place to stay, and he stayed there. That was the start of it.

O'BRIEN: How did you start making films?

WARHOL: We had gotten a video machine, and I'd gotten a sound camera, and we were just making movies through the Cinémathèque. Actually, I bought the first camera because Wynn Chamberlain was taking Taylor Mead and me to California, and since Taylor Mead was such a great screen star, we thought it would be a great idea to do Taylor going across country. So I bought this 16mm camera, and we just shot Taylor in California. That was the first movie. It was called *Tarzan and Jane Regained Sort Of*.

Then they had sort of newsreels at the Cinémathèque and every time you'd do a three-minute newsreel they'd show it at the Cinémathèque. Everybody began showing their three-minute movies. We started with the person of the week or something. Then I sort of got an idea to do John Giorno sleeping, because he could fall asleep and never know that you were around. So I just turned on the camera and photographed that, and somebody really liked it. That was *Sleep*. They showed it to Jonas Mekas, director of the Cinémathèque, and he really liked it, and from that we went into Robert Indiana eating and other things. The Empire State Building.

O'BRIEN: How did you introduce actors and plots?

WARHOL: Through Gerard we met Ronny Tavel, and he wrote scripts. They were really good scripts, but nobody would follow them. But we'd get the gist of the thing. Then we did 30–minute reels.

O'BRIEN: Did you direct them?

WARHOL: At that time anybody who turned on the camera was the director.

O'BRIEN: Who invented the word *superstar*?

WARHOL: I think it was Jack Smith.

O'BRIEN: And who were the first superstars?

WARHOL: They were all Jack Smith's stars; every one of them was really a great person. The first ones we used were Taylor Mead, Edie Sedgwick, Brigid Berlin, Alan Midgette.

O'BRIEN: Did you meet them through Gerard?

WARHOL: No, Lester Persky, who's the big producer now. Lester had a good eye. He was doing the eight-hour commercial. Really, he used to do these one-hour ads for Charles Antell. He did Melmac and some others. I guess that was where I got the idea for doing things long.

O'BRIEN: How did you meet Lou Reed?

WARHOL: He was playing at the Cafe Bizarre, and Barbara Rubin, a friend of Jonas Mekas, said she knew this group. Claes Oldenburg and Patti Oldenburg and Lucas Samaras and Jasper Johns and I were starting a rock and roll group with people like La Monte Young and the artist who digs holes in the desert now, Walter De Maria.

O'BRIEN: You started a rock band?

WARHOL: Oh yeah. We met ten times; and there were fights between Lucas and Patti over the music or something.

O'BRIEN: What did you do?

WARHOL: I was singing badly. Then Barbara said something about this group and mixed media was getting to be the big thing at the Cinémathèque,

so we had films, and Gerard did some dancing and the Velvets played. And then Nico came around, and Paul started the Exploding Plastic Inevitable.

O'BRIEN: Was that a light show before the San Francisco light shows?

WARHOL: Yeah, it was, sort of. Actually, the Cinémathèque was really combining all the arts together. Then Olivier Cocquelin was going to start a discotheque for Edie Sedgwick and me called "Up." And somehow he forgot about us, and Murray the K was doing something out on Long Island, and somehow they didn't hire us. So Paul decided to open up a place a week before they opened up. We just rented the DOM and opened before the other places. We rented it by the week, and when it was doing so well, other people just took it away from us.

O'BRIEN: When did you get the idea that you might be able to make really commercial movies?

WARHOL: We never did. We were making a movie a week, and Paul found this theater in the Forties. We made a movie, and it played for three or four weeks. When they got tired of it, we just made another one. We did about six, and they did really well. They paid for themselves. Then they played outside New York in art theaters.

O'BRIEN: Did you go on college tours yourself before you sent Alan Midgette to impersonate you?

WARHOL: Oh, yeah, I went on a couple. I wasn't getting any work done, and every time I did go, I didn't do any of the things the kids had read I would do. So we thought we'd send somebody who was more what they really wanted. He was more entertaining and better looking and he could keep up and go to 18 different parties afterward. The people were happy with him.

O'BRIEN: How did Paul Morrissey start directing your films?

WARHOL: Well, it was always whoever worked the camera. Then I guess I was in the hospital, and he worked the camera so—that's how it happened.

O'BRIEN: Did you ever get any Hollywood offers before a commercial hit?

WARHOL: We went out to Hollywood a lot of times, and everything always fell through. Most of the studios took us out, and nothing ever happened. It still doesn't happen.

O'BRIEN: Do you think Hollywood is afraid of you?

WARHOL: No, it's just that I was too wishy-washy. If you have a project and you know exactly what you want to do you can get them to do it. It's all learning.

O'BRIEN: Would you like to make really expensive movies or do you want to keep it simple?

WARHOL: No, I think it would be great to make a $2– or $3–million art movie where nobody would really have to go to it. I thought that would be a good project to work on . . . do something really artistic. I think video is the best market. When the cassette market comes out, if you just do movies that nobody else can do, that'll be the new way.

O'BRIEN: Would you ever put out your old films on cassettes?

WARHOL: No. I'd rather do new stuff. The old stuff is better to talk about than to see. It always sounds better than it really is. New things are always much better than old things.

O'BRIEN: How did you get the idea to start your magazine *Interview*?

WARHOL: It was just to give Gerard something to do. He was supposed to work on it. Also, Brigid Berlin's father ran the Hearst Corporation, and we thought Brigid could really run the magazine. But she didn't get interested in it.

O'BRIEN: Did you ever think it would be successful?

WARHOL: It still isn't successful. It would just be great if it could pay for itself. I always thought it should be for new people, but I guess there aren't

enough new people to buy it. You go to these rock concerts, and they can fill up a place with 30,000 people. It's funny. They aren't the same people who look at magazines.

O'BRIEN: You've done art, movies, records, books, TV, a play, a magazine. Is there anything that you'd still like to do?

WARHOL: Uh, have a baby? Oh, I had my first Coke in ten years.

O'BRIEN: Really?

WARHOL: I mean Coca-Cola.

HIGH TIMES: Why did you abstain for ten years?

WARHOL: Well, it was always so sweet. But we went to this apartment, and they had every brand food there. It was just so great to try all the Twinkies. It was a junk-food party. It was so good. I used to drink Coke all the time. It was so good. It gives you a lot of energy. You drink Coke a lot?

O'BRIEN: I think I like Pepsi better now.

WARHOL: You really do? Can you really taste the difference? I'm really going to do the test now. What does Coke taste like?

O'BRIEN: It's more carbonated and has a sharper taste. Pepsi is sweeter, easier on your stomach.

WARHOL: But if you do the test, you've got to take it out of bottles or cans. If you take one out of a big bottle and the other out of a can, or a big bottle and a small bottle, they taste really different. The little Coke bottle and the little Pepsi bottle, which is a bigger bottle, are still the best.

O'BRIEN: How did it happen that Valerie Solanas attacked you?

WARHOL: I had just ridden up in the elevator with her and I turned around to make a telephone call and just heard noise, that's all.

HIGH TIMES: Did you think about dying?

WARHOL: No, my life didn't flash in front of me or anything. It was too painful. I put it together after a couple of weeks . . . what happened. I was so drugged up. I just never think about it.

O'BRIEN: How did you start taking a tape recorder around?

WARHOL: I had a big Uher that could go on for four hours at a time, and that all started around '64. Then I got the idea to do Ondine talking for 24 hours. That's why I got a tape recorder.

O'BRIEN: Was that for your novel *a*, which was Ondine talking?

WARHOL: Yeah. Ondine used to sit up 24 hours a day, and that gave me the idea to have somebody talking for 24 hours.

HIGH TIMES: How did you write *The Philosophy of Andy Warhol*?

WARHOL: I taped most of it talking to my secretary, Pat Hackett. I used to call her in the morning to tell her what I did the day before.

O'BRIEN: Have you taped every day since you got your tape recorder?

WARHOL: Yeah, I try to. It gets so boring now. The only person I really tape is Brigid Berlin.

HIGH TIMES: Do you keep all of your tapes?

WARHOL: Yeah, I throw 'em in a box.

HIGH TIMES: Brigid is one of the *B*'s in your book: how many *B*'s are there?

WARHOL: Brigid is the only *B* I know.

O'BRIEN: There are other *B*'s in the book.

WARHOL: Yeah, but Brigid is the queen.

O'BRIEN: You made your dramatic film debut in *The Driver's Seat* with Elizabeth Taylor. What's Elizabeth Taylor really like?

WARHOL: We've seen a lot of her recently, and she's just so terrific. I like her mother. Her mother's really cute. I just got another movie role. I play an art teacher in *Grease*. Eve Arden is the principal, and John Lindsay is somebody, and John Travolta, the star of *Grease*, is in it.

O'BRIEN: How was it acting in a movie?

WARHOL: Oh, I was just really rotten. I couldn't remember anything. I got too nervous. I shouldn't be nervous, and I can't think of why I get so nervous. It's just stupid. I can't remember anything. I was on Merv Griffin a couple of times, and I was so nervous I couldn't even get a word in.

O'BRIEN: Since you've been making bigger movies, you haven't made as many. Do you miss doing it?

WARHOL: Yeah, we used to shoot a scene every night. They were so much fun. But the hardest thing is putting away and packing up. The movie we just made, *Bad*, was a union movie, and it cost so much to do, we're just hoping we get back enough money to do the real cheap movies again.

O'BRIEN: Who do you think are the best actors you've discovered?

WARHOL: Well, my favorite person is Viva, I guess—Susan Hoffman.

O'BRIEN: Why do you think Viva hasn't made it as a star?

WARHOL: Well, she still might. I think she's out in Hollywood. We might use her on a TV thing. Sylvia Miles just worked with us, and she's great. And Joe Dallesandro is making a lot of movies now.

O'BRIEN: What was your favorite publicity stunt?

WARHOL: This? I didn't do any publicity stunts.

O'BRIEN: What about your Rent-A-Superstar service for parties?

WARHOL: Yeah, I guess that was the best one, but nobody ever rented us. Wait a minute . . . maybe someone did rent somebody. I think someone rented Eric Emerson once.

O'BRIEN: What kind of toys do you have?

WARHOL: I sort of just started getting these toys—what were they called before they were plastic?—Oh . . . celluloid. I just started getting a couple of those.

O'BRIEN: You collect a lot of things that weren't too valuable when they were new. Do you think there's a lot of junk being made today that will be valuable some day?

WARHOL: Yeah. I think you should go to F.A.O. Schwarz and buy a new toy every day and just put it away.

O'BRIEN: Do you paint every day?

WARHOL: Yeah, I paint every day. Now I'm painting with a mop.

O'BRIEN: Do you change your clothes?

WARHOL: I have paint clothes. They're the same kind of clothes I wear every day with paint on them. I have paint shoes and paint shirts and paint jackets and paint ties and paint smocks and, Ronnie gave me a great smock from Bendel's. And carpenter aprons. And paint hankies.

O'BRIEN: Do you think the underground will ever come back?

WARHOL: No. I don't think there was an underground before. It's a silly word.

O'BRIEN: What about *psychedelic?* Do you think that will ever come back?

WARHOL: I think so, yeah. Really soon. I'll bet it really does come back.

O'BRIEN: Did you ever take acid?

WARHOL: No. Someone thought they slipped it to me once, but I wasn't eating.

O'BRIEN: Did you ever smoke pot?

WARHOL: No, but I like the smell of it.

O'BRIEN: Did you ever take any drugs?

WARHOL: No, nothing that ever made me funny or anything. When I was in the hospital after I was shot they gave me drugs, but it was so great to get off those.

O'BRIEN: Did you ever get drunk?

WARHOL: Yeah.

O'BRIEN: What happens when you get drunk?

WARHOL: Nothing. I tell everyone they can be on the cover of *Interview*. It's fun getting there, but when you get there, it's such an awful feeling. It's not worth it.

O'BRIEN: Do you think drugs make people more or less creative?

WARHOL: I don't think they do anything.

O'BRIEN: Do you think pot should be legal?

WARHOL: Yeah, I do.

O'BRIEN: Do you have any habits that you'd like to kick?

WARHOL: Constipation? No. Waking up people? Gossiping? Refusing to buy luggage.

O'BRIEN: Do you like traveling?

WARHOL: When I get there I really like it. Flying is really great too. People care for you on a plane. They never care for you like that on the subway. You can get a drink whenever you want. They haven't gotten to the point where planes are really rotten yet.

O'BRIEN: What's your favorite airline?

WARHOL: Iran Air? No. Pan Am? Pan Am was our favorite, but it's not around any more.

O'BRIEN: It's not around?

WARHOL: You can't take it to Paris any more.

O'BRIEN: What's your favorite place to travel?

WARHOL: New York City.

O'BRIEN: What do you think things will be like in the year 2000?

WARHOL: I think it's just going to be the same. Just like it is now.

O'BRIEN: Have you been to Russia?

WARHOL: No.

O'BRIEN: Would you like to go there?

WARHOL: No.

O'BRIEN: Have you ever been to Czechoslovakia?

WARHOL: No.

O'BRIEN: Would you like to go to Czechoslovakia?

WARHOL: No. I don't like to travel.

O'BRIEN: Do you think people will still be buying art in 2000?

WARHOL: Oh, I don't know. Everybody keeps saying nobody will be buying anything, but they keep buying, so I don't know about that.

O'BRIEN: Do you think your work will go up in value when you're gone?

WARHOL: No. It'll just stay at the same level.

O'BRIEN: Do you believe in life after death?

WARHOL: I believe in death after death.

O'BRIEN: Now that you've made films with Hollywood stars like Carroll Baker, Sylvia Miles, and Perry King, would you like to use big stars instead of superstars?

WARHOL: I don't think a big star makes a movie. I think interesting people make movies. Anybody could be a big movie star if they're interesting. A big star won't even make anybody go to a movie now.

HIGH TIMES: Who are your favorite movie stars now?

WARHOL: I like them all—I mean anybody who's in a movie.

HIGH TIMES: Will you do anybody's portrait who has the money?

WARHOL: Yeah, and I'll do anybody's portrait who doesn't have the money.

HIGH TIMES: Do you think that because of women's liberation there will be more women artists?

WARHOL: I always thought that most artists were women—you know, the ones that did the Navajo Indian rugs, American quilts, all that great handpainting on Forties clothes.

HIGH TIMES: Who are your favorite women artists?

WARHOL: Lynda Benglis, Alice Neel, Louise Nevelson.

HIGH TIMES: Who has the best gossip?

WARHOL: Actually, I think the newspapers have the best gossip.

HIGH TIMES: What's your favorite newspaper?

WARHOL: *The Daily News.*

HIGH TIMES: Do you think that people should live in outer space?

WARHOL: Oh yeah, I think that would be really great.

HIGH TIMES: Would you like to take a trip to outer space?

WARHOL: No, I really hate heights. I always like to live on the first floor.

HIGH TIMES: Do you think the future will be futuristic?

WARHOL: No. I always wished it would be but I don't think so. I guess it

could—if people didn't have to do anything they could just sit around. I don't understand it. Maybe people will just think that they're alive or something and therefore they might not be alive and just think they are, so they won't have to do anything.

HIGH TIMES: Do you like to work?

WARHOL: Nowadays I really like to work a lot. It makes time go by fast. Traveling makes time go by fast too. So maybe traveling in space will give people time. You know if you're traveling for five years or something like that, you're going somewhere. But five years are being used up, and you don't have to do anything. You just sit on the plane. That might make time go really fast.

HIGH TIMES: What do you like to do when you're not working?

WARHOL: I like to work when I'm not working—do something that may not be considered work, but to me it's work. Getting my exercise by going to the grocery store.

HIGH TIMES: Do you play any games?

WARHOL: I'm learning how to play bridge. It's nice. You can play with four people instead of two.

HIGH TIMES: Did you ever play any sports?

WARHOL: No. I was never any good in any of them.

HIGH TIMES: Do you know how to swim?

WARHOL: Well, I think I could swim.

HIGH TIMES: Do you know how to drive?

WARHOL: I ran into a cab, so I stopped. On Park Avenue and Forty-seventh Street.

HIGH TIMES: Do you have a license?

WARHOL: I had a learner's permit.

O'BRIEN: Was anybody hurt?

WARHOL: The cab had a big dent in it.

O'BRIEN: What time do you get up in the morning?

WARHOL: I get up early—7:30.

O'BRIEN: Do you have an alarm clock?

WARHOL: No, I wake up naturally.

O'BRIEN: What do you do in the morning?

WARHOL: Now Brigid Berlin calls me every morning because she's on a diet. I've taped her for ten years, and she always told me what she ate. She used to lie. Now she tells me what she ate and what she lost. Today she did the best story. She called me up to tell me she was being bad and went off her diet, and she felt so bad she took a dehydration pill and within an hour she lost 10 pounds. She'd lost 50 pounds, so this made it 60. Then she took her laundry out, and she fainted in the laundromat. She got so scared. While she was on the floor she asked the laundromat lady to give her some water; she drank two glasses of water, was able to get up again, crawl out and go to a cafeteria and drink eight more glasses of water. Then she called back the laundromat and asked the laundromat lady to do her laundry. Then she took a lot of salt, and she was back up to where she was before she took the dehydration pill. She's making a whole career out of losing weight. She's been dieting for two months. She decided to get down to 149 from 275.

O'BRIEN: Do you eat breakfast in the morning?

WARHOL: Just a cup of tea.

O'BRIEN: What time do you go to bed?

WARHOL: I go to bed early now, around 12:00.

O'BRIEN: Do you sleep alone?

WARHOL: No, I sleep with my two dogs, Archie and Amos.

O'BRIEN: Do they behave in bed?

WARHOL: No, they fool around.

O'BRIEN: Do you sleep in the nude?

WARHOL: I sleep with my underwear. And my corset.

O'BRIEN: Do you wear boxer shorts or jockey shorts?

WARHOL: Jockey shorts. Small. 30.

O'BRIEN: How much time do you spend on the phone every day?

WARHOL: Not as much as I used to. I like to tape on the phone. I like to tape Brigid. But I go to work earlier now, so I only tape her in the morning and at night.

O'BRIEN: Does she tape you?

WARHOL: No, I think she stopped. Ever since she's been on her diet, she has no ambition. Her only ambition is to lose weight, so she doesn't do anything.

O'BRIEN: Do you still watch TV?

WARHOL: Oh, yeah. Now my favorite show is the "Gong Show." And they asked me to be on it. I really should go.

O'BRIEN: As a performer?

WARHOL: No, as a judge. Performing on it would be funny too. But I decided that the performers are all professional people. They just dress up as an act, because they always know when they're going to get the gong. And "Hollywood Squares" with Peter Marshall is one of my favorites too.

O'BRIEN: Have you ever been asked to go on "Hollywood Squares" or any of those celebrity guest shows?

WARHOL: No, but I would really like to do them.

O'BRIEN: Do you still go to church?

WARHOL: Yeah. I just sneak in at funny hours.

O'BRIEN: Do you go to Catholic church?

WARHOL: Yeah, they're the prettiest.

O'BRIEN: Do you believe in God?

WARHOL: I guess I do. I like church. It's empty when I go. I walk around. There are so many beautiful Catholic churches in New York. I used to go to some Episcopal churches too.

O'BRIEN: Do you ever think about God?

WARHOL: No.

O'BRIEN: Do you believe in the Devil?

WARHOL: No.

O'BRIEN: Do you believe in the end of the world?

WARHOL: No. I believe in "As the World Turns."

O'BRIEN: Do you think psychiatry helps at all?

WARHOL: Uh, yeah, if you don't know anything about anything. Yeah, it can help you.

O'BRIEN: Did you ever go to see a psychiatrist?

WARHOL: I went to one once, and he never called me back. Then I got over whatever I got over. Everybody I knew was going, and they make you feel as if you've got to go. So I went once, and they never called me back, and I felt so funny. But then I guess someone came along and took me out to a movie, or I got a new hat or something.

O'BRIEN: Do you take vitamins?

WARHOL: Yeah, I take a multivitamin.

O'BRIEN: What do you like to eat?

WARHOL: Just plain food. Plain American food.

O'BRIEN: Do you still eat a lot of candy?

WARHOL: I've changed. Now I just make jelly. I pour the sugar into the fruit. I thought it would be better than candy, but it's the same thing.

O'BRIEN: Do you think sugar's bad for you?

WARHOL: Everybody says it is. I'm sure it is.

O'BRIEN: Do you think there are more gay people now, or do people just talk about it more?

WARHOL: There must be more. But I think they're talking about it less now. It's probably the same percentage.

O'BRIEN:Do you think gay people are more creative than straight people?

WARHOL: No.

HIGH TIMES: Do you believe in marriage?

WARHOL: Only to have children. But it's gone on for so long and people have thought it was right, it must still be right.

HIGH TIMES: Would you ever like to get married and settle down?

WARHOL: No.

HIGH TIMES: Has anybody ever asked you?

WARHOL: No.

O'BRIEN: Do you miss having any children?

WARHOL: No.

O'BRIEN: Do you think you're a father figure to anyone?

WARHOL: Just to my dogs.

O'BRIEN: Have you ever been in love?

WARHOL: Let's come back to that one.

O'BRIEN:: Did you ever hate anybody?

WARHOL: Let's come back to that one.

O'BRIEN: What do you think of violence on TV?

WARHOL: I was out with Marshall McLuhan's daughter Stephanie the other night, and she told me she'd just come from seeing *Marathon Man*, and she had to look away during some of the violence. She works on TV, and she saw the baby that was eaten by the dog, and it didn't bother her. She had the crew set up and photograph it right. She said it was work, and she really didn't have time to think about it, but in the movie it's something else.

O'BRIEN: Do you think violence on TV and in the movies makes people violent?

WARHOL: No. If you're not violent it wouldn't make any difference.

O'BRIEN:: Did you ever try to grow a mustache?

WARHOL: I beg your pardon. No, I never tried.

O'BRIEN: Do you wear a wig?

WARHOL: It says so in my book.

O'BRIEN: How many do you have?

WARHOL: Uh, three. The last maid stole one.

O'BRIEN: What's your natural color?

WARHOL: Pink.

O'BRIEN: Do you believe in flying saucers?

WARHOL: My mother used to like them.

O'BRIEN: Do you believe in magic?

WARHOL: Black magic.

O'BRIEN: Do you think Lee Harvey Oswald acted alone?

WARHOL: Perhaps.

O'BRIEN: Do you think Nixon got a raw deal?

WARHOL: That's for sure.

O'BRIEN: Do you think the Pope is infallible?

WARHOL: How dare you ask me that.

O'BRIEN: Do you own any stock?

WARHOL: I'm stocking toys these days.

O'BRIEN: Do you know how to dance?

WARHOL: I don't know how to move.

O'BRIEN: What's your favorite scent?

WARHOL: Halston, of course.

O'BRIEN: Do you believe in the American Dream?

WARHOL: I don't, but I think we can make some money out of it.

O'BRIEN: Are rich people different from poor people?

WARHOL: Yes and no.

O'BRIEN: Are they happier?

WARHOL: If they have a dog.

O'BRIEN: Can you take it with you?

WARHOL: Everywhere.

O'BRIEN: Do you read a lot?

WARHOL: Not too much. I mostly look at the pictures.

O'BRIEN: Do you think there are any good writers any more?

WARHOL: Oh, yeah. Jacqueline Susann. Frank Rich. Victor Hugo.

O'BRIEN: What are your favorite magazines?

WARHOL: *Blueboy, Pussy, Penthouse.* Whatever I'm in.

O'BRIEN: Do you look in the mirror when you get up?

WARHOL: Well, there's always one there, I guess. I brush my teeth.

O'BRIEN: Do you take a shower or bath?

WARHOL: Well, a shower's easier, but a bath is much better.

O'BRIEN: Do you have any secrets you'll tell after everyone's dead?

WARHOL: If I die I'm not letting on.

O'BRIEN: Do you think the world can be saved?

WARHOL: No.

O'BRIEN: Do you believe in Atlantis?

WARHOL: It's very sexy to believe in it.

O'BRIEN: If you had an hour TV show every week, what would you put on it?

WARHOL: Kate Smith. "The Andy Warhol Hour Starring Kate Smith."

O'BRIEN: What's your favorite news show?

WARHOL: Channel Five at ten o'clock. I like it because it's fast. News is my favorite program, but the networks aren't my favorite. I hate Barbara Walters.

O'BRIEN: Do you think TV is good for kids?

WARHOL: I met two kids yesterday who used to go to bed at eight. And then in the morning the kids had bags under their eyes and were very list-

less and grumpy, and the mother didn't understand. So months later the mother happened to go up to their room at one in the morning, and the kids were sitting glued to the TV. I think they learn everything. Everything on one plane. It's great.

O'BRIEN: Do you think there should be any censorship?

WARHOL: Of course.

O'BRIEN: Where should they draw the line?

WARHOL: Things should be more sexual.

O'BRIEN: Do you believe in capital punishment?

WARHOL: For art's sake, of course.

O'BRIEN: Are you to the left of Dalí?

WARHOL: On the bias.

O'BRIEN: What do you look at first on a woman?

WARHOL: Her bag.

O'BRIEN: What about a man?

WARHOL: His bag. The way he wears his hat.

O'BRIEN: What's your favorite sport?

WARHOL: The one with the baskets.

O'BRIEN: Did you ever see a movie that got you hot?

WARHOL: *Behind the Green Door, Going on Sixteen, State Fair.*

O'BRIEN: Who is the sexiest woman in the world?

WARHOL: Bianca Jagger, Divine, Diana Vreeland.

O'BRIEN: Who do you think is the sexiest man in the world?

WARHOL: Henry Kissinger, Jack Ford, Steve Ford, O. J. Simpson. Woody Allen for sure not, but some people masturbate to his image anyway.

O'BRIEN: What do you think about masturbation?

WARHOL: It helps.

O'BRIEN: What's your all-time favorite movie?

WARHOL: *Alice in Wonderland*. Bill Osco's *Alice in Wonderland*.[2]

O'BRIEN: Do you think Jimmy Carter is going to get America moving again?

WARHOL: Oh I hope so. Yeah, he will.

O'BRIEN: What would you do to reorganize America if you were Jimmy Carter?

WARHOL: I don't think it's so bad the way it is. I don't think he has to do really much. It's really a great country.

[2] *Alice in Wonderland* (1976). Directed by Bill Osco, starring Kristine DeBell. A XXX rated film.

29 "An Interview with Andy Warhol: Some Say He's the *Real* Mayor of New York"

CLAIRE DEMERS
Summer 1977
Christopher Street, September 1977

Andy Warhol went out every night; he once said that he'd go to the opening of anything, even a toilet seat. In September of 1977, although he was traveling for much of the month, Warhol's diary records several evenings out at New York landmarks including The Four Seasons, Studio 54, The American Folk Art Museum, the Pierre, the Waldorf, The Ginger Man, P.J. Clarke's, and several gay bars. His companions included Sophia Loren, Diana Vreeland, Peter Beard, Steve Rubell, Valentino, Edgar Bronfman, Péle, Ahmet Ertegun, Howard Cosell, David Whitney, Mick Jagger, Ron Wood, Keith Richards, and Anita Pallenberg.

But it wasn't always this way. When Warhol first arrived in New York from his hometown of Pittsburgh in June 1949, he and the painter Philip Pearlstein moved into a small, dirty, sixth-floor walk-up on St. Mark's Place in the East Village. In 1959, after several apartment shares, his success in commercial art enabled him to purchase a town house on Lexington Avenue and 89th Street on the Upper East Side. Years later, Warhol bought an elegant town house at 57 East 66th Street, where he lived until his death.

By the time of this interview, Warhol had climbed to the top of several ladders, thereby establishing himself as a denizen of New York City's top-tier social scene. When Warhol was starting out as a painter, he painted celebrities in the hope that their aura would rub off on him; now it was the celebrities that wanted to be photographed with Andy.

In April 1977, just months before this interview was published, Studio 54 opened and immediately became the playground of the rich, beautiful, famous, funny, intelligent, and powerful. Warhol became a regular there. It has often been remarked that the Studio 54 scene in many ways paralleled

*the social hierarchies of Warhol's late-sixties hangout Max's Kansas City; it
became as much a lifestyle as it was a club. Warhol's continuous presence at
Studio 54 greatly increased his profile in the popular media and made his
name synonymous with New York nightlife in the late '70s.*

*This interview, originally published in the gay literary magazine Christo-
pher Street, focuses on the city that made Andy and, in many ways, Andy made.*

— KG

What do you think your influence has been on the New York art scene?

Gee, I don't know. I just work all the time. There are so many different
styles, you know, different ways of people painting and categories and . . .
there's so much, so much variety. I don't know if I have influenced it or not.

How do you feel about New York?

I just love New York. I have to fly around a lot, but I just can't wait to get
back to New York. I think it's the best place in the world. I'd rather have an
apartment Uptown than Downtown or in the middle, and that would be
my vacation—going Downtown.

What makes New York unique compared to other cities?

Well, right now we're getting all the kids from the different countries in
Europe and they're creative and bright and rich and you get these different
people here and they're all so talented and there's just so many . . . it's just
actually a country in itself. It's different from any other place in the world.

Do you have any nostalgia for the old New York?

Oh no. I like old things torn down and new things put up every minute. I
like new buildings going up.

Who has changed more in the last twenty-five years: you or the city?

Well, I was just thinking—when I walk on 17th Street, where we are, and

across the street to Park Avenue—that about twenty years ago everybody had short hair and then they gradually got long hair and now it's like it was twenty years ago. Everybody has short hair again and it looks like nothing has happened. It's really strange. But there's a lot more people. They always say New York never increases—people are leaving it and stuff like that— but I don't think so. I think there's actually a lot more people. It's not as bad as Japan. Japan is just *too* crowded.

I've never been there.

Oh, really. You'd hate it. It's just so jam-packed.

If you were to paint New York, what color would you paint it?

I'd paint it red.

What changes would you like to see in this city?

Oh, no changes. I like it just the way it is. But the crime is really so bad. That would be the only change: if they could do something about that.

Have you ever done any of the touristy things like climb the Statue of Liberty or take the Circle Line boat tour?

I haven't done *those*. I really would like to do that. But I've done other things like the Twin Towers, gone to the top of that and the Empire State Building and to the Rainbow Room.

Do you like to walk through the city?

Oh yes, I like walking the best.

What's your favorite building?

My favorite building is that new one on 54th Street and Lexington Avenue. I looked at it this morning about 5 o'clock. It's where the church is. There's a modern church and then they built a high-rise over it. Have you seen it

yet? Oh, it's great. I forget who is the designer, but if you'll look it up you'll find it. It's really great. It's on Lexington right around the corner from The Brasserie.

What would your next favorite building be?

A church I go to on 66th Street and Lexington Avenue. I forget what it's called.

What did you do the night of the blackout?[1]

The papers said I was at Elaine's, but—I wasn't. I was seeing a play at Lincoln Center with Irene Worth, Chekhov's *The Cherry Orchard.* The lights went out and they decided to continue with the play. The stagehands had candles and they just went on with it and it was really great. We were going to interview her afterwards and she was having dinner with somebody named Rudi Standish. We just walked outside and got a cab really quickly and went right across through the park to where he lived, on the second floor in a big building. He sort of invented omelets and stuff like that.

So you had a good night?

It was really very easy.

You've talked about not wasting things and recycling things. What advice would you give New York in that area?

I think they should give money to people for old newspapers, I mean if they pack up the newspapers and put them all together, and tin cans and bottles and. . . . They should have a department store where you could actually go and sell it back. I think it would be a great new shop and give work to a lot of people besides.

What do you think New York needs the most?

A woman mayor. Bella Abzug. She'd be great.

What has New York taught you and what have you taught New York?

1 New York City blackout. July 13, 1977.

Oh, New York just taught me that it's just really exciting. I haven't taught it anything.

What's happening with the Andy Mats, your new restaurant chain?

The Andy Mats? Oh, they're scheduled to open in November. We're still hoping it works out that way.

Do you think your films have had any influence on the gay movement?

Well, I don't really know, because we never . . . I never really directed movies. They made up the scripts and so we just . . . it was like shooting documentaries, in a funny way. They were actors who would turn on for the camera and so whatever they wanted to show in the movies they usually did.

Are you still in touch with Holly Woodlawn?

We see Holly all the time. I think its so hard to be . . . if you're a boy and you try to be a girl, it's double work and stuff like that. And I mean I think it's harder to be what they are because they have to do two things. First they have to be a boy and then a girl and then a boy and a girl at the same time and it's really, really hard. I keep trying to tell them they should be a girl only when they're performing because then they could be, you know, whatever they are during the day, and then it becomes work and it doesn't become so hard. There are just too many pretty girls and if you have to compete with a girl when you're not a girl it's just so hard.

Which leads me into the next question. . . .

But Holly's the best comedian, I think, ever. She's still working; I notice she's still performing in town.

There was a fascination among the Symbolists and Surrealists with transvestism. Do you think that the ability to move from one sex to another is an art form—an added dimension or even an intellectual achievement?

I think it's all that. I really do. Like I say, I think it's so hard to do, and if

they can do it and they do it really well. . . . Some guys would be lucky if they could get a boy and a girl at the same time. I mean, that's what they should marry because they could have both.

The recent painting of Marsha:[2] *how did you meet her?*

I used to go the Gilded Grape[3] bar and the transvestites there were just so exciting looking, I decided to do some paintings of them.

In your book A to B *you stated that men who work at being women work the hardest. What about women who work at being men?*

Oh, the same thing. It's hard too. But it doesn't show. . . . They're usually such intelligent kids, they usually have more brains than other people do.

Do you think the feminine principle is in control in the art world and in the business world or in the art-business world?

Well, mostly in the art world. I was in theater and everything like that. They're the people I know and girls can have a big opportunity to be up there. Even in the art world there are so many more girls working now and they're doing things . . . if you don't see their name it looks like a boy was doing it or something. I mean they've gotten so great—but then I think the women were the best anyway. You know they did those things that I like the best, the Indian rugs—they wove all those beautiful things—and then also a lot of craftworks and all those quilts, those American quilts. They're so beautiful. I mean they're works of art. I think women do a lot of conceptual art. And now in galleries there are so many. Do you know Linda Banglewurst?[4] [*sic*] Do you know her work at all? She does, oh, work that you'd never know. There are so many of them. It would be a man doing it or something like that.

Would you like to live your life twice as fast forward or backwards?

2 From Warhol's painting series of drag queens, "Ladies and Gentlemen," 1975.
3 Bar on Eighth Avenue and 45th Street frequented mostly by black and Hispanic transvestites. Most of the models for the "Ladies and Gentlemen" series were found here.
4 Lynda Benglis. Artist, b. 1941.

Twice as fast forwards. Get it over with.

You've seen great changes in your lifetime. For instance, the merging of art with fashion, the merging of art with business. In what direction do you think art is going?

Oh, I think it's going to become fashion art. That's the direction it's going.

On your talk show, "Nothing Special," what would you do differently? Would you use what you call "transmutations"? Would you recycle the left-overs on your TV show?

Well, no, I think people look at anything. So I think if you just had the camera on anything, that would be nothing special and people would look at it—just like sitting looking out of a window or sitting out on a front porch. You could just watch things go by. I mean you could do that for hours.

You have a wonderful way of discovering talent in unknowns. What do you look for?

Anybody doing different things, interesting things, being imaginative, so I think then it works in the other direction where if you've really no imagination, then it's really great too, just the complete opposite.

The success syndrome never seems to affect you. How do you keep your sanity? How do you keep yourself intact?

I just keep on working . . . and take a lot of plane trips. I read a lot on the plane. Do you get a chance to read on the plane, at all?

If there aren't too many people on board.

Oh, it's summer now, it's so crowded, isn't it. You can really notice the difference.

You are a paradox of endless combinations. There's the human and the mystical, there's the passive and the active, there's the sexual and the anti-sexual, there's the masculine and the feminine. And yet what is most often heard about

you is praise about your love and tolerance of people. Do you feel that you have any kind of negative influence over any of the people who have surrounded you?

Oh no. I don't really believe in negative things. That's one thing I just wouldn't do. I think kids are so great. I like everybody.

Do you have a message? Any special message?

I have no special message. I wish I did. It would be great if I had one. I just think entertainment is the best message. So we try to be funny.

Do you think that talking is more important than writing?

I wish I could do both. I can't. I think writing is just really great and actually talking is so terrific. We just interviewed Pat Wayne—you know, John Wayne's son—and oh, God, he was just so good looking and so talkative. He had just wonderful stories.

What do think will be the fate of the written word?

I think it's going to go on. They keep saying that it's going to disappear but as they say it gets bigger and bigger. More magazines are produced and more books are being written. I'm so amazed at how many books they do and how few really become successful. But, thousands and thousands of books are being written.

Do you have a favorite poet?

John Ashbery, and Gerard Malanga. Do you know him?

Yes, I knew he was your friend. What is it that you don't like about time? Why do you want it to go by so fast when most people are afraid of the swift passage of time?

To get it over with.

Do you think that reality is more or less an idea in the mind rather than in the world?

I guess it's in the mind so actually it's different for everybody. You know every-

body just has a different idea and everything is right. When a person is guilty they can be not guilty too. I was just reading in the paper where the jury found a person guilty, but the judge was able to overturn it. I didn't know that they could do things like that. He said he wasn't guilty, so the person got freed.

You've mentioned a play called "The Beard." I just wondered why that particular play would make you wish that all your films were as beautiful.

Well, it's a two character play and I think the person who wrote it, wrote poetry, so the combined art and poetry . . . everything together and it was a great production. It's about Jean Harlow and a famous cowboy, the James Dean type of his day. I think I've seen three productions of it. Did you see it at all? They were going to make a movie of it but I don't think they ever did.

Why don't you?

I guess I should. Oh, maybe they did make a movie of it, I can't remember.

In competing with Hollywood there is the loss of the aesthetic and I just wondered how you felt about that, if that was the reason you were going back to making smaller films.

We just can't compete with the $50 million movies, so we have to think in another direction. If you can do something unusual on a lower budget then you can do a little more, make it different. It's just trying to make it different because you can't compete with movies on such a great scale.

You mentioned that if you ever did a big film, a two or three million dollar film, nobody would have to go and see it.

Oh, wouldn't that be great! If you could just make them and not have to feel that you lost money or something like that if people didn't go to see them. You don't really lose money because you pay a lot of salaries. They're always talking about campaigns where people spend so much money when actually so many other people make it.

THE EIGHTIES

THE EIGHTIES

30 "Dinner with Andy and Bill, February 1980"

VICTOR BOCKRIS
Blueboy, October 1980

Warhol biographer Victor Bockris began working freelance for Interview *magazine in 1973 and became a contributing editor in 1978. During this time, Bockris was also working on a book about the writer William S. Burroughs. His idea, inspired by Warhol and Bob Colacello, was to record a series of meetings between Burroughs and other prominent cultural figures, letting the tape run, and seeing what came out of it. The interviews and writings on Burroughs were collected into a book,* With William Burroughs: A Report *from the Bunker (New York: Seaver Books, 1981).*

Although Warhol and Burroughs were both legends at the time of this interview and had met formally in the 1960s, they had never really connected with one another on more than a superficial level. In January of 1980, Bockris took Burroughs to the Factory to meet Warhol. The meeting went well and Warhol suggested that he take Polaroids of Burroughs as the basis for a potential portrait. Photos were taken a week later and Warhol suggested that they all have dinner at one of his favorite restaurants, 65 Irving Place. Fashion consultant Andre Leon Tally was invited to join them.

The evening started off with two martinis each, followed during the meal by several bottles of wine shared by the table. "We sat down, ordered drinks and the conversation went off like a brush fire," recalls Bockris. "It was very light cocktail conversation but it kept moving, occasionally pausing over deeper moments." The dinner lasted an hour and a half with Bockris acting as the master of ceremonies. "I thought this was a one-time thing and that I'd never get them together again. I wanted to get it all on tape: them being outrageous. If they started wandering off and discussing something boring I would keep them on track."

The dinner was a success: the next day, Burroughs commented how surprised he was about how open Warhol had been the night before and went

*on to say how much he enjoyed the meeting. Warhol responded in kind. How-
ever, the interview at first proved difficult to place. After several rejections,
Bockris hit upon the idea of pitching the story to Blueboy—the most suc-
cessful hardcore gay magazine of its day—as a meeting between two great
icons of gay liberation. Initially the magazine showed skepticism that the
interview was real. On request Bockris sent the magazine a copy of the tape
in which all material not in the interview was edited out to prove its authen-
ticity. They decided to use it in their 15th anniversary edition, published in
October of 1980.*

*While Warhol was amused with the final transcript, he insisted that
Bockris "take out some of the stuff about piss and shit." Both Warhol's and
Burroughs's handlers were annoyed by the interview when it was published
in between photos of large, erect penises, afraid that it would tarnish their
public images. However, both Burroughs and Warhol confided separately to
Bockris that they found the results entertaining.*

*Although a Burroughs portrait was never painted, Bockris arranged for two
subsequent dinners that year: one in March at Burroughs's home with Warhol
and Mick Jagger, and another in October with Warhol for a BBC documen-
tary about The Chelsea Hotel. "It was a very happy occasion for me," remem-
bers Bockris. "It was somehow appropriate: myself, a younger man, bringing
these two distinguished older men together and recording them enjoying each
other."*

—KG

William Burroughs and Andy Warhol have several things in common. They
both produced major bodies of work that changed the way people saw and lived,
while personifying the radical lifestyles their art released. They both became
major figures in a cultural revolution, then outgrew that period before it out-
grew them and continued producing work that continues to surprise a broad
spectrum of the population. They both maintained their sense of humor.

It was a great pleasure to see them together at a dinner table, for,
although they'd met several times in public, they never had the opportu-

nity to converse undisturbed, and I was sure they would both enjoy it. Former Fashion Editor at *Womens Wear Daily*, and current social observer on the New York scene, Andre Leon Tally, was also present as a guest of Andy, who gave the dinner party at 65 Irving Place.

ANDY: I still never understand why a boy's never had a baby. I mean if people are peculiar and stuff. . . .

VICTOR: Well, Allen [Ginsberg] and Peter [Orlovsky] are planning to have a baby together.

ANDY: There must be a way! You know how freaks are around all the time . . . I mean there has to be a freak who is going to have a baby. There are so many different freaks, you know, geniuses. They call a freak a genius, right, because half their brain's gone, so they discover the atomic bomb or something. There's always a freak.

BILL: There was a story that Mohammed was supposed to have been reborn from a man.

ANDY: Mohammed who?

BILL: Mohammed The Prophet!

ANDY: Oh. We know a lot of waiters called Mohammed.

BILL: But why bother when you have cloning.

ANDY: Yeah. Cloning's better. But a man could probably have a baby in a day, or something. How old were you when you first had sex? Thirteen, fourteen?

BILL: Sixteen. Just boarding school boys at Los Alamos ranch school, where they later made the atom bomb.

ANDY: So you had sex when you were sixteen. With who?

BILL: This boy in the next bunk.

ANDY: What did he do?

BILL: Not very much. Mutual masturbation. But during the war this school, which was up on the mesa thirty-seven miles north of Santa Fe, was taken over by the army, and that's where they made the atom bomb. And the reason why is that Oppenheimer had gone out there for his health and he was staying at a dude ranch near this place and had seen it and said, "Well this is the ideal place." So it seemed so tight and appropriate somehow that I should have gone there.

ANDY: Was the sex really like an explosion?

BILL: No, no.

ANDY: It was pretty boring? Was it fun?

BILL: No, I don't remember, it was so long ago.

ANDY: Oh c'mon.

BILL: I don't!

ANDY: Was it fun?

BILL: Well, it was. . . .

ANDY: Just okay? I think I was twenty-five the first time I had sex.

VICTOR: Then what happened?

ANDY: I stopped at twenty-six. But the first time I ever knew about sex was in Northside, Pittsburgh, under the stairs and they made this funny kid suck this boy off. I never understood what it meant. I was just sitting there watching when I was five years old. But how did you get this kid to do it?

BILL: Oh, I don't know, sort of a lot of talking back and forth.

ANDRE: Do you think you should charge for sex?

BILL: Well, it depends on the circumstances. You cannot generalize about these things. Who should pay who?

ANDY: I think the girl who's standing on the street corner should pay the guy who comes up to her, because she's hot, right? The guy's not hot, she's hot, right? She's the prostitute, but she's hot, and she should pay the person that wants it. She should be on easy street and pay the person for doing it to her, don't you think. I think it should be that way. She should just have a lot of money from the city to pay him.

VICTOR: The prostitute should be supported by the city?

ANDY: That's it. They should be hired by the city. Its part of the city and they should be paid by the city instead of going to jail.

VICTOR: Have you ever found the process of paying for sex heightened the pleasure?

BILL: No.

ANDY: Pleasure of what?

BILL: The only way it could heighten the pleasure would be if you paid in the middle of sex and this is. . . .

ANDY: But you know what I really don't understand is when white guys have these really great dark cocks.

VICTOR: The cock is darker than the rest of the skin?

ANDY: Oh, really dark sometimes.

VICTOR: Well, Bill said Arabic boys have wedge-shaped cocks.

ANDY: Wedge-shaped! What do you mean wedge-shaped?

BILL: Well, yeah. There's a sort of wider—wedge shaped, but it isn't at all uniform. My dear, it's not all that different. Some of them tend to be a little bit, ah, you know, shaped wide.

ANDRE: The tip? The head?

ANDY: It's hard to get the head in then, isn't it? Here, draw it.

BILL: My dear, I can't, it's not so well defined. Victor has misled you to think that there's anything very special about this. Actually it has nothing to do with the nationality. There are a lot of people like that.

ANDY: Bill has a big cock.

ANDRE: How do *you* know?

ANDY: Well he does. Huh?

BILL: Average, average.

VICTOR: Average.

ANDRE: Average average.

VICTOR: Do you have an average. . . .

ANDY: Yeah.

BILL: Everybody's got an average cock.

ANDY: Andre's got a really big cock.

ANDRE: Andy's so sure that I have a big cock! It's not true.

ANDY: Oh come on.

BILL: He said he had an average average.

ANDRE: It's all right to be average.

ANDY: I only fall in love with kids who have what's-it-called ejaculation.

ANDRE: You mean premature ejaculation.

ANDY: Yeah. That's my favorite trick. Are you one?

BILL: What?

ANDY: Are you a premature ejaculator?

BILL: Uhmmm, pretty quick, pretty quick!

ANDY: Really?

VICTOR: I figure sex should be right away.

BILL: I do too, but see, women have different cycles.

ANDY: Bill is not a premature ejaculator!

BILL: Well certainly I am.

ANDY: Are you really? What do you mean—seconds?

BILL: Nnnnnooooo, twenty seconds, twenty seconds. . . .

ANDY: What, just petting?

BILL: Well no no no, you have to get a little beyond that.

VICTOR: Petting and then ah. . . .

ANDY: Oh, no no no, I. . . .

VICTOR: No, but once it's in. . . .

ANDY: No no no, *not* in. I mean, it's premature!

VICTOR: Before it gets in?

ANDY: Yeah, you just sort of go like this and. . . .

VICTOR: Don't you find it harder to get sex though?

ANDY: Yes, really really hard.

BILL: Harder than when?

VICTOR: Ten years ago when you were a young febrile personality jumping around. Don't you find it harder now?

BILL: Well, I just say harder than when?

VICTOR: It's harder than ten years ago when you were a young febrile personality jumping around, don't you think?

BILL: I suppose presumably it gets more difficult as you get older. That seems to be what they tell me.

VICTOR: Is it not true? See, actually it's not . . . it's easier for Bill to get sex now.

ANDY: Oh it is?

VICTOR: He gets more sex now than ever.

ANDY: Yeah, 'cause he's good-looking and adorable.

VICTOR: Yes, he is good-looking.

ANDY: He is good-looking. He's adorable.

VICTOR: And very together.

ANDY: He's charming and. . . .

VICTOR: . . . he travels and. . . .

ANDY: Yeah, he's great. You're the one that should be worried! You like shit and piss. You do!

VICTOR: I like shit and piss?

ANDY: The smell of shit and piss. [*Turning to Bill*] He's English.

BILL: Yes, I'd forgotten. That would do it, that would do it. . . .

ANDY: And leather. Leather, shit and piss. I mean, that's synonymous with. . . .

BILL: *Absolutely.*

ANDY: In G.B. You know, *Great Britain.* Shit, Piss and Leather.

VICTOR: It's odd, I have to admit the British are very strange sexually. . . .

ANDY: They're really odd, but they're so sophisticated that's why they. . . .

BILL: Like to be beaten with rulers and hairbrushes.

VICTOR: And pissing and ejaculation on their faces.

ANDY: No! Really? God. . . .

BILL: Absolutely, yes. . . .

VICTOR: But I think the English. . . .

ANDY: Are the sexiest people. . . . Good sex.

VICTOR: Did you ever have any really good sex in England?

ANDY: Oh yeah, the best.

BILL: Yeeessss. . . .

VICTOR: Well, Bill, you had good sex there too? And Andy, you had the best sex in England?

ANDY: No, the best one was when this guy bit off this guy's nose. That was the best sex.

BILL: I heard about that.

ANDY: Wasn't that the best sex, Bill?

BILL: Ah yes. I imagine so.

ANDY: The best.

ANDRE: I know somebody who's thirty-seven and still has wet dreams. Does that mean he has a strong sex drive?

ANDY: I don't have any sex dreams.

VICTOR: You mean wet dreams where you come all over your pants and then in the morning you're embarrassed?

ANDY: Are you kidding? Come on! That's stupid.

BILL: These phenomena are generally associated with adolescence, but can occur at any age.

VICTOR: Andy, Bill is a great actor, he's a natural, and if you don't use

him in your next movie you're really crazy. He could be a big star. Look at his face, he is really naturally

BILL: Yes, I can play doctors and C.I.A. men, and all kinds of things.

VICTOR: You know what it's like for a writer. He writes and writes; he wants to act.

BILL: I do war criminals very well.

ANDRE: War criminals?

ANDY: I think you should be a dress designer.

BILL: A Nazi war criminal I could play very well.

VICTOR: A what?

ANDY: I think you should be a dress designer. You gotta change your profession and become a dress designer.

BILL: Well . . . hmmm, that's not my sort of thing.

ANDY: Well, actually, you're the best-dressed person I've ever known.

BILL: Really?

ANDY: Isn't he the best? He's always worn a tie since I've known him.

VICTOR: But seriously, I think Bill's career is in acting, because he's written so much and now he needs a change. Do you know he didn't start writing until he was thirty-five?

ANDY: What were you doing before?

BILL: I was just fooling around. Very marginal.

ANDY: Just bumming around? Working at an office?

ANDRE: You were killing roaches! He was killing roaches in Chicago! He was an exterminator!

ANDY: No! You owned the company?

BILL: No, no.

ANDRE: He *killed* the roaches.

BILL: It was the best job I ever had. It was so easy, I enjoyed it. To this day I know all about roaches.

ANDRE: Can you tell me the sex life of a roach?

BILL: I don't know about that, but I do know how to get rid of them. I know where they live.

ANDRE: Where do they live in apartments?

BILL: Well, I'd have to look around and analyze the case, see. They get, of course, into sinks. If there's linoleum they'll get under that. They'll get in the kitchen cabinets, woodwork.

ANDRE: So how do you keep them out of the kitchen cabinets where you have your best china and silverware and all that?

ANDY: Well, they can be with the best china. It's the best food you don't want them to be with.

BILL: Take it out and spray it.

ANDY: No. Spray it and serve the people food with the spray on it. That's what you do!

BILL: Well, you spy out where they are and then you spray there, and pretty soon you're rid of them.

ANDRE: But if you're a lay person. . . .

ANDY: A lay person! A person who lays?

ANDRE: How do you go about finding them in dark corners in your kitchen cabinet?

BILL: Well, you have to have a feel [*rubbing hands*] for where they are.

ANDRE: And you had a feel for it?

BILL: Well, yes, because I did it for nine months, man.

ANDY: But I used to come home and I used to be so glad to find a little roach there to talk to, I just . . . it was so great to have . . . at least somebody was there to greet you at home, right? And then they just go away. They're great! I couldn't step on them.

BILL: Oh God, no man! I either have a sprayer. . . . Occasionally I get a water bug in my place. There's something called TAT with a thin tube coming out from the nozzle and it makes this fine spray. If you see a water bug you can just. . . .

VICTOR: A roach who shows its face in Bill's presence is definitely a dead roach. Bill is very quick. In the middle of a conversation he will leap up and rush across the room grabbing a can of TAT on the way and he will sssshhhhh. But you had a slight bed bug problem. That was a problem.

ANDY: Oh well, that's the worst. You have to get a bomb. . . .

BILL: I did, I did.

ANDY: You get a bomb and then you run out of the room.

BILL: I got a bomb and put it under the mattress and under where the springs are. That's where they get to, and I got rid of them.

ANDY: God, I had bedbugs. I . . . only last year. . . .

ANDRE: Andy, please!

ANDY: [*To Bill*] What's your last novel about?

VICTOR: *Cities of the Red Night*. It's about brain transplants. It's a very very interesting book, it's a fascinating, fascinating book.

BILL: It's very complicated and tricky.

VICTOR: It's a detective story but it's fabulously complicated, but it's a story . . . and it ends up in South America with some very rich people who are developing the possibility of brain transplants.

ANDY: You mean they transplant their brain to a younger person?

VICTOR: Well, the thing is, you can transplant the "I" from a younger person into another person, correct?

BILL: Yes, presuming you knew where it was located, just as you can transplant a liver. Dr. Stargill is working on the idea of brain transplants now.

ANDY: A lot of people don't want to be transferred though.

BILL: Well, that's true. It isn't compulsory.

ANDY: Oh well, that's fascinating. Would you want to be, Victor?

VICTOR: Transplanted?

BILL: Transplanted into what?

VICTOR: Well, what do you want to do?

ANDY: No, I don't want to be transplanted.

VICTOR: What do you want to do when you die?

ANDY: Oh, er . . . nothing.

VICTOR: What was the biggest change in sex in the seventies so we can see what it's going to be like in the eighties?

ANDY: You're talking about entertainment sex. Entertainment sex is different, see.

ANDRE: What is entertainment sex?

ANDY: Entertainment sex is the S&M thing when you go down to those S&M bars.

BILL: It entertains *some* people.

ANDY: Yeah, well, a lot of people, and then, you know, where sex spends a whole evening and it's like entertainment. It's like going to a Broadway show. It's entertainment sex and that's what the eighties are.

31 "Modern *Myths:* Andy Warhol"

BARRY BLINDERMAN
August 11, 1981
Arts, October 1981

"*Interviewing Andy was one of the highlights of my career; it didn't get much better than that,*" *recalls Barry Blinderman, then a freelance writer who had arrived in New York at the beginning of 1980, landing himself a job writing for* Arts *magazine.*

Blinderman decided to write a piece on Warhol's Ten Portraits of Jews of the Twentieth Century *exhibit at the Jewish Museum in New York City*[1]. *The exhibition was of a suite of prints that included Franz Kafka, Gertrude Stein, and the Marx Brothers. The series was published by art dealer Ronald Feldman. The following year, Feldman published another Warhol portfolio,* Myths, *consisting of ten silkscreened prints with images taken from American popular culture.*

Feldman was impressed by Blinderman's writeup of the Ten Portraits *and offered to introduce him to Warhol. An interview was arranged at the Union Square Factory on an extremely hot and sunny Tuesday in August of 1981. Blinderman found talking to Warhol comfortable. "He made me very much at home. He was dressed casually in a white button down shirt, a pair of jeans and a conservative wig," Blinderman remembers. "I saw from the start that he was very intent on answering my questions, which were focused on art, as opposed to gossip or fashion."*

The interview was heavily edited. "Andy would end many sentences with 'or something like that' or 'oh really' and 'oh gee', which I deleted from the final piece." Blinderman also changed the order of the conversation to make things cohere thematically.

As Jeanne Siegel wrote in her introduction to this interview when it was

[1] September 17, 1980 to January 4, 1981.

reprinted in Art Talk: The Early 80s *(New York: Da Capo, 1990):* "Warhol had already acknowledged that the results of his artistic endeavors were marketable, profit-oriented goods. But by now he had entered what he termed his Business Art period, which followed his Art period. This new and final phase is reflected in the interview" *(Siegel, 16).*

—KG

Myth/'mith/n [Gk mythos] 1: a traditional story of ostensibly historical events that serves to unfold part of the world view of a people or explain a practice, belief, or natural phenomenon; 2: PARABLE, ALLEGORY; 3a: a person or thing having only an imaginary or unverifiable existence
— WEBSTER'S New Collegiate Dictionary

From ancient times up to the present, artists have pursued the representation of myths. The power of pagan legend has survived through new interpretations by each generation, as seen, for example, in Thomas Hart Benton's portrayal of Persephone as an American farm girl. But when Andy Warhol decides to do a series of ten silkscreens entitled "Myths," we're talking about a whole other pantheon. As an artist who represents an era in which advertising, film and TV are as great a source of heroes and villains as Homer or the Bible were for pre-media society, Warhol chose to update the classical order. His myths are: Dracula, Howdy Doody, Mammy, Mickey Mouse, Santa Claus, Superman, The Shadow, The Star, The Witch, and Uncle Sam.

In a certain sense Warhol himself is a myth. He has come to symbolize success and stardom in the arts, yet still somehow remains an elusive figure. The mystification surrounding his public image renders it difficult for some to see his art for what it really is—powerful, persistent images that have never failed to capture the spirit of the time. It is no wonder that The Shadow print is a self-portrait. A red-tinted photo-silkscreened image of the artist's face casts a distorted shadow haloed by the application of diamond dust. We see man and myth, artist and stardust, portrayed side by side.

BARRY BLINDERMAN: How did the "Myths" series come about?

ANDY WARHOL: Ron Feldman, who published the prints, has a lot of wonderful ideas. He and I went through lists of people. Actually, I wanted to do a whole Disney series with Donald Duck and other characters, but I ended up using only Mickey Mouse.

BB: Did you see the Whitney Disney exhibit?

AW: Yes. It was interesting to see how other people did so much of the work. I liked the show so much that I went to see *The Fox and the Hound*. That movie looked like it was done 50 years ago because the backgrounds were so painterly. But I wish the Whitney show had been larger; I wanted to see more.

BB: This series brings your work full circle in a sense. You did a Superman painting in 1960, and Lichtenstein and Oldenburg did Mickey Mouse shortly afterward. Here it is over 20 years later, and you're painting these characters again.

AW: I know, I just can't believe I did it. But this time it was more complicated. We had to go through getting copyrights and everything like that.

BB: Now that the history of Pop Art is behind Superman and Mickey Mouse, do these characters mean anything different to you than when you originally painted Superman?

AW: No, it just means that I liked it then and I still like it now.

BB: "Myths" really captures the American spirit from a lot of different angles.

AW: The only one I didn't understand was *The Shadow*, and that was me, so. . . .

BB: The image of The Witch is really striking. Is that Margaret Hamilton, the same woman who played the Wicked Witch in *The Wizard of Oz*?

AW: Yes, she's so wonderful. She lives right in this neighborhood. She looks and acts the same as she did back then.

BB: There's probably no child or adult in this country who hasn't seen *Oz*. It's easily as American as Mickey Mouse.

AW: I wonder if kids who see that movie think it's a new movie or an old movie. Some kids know about old movies and others haven't even heard of some of the stars that were around.

BB: What impressed me most about *The Witch* was the color. The way the shape and color interact reminds me of things Ellsworth Kelly used to do. I've always wanted to know if you ever thought of your paintings in the '60s in terms of Kelly and Noland, your contemporaries doing abstract art.

AW: I always liked Ellsworth's work, and that's why I always painted a blank canvas. I loved that blank canvas thing and I wish that I had stuck with the idea of just painting the same painting, like the soup can, and never painting another painting. When someone wanted one, you would just do another one. Does anybody do that now? Anyway, you do the same painting whether it looks different or not.

BB: Yes, for example the *Dracula* looks similar to the way you did Kafka in the last series. Both emerge from the darkness like ghosts. So does the *Mammy*. Powerful image and color have been the issue from the start. Was the Superman you used from a DC comic?

AW: Yes. I wanted to do Wonder Woman, too.

BB: Did you consider using one of the movie or TV actors for your *Superman*?

AW: Well, I thought the man who played in the TV series [George Reeves] looked just like the comic book character.

BB: More than half of the *Myths* are based on TV or movie characters. Is this to say that modern myths are mostly made on the screen?

AW: Yes, I guess so. Afterward, yes. But the TV is so much more modern.

BB: From the beginning you've been doing prints in one form or

another—from the blotted paper technique to rubber stamps, and then to silkscreens, which you use to this day.

AW: The silkscreens were really an accident. The first one was the *Money* painting, but that was a silkscreen of a drawing. Then someone told me you could use a photographic image, and that's how it all started. The *Baseball* painting was the first to use the photo-silkscreen.

BB: When you first began using silkscreens, you were concentrating on removing your personal touch from the work. Now your paintings have a lot of brushwork and drawing, and are expressionist by comparison.

AW: I really would still rather do just a silkscreen of the face without all the rest, but people expect just a little bit more. That's why I put in all the drawing.

BB: As a portraitist, what do you feel is most important to express?

AW: I always try to make the person look good. It's easier if you give some-body something back that looks like them. Otherwise, if I were more imag-inative, it wouldn't look like the person.

BB: How many shots do you take for each portrait? Do you take them all yourself?

AW: Yes, I take them all. Usually about 10 rolls, about 100 shots.

BB: Do you still use the SX-70?

AW: No, I use the "Big Shot" now.

BB: What's been the general response to the portraits from the people who commissioned them?

AW: The Polaroids are really great because the people can choose the photo they want. That makes it easier. And this camera also dissolves the wrinkles and imperfections.

BB: Polaroid is like color TV in a way. It has its own idea about what blue is or what red is. It's a very subjective color that seems like it was custom made for your art.

AW: Yes, it seemed to be. But it's hard to do whole bodies with it. I haven't learned to take whole bodies with it yet. I do have a camera that can take whole bodies, though.

BB: The camera has been an essential part of your art for so long. I saw some early Campbell's soup can drawings at a Guggenheim drawing show some years ago. How did you do those drawings? Were they projected onto the paper?

AW: Yes. They were photographs that I projected and traced onto the paper. I used both slides and opaque projectors in those days. I also used a light box.

BB: Your use of photography as a direct source for images was pretty unique at that time, and is interesting to consider in view of the continued use of photographs by the Photo-Realists several years later. What did you think of Photo-Realism when you first saw it?

AW: I loved all their work.

BB: I thought your recent book *POPism* expressed the true sense of the 60s, both positive and negative. You really point out the exhilaration of that decade. In one part of the book, you say you felt like you could do anything then. You had gallery shows, made films and produced the Velvet Underground.

AW: Yes, but there are a lot of kids who are doing the same thing now. It probably will be back again.

BB: I know a young artist who does drawings, reliefs, plays in a band, and makes films and video. I don't know where he gets all his time.

AW: If you don't get so involved in business, you can have the time. Since we have a business here, I can't do all the fun things I did at one time.

BB: No more rock bands?

AW: No, we're managing Walter Steding and the Dragon People. We're doing a video promo of that right now at our studio downtown.

BB: I've seen some of Steding's portraits. He's a good painter, too. . . .

Throughout *POPism* you wonder if Picasso had heard of your work yet. Did he ever?

AW: I don't know—I never met him. We just know Paloma. Now her husband is writing the Paris gossip column for *Interview*.

BB: Since at least 1970, particularly with the *Jaggers* and *Jews*, there are some stylistic touches that bring to mind Cubism and Picasso's succinct way of drawing. Was he an influence?

AW: I was trying to do the portraits differently then. Since the transvestite portraits, I've tried to work more into the paintings. I may have been thinking of Picasso at the time.

BB: For a whole new generation of figurative artists, you're now the Picasso figure of sorts. Many young artists I speak to name you as a major inspiration. What do you think about this new image-oriented art?

AW: I like every art in New York. It's so terrific and there's so much of it.

BB: Do you have any favorite artists or galleries?

AW: There are so many artists that are so good now that it's very hard to pick out one or two. It's hard for me to go to galleries because the kids stop me all the time. There was a show at the Whitney of young artists that I liked— Lynda Benglis and the young guy who does the chairs [Scott Burton].

BB: Did you see the Times Square Show[2] last summer?

AW: No, I didn't, but I saw pictures of it in magazines and the newspaper. It looked like the early 60s—the Reuben Gallery and places like that.

BB: There's an excitement in the air that seems quite similar in spirit to the early Pop days.

2 "The Times Square Show" (1979) was considered a watershed exhibition, featuring hundreds of artists (including very early appearances by Jean-Michel Basquiat, Jenny Holzer, Kiki Smith, and others) and nightly performances. It inspired many other exhibitions in disused buildings and unconventional sites during the 1980s.

AW: It was funny then—I guess there was a different mood. Now, in New York I just notice how beautiful the people are. Since there's no war that everybody's going to, they have the pick of the best athletes, models, and actors. They always had great girl models, but now the boy models are just as good. The pick is so much better now because they're all in New York instead of in the army. Sixties actors were all peculiar-looking people and now the new stars are really good-looking, like Christopher Reeve.

BB: What about the art world?

AW: Twenty years ago was such a different time for artists, too.

BB: Now that we've come out of '70s art, artists can do paintings of people instead of putting sticks on the floor. Painting is a vital issue now, whereas 10 years ago people were talking about the end of painting.

AW: Well, *I* did. I always said that back then.

BB: Was that tongue-in-cheek, or did you really think that you had stopped painting?

AW: I was serious. We wanted to go into the movie business, but every time we went out to Hollywood nothing much ever really happened. Then I was shot. It took me a long time to get well, and at that point it was easier to paint than to try the movies.

BB: How often do you paint now?

AW: I paint every day. I'm painting backgrounds out there right now. *Interview*'s getting so much bigger that they're moving me out of the back. So I'm painting out front, and also come in Saturdays and Sundays a lot.

BB: In *Painters Painting*, the movie by Emile de Antonio, you pointed to Bridget Polk and said that she was doing all of your paintings. And then she said "Yeah, but he's not painting now." Did people call you up after that and try to return their paintings?

AW: Yes, but I really do all the paintings. We were just being funny. If there

are any fakes around I can tell. Actually there's a woman who does fakes that really aren't fakes. She's doing everybody, even Jasper Johns.

BB: So many people insist that other people do your paintings.

AW: The modern way would be to do it like that, but I do them all myself.

BB: The accessibility of your art has always been important. I can walk around the Village and see a *Jagger* or a *Mao*, or I can see a portrait retrospective at the Whitney, or see a *Kafka* or a *Buber* at a synagogue. You have such a large and diverse audience.

AW: We sell more of the Mick Jagger prints in the Village than anywhere else, which is very surprising. Nobody ever did anything about the prints. These little galleries downtown were doing more by just coming up here and getting some and putting them in the window. They look funny down there but they really sell. The tourists walk about and buy them. Castelli is going to do a retrospective of the prints sometime soon.

BB: It's good that your art can be bought by all kinds of people, at least the prints.

AW: People think that my art is so expensive, and they're amazed when they find out that they can just walk in and buy one.

BB: In the last issue of *Interview* you mentioned that you were working on a Madonna and Child series, or actually mothers with babies at their breasts.

AW: Yes, we've been renting models from an agency called "Famous Faces." You just rent a baby and a mother. I've photographed about 10 of them already.

BB: The theme makes me think back to Raphael's fat cherubs. Yours must be so different.

AW: Well, not really. They're beautiful babies because they're models and the mothers are sort of beautiful, too.

BB: I see you're doing some landscapes out there in the studio. That's an unusual subject for you, isn't it?

AW: Yes. I was commissioned to do the Trump Tower. I also did a series of ten German landmarks: houses, churches, and other buildings.

BB: It's a good idea, considering that most of your recent paintings are portraits.

AW: Well, these are portraits of buildings.

BB: You're also painting shoes now. I remember seeing an illustrated book of shoes you did before you were known as a painter.

AW: That was so long ago. Recently, someone commissioned me to do a painting of shoes. I liked it so I started doing more of them.

BB: Any other new painting themes?

AW: I'm doing knives and guns. Just making abstract shapes out of them.

BB: Like the *Hammer and Sickle* series?

AW: Yeah.

BB: What else is in the works?

AW: I'm a Zoli model now. Also, I'm doing a Barney's ad for the *Times*. I'm actually trying to get the Polaroid commercial, but that's so hard to get. And we're doing that TV fashion show once a week.

BB: Do you think you'll ever do the show you used to talk about that you'd call "Nothing Special"?

AW: The mayor's the only one who can give you a cable station. I still want to do that show, though. We'd just put a camera on a street corner. People watch anything nowadays.

BB: What American artists do you admire?

AW: I always say Walt Disney. That gets me off the hook.

BB: Didn't you once mention that you liked Grant Wood?

AW: I used to love his work. But my favorite artist now is Paul Cadmus.[3] I also like George Tooker.[4]

BB: Tell me the story of how you photographed Howdy Doody.

AW: Well, since then I've found out that there are three Howdy Doodys. The guy who owned the original brought him in here. Actually, I found somebody recently who looks like Howdy Doody and it would have been better to do him, just like the way we used Margaret Hamilton as *The Witch*, or the Santa and Uncle Sam that they always use in the ads. Everyone likes the Howdy print. But do you think people would really like to have one in their living room?

[3] Paul Cadmus. Artist, 1904–1999.
[4] George Tooker. Artist, b. 1920.

32 "A Shopping Spree in Bloomingdale's with Andy Warhol"

TRACY BROBSTON
Dallas Morning News, November 25, 1981

Andy Warhol was a world-class shopper. In 1973, when asked if he thought his art belonged in museums, Warhol responded: "Well, I thought department stores were the new museums . . . then they could sell the paintings off the walls."

He had several regular shopping routes on his way downtown to the Factory from his home on East 66th Street. On these daily trips, he would purchase anything that would increase in value, from original Walt Disney acetates to Elsa Peretti jewelry at Tiffany's; it was another part of his job. He would often stop in the 47th Street diamond district, where he became an expert at assessing the gems.

At the time of his death, every room except the bedroom and kitchen in Warhol's town house was packed to the gills with purchases made on his daily shopping expeditions; the dining room was impossible to enter due to the volume of boxes of unopened goods. In the spring of 1988, a year after Warhol died, Sotheby's auctioned off his possessions. It took more than two dozen people several months to catalogue nearly 10,000 items, ranging from valuable works of art to flea-market finds. The Warhol haul was the largest single collection sold at Sotheby's to date since its founding in 1744. It also proved to be a great popular draw: some 60,000 people visited to view the collection over a ten-day period beginning on April 23, 1988. The total sale amounted to $25,313,238.

This interview gives us a rare glimpse of Andy Warhol doing what he loved most.

—KG

NEW YORK—Andy Warhol, artist, ultimate consumer and purveyor of pop culture, describes Bloomingdale's as "the new Kind of Museum for the '80s." To find out why, we asked him to spend an hour with us in Bloomingdale's flagship Manhattan store. Andy thought it was a great idea.

THE ELEVATOR

ANDY WARHOL: So should we just go shopping?

TRACY BROBSTON: That's fine. However you want to do it.

AW: My favorite thing here is the parties they give in the different sections. The last party was in the rug room. That was for Martha Graham and Halston. I was a model in that show. It was my longest modeling assignment, eight hours. The other great party was at the hardware room.

TB: Who was that for?

AW: Uh . . . (*to Jill Glover, Bloomingdale's fashion coordinator*) uh . . . who was the party in hardware for?

JILL GLOVER: You mean on the Main Course?

AW: No, uh, it was about six months ago. Well, they give different parties in different sections all the time.

JG: They're incredible. Well, where you have to go now is the new bakery.

AW: Oh yeah. Well, we're going there first.

JG: You're gonna *die*.

AW: Is it on the first floor?

JG: Yeah. But you now have to go outside the store to get there.

AW: Oh really?

JG: Yeah, like by *Au Chocolat* (the chocolate department).

AW: But you didn't have to go outside for the bread shop before.

JG: I know, but now you do, since they built the bakery.

AW: Now you do, oh really?

JG: Well, you'll find it. Bye.

TO THE BAKERY

AW: (*To a salesgirl*) Has the bakery been moved?

SALESGIRL: Yeah.

AW: Well, how do we get there?

SALESGIRL: Through Delicacies and the Candy Shop.

AW: Oh you can walk right through it over there? Oh thanks. So can I buy some jelly for my bread first?

TB: That's fine.

AW: Is *The Dallas Morning News* going to pay for it?

TB: No, no, you have to do all the shopping yourself.

AW: So, uh, what can I get? I'll just take these two.

TB: Which ones did you get?

AW: Let's see. Uh, black currant and apricot preserve. So, here we are passing through the delicacy department, passing up the *foie gras* . . . and caviar . . . and tea . . . and pretzels. And now they have a *new* department called bread. (*Heading through the chocolate department.*) I guess you can get to it this way. Is it?

TB: I don't know. Look, they have Bill Blass chocolates.

AW: (*excited*) Oh they do? They're the *best*.

TB: Are they really good?

AW: Yeah, they're really, really, *really* good. Oh this looks terrific, this looks so great. But we've got to pass this 'cause we don't eat candy any more. We're into health-food breads. Oh look at the chocolate chip *cookies*! They look just like. . . .

TB: I think they're Famous Amos.

AW: Are they? Oh they *are*. We did a really great thing, that's what you should do, is go out to New Jersey, which is about five minutes from New York, and you can go to the Famous Amos factory and you can meet Famous Amos. There really is one.

TB: He came to Dallas once.

AW: Oh he did? Did you meet him?

TB: Just for a minute. He signed my cookie.

(In the bread department, a kilted man is holding bagpipes. Apparently, he is part of Bloomingdale's current Irish promotion.)

TB: Are you Irish? You don't look Irish.

AW: Were you in the Halston show that day?

BAGPIPE MAN: No. I'm wearing an Irish kilt though.

TB: I thought kilts were Scottish.

MAN: Well, they are, actually, but the kilt *pin* is Irish. It's Connemara marble, from my Irish ancestors.

TB: Oh. That's neat.

AW: Well, we're doing a story for *The Dallas Morning News*. So what's your name?

MAN: Darrel McClair. This is a fabulous store.

AW: Oh isn't it a great store? Are they letting you eat some Famous Amos cookies?

MAN: Yeah. I remember this store when it was a junk shop. Remember that?

AW: Really? No. When was that?

MAN: Oh, 30 years ago, you probably weren't in New York then. Well, "junk shop" is a little much but it wasn't anywhere near the pre-eminence it is now. They've done a fantastic job with this store in every way. Fantastic. Fantastic job.

TB: Well, are you working here now or just shopping?

MAN: I'm supposed to be demonstrating, but the man who's selling the shortbread isn't here and they said there's no use playing 'til he gets here.

AW: Well, I'm here to buy some Irish bread.

MAN: Really, what bread?

AW: Just, uh, that up there. Can you pull a few strings and get us the bread fast?

MAN: No, sorry, but nice to talk to you.

AW: OK, thanks. (*To salesgirl*) I wanted to get a loaf of bread like that. Do you have a big one?

SALESGIRL: This moss bread?

AW: Yeah, a big one. Oh, and a big dark bread, too.

SALESGIRL: Anything else?

AW: No, that's all. This cash?

BREAD SALESGIRL: Is this cash?

AW: Yes. It's harder to pay cash here than anywhere else in the world.

TB: In New York or Bloomingdale's?

AW: In Bloomingdale's. As soon you give them cash they don't know what to do with it. You have to have a card. I don't believe in credit cards. (*To salesgirl*) Do you have anything good to say about Altman's, I mean, Bloomingdale's?

SALESGIRL: It's a beautiful place to work.

AW: Oh really? Oh. Well, that's good. Thanks a lot. 'Bye. Now we're going to the perfume department.

TO COSMETICS

AW: Here we are passing through the smelly fish counter. They sell the best lox here and smoked salmon. It's really fresh—terrific—but let's go to the perfume department. It's too hard to shop here. There're too many people. I shop here only after I go to my gym class in the morning 'cause there aren't as many people. Then I come by here and try to get a lot of free samples. You can get your face made up, too. Do you want your face made up?

TB: No, not today.

AW: Oh, shall we go to Calvin Klein? Do you have any free samples of the new men's cologne?

CALVIN KLEIN SALESMAN: No, actually we just ran out, but if you want to wait a second I have some hidden.

AW: Oh great. I came to a lunch here with Calvin Klein when they introduced his new men's cologne. It was so exciting.

SALESMAN: (*Returning with a handful of samples*) Here you go.

AW: Oh great, thanks. Well, let's go to all the people I like best of all. Can we go to Halston?

TB: Sure.

AW: Well, actually, my favorite product, I don't know if they sell it here, is Janet Sartin. She does my face. Oh, there's something free. Are you giving away something for free?

SALESGIRL: It's for a trip to Ireland.

AW: Oh well, never mind. It's too dangerous. There's Halston. Let's take a picture. (*To Halston salesgirl*) How's the perfume selling?

HALSTON SALESGIRL: Very well. It's one of our best sellers.

AW: Oh great. Well, did anything funny happen to you today? Any big movie stars like Rex Smith come in today?

SALESGIRL: No. But I've waited on Cher Bono before. She comes in a lot. And Sylvester Stallone. I think he lives nearby also.

AW: Well, thanks a lot.

TO MEN'S HOSIERY

AW: Okay, let's blow this joint and go into the Maud Frizon shoes. Oh I have to get some Supp-hose (he calls them "suppose") first. Can I do that?

TB: Sure. What do you do with Supp-hose?

AW: Oh, I *wear* them. They keep my feet less wrinkly. Where do you think they are? Oh I know, over in men's.

HOSIERY SALESWOMAN: Who's next?

AW: I want some Supp-hose.

SALESWOMAN: (*brusquely*) What size?

AW: Small.

SALESWOMAN: What's your shoe size?

AW: Oh, uh, 8.

SALESWOMAN: Well, you need medium. I don't have smalls anyway.

AW: Okay, medium, I guess black. How much are they?

SALESWOMAN: $5.50 a pair.

AW: Well, can I have about 10 pairs?

TB: Go through Supp-hose, fast, do you?

AW: No, they last *forever*. I don't think I've thrown a pair away. It's so incredible, really, this is the first time I'm buying them in 20 years.

SALESWOMAN: Here you are.

AW: Oh, those look brown.

SALESWOMAN: No, that's just the box. They're black. Is this a charge?

AW: Cash (*pays with $100 bill*). But it's not going to take hours, is it?

SALESWOMAN: Well, I'll have to go to the service desk and change it. You'll have to wait a few minutes.

AW: It takes so long here. They take all money to the service desk. Even $20. You can't give money here, I'm telling you. They actually have to go up to the ninth floor, I think.

TB: It takes a long time at Neiman's, too.

AW: Oh, I *love* Neiman's. It's great—less people. They gave me the best party. They did it in the boiler room at the main store in Dallas. It was so exciting. (*Saleswoman returns with Supp-hose*) Thanks a lot. I have a bag.

TO MEN'S SWEATERS

AW: So where do you want to go now? Look! That's a real person sitting with those mannequins, but we just passed him by. Let's see if we can buy a white sweater. Let's see if they have those cable . . . cable, uh, what are they called?

TB: Cable-stitch?

AW: Yeah, they must be around here somewhere. Is that the movie star Meryl Streep? No, I don't think so. . . . Oh, here's the Ralph Lauren. These are the best clothes. Look at the cowboy shirts, aren't they beautiful? (*Pointing to white cashmere sweater*) Do you have this in large?

SWEATER SALESMAN: (*with a British accent*) No I don't, sir. I have medium, small and extra. Obviously this is not for you.

AW: No, it's a gift. What about these, with the sleeves?

SALESMAN: Now that I could give you in a large. How large is he? A 44? You see they come in sizes. Is he a big large or a. . . .

AW: Gosh, I don't know.

SALESMAN: How about this, does this look like him? This is about 180 pounds.

AW: Gee. You get more for your money with a bigger size, don't you?

SALESMAN: That's right, you certainly do. That's one way of looking at it.

AW: So you don't have just a large?

SALESMAN: Well, that would be a large, you see. 44 *is* large.

AW: Uh, pretty, gosh. Well, what size are you?

SALESMAN: I'm a medium.

AW: You are?

SALESMAN: Yes, I'm a skinny medium. So, is he much bigger than me, or. . . .

AW: No, I think he's about as big as you. A medium. What size is that? A 40? Does that fit you?

SALESMAN: Yes, this would fit me. In fact, it would be a little big for me because I'm a *skinny* 40.

AW: A skinny 40? How skinny are you?

SALESMAN: I'm only 162 pounds.

AW: Really? Gosh. Well, I don't know. These stretch, don't they?

SALESMAN: They do, yes.

AW: How much are they?

SALESMAN: They're $195 with the sleeves and $130 without.

AW: OK, well. I'll take this and if it's not right I'll bring it back.

SALESMAN: All right, sir, fine. Shall I have it gift wrapped?

AW: No, just in a bag.

SALESMAN: How will that be, sir, cash?

AW: Well, do you have to go upstairs?

SALESMAN: (*laughs*) No sir, we'll trust you.

AW: Well, thanks very much. Have a nice day.

TO SHOES

TB: Do you still want to go to Maud Frizon?

AW: Yeah. They are right there by the Armani. They're *really* beautiful.

Aren't they *great?* Let's take a picture. (*Kissing the shoe*) This is the picture in *Vogue*.

TB: That's going to be good.

AW: Did you hear those people that just walked by? They said "Oh, there's Andy Warhol—oh, we don't care." That's why I go shopping here.

33 "Q & A: Andy Warhol"

1985
MICHELLE BOGRE
American Photographer, October 1985

Andy Warhol recalled his attitude toward photography in 1964: "I'd gotten myself a 35–mm still camera and for a few weeks there I was taking photographs, but it was too complicated for me. I got impatient with the f-stops, the shutter speeds, the light readings, so I dropped it" (POPism, 74). He gave his camera to Billy Name, instructing him to take the pictures. By the late sixties, however, his attitude changed when he was sued by the woman who took one of the original photos of flowers that Andy had appropriated from a flower catalog for his famous Flower paintings. As a response, Warhol began taking his own photographs. By the late '70s photography had become second nature to him and he would rarely leave the house without a few rolls of film, his camera, and his tape recorder.

In 1985, upon the publication of America—a book of Warhol photographs accompanied by his observations about America—Sean Callahan, founder and editor-in-chief of American Photographer, assigned Michelle Bogre to interview Warhol about his new book. Bogre, a writer and photographer based in Miami, specialized in Q&A interviews and had a knack for getting difficult photographers such as Garry Winogrand to open up.

Although not intimately familiar with Warhol's photographic work, Bogre delved into intensive research about her subject beforehand and arrived fully armed for a face-to-face interview at the 32nd Street Factory. Warhol proved to be a tricky subject. "It was what I'd call a cat-and-mouse interview," Bogre recalls. "He was playing a game or a role but eventually, I began to wear him down because I kept coming at him with skeptical questions." She found Warhol to be "a small presence as a person, but a huge presence as an artist."

—KG

Andy Warhol's *America*, published this month by Harper & Row, is a photographic essay by one of the most well-known artists in this country. At 58, Warhol has produced a book with more than a few surprises. Coming from an artist whose prevailing expression always has been deadpan and whose dominant trait appears to be passivity, his pictures are oddly funny, touching, and sad. There are celebrities, of course (Warhol, a professional celebrity himself, has access to nearly everyone and anyone). But in *America* Warhol delights in making his famous people look ordinary. These are Pop pictures portraying the flip side of America—the downtown, underground culture—an iconoclastic view of mainstream culture. The pictures comprise an unmistakably singular vision of the United States.

American Photographer's Michelle Bogre talked with Warhol (and H&R editor Craig Nelson, who spent nearly every afternoon for two years sorting through 200,000 contact sheets) at the renovated power station on East 32nd Street in New York, which serves as the offices of Warhol's *Interview* magazine and headquarters of Andy Warhol Enterprises Inc.

AMERICAN PHOTOGRAPHER: Before we start, I want to tell you that I really like these pictures. They are very funny. I think they show a side of you that most people don't know about. How did the project evolve?

ANDY WARHOL: We took too many trips, and when we went on trips I always took the camera with me.

AP: At what point did you decide you were going to do the book and take pictures specifically for it?

AW: Half and half.

AP: What kind of camera did you take with you while you were traveling?

AW: I use a Chinon. It has automatic focus.

AP: Do you ever go out just to make photographs?

AW: No, except for this book. To get some stuff we took a $50 taxi ride to get parts of the city we hadn't seen.

AP: Why do you take pictures?

AW: I just do it because the camera is something to carry around in my pocket.

AP: How long have you been taking pictures? Not just for this book. . . .

AW: Since 1974. It was a big mistake not to have started much earlier.

AP: In your book *POPism* you wrote that you had started taking pictures in the early sixties, but that you stopped because cameras were too complicated.

AW: Yes, they didn't have the good automatic cameras then. It just takes too long to set up the other kind. I did try using a Minox because it was the smallest camera, but I had to set the focus by distance, and two out of three of the pictures would be out of focus. I love Minox cameras, though. I have about 40 of them. It's such a nice camera and takes real nice pictures.

AP: Were most of the photographs in the book taken in the past two years?

AW: Yes. This is a book about what is going on now. We wouldn't want to use faded celebrities from the past.

AP: What criterion did you use to select the 300 or so final images for the book? There were hundreds of thousands of negatives.

AW: We picked out the bad ones and left the good ones in the box.

AP: Do you think it's possible to take a bad picture?

AW: No. Every bad picture is a good picture.

AP: So every good picture is really a bad picture?

AW: Yeah.

AP: That sounds Pop. Do you think your photography is Pop photography?

AW: Well, yes. . . . Anyone can take a good picture. Anybody can take a picture.

AP: So that makes it Pop photography?

AW: Yeah. All photography is Pop, and all photographers are crazy.

AP: That includes you, then. Why are all photographers crazy?

AW: Because they feel guilty since they don't have to do very much—just push a button.

AP: Maybe they feel guilty about being voyeurs?

AW: No, only about pushing a button. Most of them don't even look.

AP: Don't you look when you take pictures?

AW: No. And with the Chinon, you can push the button more than once 'cause it just keeps going.

AP: Good pictures aren't quite that random. I don't believe you don't look, and I don't think the humor in your pictures is accidental. It's too consistent.

AW: Well, I shoot at least two rolls a day.

AP: The humor is interesting. It contradicts your image and any assumptions that you're emotionless.

AW: Oh, no! You mean the assumptions are gone? We can't have that.

AP: So you think the good ones are just good luck?

AW: Yeah, I do.

AP: Then what made you choose one bad picture over another?

AW: I didn't have anything to do with the selection . . . Actually, we tried to select best sellers.

AP: Did Craig make the initial selections for the book?

CRAIG NELSON: Yes. Then Andy would say "No, no, no, no, yes, no . . ." to my choices. I usually got approval for one picture out of nine.

AP: Do you have releases for all the photographs that went into the book?

AW: No, we had to go back and get them. That was drudgery. If we couldn't get the release, we wouldn't use the photo.

AP: What is your vision of America?

AW: It's a good vision. Actually, the best vision is on TV. I wanted to shoot all the pictures off the TV. No one would have known the difference.

AP: The book seems very patriotic. Are you patriotic?

AW: Yeah, I am very patriotic. This is a book for those who never thought they would be patriotic.

AP: It looks as though some pictures here took you to places you might not normally go, such as the Fort Worth Livestock Exchange.

AW: I went to Fort Worth to see, uh . . . the cowboys, the rodeo. The Exchange is the only other thing to do in Fort Worth. It's a very small town.

AP: Do you like to look at work by other photographers?

AW: I try to copy them.

AP: Do you have a favorite?

AW: Actually, I used to collect photos from the drugstore that people forgot to pick up. I have boxes of those.

AP: Did you try to copy any of those?

AW: No. But it's so weird to have pictures of people you don't know. The most exciting work I've seen lately are these paparazzi photos from the forties of movie stars and things that someone is printing on really good paper. They look so beautiful . . . like the greatest pictures in the world.

AP: Nowadays do you ever print your own photographs?

AW: Not now. When I first started out in New York, art was out and

photography was in, so I got a camera and set up a darkroom. But then I got some art assignments from Bonwit's or something like that.

AP: Who prints your work now?

AW: I get someone who is sort of famous as a photographer to do my printing. Then I don't know whether it's his picture or my picture.

AP: You've dabbled in all sorts of art mediums, and you've made films. Are painting and photography some sort of consistent thread?

AW: Yeah. [*He looks at his fingers, stained with black paint from the painting he was working on when we arrived at the Factory.*]

AP: Do you shoot only in black and white?

AW: Sometimes I use color film that develops itself.

AP: You don't use any other kind? It seems that color would be interesting to you since you are a painter and your sense of color is so vivid.

AW: Well, nobody is interested in color pictures, so we do black and white.

AP: So you avoid using color for commercial reasons, not artistic?

AW: Yes. Besides, I don't know what to do with those little slides. I hate them. Nobody can see them. Black and white is easier.

AP: Is it more interesting?

AW: No, it's just a record. Color makes it more like a photograph. You have to think of it as a photograph. But in black and white its just a picture.

AP: What's the difference between a picture and a photograph?

AW: A picture just means I know where I was every minute. That's why I take pictures. It's a visual diary.

AP: When you shoot alongside other paparazzi, do you consider yourself one of them?

AW: I am. I always get in because I'm with the magazine.

AP: As founder and publisher of *Interview*, you have access to almost everyone—access that most photographers would kill for.

AW: I get scared sometimes when I'm taking pictures.

AP: Scared of what?

AW: That someone might hit me.

AP: You're probably the world's least intimidating human being. Has anyone ever threatened you?

AW: I don't know. No one has ever tried to take my film away.

AP: In the book you have a section on wrestling. Do you go to wrestling matches to photograph or for fun?

AW: Oh, we go for fun. Everybody says the wrestlers don't hurt each other, but they do. Debbie Harry says that sometimes they really miss and that they like the pain. She knows all about wrestling.

AP: Did you meet the wrestlers you photographed?

AW: We went backstage. They are really adorable. They put those images on when they go onstage.

AP: Do you usually talk to the people you photograph?

AW: I only talk to the people when I have to. The other people in my pictures are miles away. These are just snapshots.

AP: When did your interest in social issues develop? That's a seldom-seen side of you that's in the book.

AW: What pictures show that?

AP: The text and pictures about the land, and the infrastructure.

AW: Meeting people in Aspen made me aware of the land.

AP: Do you still go out and do interviews for *Interview*?

AW: I don't know, maybe they dropped me; they took my name off the cover. I could do every one if I wanted to.

AP: Yes, since it is your magazine. What do you ask people?

AW: I just ask the same questions: What is their favorite color? Do they like Craig Nelson?

AP: If in the sixties, as you wrote in *POPism*, "the crazy, druggy, jabbering away and doing their insane things" inspired you, what inspires you these days, since the scene is much quieter?

AW: Oh, no, it's much more exciting now.

AP: In what way?

AW: There's more of everything. Artists are being the stars. Now you have nightclub art, video art, and late-night art.

AP: So artists are finally getting the respect and recognition they deserve?

AW: No, they're just getting the media attention.

AP: So, what inspires you?

AW: Keeping the payroll going.

CN: Staying in the papers.

AW: Not staying in the papers.

AP: You're not really interested in all the publicity?

AW: No, I never was.

AP: Come on.

AW: No, I never really wanted it.

AP: Do you consider photography a passive activity? Is that why you like it?

AW: It's not passive for the photographers who really fight to take their pictures. My God, it's really crazy. There are real fights. More and more people are beating up photographers.

AP: Do you really fight people to take your pictures?

AW: I am there in the front row, and I can't even get a picture 'cause they push me away. They are really aggressive. . . . It's sick . . . they hit each other, and they swing their camera bags. You can really get hurt.

AP: Do you carry a camera bag?

AW: No, I just carry my camera in my pocket.

AP: Then you should be able to sneak in front of those other photographers.

AW: Well, the funny thing is people get too excited and try to take all their pictures all at the beginning of an event. They just stand around at the end when, I think, you can get the best pictures.

AP: Do you wait around?

AW: I should, but I always take my pictures at the beginning. The good pictures are at 4 in the morning, and I go to bed at 11:30.

34 "An Interview with Andy Warhol"

BENJAMIN H. D. BUCHLOH
May 28, 1985
October Files 2: Andy Warhol (Cambridge, Mass.: MIT
Press, 2001)

*This interview with art critic Benjamin Buchloh focuses on Warhol's late fine
art output and gives the reader a sense of Warhol's own interpretation of his-
tory and his place in it as it relates to the contemporary art world.*

The following late works are discussed:

The Oxidation *paintings—originally called the* Piss *paintings—begun in
December 1977, were created by urinating on canvases coated with wet copper
paint. Warhol hints at his return to religious subject matter (see Paul Taylor,
"The Last Interview", 1987, p.382) when he discusses how they melted when
placed under the hot gallery lights: "Well, when I showed them in Paris, the
hot lights made them melt again; it's very weird when they drip down. They
looked like real drippy paintings; they never stopped dripping because the lights
were so hot. Then you can understand why those holy pictures cry all the time."*

In 1984, Warhol created a series of works known as the Rorschach *series,
which were large white canvases upon which black paint was poured. These
were folded in half and stretched to create wall-sized Rorschach images.*

Warhol's Invisible Sculpture *was installed at the TriBeCa nightclub Area
on May 8, 1985 as part of a group exhibition. An earlier version set up at the
Factory was comprised of various burglar alarms and their optical light beam
systems. When someone would walk into the sculpture, the alarms were trig-
gered and various sounds—chirping, booming, buzzing—would be heard.*

—KG

BENJAMIN BUCHLOH I am currently doing research on the reception
of Dada and Duchamp's work in the late 1950s, and I would like to go a

bit into that history. I read, I think in Stephen Koch's book, that in the mid-sixties you were working on a movie project on or with Duchamp which apparently has never been released. Was it actually a project?

ANDY WARHOL No, it was just an idea. I mean, I shot some pictures, but not really. They're just little sixteen-millimeters. But the project only would have happened if we had been successful at finding somebody, or a foundation, to pay for it. Since I was doing these twenty-four-hour movies, I thought that it would have been great to photograph him for twenty-four hours.

BUCHLOH You knew him well enough at the time to have been able to do it?

WARHOL Not well enough, but it would have been something he would have done. We just were trying to get somebody to pay for it, like just for the filming, and to do it for twenty-four hours, and that would have been great.

BUCHLOH So it never came about?

WARHOL No. I didn't know him that well; I didn't know him as well as Jasper Johns or Rauschenberg did. They knew him really well.

BUCHLOH But you had some contact with him?

WARHOL Well, yeah, we saw him a lot, a little bit. He was around. I didn't know he was that famous or anything like that.

BUCHLOH At that time, the late fifties and early sixties, he was still a relatively secret cult figure who just lived here.

WARHOL Even people like Barney Newman and all those people, Jackson Pollock and Franz Kline, they were not well known.

BUCHLOH In retrospect, it sometimes seems unbelievable that the reception process of Duchamp's work should have taken so long.

WARHOL But some people like Rauschenberg went to that great school called Black Mountain College, so they were aware of him.

BUCHLOH So you think that it was through John Cage that the Duchamp reception was really generated? One of the phenomena that has always interested me in your work is the onset of serialization. Your first paintings, such as *Popeye* or *Dick Tracy*, are still single images of ready-mades, and it seems that by 1961–1962 you changed into a mode of serial repetition.

WARHOL I guess it happened because I . . . I don't know. Everybody was finding a different thing. I had done the comic strips, and then I saw Roy Lichtenstein's little dots, and they were so perfect. So I thought I could not do the comic strips, because he did them so well. So I just started other things.

BUCHLOH Had you seen accumulations by Arman at that time? He had just begun his serial repetitions of similar or identical readymade objects a few years before, and that seems such a strange coincidence.

WARHOL No, well, I didn't think that way. I didn't. I wasn't thinking of anything. I was looking for a thing. But then I did a dollar bill, and then I cut it up by hand. But you weren't allowed to do dollar bills that looked like dollar bills, so you couldn't do a silkscreen. Then I thought, well how do you do these things? The dollar bill I did was like a silkscreen, you know; it was commercial — I did it myself. And then somebody said that you can do it photographically — you know, they can just do it, put a photograph on a screen — so that's when I did my first photograph, then from there, that's how it happened.

BUCHLOH But how did you start serial repetition as a formal structure?

WARHOL Well, I mean, I just made one screen and repeated it over and over again. But I was doing the reproduction of the thing, of the Coca-Cola bottles and the dollar bills.

BUCHLOH That was in 1962. So it had nothing to do with a general concern for seriality? It was not coming out of John Cage and concepts of musical seriality; those were not issues you were involved with at the time?

WARHOL When I was a kid, you know, John Cage came — I guess I met

him when I was fifteen or something like that—but I didn't know he did serial things. You mean . . . but I didn't know about music.

BUCHLOH Serial form had become increasingly important in the early 1960s, and it coincided historically with the introduction of serial structures in your work. This aspect has never really been discussed.

WARHOL I don't know. I made a mistake. I should have just done the *Campbell's Soups* and kept on doing them. Because then, after a while, I did like some people, like, you know, the guy who just does the squares, what's his name? The German—he died a couple of years ago; he does the squares—Albers. I liked him; I like his work a lot.

BUCHLOH When you did the Ferus Gallery show in Los Angeles, where you showed the thirty-three almost identical *Campbell's Soup* paintings, did you know at that time about Yves Klein's 1957 show in Milan, where he had exhibited the eleven blue paintings that were all identical in size, but all different in price?

WARHOL No, he didn't show them in New York until much later. No, I didn't know about it. But didn't he have different-sized pictures and stuff like that? But then Rauschenberg did all-black paintings before that. And then before Albers, the person I really like, the other person who did black-on-black paintings.

BUCHLOH You are thinking of Ad Reinhardt's paintings?

WARHOL Right. Was he working before Albers?

BUCHLOH Well, they were working more or less simultaneously and independently of each other, even though Albers started earlier. There is another question concerning the reception process that I'm trying to clarify. People have speculated about the origins of your early linear drawing style, whether it comes more out of Matisse, or had been influenced by Cocteau, or came right out of Ben Shahn. I was always surprised that they never really looked at Man Ray, for example, or Picabia. Were they a factor in your draw-

ings of the late 1950s, or did you think of your work at that time as totally commercial?

WARHOL Yeah, it was just commercial art.

BUCHLOH So your introduction to the work of Francis Picabia through Philip Pearistein took place much later?

WARHOL I didn't even know who that person was.

BUCHLOH And you would not have been aware of Man Ray's drawings until the sixties?

WARHOL Well, when I did know Man Ray, he was just a photographer, I guess. I still don't know the drawings, really.

BUCHLOH His is a very linear, elegant, bland drawing style. The whole New York Dada tradition has had a very peculiar drawing style, and I think your drawings from the late fifties are much closer to New York Dada than to Matisse.

WARHOL Well, I worked that way because I like to trace, and that was the reason, just tracing outlines of photographs.

BUCHLOH That is, of course, very similar to the approach to drawing that Picabia took in his engineering drawings of the mechanical phase around 1916. I wasn't quite sure to what degree that kind of information would have been communicated to you through your friend Philip Pearlstein, who had, after all, written a thesis on Picabia.

WARHOL When I came to New York, I went directly into commercial art, and Philip wanted to, too. But he had a really hard time with it, so he kept up with his paintings. And then, I didn't know much about galleries, and Philip did take me to some galleries, and then he went into some more serious art. I guess if I had thought art was that simple, I probably would have gone into gallery art rather than commercial, but I like commercial. Commercial art at that time was so hard because pho-

tography had really taken over, and all of the illustrators were going out of business really fast.

BUCHLOH What has really struck me in the last few years is that whenever I see new works of yours, they seem to be extremely topical. For example, the paintings that you sent to the Zeitgeist show in Berlin depicted the fascist light architecture of Albert Speer. When—at the height of neo-expressionism—you sent paintings to Documenta in Germany, they were the *Oxidation* paintings. Then, slightly later, I saw the *Rorschach* diptych at Castelli's. All of these paintings have a very specific topicality in that they relate very precisely to current issues in art-making, but they're not participating in any of them.

In the same way, to give another example, your series of de Chirico paintings is not really part of the contemporary movement that borrows from de Chirico; it seems to be part of that, and yet it distances itself at the same time. Nevertheless the paintings are perceived as though they were part of the same celebration and rediscovery of late de Chirico. Is this critical distance an essential feature that you emphasize, or does the misunderstanding of the work as being part of the same attitude bother you? Or is the ambiguity precisely the desired result?

WARHOL No, well, I don't know. Each idea was just something to do. I was just trying to do newer ideas and stuff like that. I never actually had a show in New York with any of those ideas. No, well, I don't know. I've become a commercial artist again, so I just have to do portraits and stuff like that. You know, you start a new business, and to keep the business going, you have to keep getting involved.

BUCHLOH Vincent Fremont just mentioned that you got a number of commissions going for corporate paintings. That's very interesting because, in a way, it leads back to the commercial origins of your work.

WARHOL Well, I don't mean that, I mean doing portraits, that sort of thing. Because, I don't know, now I see the kids just paint whatever they paint, and then they sell it like the way I used to do it. Everything is sort of

easier now, but you have to do it on and on. So those other things were just things that I started doing and doing on my own.

BUCHLOH So do you still make a distinction between commercial commissions and what you call the "other things"?

WARHOL Yes. The next idea for a show I have here is going to be called "The Worst of Warhol"—if I ever have my way with Paige [Powell], this girl in our advertising department at *Interview*. So it would just be all of those things, you know, the little paintings. Except most of those things were supposed to be in that show, but then they got a little bit bigger, and then everybody always . . . I sort of like the idea. The *Rorschach* is a good idea, and doing it just means that I have to spend some time writing down what I see in the *Rorschach*. That would make it more interesting, if I could write down everything I read.

BUCHLOH Yes, but aren't they also commenting in a way on the current state of painting, in the same manner that the *Oxidation* paintings are extremely funny, poignant statements on what is currently going on in the general return to painterly expressivity and technique?

WARHOL Oh, I like all paintings; it's just amazing that it keeps, you know, going on. And the way new things happen and stuff.

BUCHLOH But don't you think that there is a different attitude toward technique in the *Oxidation* paintings or in the *Rorschach* paintings? They don't celebrate technique; if anything, they celebrate the opposite.

WARHOL No, I know; but they had technique too. If I had asked someone to do an *Oxidation* painting, and they just wouldn't think about it, it would just be a mess. Then I did it myself—and it's just too much work—and you try to figure out a good design. And sometimes they would turn green, and sometimes they wouldn't; they would just turn black or something. And then I realized why they dripped—there were just too many puddles, and there should have been less. In the hot light, the crystals just dripped and ran down.

BUCHLOH That's a different definition of technique.

WARHOL Doing the *Rorschach* paintings was the same way. Throwing paint on, it could just be a blob. So maybe they're better because I was trying to do them and then look at them and see what I could read into them.

BUCHLOH So the shift that has occurred in the last five years has not at all bothered you? The return to figuration, the return to manual painting procedures—that's nothing that you see in conflict with your own work and its history?

WARHOL No, because I'm doing the same. . . . If only I had stayed with doing the *Campbell's Soup* well, because everybody only does one painting anyway. Doing it whenever you need money is a really good idea, just that one painting over and over again, which is what everybody remembers you for anyway.

BUCHLOH The fact that people are now pretending again that painting is something that is very creative and skillfully executed and depends on an artist's competence—I mean the reversal of all the sixties' ideas that has taken place— you do not consider that to be a problem at all? Because the statements I see in your recent paintings seem to distance themselves from all that. In fact, the *Oxidation* paintings or the *Rorschach* paintings seem very polemical.

WARHOL No, but at that time they would have fit in with the conceptual paintings or something like that.

BUCHLOH It's too bad that the *Oxidation* paintings weren't shown in New York.

WARHOL Well, when I showed them in Paris, the hot lights made them melt again; it's very weird when they drip down. They looked like real drippy paintings; they never stopped dripping because the lights were so hot. Then you can understand why those holy pictures cry all the time—it must have something to do with the material that they were painted on, or something like that. They look sort of interesting. I guess I have to go back to them. But the thing I was really trying to work on was the invisible painting, the invisible sculpture that I was working on. Did you go see the show at Area?

BUCHLOH No, not yet.

WARHOL Disco art? You haven't done disco art yet? Really good art—you should see it. It's going to be over soon. A lot of work by about thirty artists; it's really interesting.

BUCHLOH What did you do at Area?

WARHOL The invisible sculpture, but it's not really the way I had planned it. I've been working on it with the electronic things that make noises go off when you go into an area. But this one down here, it's just something or nothing on a pedestal. But Arman has a beautiful bicycle piece down there at Area. It filled one whole window, one whole window filled with bicycles. It's really beautiful. I think he's such a great artist.

BUCHLOH So you are aware of his work later on, just not in that early moment of the early 1960s accumulations. And you think that the early work is interesting as well, the work from the late fifties and the repetition of the readymade objects?

WARHOL Yes, well, that's what he always does.

BUCHLOH The earlier ones are more direct and poignant than the later work, which is kind of aestheticized.

WARHOL The earlier ones I saw were like a car. What was that, a cop car or something?

BUCHLOH He put a package of dynamite under a car, a white MG, and blew it up. There was a collector in Düsseldorf, an advertising man who gave him a commission to do a work. So Arman said, "OK, Charles Wilp, give me your white MG car," and blew it up. It's called *White Orchid*—it's a wonderful piece.

WARHOL But his work now is really great.

BUCHLOH I would be interested in discussing how you saw the subsequent development in the 1960s with the rise of minimal and conceptual art, before the rather rapid inversion of all of these ideas in the early 1980s. Do you have any particular relation to those artists that came out of conceptual art? Did you follow up on these issues? Do the

non-painterly artists who are now working interest you as much as the painters do?

WARHOL Yes, but there are not many. There are [fewer] conceptual artists around now for some reason.

BUCHLOH But at the time when conceptual art was done—people like Lawrence Weiner, for example—does that kind of work interest you?

WARHOL Yeah, that was great. But are they still working? Are they doing the same thing?

BUCHLOH Yes, they're still working; they've continued to develop these approaches. In public, you seem to support painting more than anything else.

WARHOL Oh no, I love that work. They're all great.

BUCHLOH So you don't see painting now as contrary to your own work.

WARHOL Nowadays, with so many galleries and stuff, you can just be anything. It doesn't matter any more; everybody has taste or something like that. There are so many galleries. Every day a new one opens up, so there's room for everybody. It's amazing that you can go in every category and it's just as good, and just as expensive.

BUCHLOH So you don't attach any particular importance to one principle any longer? In the sixties, there was a strong belief system attached to the art.

WARHOL In the sixties everything changed so fast. First it was pop, and then they gave it different names, like conceptual art. They made it sound like it was modern art or something because it changed so fast, so I don't know whether pop art was part of that, or whether it was something else, because it happened so fast.

BUCHLOH But the question of the original, for example—the artist as an author, as an inventor, or as somebody who manufactures precious objects—was a question that was really criticized in the sixties. You were

always the central figure in these debates, or at least you were perceived as the central figure who had criticized that notion in the same way that Duchamp had criticized it. And now things have turned around, and now it seems that this is no longer an issue at all.

WARHOL Certainly I would like to think that I could only work that way. But then you can think one way, but you don't really do it; you can think about not drinking, but you drink, or something like that. And then I hear about this kind of painting machine a kid just did, and then I fantasize that it would be such a great machine. But, you know Tinguely did one sort of like that.

BUCHLOH Yes, in the late 1950s, at the height of tachism,[1] when it became too absurd.

WARHOL I still think there is another way of doing that painting machine. This kid has done it, but it falls apart. But I really think you could have a machine that paints all day long for you and do it really well, and you could do something else instead, and you could turn out really wonderful canvases. But it's like . . . I don't know, this morning I went to the handbag district, and there were people that spend all day just putting in rhinestones with their hands, which is just amazing, that they do everything by hand. It would be different if some machine did it. . . . Have you been going to galleries and seeing all the new things?

BUCHLOH Yes, I go fairly consistently, and I have never really quite understood why everything has been turned around in that way, why all of a sudden people start looking at paintings again as if certain things never happened.

WARHOL It's like in the sixties when we met our first drag queens, and they thought they were the first to do it. Now I go to a party and these little

1 Tachism was a style of painting practiced in Paris after World War II and through the 1950s. Like its U.S. equivalent, action painting, it featured the intuitive, spontaneous gesture of the artist's brush stroke.

kids have become drag queens. They think they are the only people who ever thought of being a drag queen, which is sort of weird. It's like they invented it, and it's all new again, so it makes it really interesting.

BUCHLOH Are your TV program and your paintings, then, in a sense the extreme opposite poles of your activities as an artist?

WARHOL Yes, we are trying to do two things, but the painting is really exciting. I don't know, I'm just really excited about all the kids coming up, like Keith Haring and Jean-Michel [Basquiat] and Kenny Scharf. The Italians and Germans are pretty good, but the French aren't as good. But like you were saying about Yves Klein and stuff being. . . . But the French do really have one good painter, I mean, my favorite artist would be the last big artist in Paris. What's his name?

BUCHLOH A painter?

WARHOL Yes, the last famous painter. Buffet.

BUCHLOH Many of the new painters seem to imitate him anyway.

WARHOL Well, I don't know, I don't see any difference between that and Giacometti. Somewhere along the line, people decided that it was commercial or whatever it was. But he's still painting, and I still see the things; the prices are still $20,000 to $30,000. He could still be there. His work is good; his technique is really good; he's as good as the other French guy who just died a couple of days ago, Dubuffet. What do you think has happened? Do you think it is not that good?

35 "Andy Warhol: An Artist and His Amiga"

GUY WRIGHT AND GLENN SUOKKO
1985
AmigaWorld, January/February 1986

Warhol's infatuation with technology never let up. In the way that Norelco approached Warhol to help promote their early portable video equipment in the mid-60s,[1] the Commodore computer company in 1985 asked Andy to endorse their new graphics-savvy machine, the Commodore Amiga A1000. In return, Warhol received a machine to use in his studio.

On July 23, 1985, Commodore unveiled the A1000 at a high-profile media event at New York's Lincoln Center. As a demonstration of the Amiga's ability, Warhol was invited to create a live portrait of Debbie Harry, lead singer of the rock group Blondie, using a graphics program called Graphicraft in front of a mob of spectators. Warhol's performance was accompanied by music written on a software program called Musicraft which also ran on the Amiga.

In its day, the Commodore A1000 was a rival to the graphical user-interfaced Macintosh and had some of the most impressive audio and visual capabilities available to the home user. The machine had hardware that smoothly integrated the computer with video, creating an ideal environment for the capture and manipulation of images. But the A1000 never managed to catch the popular imagination: most retail outlets were toy stores instead of computer stores, and, priced at about $2000, it was considered too expensive for the average consumer. Commodore went bankrupt in 1994.

The following interview was conducted after the Lincoln Center event and published in the trade magazine AmigaWorld, *which ceased publication in 1995.*

—KG

[1] See Richard Ekstract's 1965 interview, "Pop Goes the Videotape: An Underground Interview with Andy Warhol.", p. 71.

Warhol Studios, New York City. Into the front to shake hands, all around.
Managers, producers, art dealers, and, in the back of the crowd, Andy
Warhol. Small, black jeans, sneakers, bright pink glasses, white hair. He
shakes hands with a quiet "Hi," then disappears somewhere into the large
building while the rest of us are taken up, two at a time, in a very small Otis
elevator to a second or third floor dining room for lunch.

The cozy affair is filled with editors from *Interview* magazine, art critics,
friends, managers, us (Glenn Suokko, *AmigaWorld's* Art Director, and
myself), and others all talking, drinking wine, sitting at some unheard com-
mand and eating. Andy drifts in quietly, sits and eats at the far end of the
table. Monosyllabic answers to questions asked by others at the table.

I ask an editor of *Interview* what questions I should ask Andy. "Is there
anything he likes to talk about?"

"That's a hard one," he says. "Andy doesn't do interviews. I'm just glad
that because he is the publisher [of *Interview*] I will never have to interview
him. I don't know what I would ask. You should ask his manager."

Earlier, I asked Jeff, an engineer from Commodore who has been
working with Andy for weeks on his new video for MTV, the same ques-
tion. "I don't know," Jeff said. "He doesn't talk much. He doesn't talk at all.
He doesn't do interviews, as far as I know. You guys are really lucky to get
an interview with him."

Finally, I ask the Commodore exec who set up the interview in the first
place. "Maybe I should ask the questions," he says. "Andy doesn't talk
much, and I have no idea how it will go."

Our photographer arrives and Glenn goes up to the video studio to help
set up lights. Lunch ends and I follow Andy upstairs to the studio.

"So you don't do interviews?"

"No," Andy says abruptly. He disappears again.

Great.

The video studio where the MTV video was put together has chairs,
equipment racks, monitors, video editing decks, cameras, lights and two
Amigas. Some paintings are brought in. Four by four foot Dolly Parton,
Punching bags. Things. Vincent Freemont, Producer for *Andy Warhol's*

T.V., has everyone sit and we preview *Andy Warhol's Fifteen Minutes (More or Less)* video for MTV. The portions done on the Amiga are pointed out. Titles and special effects. Andy has drifted in to watch.

When it is over, most of the people in the room either leave or move or remain seated. A video camera is connected to a digitizer connected to one of the Amigas, and Andy sits before it. Lights are adjusted. The camera is turned on. The software is loaded.

Our photographer begins shooting almost nonstop. He uses a camera with an auto-winder so he can click-zhhh, click-zhhh, click-zhhh as fast as he can paint and focus. He moves around the room quickly using up roll after roll of film.

No one is sure who is supposed to be there and who isn't. People wander, people sit, people talk. The engineer plugs in cables, types on the keyboard, moves and clicks the mouse, changes settings.

And Andy Warhol sits before an Amiga that is soon alive.

Images of what the video camera sees are fed into the Amiga and onto the screen. At first there are flickers of color and interference. The camera is pointed at nothing, and then (more for something to focus on than anything else) the engineer points the camera at the painting of Dolly Parton leaning against a rack filled with videotapes.

It doesn't really start anywhere. At some point tape recorders are turned on. At another point the software is working. Throughout there is the click-zhhh, click-zhhh, click-zhhh of the photographer's 35mm camera. Andy begins playing with the mouse, and the colors on the screen change with each move and click. He is intrigued with the changing colors and weird effects caused by the camera-light-software-mouse-people combination.

While waiting for the interview to begin, the interview began. More as a conversation than an interview. Andy playing with the computer image, people coming in and going out. Many people asking questions, even Andy asking questions. The photographer shooting from every possible angle in the room. The engineer constantly adjusting equipment. People doing nothing but watching the screen as the colors change or the video camera is moved or the lights are moved or as Andy tries something else.

A color painting of Dolly Parton is, at first, shades of black, white and gray, but soon is illuminated, replacing the original colors with electronic Amiga colors.

An interview with Andy Warhol, who doesn't do interviews—an artist at the Amiga launch, an artist long before Amigas. Publisher of *Interview* magazine. Involved with video, MTV, rock, films, people and things like Amiga computers.

GLENN: When did you do this portrait of Dolly?

ANDY: Last week.

GLEN: Hmmm. Look at that color.

ANDY: It would be great to just drop this color in. Oh yeah. So, do you want to ask me any questions?

GSW (GUY WRIGHT): What do you want to talk about?

ANDY: Oh, I don't know.

GLENN: Is this the greatest thing since sliced bread?

ANDY: Oh yeah, it is.

GLENN: How do you see this work being displayed? How would you show something that you create on an Amiga to the general public?

ANDY: Well, we could get a printout. I could just print this out if we had the printer.

GSW: Would you sell the prints or distribute the disk itself?

ANDY: Well, this friend of mine, named Jean-Michel Basquiat, goes to the xerox machine and puts xerox all over his paintings. So, if we had a printer right here I could do it this way and just sign it as a print. But, I guess if printers ever get really big, like a twenty by thirty or thirty by forty, then it would really be great.

GSW: So you don't see any problem? Something you do on the computer can be re-created pixel for pixel, an exact duplicate?

ANDY: Well, in prints they are supposed to be exact duplicates. So. . . .

GSW: But there is a finite number, like print number fifty-six of one hundred.

ANDY: Well, you can stop at whatever number you want. Etchings usually stop at a certain number.

[*The motorized film advancer on the photographer's camera is furiously click-zhhhing, click-zhhhing, click-zhhhing while people move around the room and Andy taps the buttons on the mouse.*]

GLENN: Could you ever imagine monitors sunk into walls in museums or galleries?

ANDY: Kids have been doing it already. The Palladium has two big square TV sets going all the time, with about 25 to 50 sets on each side. They haven't done any art yet, but it would be great to do that.

GSW: Like the Limelight with their bank of TV sets along one wall.

ANDY: Yeah, but actually Private Eyes is a video bar. [*To Glenn*] Have you been there?

GLENN: No.

ANDY: It used to be right around here. So if you have a video you want to screen down there for a party, you can. It's not a dancing place. It's just a video bar.

GSW: Do you think that might be the new wave museums?

ANDY: Well, yeah, actually, when I worked on this at Lincoln Center [the Amiga launch], it was like a museum, because we had a couple thousand people and I was working with it on the stage. It was like a museum because you could show your work.

GSW: Instant museum in a finite time period.

ANDY: Yes.

GSW: So it's not a static art?

ANDY: Jack [*Haeger, Art and Graphics Director at Commodore-Amiga*], who was working with me before, uses it more like brushes and paint.

GSW: Do you like working with it?

ANDY: I love it.

GSW: Are you going to buy one?

ANDY: Well, we already have two, so we are going to buy the printer.

GSW: You are talking about the high-quality printer?

ANDY: Well, they had the one at the launch, which was this big [*measuring four square inches in the air with his hands*]. It was really cute. Very pretty.

[*People wander about the room. There is conversation in the background. The engineer adjusts cables. The photographer loads film, shoots some more. The image on the Amiga vibrates with the changing room lighting and with the passing of people in front of the video camera angle.*]

GLENN: I like the movement.

ANDY: Well, it's not—oooh [*as the engineer moves the video camera, sending electric streaks of color across the Amiga's screen*]—it is usually still. I guess the cycle is on. Oh, that stops it. Ooh yeah, that is nicer.

[*The image settles down to crimson polarized wash of the day-glo Dolly Parton painting leaning crooked behind a bank of video production equipment.*]

GSW: Do you see this as more video-oriented, as opposed to computer-oriented?

ANDY: I think everything—anyone can use it.

GSW: Do you think there will be a rise in personal art?

ANDY: That too, yeah. [*Crimson changes to mauve to orange to fuchsia as Andy moves and clicks the mouse.*] Well, I've been telling everybody about the machine, but they haven't been able to get one yet.

GLENN: Have any of your artist friends seen the stuff that you've done?

ANDY: We had somebody come down the other day, and people heave read in magazines about the stuff we did at the launch.

GLENN: How do your friends feel about computer art generally?

ANDY: They all like it. They have been using the xerox, and they can't wait until they can use this because there are so many people into xerox art. You do it and then take the stuff to the xerox store and do the prints there. Jean-Michel Basquiat uses xerox. So, if he could be printing out on his own machine, he would be using this.

GLENN: Jean-Michel was the artist who worked with you on this? [*An illustrated punching bag.*]

ANDY: Yes.

GSW: Do you like the machine because it is so quick?

ANDY: I think it's great. It's quick and everything.

GSW: What influence do you think this will have on mass art as opposed to high art?

ANDY: Mass art is high art.

GSW: Do you think it will push the artists? Do you think that people will be inclined to use all the different components of the art, music, video, etc.?

ANDY: That's the best part about it. I guess you can. . . . An artist can really do the whole thing. Actually, he can make a film with everything on it, music and sound and art . . . everything.

GLENN: Have you been doing anything with the music capabilities?

ANDY: Not yet. We were just trying to learn the art part of it first. [*Another color change on the digitized video image of Andy's photographic painting of Dolly. Where there were reds are now blue-blacks, where there was flesh-pink there is now yellow-green.*] Oh, this is great.

GSW: Do you think the computer has a limiting effect?

ANDY: No.

GSW: Do you think it is open ended?

ANDY: Yeah. [*Andy is distracted constantly by the changing colors on the Amiga screen. The Dolly Parton portrait is color animated with each mouse move and click.*] Gee, if we had a printer now, I could just print these out and send them to Dolly Parton in all these different colors. It would save us a lot of trouble.

GLENN: Has she seen the portrait?

ANDY: No, we were going to send it out. This would be great because I could do it in green and another color.

COMMODORE EXEC: Like you did with the Deborah Harry thing?

ANDY: Yeah.

[*At the Amiga launch, Deborah Harry, singer for the group Blondie, posed before a video camera. A single black-and-white frame was frozen and transferred to a paint program where Andy filled in colors, added lines, drew with the mouse and finished in ten minutes what would have taken weeks in a studio.*]

GSW: How much time have you spent with the Amiga?

ANDY: Just the few weeks that Jack [Haeger] was here. We are waiting to get the final software. And then we need Jack back again for a couple of weeks. Has Jack discovered any new techniques?

EXEC: I'm sure he has, because the new programs have a lot of different capabilities.

ANDY: What are they? What new things have come up in the last few months?

EXEC: I haven't even seen them myself. Everyone has been working on their separate piece of the puzzle. But the last time I spoke with Jack, he asked when he was coming back here. So I know that he is eager to come back.

[*Another option of the paint program is activated and the colors cycle through the spectrum on their own with a light and color strobe effect.*]

ANDY: Oh yeah. Oh, that's weird. Oh, look at that.

GSW: Is there anything that you don't like about the Amiga?

ANDY: No, no. I love the machine. I'll move it over to my place, my own studio. That way I'll be able to do the colors. It'll be really great, and if we can get a printer, I'll do this portrait in four different colors and send them out to Dolly.

GSW: Then you see yourself using it as a major tool?

ANDY: Oh yeah. It would save a lot of time. I wouldn't have had to do all these portraits all at once. I could have just picked out the colors I wanted and sent them out, and then picked the one I wanted.

GLENN: Do you think that it will have any effect on the value of an "Andy Warhol original"?

ANDY: No, it would just be a sketch. Call it a sketch.

GSW: Do you ever see that as becoming an artwork in its own right?

ANDY: Oh yeah. Well, actually Stephen Sprouse really did most of his artwork this way. He did his last print, I think, with the planets and stuff, in this way. Beautiful things, geeze!

GLENN: Would you ever think of sending them out as finished pieces?

ANDY: Well, we are doing that already. After I did that and Stephen saw them, he showed me some of his things and they're just great.

GSW: The great thing is that you can play with all the color combinations, take a picture of the combination or make a printout and then decide which combination works best.

ANDY: Well, maybe I could take the painting up there and I could do the color variations on it. There must be a printer we could get, even the small one.

EXEC: Actually I think we have a larger printer.

ANDY: How big is it?

EXEC: Eight by eleven.

ANDY: Oh really? Could we do that maybe this week?

EXEC: Next week.

ANDY: OK. If I brought this picture up, could I just do different colors of this?

JEFF: Sure.

ANDY: [To Guy] And then you could use this in your article. You could show how I could change the picture. Do you know what day next week? Early next week?

EXEC: They're around. It's just a matter of picking one up.

ANDY: Oh. Okay.

[More adjusting of the camera and painting of Dolly. The photographer is beginning to slow down, but his camera continues to click-zhhh, click-zhhh.]

GSW: What are the things that you like the most about doing this kind of art on the Amiga?

ANDY: Well, I like it because it looks like my work.

GSW: How do you feel about the fact that everyone's work will now look like your work?

ANDY: But it doesn't. You just showed me other artists' work in the magazine [*AmigaWorld*]. It looks like the work that I started doing. I still think that someone like a decorator could use it when he wants to show somebody how their apartment would look all in blue or all in white, or . . . they could just do it so easily. Change a chair or a color.

GSW: Would you ever consider using the Amiga for "traditional" uses?

ANDY: The kids from *Interview* [*whose offices are downstairs*] want to steal it already. We just haven't given it to them.

GLENN: Do you think that you might ever use any of the pictures generated on the Amiga in the magazine [*Interview*]?

ANDY: Oh yeah. This would be a really good thing for our covers.

GSW: Do you ever play computer games?

ANDY: I'm not fast enough.

GSW: There are some slow ones. Interactive fiction. Electronic novels.

ANDY: Oh really. [*To exec*] Are the ad agencies getting the machine yet?

EXEC: You got yours way ahead of schedule.

ANDY: Oh great!

GSW: How do you feel about using the mouse instead of a paintbrush?

ANDY: I thought I would have the pen [*light pen*] by now.

GSW: Do you find the mouse a little awkward?

ANDY: Yeah, the mouse is hard. Why isn't there a pen around?

EXEC: Kurta is working on one right now, and we thought that we would have it by now, but. . . .

ANDY: Would a pen work the same way? I mean, it could even be a square pen. You could put the ball down here [*indicating the corner of the mouse*], just holding it differently. If you had a ball at the tip, you could hold it differently.

GSW: A ball point mouse.

JEFF: The one we are working on doesn't even have a cable.

ANDY: You mean just like a pencil?

JEFF: Yes.

ANDY: Oh, how great. That is going to do so much. You could trace over a picture and stuff like that?

JEFF: Yes.

GSW: With something like this [*the mouse*] do you miss getting your hands in the paint?

ANDY: No. No. It's really great not to get your hands in paint. I don't know. They always say that plastic paint is bad for you. Is this bad for you?

GSW: Nowadays they say that it is the way you sit in the chair in front of the display.

GLENN: Could you do a self-portrait?

ANDY: Oh sure.

[*The video camera is moved to point at Andy, and his face appears on the Amiga display. With Andy on the monitor and Andy in front of the computer and Dolly in the background, there is photographic temptation.*]

PHOTOGRAPHER: Could you lean forward? I want to get both you and Dolly in the same shot. [*Andy leans.*] That's excellent. That's good. Okay, thanks.

GLENN: Did Dolly Parton come to you to do the portrait?

ANDY: I did it when I went out to the Madonna wedding.

[*Back to the self-portrait. The engineer adjusts colors, levels, and gray scales until Andy is satisfied.*]

ANDY: There, that one [*indicating a straight black-and-white video image of himself*].

JEFF: Like that?

ANDY: Uh huh. [*Already working on coloring in the on-screen image of his face.*] God, isn't that funny?

GSW: If there was something that you could add to the Amiga, what would you add?

ANDY: The only thing that I would add would be the pencil [light pen]. That's the only thing.

GSW: What about working on the screen itself, with a touch screen?

ANDY: Well, that would be great. That would be good with the pencil, because you could add in the color and stuff like that, but with a sharp point, you could get the lines easier.

GSW: Have you ever done anything with computers before?

ANDY: No, this is the first time.

GSW: Why haven't you used computers before?

ANDY: Oh, I don't know. MIT called me for about ten years or so, but I just never went up . . . maybe it was Yale.

GSW: You just never thought it was interesting enough?

ANDY: Oh no, I did, uh, it's just that, well, this one was just so much more advanced than the others. I guess they started all that there, all the kids from college who went to California. Weren't they the inventors?

GSW: Do you think that computers will play a larger and larger role in art?

ANDY: Uh, yeah. I think that after graffiti art, they probably will. When the machine comes out fast enough. It will probably take over from the graffiti kids.

GSW: Do you like graffiti art?

ANDY: Oh yeah, I do. I think it's really terrific.

[*Andy becomes absorbed in the self-portrait. Adding colors, lines, filling in areas, changing things. The mouse is moved and clicked and clicked, but his eyes never leave the screen. People continue to move around the room. Some leave, some enter, most just stare at the Amiga screen while the black-and-white Warhol changes from a digitized video frame displayed on an Amiga computer into a full color self-portrait, a Warhol-painting-Warhol original. The iterations of Andy Warhol painting on an Amiga, an Andy Warhol painting of Andy Warhol sitting at an Amiga doing electronic painting become too confusing to follow. Vince Freemont, producer of* Andy Warhol T.V., *enters and stares with the rest of us.*]

VINCE: You want some air conditioning in here?

JEFF: I turned it off, because of the fan.

VINCE: How about opening the door?

JEFF: Fine, thanks.

[*Squeak—door opening—crash, rumble-rumble, metal door rises.*]

VINCE: [*Stepping outside onto the roof*] I love these skylights.

ANDY: [*Rising for a moment to look outside. The image of his face on the screen, partially colored, stares at an unseen monitor.*] They were supposed to be party tables.

VINCE: Those skylights are being knocked down now.

ANDY: Are they? [*He steps outside.*] Again?

VINCE: People from the other buildings throw stuff on them, and since they put in the wrong weight of glass, they have a tendency to break.

ANDY: I haven't seen the back in a long time.

VINCE: Okay. Everybody go outside and take a break for five minutes. Is that roll up still there? Andy? Andy? Andy?

[*Andy returned and the self-portrait was finished. People wandered off. We had to leave. Other interviews. Other. . . .*]

36 "Andy Warhol"

JORDAN CRANDALL
1986
Splash No. 6, 1986

In his diary entry for May 22, 1986, Andy Warhol wrote "I just read the inter-view the guy from Splash *magazine did with me and I don't know how he made it so good because I wasn't so good when he was doing it" (Diaries, 734).*

Edited with a light but adept hand, Jordan Crandall stitched together a series of phone conversations conducted in the late afternoons over the course of a week for this lengthy interview. As evidenced by the text, Warhol was very deliberate in his choice of words. "Andy was very slow to answer and always trying to turn the tables," says Crandall. "The conversation was generally easygoing, but with many lulls. Warhol would become distracted and want to end the conversation for the day."

Crandall, then in his early 20s, was living in Sarasota, Florida when he started Splash, *an art and culture magazine. Crandall wrote requesting the interview but never got a firm commitment from Warhol's staff. Unan-nounced, he made a trip to New York, showed up at the Factory and requested to meet Warhol. "I was left alone in the office for a few minutes, and then Warhol suddenly appeared like a ghost," recalls Crandall. "I think he admired my determination in getting the interview, so he said he would do it." Warhol set the terms: "He didn't want to conduct it in person; he wanted to do it over the phone because he said that's what he was most com-fortable with."*

Soon after the interview was complete, Crandall moved to New York and Splash No. 6 *was published. Crandall arranged for Robert Mapplethorpe to photograph Andy for the magazine; a striking Mapplethorpe portrait of Warhol graced* Splash's *cover.*

The magazine produced four more issues and folded in 1989.

—KG

ANDY WARHOL: Did Ultra Violet tell you that she was eating gold and she almost died? She was eating pounds of it a day.

JORDAN CRANDALL: Really?

AW: Someone told her to eat gold so she was eating it by the handful.

JC: What did you eat for lunch today?

AW: Fish. And a piece of bread.

JC: Do you eat fast food?

AW: No, I eat food fast.

JC: You're into health foods.

AW: Yes, but I eat health foods fast.

JC: What is your typical breakfast?

AW: Seven grains. Apple pie. Twenty vitamin pills. Carrot juice. And I'm a wreck.

JC: You're pretty healthy.

AW: Not really. I try to stop eating candy.

JC: Do you keep healthy creatively?

AW: No. These two great kids who have a book *Positive Thinking* have caught me being unpositive a couple of times.

JC: You do think positively then.

AW: Not consciously but I try to.

JC: You don't dwell on the negative things.

AW: I don't know what negative things are.

JC: What is your favorite vice?

AW: *Miami Vice.*

JC: What kind of exercise do you do?

AW: Free weights.

JC: Three weights?

AW: No, free.

JC: Sit ups? Push ups?

AW: Twenty push ups.

JC: Every day?

AW: Yes.

JC: Do you look at yourself in the mirror?

AW: No. It's too hard to look in the mirror. There's nothing there. We have a good mirror here, though. It's one of the ones that make you look tall and thin. One of those dime store mirrors.

JC: Do you think the preoccupation with the physical is good?

AW: Well, not mine. Everybody else, yes.

JC: The Andy Warhol exercise program would consist of. . . .

AW: Just getting up, about the most exercise anybody can ask for. Getting up and out.

JC: What do you think about when you exercise?

AW: Nothing. Same thing I think about before.

JC: Do you get lost in your reveries?

AW: I don't really have a memory.

JC: Do you dream?

AW: No.

JC: Do you have any secret fantasies?

AW: No.

JC: What makes you happy?

AW: Being able to get up in the morning. How are things in sunny Florida?

JC: We're having a cold wave. The oranges go into shock and fall off the trees.

AW: Do you drink a lot of orange juice?

JC: California orange juice.

AW: Are there a lot of orange trees?

JC: Yes.

AW: I never see any orange trees when I go to Florida.

JC: Where do you go?

AW: Palm Beach, Miami Beach.

JC: Well, you'd rather see people than oranges.

AW: No, I'd rather see oranges. Where do you see the oranges?

JC: In the rural areas. You can fly over them and see them for miles.

AW: Oh you can really?

JC: Do you get depressed in New York?

AW: No. Do you get depressed in Florida?

JC: Yes.

AW: Why? You have funny looking old people.

JC: Do you ever go to the beach?

AW: No.

JC: Never?

AW: Well, I go to the beach to take photographs of the people on it.

JC: What do you wear?

AW: An umbrella.

JC: Bathing suit?

AW: No, umbrella.

JC: What is your favorite thing to wear?

AW: I just wear the same thing every day.

JC: Are you an impulsive shopper?

AW: Yes.

JC: Clothing?

AW: I buy anything. But I can't wear anything. I just put it in the closet. I wear Stephen Sprouse black pants, black T-shirt, black turtleneck, black shirt, black leather jacket and Adidas shoes.

JC: What is your style?

AW: Anti-fashion.

JC: Would you call your art anti-art?

AW: No, it's any art.

JC: What would you like to do that you haven't done?

AW: Like what?

JC: Oh, go in a spaceship, elevate the consciousness of people in Third World countries, play basketball. . . .

AW: They all sound pretty good.

JC: If you were given three wishes, what would you wish for?

AW: The first wish would be to be able to wish.

JC: Do you think there is life on other planets?

AW: Oh yes, I believe there are people out there.

JC: I wonder what they'd be like.

AW: They'd be different. I like the idea of those power stations where you can go and get powered up. I do believe in that. Walking in other people's bodies. They're called walk-ins.

JC: What do you think people from another planet would look like?

AW: I think there are a lot of them down here. Walk-ins. People who just walk into other people. They're here already.

JC: You don't know they're here?

AW: No, you don't.

JC: What happens to the people who were there before?

AW: They decided to give up but they didn't want to give their bodies up. So somebody just walks in and takes over.

JC: Do they ask?

AW: No, one day you just wake up and you're a new person again.

JC: You talk about how you'd like your tombstone to be blank. Wouldn't you really love a mausoleum, a crypt, something slightly monumental?

AW: No. I think the best way is to be disintegrated by a ray gun. Without smoke or anything. There are just those little stars that sort of just flicker away.

JC: I don't like those little stars.

AW: I was just reading *The Examiner,* my favorite newspaper; a story called "Life After Death."

JC: They have a lot of UFO stories in there.

AW: Yes, those are good. Those are my favorites.

JC: Have you ever seen a UFO?

AW: I'd love to see one. Have you seen one?

JC: No. I'd love to meet someone from out there. Did you read in *The Enquirer* about the top US Senator who saw two UFOs and Washington kept it under wraps for thirty years?

AW: Really?

JC: They just came public with it.

AW: Which senator?

JC: I don't remember. He's dead now, though. It's great that it was a senator, because it's usually farm people.

AW: Which issue is this?

JC: The newest one.

AW: With Don Johnson on the cover?

JC: Yes, that's the one.

AW: He just called and wants me to be on *Miami Vice.* But I don't know, I have so much work to do.

JC: Would you play a good guy or a bad guy?

AW: Bad guy. My acting is so bad I can't believe they would ask me.

JC: What are your favorite TV shows?

AW: The rerun of the 11:30 news at 1:30 is my favorite favorite.

JC: Do you watch soaps?

AW: Just the nighttime soaps. They're richer. In daytime soaps they don't have maids any more. They're too normal. They just have sex. They have normal clothes.

JC: What else do you watch?

AW: I watched the Donahue show and they were wondering whether or not retarded people should be allowed to have television. It was really interesting. I like to watch daytime television at night.

JC: Do you speed through the commercials?

AW: No, I love them. I speed through the show.

JC: What is your day like?

AW: I sleep with the television on. I wake up two or three times to go to the bathroom. I watch TV and get up at 7:30. I watch more television. MTV. I walk to work. I work until 9:00 and then try to go to a movie. Last night I went to see the movie that was eight hours long but we only got there for the last hour. They charged us forty dollars anyway. It was really interesting.

JC: What was it about?

AW: The Warsaw ghettos.

JC: What kind of films do you like?

AW: I like comedies. I like to see kid movies.

JC: What is your favorite movie?

AW: Just the last one I've seen.

JC: What movie do you wish you were in?

AW: A walk-on on *Citizen Kane*.

JC: Who is your favorite comedian?

AW: Whoopi Goldberg.

JC: Did you see *The Color Purple*?

AW: Yes.

JC: Did you cry?

AW: Almost.

JC: Do you cry?

AW: No.

JC: Do you like horror films?

AW: Yes, a lot. Do you?

JC: Yes. I like vampires. Do you scare easily?

AW: Yes, I scare all the time.

JC: Are you scared of the dark?

AW: Scared of the dark, scared of the light. . . .

JC: Have you had any scary experiences?

AW: Walking down the street.

JC: Can you think of one that's scarier?

AW: No. It could happen later.

JC: Your life story, with Tab Hunter starring, would be a comedy? Romance? Drama?

AW: To make it interesting it would have to be a comedy.

JC: Would it have a happy ending?

AW: Every movie has a happy ending.

JC: Who would direct it?

AW: Kurosawa. And they'd all be wearing Japanese outfits. I could just sit there watching it rock.

JC: Are you satisfied with your life?

AW: I don't think about that.

JC: Have you ever thought about writing your life story?

AW: No.

JC: Would you let someone else write it?

AW: No.

JC: If someone had to write it and you had no choice, who would you want to write it?

AW: Stephen Saban.

JC: Do you believe in destiny?

AW: What does destiny mean? It happens all by itself?

JC: It's planned.

AW: You're just at the right place at the right time.

JC: Do you believe in. . . .

AW: Life after death?

JC: How did you know I was going to say that?

AW: Do you believe in Santa Claus?

JC: You knew what I was going to say. You might be psychic.

AW: No, I'm not really.

JC: If you were psychic, what would you predict for the future?

AW: That the world is round.

JC: What would you predict for America?

AW: That it will be around for a while.

JC: What do you like most about America?

AW: Traveling around the country: one day trips, and coming back the same day. It's really fun.

JC: What do you like most about American culture?

AW: Most everything's free. Do you paint?

JC: I painted my walls the other day.

AW: That's what I want to do. I think that's the best artist, a wall painter. My favorite painting is when they spackle. That's the look I like. And the next year paint over that. That's the look.

JC: Do you collect art?

AW: I like everybody's art.

JC: You think we're going in a good direction?

AW: Yes, it's just terrific now.

JC: Why do you create?

AW: I don't know. We have this building.

JC: If there were an Andy Warhol museum, what would it look like?

AW: Neiman Marcus. Lots of clothes, jewelry, perfume.

JC: Would it be in New York?

AW: No, down south. Houston.

JC: Do you like Texas?

AW: Yes, I love Texas.

JC: Everything is so big in Texas.

AW: Yes.

JC: I'm looking forward to seeing the Campbell's soup boxes. We don't have them in Florida yet.

AW: It's pretty good soup, there are no preservatives or anything like that. You'll have to come and paint some canvases with me sometime. If you can paint walls you can paint canvases. It's real easy. Do you have a dog?

JC: No. You have two, right? Fame and Fortune?

AW: Yes, and Amos and Andy.

JC: Do you like children?

AW: Yes, I think they're cute.

JC: You don't want to have any, though.

AW: No.

JC: Did you have a happy childhood?

AW: Yes.

JC: Have you ever thought of marriage?

AW: I'm too young for that. Where are you from?

JC: Detroit.

AW: Did you work in the auto factories?

JC: No.

AW: You didn't? That's so artistic. I think Detroit is one of the most exciting places I've ever been to. Everybody is so big and beautiful there. Everybody's so big.

JC: Bigger than Texans?

AW: Yes, they're bigger in Detroit.

Ming Vase, the bodyguard, enters.

MING VASE: Hello. I'm Ming Vase.

JC: Hi. Are you fragile?

MV: Not really.

JC: Does anyone threaten Andy? Does he have threats on his life?

MV: No, just on his aura.

JC: So you protect him from himself.

MV: Yes! The myth from the truth.

JC: We'll never get anywhere with you here. Are there ever any problems?

MV: No, it's always smooth.

JC: Andy doesn't get into fights or into trouble.

MV: No.

JC: He's like Switzerland.

Andy returns, Vase breaks.

JC: Who attacks you?

AW: Think positive! Who attacks you? That was Ming Vase the bodyguard. Drag queen by night, bodyguard by day.

JC: I really liked your book *America*.

AW: Oh, you did?

JC: Yes. It seems from the book you're becoming more opinionated.

AW: We had to fill the pages up.

JC: Do you go to beauty salons?

AW: I used to. I used to have so much paint in my fingernails. There was a wonderful Russian lady who used to do them.

JC: Have you ever been to Russia?

AW: No.

JC: Do you want to go?

AW: No.

JC: Why? Too scary?

AW: No, too far. I'd rather go to Kansas City.

JC: Are you more left-wing or right-wing?

AW: I don't have any wing.

JC: Do you think the negotiations with Russia are good?

AW: It keeps a lot of people busy.

JC: Have you thought of going into politics?

AW: You have to be a lawyer to study politics.

JC: You do?

AW: I don't want to have to go back to school.

JC: You could have a great political campaign. Do you like Reagan?

AW: Yes, he's pretty good.

JC: Nancy Reagan?

AW: Yes, I've met her at the White House. She's wonderful.

JC: Would you like to be sainted?

AW: Painted?

JC: No, sainted. Saint Andy.

AW: No, you have to be on your knees all the time.

JC: What color are your walls?

AW: My walls are off-white.

JC: What kind of a bed do you have?

AW: I have a cornball bed. Four poster, 1830 or something. It's ugly. There's a canopy on it.

JC: Satin sheets?

AW: What's that?

JC: Do you cook in your kitchen?

AW: Yes, I cook in my kitchen.

JC: What do you cook?

AW: Seven grain.

JC: Hot cereal?

AW: Hot cereal, but you can eat it all the time, like brown rice.

JC: In a microwave oven?

AW: No, I wish I had one.

JC: What does your place look like?

AW: It's messy.

JC: Paper, clothes, paint. . . .

AW: Candy.

JC: You don't have a maid?

AW: I don't like that word *maid*.

JC: Servant?

AW: No.

JC: Serf?

AW: Ming Vase is a serf. No, he's a drag queen.

JC: If you had a car, what kind would you have?

AW: One with good brakes.

JC: Dodge Dart? Mercedes? Honda Prelude? Cadillac? Jeep?

AW: I guess the Honda Praline.

JC: If you had a custom license plate, what would it say?

AW: BATMOBILE.

JC: What is your favorite number?

AW: Zero.

JC: Have you ever been into numerology or astrology? Psychic things?

AW: I knew a psychic but I decided to know him socially instead. Do you go to psychics?

JC: On occasion. What sign are you?

AW: I'm a Doras.

JC: What are Dorases like?

AW: I don't know. I can't figure out other Dorases.

JC: Are there common attributes?

AW: I don't know any other Dorases.

JC: What is your favorite sign?

AW: Taurus.

JC: Why?

AW: They're beautiful people.

JC: Tauruses are supposed to have a lot of sex. Multiple orgasms.

AW: Multiple orgasms, really?

JC: Yes.

AW: I guess I don't know any then.

JC: What is your favorite color?

AW: Black.

JC: Is that the absence of color or all colors?

AW: No, it has all colors in it. White is my favorite color.

JC: Which is your favorite color—black or white?

AW: Black is my favorite color and white is my favorite color.

JC: Have you ever been into a consciousness-raising thing like EST?

AW: No.

JC: TM?

AW: No, TV.

JC: You've never felt a need to elevate your consciousness.

AW: We have an elevator. I go to crystal doctors. They throw some crystals on you and you feel better.

JC: Powdered crystals?

AW: Sometimes.

JC: Do you lay there?

AW: Yes, I lay there. They put crystals on the hands, the body.

JC: Have you ever been in an isolation tank?

AW: No, but I saw John Denver's. It was pretty nice.

JC: I saw an ad for one that looks like a couch. It's a living room sofa and you just lift up the cushion and crawl in.

AW: What is it like going in a tank? Is it like going deep-sea fishing?

JC: Do you fish?

AW: No, I don't fish. My nutritionist has a lot of fish.

JC: Do you wear cologne?

AW: Do you wear cologne?

JC: Kouros.

AW: Because of the ads?

JC: That's part of it.

AW: They have the best ads. I try to wear Aramis, and the girls' perfumes. My favorite right now is called "Beautiful" by Estée Lauder.

JC: If you were doing cologne, what would the bottle look like?

AW: I did one years ago. I did a perfume in a Coca-Cola bottle.

JC: It was called. . . .

AW: Urine. The new one I was going to do was called Stink.

JC: What would the bottle look like?

AW: It would look like the stuff you use to spray the bathroom walls with.

JC: What about an Andy Warhol watch?

AW: I was asked to do a watch. I didn't do it.

JC: You could do one that would just tell daytime and nighttime.

AW: The one I have now is pretty big. It's digital, about two inches by three inches.

JC: That's great. You can see it from far away. You can see it from across the room.

AW: It's the Palladium watch by Watchez.

JC: What about clothing?

AW: I just went to all the Italian men's fashion shows. It was really exciting. They had all this stuff by Gianfranco Ferré and it was really great.

JC: Do you like to go to Europe?

AW: Yes.

JC: What is your favorite city in Europe?

AW: Venice.

JC: Do you like the Italians?

AW: Yes.

JC: Do you like the French?

AW: They're okay.

JC: Do you speak any other languages?

AW: No. I've been going to Paris for about twenty years and I can't even speak one word of French. I got away with it though.

JC: You can say yes or no. . . .

AW: Not all the time.

JC: You prefer America.

AW: No, I like every place.

JC: Where do you travel?

AW: I like to travel from the first floor to the fifth floor.

JC: Where other than New York?

AW: LA is my favorite place.

JC: Have you thought of moving there?

AW: We tried to.

JC: What do you like most about LA?

AW: I like Melrose. It's so grand to say you have a car without a top.

JC: A topless car.

AW: Yes, topless. Holly Woodlawn called and I was taping her on how she came to New York from Florida. She left Florida a boy and by the time she got here one year later she was a full-fledged girl. She put on a pair of stockings in Florida. Plucked her eyebrows in Atlanta. Stopped off at another bus stop in Baltimore and bought a skirt. Did you check your coins today? They may be worth ten thousand dollars.

JC: Do you like to gossip?

AW: Yes. Do you have any?

JC: No, but I'm sure you do.

AW: You have better gossip than I do.

JC: No. I like to hear gossip.

AW: What is your best friend doing? Tell me, then everyone will read about it.

JC: I'll fill it in.

AW: No, tell me and then they can read about it.

JC: If I tell you about my best friend will you tell me about your best friend?

AW: I don't have a best friend.

JC: Do you have a close friend?

AW: No, I don't really have a close friend.

JC: What about Ming?

AW: No, he's just a drag queen by night and bodyguard by day. So come on, tell me about your best friend. He can get written up.

JC: I'll fill it in.

AW: No, I've got to know to see if it's right.

JC: How would you know if it's right?

AW: If it sounds peculiar enough, it's right. So what happened?

JC: With what?

AW: Your best friend.

JC: When?

AW: Tell me about yourself then.

JC: I'll tell you about myself if you tell me about yourself.

AW: I asked you first.

JC: I can tell you about myself first and then you won't tell me about yourself.

AW: If you tell me about yourself I might tell you about myself.

JC: What do you want to know?

AW: Well, you just start. Just talk.

JC: Ask me a question.

AW: Oh, come on. You can do it.

JC: Okay. I got an invitation yesterday to the grand opening of McDonald's new double drive-thru window.

AW: Do you have to wait in line?

JC: Yes. It would be great if you had a drive-up gallery. You could order through the speaker.

AW: They have drive-up churches.

JC: Do you drive up to the window and they give you alms?

AW: I guess.

JC: What are you doing tonight?

AW: There are so many things I can't do any of them.

JC: What?

AW: There is a screening for *9 ½ Weeks* which I can't go to. Yoko Ono asked me to dinner and I'm not sure I can make it. I have an appointment. David Letterman is having a party for his four years on TV.

JC: What is an ideal party for you?

AW: If it's easy.

JC: Simple?

AW: Yes.

JC: Do you have any favorite parties?

AW: Just something different from the last one. What did you do last night?

JC: I went to an opening of Syd Solomon's. Then a party afterwards. John Chamberlain was there.

AW: Oh really?

JC: He asked about you.

AW: Oh really? He's great. All my friends have left town. Keith Haring's gone to Brazil, Kenny Scharf's gone to Brazil, everybody's gone away.

JC: You have good friends. Who do you reveal yourself to?

AW: I don't have anything to reveal.

JC: Who is your best friend?

AW: Everybody's my best friend.

JC: Who is your favorite friend?

AW: My Reebok shoes are great. I'm not wearing them today. I'm wearing my Aspen shoes.

JC: What about a person? Who are you closest to?

AW: J & B.

JC: J & B Scotch?

AW: Um. . . . That's a good answer.

JC: You don't drink Scotch, do you?

AW: No, but that's a pretty close friend.

JC: What do you do with it?

AW: Use it as perfume. I sprayed myself with Absolut this morning.

JC: Who is your favorite person to talk to?

AW: My two dogs, Fame and Fortune.

JC: Do they answer?

AW: Sometimes they bark. At the ASPCA dog show we had to pick the dog that went to entertain troops at the hospitals.

JC: What do you talk to your dogs about?

AW: I talk to them in dog talk, so . . . you can't understand it.

JC: What do you do?

AW: I whine.

JC: You what?

AW: Whine.

JC: What do you feed them?

AW: Dry dog food. The kind you add water to. Do you drink?

JC: Yes. Do you?

AW: I drink tea.

JC: Milk?

AW: No, I don't like milk.

JC: Coke?

AW: No. Just Diet Coke.

JC: Champagne?

AW: No.

JC: What do you drink at dinner?

AW: Tea.

JC: You like to go out to dinner.

AW: Yes, because New York has a new restaurant every day.

JC: Who is your favorite dinner companion?

AW: The TV.

JC: Do you eat TV dinners?

AW: I had my first TV dinner last week. It was Cajun. Cajun TV dinner.

JC: What is your favorite frozen food?

AW: Raspberries. Frozen peas.

JC: What is your favorite canned food?

AW: Spam.

JC: What do you like about it?

AW: The can. I like Poppycock, too. That's my favorite canned food.

JC: Do you have hobbies?

AW: Taping and typing. Looking and listening.

JC: You type?

AW: Yes, with one finger.

JC: What kind of music do you listen to?

AW: Any kind of music. I usually watch TV. I love all music. Classical, country, opera, everything.

JC: What is your favorite band?

AW: The last one I've seen. Let's see—The Residents.

JC: Do you dance?

AW: No. Do you?

JC: Yes.

AW: Can you dance for four hours straight?

JC: Oh, yes. Why don't you dance?

AW: I don't know. I don't have any soul.

JC: You like to go out.

AW: Yes, but just for a few minutes.

JC: Then go somewhere else?

AW: Home.

JC: And watch TV?

AW: Yes.

JC: What do you read?

AW: *The Enquirer, The Examiner* and *The Globe.*

JC: Do you like the sensationalism?

AW: No, I like the photographs. Do you read *Eagle Magazine*?

JC: No. Do you?

AW: Yes, I do. How about *Guns In Action*? Do you read that?

JC: No.

AW: They're really good magazines to read. How about *Soldier of Fortune*?

JC: No.

AW: I get those weekly.

JC: You don't like guns, do you?

AW: Yes, I think they're really kind of nice.

JC: Do you have a gun?

AW: No, I don't have a gun.

JC: Do you believe in self-defense?

AW: I guess so, for people who can do it.

JC: Karate?

AW: Yes, I think it looks beautiful.

JC: Can you do it?

AW: No, I don't do it. I wish I could. I can barely get up in the morning.

JC: You have your bodyguards to defend you.

AW: My bodyguards? Well, they're drag queens, so I don't know how they could really watch my body.

JC: Who is your favorite aristocrat? Do you like Princess Diana?

AW: Yes, I think she's great.

JC: The Queen Mother?

AW: Yes, she's pretty good. Do you know any queens?

JC: I have a great chess set.

AW: Chest?

JC: Chess.

AW: They used to make chess sets out of Ivory Soap. It floats.

JC: Did you ever enter Ivory Soap contests?

AW: Yes, but I never won.

JC: What kind of soap do you use?

AW: I'm into liquid soap. I just got really excited about it, so I went to B. Altman's and got four big bottles of it, plastic bottles, really cheap.

JC: What scent?

AW: Sandalwood, but they all smell alike.

JC: If you had a half an hour shopping spree in any store, which store would you pick?

AW: The Emporium. They have everything and they're open 24 hours. It's really great.

JC: If you had a half an hour shopping spree in Neiman-Marcus what would you buy?

AW: Popcorn without the added yellow. When are you going to start making movies?

JC: I'm doing a video magazine that's sold at newsstands.

AW: That's a good idea.

JC: Do you oversee everything in *Interview*?

AW: Sort of.

JC: Do you give yesses and nos?

AW: I guess so. Sometimes.

JC: Who was on the first cover of *Interview*?

AW: I don't remember. Marilyn Monroe or Racquel Welch.

JC: How long ago was that?

AW: Sixteen years ago. They took my name off the cover so it would sell more copies.

JC: Did you do a lot of the work yourself in the beginning?

AW: Gerard Malanga did.

JC: What were your ambitions when you were starting?

AW: I never had any.

JC: Did you want to make money?

AW: Just to pay my rent.

JC: What's the most exciting thing that's happened to you this week?

AW: Talking to you.

JC: Do you like interviews?

AW: Yes.

JC: Yes?

AW: No.

JC: No?

AW: No.

JC: Yes and no?

AW: Yes.

JC: Do you like everyone?

AW: Yes.

JC: Why do people like you?

AW: Not everybody does. Somebody threw a banana at me at the Sugarreef.

JC: A real one?

AW: It was a plastic banana.

JC: Does anything intimidate you?

AW: Young rich kids. What are you wearing today?

JC: Kouros.

AW: It's warmer here today.

JC: It's great.

AW: Did you get any fan mail this week?

JC: Letters. Do you get letters?

AW: Yes, I'm going to read some right now.

JC: Fan mail?

AW: Yes, a lot of fan mail.

JC: Do you get hate mail?

AW: Some.

JC: Death threats?

AW: Not yet.

JC: What fan mail did you get today?

AW: There are a couple of fan letters here.

JC: What are they?

AW: Just fan mail.

JC: What do they say? Do they say how much they love you?

AW: No, they just want jobs

JC: What do you like most about being famous? Good tables?

AW: No, I don't get good tables. I have to wait in line to see a movie.

JC: What would the ideal person be like?

AW: The ones I know are really ideal.

JC: Money? Appearance? Brains? Charm?

AW: Yes, all that.

JC: Would you put these in any certain order?

AW: You have the right order.

JC: Money first?

AW: No.

JC: How do you spend your holidays?

AW: Working.

JC: What is your favorite holiday?

AW: I like the new one they just did.

JC: Which one?

AW: Martin Luther King Day.

JC: Who makes holidays?

AW: People do.

JC: Valentine's Day is coming up.

AW: Are you getting anything?

JC: Chocolate. Are you getting anything?

AW: I don't know. It goes by so fast. We're working on May now.

JC: Do you get lots of presents at Christmas?

AW: No.

JC: Do you give presents?

AW: I try to.

JC: What is your favorite gift to give?

AW: The same thing I gave last year.

JC: What is that?

AW: I don't know. Whatever I gave, I just usually give that.

JC: What is your favorite gift to get?

AW: The same thing I give.

JC: How have you changed in the last ten years?

AW: I haven't. I have these time capsules. All the mail I get and things I mark the date on and store down in the basement. I do twenty of them a year.

JC: What would you like your famous last words to be?

AW: Goodbye.

JC: Do you think it's bad that it's not who you are but what people think you are?

AW: No. Have you been to an analyst?

JC: Yes.

AW: What do you talk about?

JC: Yourself. He helps you deal with things.

AW: Did you entertain him?

JC: No, you have to be real.

AW: You didn't entertain him at all?

JC: No, it doesn't work then. You're paying him.

AW: What was your problem?

JC: I don't remember. Have you been to one?

AW: I've sat in on a session with Truman Capote.

JC: What did you think about it? You have to really reveal yourself.

AW: You do?

JC: You have to trust him.

AW: Did you trust him?

JC: Yes. But I wonder if they talk about it.

AW: All psychiatrists I know talk about it. What did you tell him?

JC: You just lie there and talk. Do you think people think you are boring?

AW: Yes, they do.

JC: Then why are they interested in you?

AW: After they meet me they say "Oh my God, how boring."

JC: People are interested in you.

AW: No, they're really bored. Have you started sculpting yet?

JC: No.

AW: Knitting?

JC: No. Why knit?

AW: Why not?

JC: Do you knit?

AW: No. Do you?

JC: No. Why do you ask?

AW: Seems like good knitting weather.

POSTSCRIPT

AW: Did you get the pictures yet?

JC: Yes! They're great.

AW: Is my hair too flat?

JC: No, it's sticking up wonderfully.

AW: Are you going to do them really big or small?

JC: Big.

AW: Oh, great. You should put yourself on the cover.

JC: I want you on the cover.

AW: We can both be on the cover.

37 "The Last Interview"

PAUL TAYLOR
Flash Art, April 1987

Andy Warhol was a devout Catholic all his life, attending a church near his Upper East Side town house most Sundays when he was not traveling. In April of 1980, he met Pope John Paul II at the Vatican; on Christmas Day in 1985 and again on Easter Sunday in 1986, he served dinner to homeless people at Church of Heavenly Rest on the Upper East Side. Over the years, religious subject matter appeared in his art works: he painted the Mona Lisa *in 1963, and had appropriated a detail from Leonardo's* Annunciation *for his 1984 print series* Details of Renaissance Paintings.

In 1986, Warhol was commissioned by Alexandre Iolas (the famous art dealer who gave Andy his first show in New York in 1952) to do a series of works based on Leonardo da Vinci's Last Supper *and offered to show them at a gallery in Milan, Italy across the street from the church of Santa Maria delle Grazie, which houses the original painting. Warhol agreed and went to work on the series based on a plaster kitsch reproduction of the scene that he found, according to various sources, either at a gas station on the New Jersey Turnpike or at a tourist shop in Times Square. He did both hand-painted and silkscreened paintings, but ended up showing only the screened works in Milan.*

The show opened on January 22, 1987, drawing huge crowds as well as the glare of the media. Gallery-goers were invited first to view the original painting in the church, then proceed across the street to view Warhol's versions. While in Milan, Warhol continued to feel the stomach pains that would lead to his death two weeks later on February 22, 1987.

This interview was conducted by the Australian writer and curator Paul Taylor, editor of the influential Melbourne-based magazine Art + Text. *Taylor died of AIDS a week after his 35th birthday in 1992.*

When printed, this interview contained the postscript: "This is the last interview with Andy Warhol, which took place just before the opening of Il Cenacolo (The Last Supper) exhibition in Milan." However, judging by the conversation, it is clear that the interview was conducted in New York City several months before the Milan show was confirmed, thus calling into question whether this is, in fact, Andy Warhol's last interview.

—KG

PAUL TAYLOR: You are going to be showing your *Last Supper* paintings in Milan this year.

ANDY WARHOL: Yes.

PT: When did you make the paintings?

AW: I was working on them all year. They were supposed to be shown in December, then January. Now I don't know when.

PT: Are they painted?

AW: I don't know. Some were painted, but they're not going to show the painted ones. We'll use the silkscreened ones.

PT: On some of them you have camouflage over the top of the images. Why is that?

AW: I had some leftover camouflage.

PT: From the self-portraits?

AW: Yeah.

PT: Did you do any preparatory drawings for them?

AW: Yeah, I tried. I did about forty paintings.

PT: They were all preparatory?

AW: Yeah.

PT: It's very odd to see images like this one doubled.

AW: They're just the small ones.

PT: The really big one is where there are images upside down and the right way up.

AW: That's right.

PT: It's odd because you normally see just one Jesus at a time.

AW: Now there are two.

PT: Like the two Popes?

AW: The European Pope and the American Pope.

PT: Did you see Dokoupil's show at Sonnabend Gallery?

AW: Oh no, I haven't gone there yet. I want to go on Saturday.

PT: It might be the last day. There you will see two Jesuses on crucifixes, one beside the other.

AW: Oh.

PT: And he explained to me something like how it was transgressive to have two Jesuses in the same picture.

AW: He took the words out of my mouth.

PT: You're trying to be transgressive?

AW: Yes.

PT: In America, you could be almost as famous as Charles Manson. Is there any similarity between you at the Factory and Jesus at the *Last Supper*?

AW: That's negative, to me it's negative. I don't want to talk about negative things.

PT: Well, what about these happier days at the present Factory? Now you're a corporation president.

AW: It's the same.

PT: Why did you do the *Last Supper*?

AW: Because Iolas asked me to do the *Last Supper*. He got a gallery in front of the other *Last Supper*, and he asked three or four people to do *Last Suppers*.

PT: Does the *Last Supper* theme mean anything in particular to you?

AW: No. It's a good picture.

PT: What do you think about those books and articles, like Stephen Koch's *Stargazer*, and a 1964 *Newsweek* piece called "Saint Andrew," that bring up the subject of Catholicism?

AW: I don't know. Stephen Koch's book was interesting because he was able to write a whole book about it. He has a new book out which I'm trying to buy to turn into a screenplay. I think it's called *The Bride's Bachelors* or some Duchampy title. Have you read it yet?

PT: No, I read the review in *The New York Times Book Review*.

AW: What did it say?

PT: It was okay.

AW: Yeah? What's it about?

PT: Stephen Koch described it to me himself. He said it was about a heterosexual Rauschenberg figure in the '60s, a magnetic artist who has qualities of a lot of '60s artists. He has an entourage. I don't know the rest.

AW: I've been meaning to call him and see if he can tell me the story and send me the book.

PT: Who's making a screenplay?

AW: We thought that we might be able to do it.

PT: It's a great idea. Would you be able to get real people to play themselves in it?

AW: I don't know. It might be good.

PT: Do you have screenwriters here?

AW: We just bought Tama Janowitz's book called *Slaves of New York*.

PT: Does that mean you're going back into movie production?

AW: We're trying. But actually what we're working on is our video show, which MTV is buying.

PT: *Nothing Special?*

AW: No, it's called *Andy Warhol's Fifteen Minutes*. It was on Thursday last week and it's showing again Monday and it'll be shown two more times: December, and we're doing one for January.

PT: Do you make them?

AW: No, Vincent works on them. Vincent Fremont.

PT: Do you look through the camera on these things at all?

AW: No.

PT: What's your role?

AW: Just interviewing people.

PT: If there was a movie made out of Stephen Koch's novel, what would be your role in it?

AW: I don't know. I'd have to read it first.

PT: It's not usual for business people to talk about these deals before they make them.

AW: I don't care if anyone . . . there's always another book.

PT: I saw Ileana [Sonnabend] today and asked her what I should ask you, and she said "I don't know. For Andy everything is equal."

AW: She's right.

PT: How do you describe that point of view?

AW: I don't know. If she said it she's right. (*Laughs.*)

PT: It sounds Zennish.

AW: Zennish? What's that?

PT: Like Zen.

AW: Zennish. That's a good word. That's a good title for . . . my new book.

PT: What about your transformation from being a commercial artist to a real artist?

AW: I'm still a commercial artist. I was always a commercial artist.

PT: Then what's a commercial artist?

AW: I don't know—someone who sells art.

PT: So almost all artists are commercial artists, just to varying degrees.

AW: I think so.

PT: Is a better commercial artist one who sells more work?

AW: I don't know. When I started out, art was going down the drain. The people who used to do magazine illustrations and the covers were being replaced by photographers. And when they started using photographers, I started to show my work with galleries. Everybody also was doing window decoration. That led into more galleries. I had some paintings in a window, then in a gallery.

PT: Is there a parallel situation now?

AW: No, it just caught on so well that there's a new gallery open every day now. There are a lot more artists, which is real great.

PT: What has happened to the idea of good art?

AW: It's all good art.

PT: Is that to say that it's all equal?

AW: Yeah well, I don't know, I can't. . . .

PT: You're not interested in making distinctions.

AW: Well no, I just can't tell the difference. I don't see why one Jasper Johns sells for three million and one sells for, you know, like, four hundred thousand. They were both good paintings.

PT: The market for your work has changed a little in the last few years. To people my age—in their twenties—you were always more important than to the collecting group of people in their fifties and sixties.

AW: Well, I think the people who buy art now are these younger kids who have a lot of money.

PT: And that's made a difference in your market.

AW: Yeah, a little bit.

PT: How important is it for you to maintain control?

AW: I've been busy since I started—since I was a working artist. If I wasn't showing in New York I was doing work in Germany, or I was doing portraits.

PT: What I mean is that as more and more artists come up, and as new galleries open every day, the whole idea of what an artist is changes. It's no longer so special, and maybe a more special artist is one who maintains more control of his or her work.

AW: I don't know. It seems like every year there's one artist for that year. The people from twenty years ago are still around. I don't know why. The kids nowadays—there's just one a year. They stay around, they just don't. . . .

PT: You were identified with a few artists a couple of years ago—Kenny Scharf, Keith Haring.

AW: We're still friends.

PT: But I never see you with any of this season's flavors.

AW: I don't know. They got so much press. It was great. I'm taking photographs now. I have a photography show at Robert Miller Gallery.

PT: And there's going to be a retrospective of your films at the Whitney Museum.

AW: Maybe, yes.

PT: Are you excited about that?

AW: No.

PT: Why not?

AW: They're better talked about than seen.

PT: Your work as an artist has always been so varied, like Leonardo. You're a painter, a film maker, a publisher. . . . Do you think that's what an artist is?

AW: No.

PT: Can you define an artist for me?

AW: I think an artist is anybody who does something well, like if you cook well.

PT: What do you think about all the younger artists now in New York who are using Pop imagery?

AW: Pretty good.

PT: Is it the same as when it happened in the '60s?

AW: No, they have different reasons to do things. All these kids are so intellectual.

PT: Did you like the Punk era?

AW: Well, it's still around. I always think it's gone but it isn't. They still have their hard-rock nights at the Ritz. Do you ever go there?

PT: No. But Punk, like Pop, might never go away.

AW: I guess so.

PT: How's *Interview* going?

AW: It's not bad.

PT: You're going to be audited soon for the Audit Bureau of Circulations.

AW: Yeah, they're doing it now.

PT: What difference will it make?

AW: I don't know.

PT: It will be better for advertising. . . .

AW: Yeah.

PT: What's the circulation now?

AW: 170,000. The magazine's getting bigger and bigger.

PT: What magazines do you read?

AW: I just read everything.

PT: You look at everything. Do you read the art magazines?

AW: Yeah. I look at the pictures.

PT: You've been in trouble for using someone else's image as far back as 1964. What do you think about the legal situation of appropriated imagery, and the copyright situation?

AW: I don't know. It's just like a Coca-Cola bottle when you buy it, you always think that it's yours and you can do whatever you like with it. Now it's sort of different because you pay a deposit on the bottle. We're having the same problem now with the John Wayne pictures. I don't want to get involved, it's too much trouble. I think that you buy a magazine, you pay for it, it's yours. I don't get mad when people take my things.

PT: You don't do anything about it?

AW: No. It got a little crazy when people were turning out paintings and signing my name.

PT: What did you think about that?

AW: Signing my name to it was wrong but other than that I don't care.

PT: The whole appropriation epidemic comes down to who is responsible for art. If indeed anyone can manufacture the pictures of those flowers, the whole idea of the artist gets lost somewhere in the process.

AW: Is that good or bad?

PT: Well, first of all, do you agree with me?

AW: Yes, if they take my name away. But when I used the flowers, the original photograph was huge and I just used one square inch of the photo and magnified it.

PT: What do you ever see that makes you stop in your tracks?

AW: A good display in a window . . . I don't know . . . a good-looking face.

PT: What's the feeling when you see a good window display or a good face?

AW: You just take longer to look at it. I went to China, I didn't want to go, and I went to see the Great Wall. You know, you read about it for years. And actually it was great. It was really really really great.

PT: Have you been working out lately?

AW: I just did it.

PT: How much are you lifting now?

AW: 105 pounds.

PT: On the benchpress? That's strong.

AW: No, it's light. You're stronger than me, and fitter and handsomer and younger, and you wear better clothes.

PT: Did you enjoy the opening party thrown by GFT at the Tunnel?

AW: I had already been there before.

PT: In the sixties you mean?

AW: (*Laughs.*) No—the manager or someone took me around it a few days ago.

PT: It's a very convenient club for the Bridge and Tunnel people—they'll be able to come in on those tracks from New Jersey.

AW: I don't know whether it was my idea to call it the Tunnel or whether it was someone else's idea that I liked, but I think it's a good name.

PT: And lots of people turned out for Claes Oldenburg's show that night.

AW: He looked happy. A lot of people said he looked happy. I always liked Claes actually. You looked great the other night. I took lots of photos of you in your new jacket.

PT: Yes? How did I turn out?

AW: They haven't come back yet. Next time you come by I'll take some close-ups.

PT: For the Upfront section of *Interview* perhaps? Except that I'm not accomplished enough.

AW: You could sleep with the publisher.

PT: If you were starting out now, would you do anything differently?

AW: I don't know. I just worked hard. It's all fantasy.

PT: Life is fantasy?

AW: Yeah, it is.

PT: What's real?

AW: Don't know.

PT: Some people would.

AW: Would they?

PT: Do you really believe it, or tomorrow will you say the opposite?

AW: I don't know. I like this idea that you can say the opposite.

PT: But you wouldn't in this case?

AW: No.

PT: Is there any connection between fantasy and religious feeling?

AW: Maybe. I don't know. Church is a fun place to go.

PT: Do you go to Italy very often?

AW: You know we used to make our films there.

PT: And didn't you have a studio in the country for a while?

AW: Outside of Rome.

PT: And did you go to the Vatican?

AW: We passed by it every day.

PT: I remember a polaroid you took of the Pope.

AW: Yeah.

PT: Did you take that from very close up?

AW: Yes. He walked past us.

PT: And he blessed you?

AW: I have a photo of him shaking Fred Hughes's hand. Someone wanted us to make a portrait of the Pope and they've been trying to get us together but we can't and by now the Pope has changed three times.

PT: Fred said he used to feel like the Pope in the old Factory in Union Square. He used to go out on that balcony and wave at the passing masses underneath.

AW: He has a balcony now.

PT: Yes, but from the current Factory he can only see the reception area.

AW: He can wave.

PT: And sometimes it's just as busy as Union Square too.

Afterword Warhol's Interviews

WAYNE KOESTENBAUM

1.

Andy Warhol, like Blossom Dearie, was a vocal artist: he did strange things with standards. He underspoke them. A chanteuse is supposed to "sell" the song. Andy, like Blossom, stinted the standard, gave it less, in order to give (secretly) more. He sidestepped the interlocutor's assignments. Andy's idea of an "I–Thou" relation was a talk show; both guest and host were gods, momentarily. Momentary was the only way to be. And the space of an answer—yes, no, maybe—gave Warhol room enough to stretch his fairy amplitude.

2.

He sang the *dumb* notes, the mute, anesthetized, autistic micropitches that ghost the public, declaimable melody. When Warhol's responses to questions sound inane, they interrogate our discourses of inanity. (See Avital Ronell's smart study, *Stupidity*.) When Warhol gives a girly answer, he insists on art's link to the tawdriest masquerades, the skankiest trannies. When Warhol praises porn, he pushes art's button; when Warhol announces that he's quitting painting, he rises to Sistine heights.

3.

The culture police want to limit creators to one medium, one stance. Paint, but don't make films. Write essays, but don't star in soaps. Be a docent, but don't be a public indecency. Warhol spread himself thin; the interview is one more slice of bread he insisted on buttering. Space hog, he laid permanent claim to the word *interview* by publishing a magazine with that name. His own liminal behavior, whether seen or unseen, exposed the *inter* within the *view*: vision, according to Warhol, is always cut, interrupted, interposed by a wedge of thirdness. Warhol's interviews, gathered here, play the wedge game with indisputable mastery.

4.

Like a decadent's Christ or Saint Sebastian, Warhol struck the pose of *being-stigmatized*. A journalist's hostile, unknowing questions can be acts of discursive violence. As if imitating Wilde's 1895 trial, Warhol torqued the witness stand, through irony and camp, into a tea party, and taught us how to circumvent intimidation by mesmerizing the bully.

5.

Andy wanted to be left alone, and yet he paradoxically pretended to seek interpersonal encounter; into the unsafe space of the interview, he inserted not his own, vulnerable, actual body, but a replacement body, a mannequin, a dummy. *It looks like me, but it's not. I'm elsewhere. I seem to be answering your questions, but don't be fooled. Transcendentally indifferent to your groveling, literal-minded suppositions, I protect you from my barbed fury by absenting myself from the scene of polite exchange. I'm priceless: off the market. I'm only pretending to take part in art's barter system.*

6.

Like Chaplin, Warhol impersonated *tramp* and *fool*: he also played *horny* and *moneygrubbing*. Those were four stock roles in the one-reel comedies that interviews, in his transmuting hands, became. Like Stein, Warhol performed *simpleton*; direct statement—American declarativeness—suited his temperament, which was not, in the last analysis, evasive or olympian, but nakedly confrontational. *Nude* was his favorite condition: nude restaurant, nude philosophy, nude cognition, nude art, nude anything. Put *nude* in the adjectival slot, and the noun automatically gets upgraded. Andy gave nude interviews. He *denuded* interlocution—stripped it, turned it into Laurel and Hardy, or Vladimir and Estragon. Or into a spooky mirror scene, two hand puppets operated by one puppeteer. Andy's den of interlocution transparently gave onto other rooms, other scenes, other instances of revenge, equalization, and vertigo. Reading (or watching) a Warhol interview, we're never neatly *outside* it. Because Warhol isn't exactly within his body, he nudges the interviewer, too, a few millimeters away from pat

embodiment. Andy's aim, in the interviews, is ambient destabilization. He unhinges everyone in the vicinity—especially those who think they know the difference between good and bad art, between worthwhile and useless behavior, and between elation and depression.

7.

Warhol's affect is poised between happiness and sadness, between a speedy emptiness and a lethargic fullness. We can't pinpoint his mood, and we may, sympathetically, wish to ask: *is Andy okay?* Do the interviews prove that he is ailing, or do they demonstrate his resilience, his at-homeness, his immunity? Interviews—like any of his screens, whether silk or silver— hardly offer unmediated revelation. They offer, instead, a cage: Warhol, playing Houdini, escapes conversation's captivity. His interviews perform a drag-act of imprisonment within unsympathetic interlocution; in doing so, they paint a day-glo exit sign that we would be well advised, as Warhol's acolytes and inheritors, to follow.

Acknowledgments

The trail leading to the inception of this book goes back to a dinner in New York City's Chinatown with Ken Freedman and Hank Lewis several years ago. As summer was approaching, the conversation naturally turned to beach reading, whereupon Hank suggested *POPism* as the perfect summer book. A few days later, I picked up a battered copy of it at the 26th Street flea market, and I became intrigued with all things Andy.

Fast-forward to the summer of 2002: my favored beach book was *Spontaneous Mind: Allen Ginsberg Selected Interviews 1958–1996* edited by David Carter. That summer, while in the Madison Square Park playground, I happened to mention how much I was enjoying Carter's book to another dad, Tad Crawford, who told me that he knew David Carter and he was sure that David would be pleased to learn how engaged I was with his book. He gave me David's phone number, and a meeting was arranged.

Meeting David Carter was a godsend. His book—an example of excellence in this field—is the standard to which I've to edited my own; my work lives in the shadow of Carter's achievement. A long lunch at Tea & Sympathy in the West Village provided me with a road map: I heard of the potential pitfalls, the snakes in the grass, and was warned of the landmine-laden permissions business. We discussed the vast differences between Warhol and Ginsberg and chuckled over how different the end results would be (Ginsberg's legendary loquaciousness vs. Warhol's enigmatic quips, to mention but one example). Over the course of writing this book, I called upon David several times to draw from his vast knowledge and experience. I cannot thank him enough for his generosity and for the inspiration he has provided to me.

While I had a hunch that there was plenty of Warhol interview material to be found, I didn't have any idea of its depths until I encountered Matt Wrbican, archivist of The Andy Warhol Archives at the Warhol Museum in Pittsburgh. With good humor and patience, Matt led me through the dizzying maze of Warhol's *Time Capsules*, where much of this material came from. During my two visits to the Museum, Matt was constantly making suggestions about great hidden pieces, while tossing off arcane anec-

dotes of the circumstances surrounding many of the interviews. Without Matt and the Andy Warhol Archives, this book would not exist.

Greg Pierce, of the film and video archives at the Andy Warhol Museum, was equally generous. Drawing from the vast amount of Warhol footage, Greg was able to pinpoint exactly what I needed for my project. His knowledge in this field and intimacy with the material is unparalleled. I wish to thank him and Geralyn Huxley for making available to me obscure and difficult-to-find Warhol interviews on film and video. Thanks also to Clovis Young, George Reider, Lucy Raven, and Jim Thomas for making my Pittsburgh stays more comfortable.

Back in New York, I want to thank Tan Lin for introducing me to Neil Printz, co-editor of *Andy Warhol Catalogue Raisonne: Paintings and Sculpture, 1961–1963*. I showed Neil all the material I collected at the Warhol Archive over lunch at Bottino in Chelsea, and he generously gave advice about the organization and selection of the interviews. This was greatly enhanced by Neil's introduction to Calle Angel, adjunct curator of the Andy Warhol Film Project at the Whitney Museum of American Art, who on several occasions provided leads to authors and helped shape the contents of the book. Without her input, this book would have been a much lesser work.

Of the many contacts that Neil Printz provided me with, few were as valuable as his introduction to Michael Hermann, Assistant Director of Licensing at the Warhol Foundation. Michael must be one of the most in-demand people in the Warholian universe, and I wish to thank him for taking my project with as much seriousness as he would have with a more lucrative—and sexy—project.

I had the good fortune to host Gerard Malanga on my WFMU radio show following the publication of his book *Archiving Warhol*. He regaled the listeners for three solid hours with poetry, music, and detailed reminiscences of his years with Andy. My radio encounter with Gerard served as an impetus to gather this material; he has been unfailingly generous with his materials and knowledge.

On the air with Gerard, he mentioned a show, *Andy Warhol Work and Play*, that he was going to be involved with at the Fleming Museum in

Burlington, Vermont. Curious, I looked up the show online and ordered the catalog. I couldn't believe my eyes when I read the introductory essay by Reva Wolf, "Work Into Play: Andy Warhol Interviews." Right then and there I knew I had to have Reva write the introduction to my book. A trip to New Paltz to visit her turned out to be an informative and pleasant early summer afternoon; we swapped our Warhol interview collections and shared trade secrets. Upon returning, my cache of interviews had increased twofold. Much of the material in this book comes from Reva's collection. I am grateful to be associated with such a staggeringly original and open-minded intellectual.

One night in the fall of 2002, after attending an Alan Licht performance at the Marianne Boesky Gallery, I was having a drink with the poet and scholar Michael Scharf. I mentioned that I was doing this book, and he asked who I'd like to write the preface. Jokingly, I said Wayne Koestenbaum, feeling that such a well-known New York figure and Warhol expert was far out of my league. Offhandedly, Michael said that he had studied with Wayne at the CUNY Grad Center and that they were still friendly; he offered to make an introduction when the time was right. That time was July, 2003, when the three of us met for coffee at La Gamin in West Chelsea. After an hour of frantic gossip, I asked Wayne if he'd be interested in writing a preface to the book, to which he answered yes. I responded that I was flattered but wasn't he "finished" with Warhol after spending so long working on his Penguin biography? "No," he answered, "my infatuation with Warhol just keeps on growing."

The scholar Marcus Boon suggested that I get in touch with Victor Bockris and helped me to make that connection. My weekly meetings over breakfast with Victor in a small West Village café were delightful. He is one of the greatest talkers I've ever met, and I would sit astonished as he regaled me with tales of the New York underground from days gone by. His keen editorial eye, careful proofreading, and fact-checking of the manuscript helped shape the final book. He made numerous suggestions and offered limitless advice gleaned from his years in the biographical trenches, all of which helped enrich this project.

In a pinch while looking for an elusive reference, I took a chance and e-mailed Billy Name, not knowing if I was going to get a response. However, not only did I get a response, but I received a flood of invaluable information. I cannot thank him enough for his work, his generosity, and his cooperation.

Thanks to Alain Cueff for garnering European support of this book. He is truly a kindred spirit.

Parents always mean well, but their helpfulness in professional matters is often less than helpful. Except for this book. While it was still a vague idea in my head, my mother, Judy Goldsmith, suggested that I meet Bob Markel, a literary agent, who was dating her business partner. One cold December afternoon in 2002, Bob came to my loft to discuss the project. After he left, I knew Mom had steered me right.

Bob connected me with my editor at Carroll & Graf, Philip Turner, who has been responsive and thorough with this manuscript, helping mold it into what it is today.

Although I've never met him, I must acknowledge Gary Comenas, creator of warholstars.org, a site I visited daily during my research. Gary's site could be the very best resource on Andy Warhol there is—either in print or on the Web.

Thanks to the following people who helped me track down interviews or interviewers: Michael Denneny, Michael Gerber, Susan G. Graham, Trina Higgins, Craig Highberger, Geralyn Huxley, Thom Hollinger, Paula Krimsky, Olivier Landemaine, Jules Lipoff, Lindsay Mann, Patrick Merla, Lylian Morcos, Elizabeth Neumann, Michele Robecci, Judy Sall, Grace L. Scalera, Alan Schwartz, Dan Streible, and The Andy Warhol Archives, Pittsburgh.

Finally, thanks to my interested and patient wife, Cheryl Donegan, who was exposed to every twist and turn on this long road. I owe you one, pal.

Bibliography

Bourdon, David. *Warhol*. New York: Harry N. Abrams, 1989.

Castle, Frederick Ted. *Gilbert Green: The Real Right Way to Dress for Spring* Kingston, N.Y.: McPherson & Company, 1986.

Colacello, Bob. *Holy Terror: Andy Warhol Close Up*. New York: HarperCollins, 1990.

Gelmis, Joseph. *The Film Director as Superstar*. Garden City, N.Y.: Doubleday & Company, 1972.

Koestenbaum, Wayne. *Andy Warhol*. New York: Viking Penguin, 2001.

Malanga, Gerard. *Archiving Warhol*. www.creationbooks.com: Creation Books, 2002.

McShine, Kynaston, ed. *Andy Warhol: A Retrospective*. New York: The Museum of Modern Art, 1989.

Michelson, Annette, ed. *October Files: Andy Warhol*. Cambridge, Mass.: The MIT Press, 2001.

Morrison, Catherine: "My 15 Minutes." *The Guardian*, 14 Feb. 2002.

Siegel, Jeanne. *Art Talk: The Early 80s*. New York: Da Capo, 1990.

Smith, Patrick. *Warhol*. Ann Arbor, Mich.: UMI Research Press, 1988.

Warhol, Andy. *America*. New York: Harper & Row, 1985.

Warhol, Andy. *Andy Warhol's Exposures*. New York: Andy Warhol Books/Grosset & Dunlap, 1979.

Warhol, Andy. *Andy Warhol's Index (Book)*. New York: Black Star Books/Random House, 1967.

Warhol, Andy. *POPism: The Warhol '60s*. New York and London: Harcourt Brace Jovanovich, 1980.

Warhol, Andy. *The Andy Warhol Diaries*, edited by Pat Hackett. New York: Warner Books, 1989.

Warhol, Andy. *THE Philosophy of Andy Warhol (From A to B and Back Again)*. New York: Harcourt Brace & Company, 1975.

Warholstars.org: http://www.warholstars.org

Notes to Introduction by Reva Wolf

1 Reprinted here, on p. 5.

2 Reprinted here, on p. 65.

3 Leonard Shecter, "The Warhol Factory," *New York Post*, 23 February 1966.

4 Reprinted here, on p. 162

5 David Bailey, *Andy Warhol* (television documentary transcription) (London: Bailey Litchfield/Mathews Miller Dunbar, 1972), unpaged.

6 Reprinted here, on p. 222.

7 A similar, and similarly prescribed, set of questions tends to characterize literary interviews too, as Bruce Bawer has observed in his fascinating essay, "Talk Show: The Rise of the Literary Interview," *American Scholar* 57 (Summer 1988): 428.

8 Michael Kimmelman, *Portraits: Talking with Artists at the Met, the Modern, the Louvre and Elsewhere* (New York: Random House, 1998). Kimmelman, chief art critic for the *New York Times*, concludes his introduction to this volume with the observation that his interviews "prove . . . that new art is always, in some basic way, a commentary on the past" (xviii). Warhol would have been a poor interview subject for Kimmelman, given Kimmelman's stated aim "to show that good artists, of different sorts, can talk straight about art" (x).

9 Reprinted here, on p. 198.

10 It should be noted, however, that in this same interview Warhol did talk with admiration about Newman's *Broken Obelisk* sculpture (1963–67), which is placed in front of the Rothko Chapel in Houston. Here it is worth pointing out, first, that the de Menil family, which had strong links to Warhol's business associate Fred Hughes, had acquired this particular sculpture; and second that Jeanne Siegel, as an interviewer, seemed better able to draw Warhol out than many others of those who interviewed him.

11 Judd Tully, "Artists on Picasso," *Horizon* 23 (April 1980): 50, 49, and 48, respectively.

12 Ibid., 50.

13 Several of his interactions with Paloma are recorded in *The Andy Warhol Diaries*, edited by Pat Hackett (New York: Warner Books, 1989); see, for example, pages 11–12, 45, 67, 133, 137, 262, 296–7 (where he discusses the interview with her), 336–7, 344, 383, 389, 414, 473, 559, and 601.

14 See Warhol and Pat Hackett, *POPism: The Warhol '60s* (New York: Harcourt Brace Jovanovich, 1980), 72, 82, 114, and 196.

15 Bob Colacello described this particular interview in his book *Holy Terror: Andy Warhol Close Up* (New York: HarperCollins, 1990), 65.

16 Ibid., 64–5.

17 Warhol described his sensitivity to this issue in *POPism*, 11–13. For an insightful analysis of Warhol's and Johns's sexual identities, see Ken Silver, "Modes of Disclosure: The Construction of Gay Identity and the Rise of Pop Art," in *Hand-Painted Pop: American Art in Transition, 1955–62*, ed. Russell Ferguson (Los Angeles: Museum of Contemporary Art; New York: Rizzoli, 1992), 193–97.

18 Reprinted here, on p. 120.

19 Reprinted here, on p. 393.

20 Paul C. Doherty, "The Rhetoric of the Public Interview," *College Composition and Communication* 20 (February 1969): 23. On the collaborative character of the interview, also see, for example, Elliot G. Mishler, *Research Interviewing: Context and Narrative* (Cambridge, Mass.: Harvard University Press, 1986), chapter 3 ("The Joint Construction of Meaning").

21 Jean-Claude Lebensztejn, "Eight Interviews/Statements," *Art in America* 63 (July–August 1975): 75.

22 See p. 3 here. In the social sciences, the act of reversing roles, or taking the role of the other, is sometimes called "symbolic interaction"; see Herbert Blumer, *Symbolic Interaction: Perspective and Method* (Englewood Cliffs, N. J.: Prentice-Hall, 1969), and William Foddy, *Constructing Questions for Interviews and Questionnaires: Theory and Practice in Social Research* (Cambridge, England: Cambridge University Press, 1993), 19–21.

23 John Rublowsky, *Pop Art* (New York: Basic Books, 1965), 112. Rublowsky here recognized that Warhol's statement was not meant simply as a way to avoid giving answers: "His answer is, of course, part of the pose. The probe

is deflected. Yet, it is not just a simple evasion. Warhol tells us, in effect, that a human being is a complex creature that is something more than the mere sum of his days."

24 Alan Solomon, introduction, *Andy Warhol* (Boston: Institute of Contemporary Art, 1966), unpaged. For a discussion of the television show for which Solomon interviewed Warhol, see Caroline A. Jones, *Machine in the Studio: Constructing the Postwar American Artist* (Chicago: University of Chicago Press, 1996), 91–3.

25 *The Philosophy of Andy Warhol (From A to B and Back Again)* (San Diego: Harcourt Brace Jovanovich, 1975), 78.

26 "The Austin Interview" (1965), published in *Bob Dylan: A Retrospective,* edited by Craig McGregor (New York: William Morrow, 1972), 162.

27 Christopher Lydon, "Sontag Erupts," *The Boston Phoenix,* 27 November 1992, 10.

28 This practice is discussed in Erik Barnouw, *The Golden Web: A History of Broadcasting in the United States,* vol. 2 (New York: Oxford University Press, 1968), 104.

29 Mary Morsell, "In Lighter Vein: Mickey Laments the Culture Circuit," *Art News,* 17 February 1934, 16.

30 Cleveland Amory, editor-in-chief, *International Celebrity Register,* U.S. edition (New York: Celebrity Register Ltd., 1959), 496.

31 See, for example, Ralph Flint, "Matisse Gives Interview on Eve of Sailing," *Art News,* 3 January 1931, 3–4 (this is the first interview with an artist to appear in the *Art News*), and Laurie Eglington, "Marcel Duchamp, Back in America, Gives Interview," *Art News,* 18 November 1933, 3 and 11.

32 The interviews were done with Gene Swenson and appeared in the November 1963 and February 1964 issues of *Artnews;* Warhol's interview is in the November issue. Reprinted here, on p. 15.

33 For an interesting analysis of how Warhol himself was attracted to the interview because, as with his other "pop" activities, "the vernacular and the mediated are undecidably confused," see Henry M. Sayre, *The Object of Performance: The American Avant-Garde since 1970* (Chicago: University of Chicago Press, 1989), 30.

34 For an interesting assessment of the *Paris Review* interviews, see Bawer, "Talk Show," 422–24.

35 Malcolm Cowley, introduction to *Writers at Work: The Paris Review Interviews* (New York: Viking, 1959), 3–4.

36 Alexander Eliot, foreword to Selden Rodman, *Conversations with Artists* (New York: Devin-Adair, 1957), viii.

37 Edgar Morin, *The Stars*, translated by Richard Howard (New York: Grove Press, 1960), 105; Ezra Goodman, *The Fifty-Year Decline and Fall of Hollywood* (New York: Simon and Schuster, 1961), 17; Jan Vansina, *Oral Tradition: A Study in Historical Methodology*, translated by H. M. Wright (Chicago: Aldine, 1965), chapter 4; and Erving Goffman, *The Presentation of Self in Everyday Life* (New York: Anchor Books, Doubleday, 1959). It has long been known that Warhol owned a copy of Morin's *The Stars*.

38 Daniel J. Boorstin, *The Image, or What Happened to the American Dream*, 25th anniversary edition, published as *The Image: A Guide to Pseudo-Events in America* (New York: Atheneum, 1987), 11.

39 Warhol and Hackett, *POPism*, 130.

40 Reprinted here, on p. 97.

41 Emile de Antonio and Mitch Tuchman, *Painters Painting: A Candid History of the Modern Art Scene, 1940–1970* (New York: Abbeville Press, 1984), 29.

42 Michael Pousner, "Andy, Baby! Watcha Up to these Days?" *Daily News*, 30 May 1972.

43 I offer another perspective on how these activities fit into Warhol's artistic production overall in my book, *Andy Warhol, Poetry, and Gossip in the 1960s* (Chicago: University of Chicago Press, 1997), 53, and chapter 5 (which is reprinted in *Experimental Film, The Film Reader*, ed. Wheeler Winston Dixon and Gwendolyn Audrey Foster [New York: Routledge, 2002]), 189–211.

44 Colacello, *Holy Terror*, 250–51.

45 *Andy Warhol* (Stockholm: Moderna Museet, 1968), unpaged.

46 Several television programs remained fifteen minutes long up until 1963; see Erik Barnouw, *The Image Empire: A History of Broadcasting in the United States*, vol. 3 (New York: Oxford University Press, 1970), 208 and 246.

47 See John Dunning, *Tune in Yesterday: The Ultimate Encyclopedia of Old-*

Time Radio 1925–1976 (Englewood Cliffs, N.J.: Prentice-Hall, 1976), 72 and 109, respectively.

48 See, for example, Robert Tyrrell, *The Work of the Television Journalist* (London: Focal Press, 1975); and James R. Ryals, "Successful Interviewing," *FBI Law Enforcement Bulletin* 60 (March 1991): 6–7.

49 See Robert K. Merton, Marjorie Fiske, and Patricia L. Kendall, *The Focused Interview: A Manual of Problems and Procedures*, 2nd edition (1956; New York: Free Press, 1990). In recent years it has been recognized that both "open" and "closed" approaches to interviewing can produce evasive or obscure results; see, for example, William Foddy, *Constructing Questions for Interviews and Questionnaires*, 151–52.

50 Boorstin, *The Image*, 15.

51 See p. 5 here. One journalist even compared Warhol's interviewing approach to that of the politician: "Although he loves to be interviewed, Andy has a politician's polish and poise in delivering nonanswers" (Pousner, "Andy, Baby!").

52 Of course, published Q&A interviews are edited and therefore do not record verbatim what Warhol said; yet we can be fairly sure that the pattern I have described here is an accurate characterization of Warhol's behavior in interviews, since it is evident in several of them. One good example is a conversation he participated in along with two other artists, and a moderator, that was broadcast on the radio in 1964 and published, in an edited form, two years later. Early on in this conversation, when asked how he got involved with pop imagery, Warhol replied that he was too high to respond, and recommended that the moderator ask someone else a question. However, as the discussion progressed (and was not focused on him), he began to speak up, observing, for instance, when the topic turned to Lichtenstein's comic-strip paintings, that because of such art, comic strips now acknowledged their creators when previously they had not. See Bruce Glaser, "Oldenburg, Lichtenstein, Warhol: A Discussion," *Artforum* 4 (February 1966): 20–24.

53 Bennard B. Perlman, "The Education of Andy Warhol," *The Andy Warhol Museum: The Inaugural Publication* (Pittsburgh: Andy Warhol Museum, 1994), 153.

54 Sterling McIlhenny and Peter Ray, "Inside Andy Warhol," on p. 109 here; and Glenn O'Brien, "Interview: Andy Warhol," on p. 250 here.

55 See p. 119 here.

56 "Warhol's Latest: The Silent Show," *New York Post*, 10 October 1967.

57 Warhol spoke of Allen Midgette's performances as Warhol in *POPism*, 247–48.

58 On the interview as a "speech event," see chapter 2 of Elliot G. Mishler's *Research Interviewing: Context and Narrative*.

59 Lois Shirley, "The Girl Who Played Greta Garbo," *Photoplay* (August 1929); reprinted in *The Talkies: Articles and Illustrations from a Great Fan Magazine, 1928–1940*, edited by Richard Griffith (New York: Dover Publications, 1971), 133 and 309.

60 On the characterization of Debbie Reynolds as a machine, see *International Celebrity Register*, 618; Marilyn Monroe's comments were published (just a few days before her death) in *Life*, 3 August 1962, 34.

61 This narrow assessment of Warhol's statement led, early on, to analyses such as Paul Bergin's in "The Artist as Machine," *Art Journal* 26 (summer 1967): 359–63, and, later, to more theoretical interpretations as in Thierry de Duve's "Andy Warhol, or, the Machine Perfected" (translated by Rosalind Krauss), *October* 48 (Spring 1989): 3–14. Another fruitful context for understanding Warhol's remark, aside from the language of Hollywood, is within the popularization of cybernetics in the 1950s and early 1960s, in paperback volumes by Norbert Wiener, W. Sluckin, Morris Phillipson, and other writers.

62 Jean-Pierre Lenoir, "Paris Impressed by Warhol Show," *New York Times*, 18 May 1965.

63 Gretchen Berg, "Andy Warhol: My True Story"; see p. 93 here.

64 Matthew Collings, "Andy Warhol," *Artscribe International* 59 (September–October 1986): 44.

65 Lenoir, "Paris Impressed by Warhol Show."

66 Warhol, *Philosophy*, 92; Duchamp's remark was quoted in *International Celebrity Register*, 223.

67 Walter Hopps, "An Interview with Jasper Johns," *Artforum* 3 (March 1965):

34; and Paul Taylor, "Andy Warhol: The Last Interview," *Flash Art International* 133 (April 1987): 41. ✦ *Reprinted here, p. 383 ff.*

68 Peter Selz, "Pop Goes the Artist," *Partisan Review* 30 (Summer 1963); reprinted as "The Flaccid Art" in *Pop Art: The Critical Dialogue*, ed. Carol Anne Mahsun (Ann Arbor: UMI Research Press, 1989), 80–81.

69 John Ashbery, "Andy Warhol in Paris," *New York Herald Tribune* (International Edition), 17 May 1965; reprinted in Ashbery, *Reported Sightings: Art Chronicles 1957–1987*, ed. David Bergman (New York: Alfred A. Knopf, 1989), 121.

70 G. E. [guest editors Clem Goldberger, Jan Lavasseur, and Joanna Romer], "Warhol," *Mademoiselle* 65 (August 1967): 325. For two examples of his subsequent repetition of this claim, see Neal Weaver, "The Warhol Phenomenon: Trying to Understand It," *After Dark* (January 1969): 30, and Gelmis, *The Film Director as Superstar*, reprinted here on p. 161.

71 Warhol and Hackett, *Philosophy*, 180. In this passage, Warhol falsely claimed that earlier in his career he did not read the reviews of his work. In fact, he all along had collected reviews of his work as well as interviews with him. Elsewhere in the *Philosophy* book, he suggested that he had stolen phrases from his scrapbook clippings for the purpose of crafting a description of himself (p. 10). On Warhol's idea of using these scrapbook clippings for the *Philosophy* book, see also Colacello, *Holy Terror*, 207–8. Warhol not only incorporated the words of his critics into his verbal creations, but also sometimes gave these words a visual form; see my essay, "The Word Transfigured as Image: Andy Warhol's Responses to Art Criticism," *Smart Museum of Art Bulletin* 7 (1995–96): 9–17.

72 The question of whether an interview can be art—or literature—has appeared with increasing frequency in the past few decades. It is asked by Bruce Bawer in his essay, "Talk Show" (424), where the answer is, more or less, no; and more sympathetically, if with less complexity, by John Rodden in the introduction to his recent collection of interviews with writers, *Performing the Literary Interview: How Writers Craft their Public Selves* (Lincoln, NE: University of Nebraska Press, 2001).

Permissions

Every attempt was made to obtain permission for each interview in the present volume. However, due to the obscure nature of many of the publications in which the interviews first appeared, it has proven impossible to secure permission for all of them. If you claim copyright to work appearing in this volume, and it is not listed below, please contact us so that this oversight may be amended in future printings.

Index

About the Contributors

Kenneth Goldsmith's writing has been called some of the most "exhaustive and beautiful collage work yet produced in poetry" by *Publishers Weekly*. The author of seven books and editor of the online journal UbuWeb, Goldsmith is also a music writer for *New York Press* and host of a weekly radio show on New York City's WFMU. Goldsmith is a fellow in Poetics and Poetic Practice at the University of Pennsylvania. He lives in New York with his wife and child.

Reva Wolf has written extensively on Andy Warhol, his times, and his work. Most notable among these publications is *Andy Warhol, Poetry, and Gossip in the 1960s* (University of Chicago, 1997). Wolf is an associate professor of art history at the State University of New York at New Paltz, where she teaches courses on modern and contemporary art, and on art historical methodology

Wayne Koestenbaum, a professor of English at the Graduate Center of the City University of New York, is the author of five books of nonfiction (including a biography of Andy Warhol) and three books of poetry. In Fall 2004 he will publish a book-length poem, *Model Homes*, and his first novel, *Moira Orfei In Aigues-Mortes*.